With my
affection
Esther from
miguel'niece
Ma. Elena

COVARRUBIAS

Para Ester –

Con cariño –

Adriana Williams

San Francisco

3/ 14/ 2000

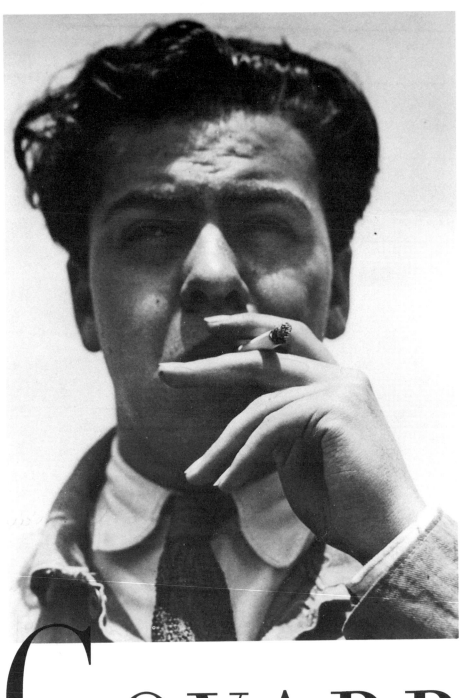

COVARRU

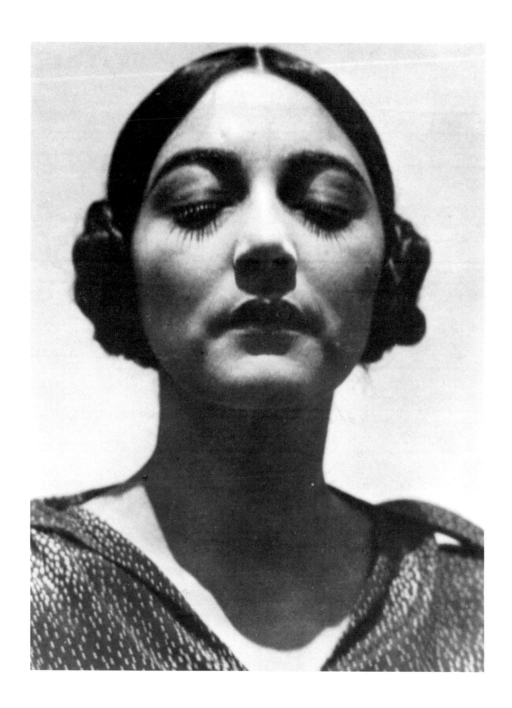

BIAS

By Adriana Williams
EDITED BY DORIS OBER
University of Texas Press
AUSTIN

Photographs on the title page: Miguel Covarrubias, ca. 1926, Rosa Covarrubias, ca. 1926. Photographs by Edward Weston. Collection of Rosa Covarrubias. © 1981 Center for Creative Photography, Arizona Board of Regents.

Publication of this book was made possible by a grant from the Sid W. Richardson Foundation.

Publication was also assisted by a generous contribution from Comerica Bank–Texas. In the past year, as Comerica Bank–Texas has more than doubled in size, so has its commitment to preserving the rich heritage of the arts in the communities in which it serves.

Four works of art by Amado Peña were donated by the artist to be sold in support of the book. The works were framed by Los Mercados Picture Framing (Arturo Mercado, owner) and Fine Arts Services (John Traber, owner). El Taller Gallery (Olga Piña, owner) provided space for the sale event.

First edition, 1994

Requests for permission to reproduce material from this work should be sent to Permissions, University of Texas Press, Box 7819, Austin, TX 78713-7819.

∞ The paper used in this publication meets the minimum requirements of American National Standard for Information Sciences—Permanence of Paper for Printed Library Materials, ANSI Z39.48-1984.

LIBRARY OF CONGRESS CATALOGING-IN-PUBLICATION DATA

Williams, Adriana, date
 Covarrubias / by Adriana Williams ; edited by Doris Ober. — 1st ed.
 p. cm.
 Includes bibliographical references (p.) and index.
 ISBN 0-292-79088-0 (alk. paper)
 1. Covarrubias, Miguel, 1904–1957. 2. Covarrubias, Rosa, d. 1970. 3. Mexico—Biography. 4. Illustrators—Mexico—Biography. 5. Cartoonists—Mexico—Biography. 6. Anthropologists—Mexico—Biography. 7. Archaeologists—Mexico—Biography. 8. Indian Art—Mexico—History. 9. Mexico—Civilization—Indian influences.
 I. Ober, Doris. II. Title.
 CT558.C68W55 1994
 920.07—dc20 94-4788

Designed by Ellen McKie

With love and gratitude to my husband,

TOM WILLIAMS,

*whose support and contributions have been
unfailing and profound.*

The transition between Vasconcelismo and Callismo; the birth of folklore. The interest in exotic Mexico, as exotic as the Bali which Miguel had put on the map, and about which Anita Brenner, Walter Pach, Bertram Wolfe, Carleton Beals and even D. H. Lawrence would write.

The Mexico discovered by Eisenstein; clouds and maguey and cactus photographed from the ground by the camera, images which remain with us; the modern photography of Mexican images of Paul Strand, Tina Modotti and Edward Weston. The Taxco rediscovered by Bill Spratling, who guided the resurrection of silver production; by Paca Toor, who came for summer classes and soon became the editor of **Mexican Folkways.**

Lyric anthropologists along with Guty Cárdenas and Tata Nacho, and in the midst of all this activity, "Chamaco," Miguel's smiling face, and the fiery figure of his wife on excursions with Moisés Sáenz, enthusiastic maecenas of artists and composers.

—SALVADOR NOVO,
"Novísimas, cartas a un amigo," on the death of Rosa Covarrubias,
for El Heraldo, 1 April 1970

CONTENTS

ACKNOWLEDGMENTS

This book would never have been written if not for Tomás Ybarra-Frausto, who persuaded and encouraged me from the beginning and helped me in the initial stages of information gathering. To reconstruct Miguel's life, I had to locate family members, friends, and colleagues. I began the work in 1984. Since then I have traveled from Bali, Indonesia, to Washington, D.C. and Salt Lake City, made ten trips to New York and Los Angeles, and more than twenty-five to Mexico in that pursuit.

I want to extend my deep gratitude to the following people who gave of their time and energy, and have become my friends in the course of this project: Ida Ayu Mediani, the young Balinese anthropologist, who for three weeks acted as my interpreter and introduced me to all those who had known Miguel and Rosa; Mary Anita Loos, who spent many hours talking to me, invited me to stay in her house, and lent me books, photographs, and other material relative to my subject; María Asúnsolo, with whom I met six times, and who tirelessly searched her memory for anything that might be of interest; María Elena Rico Covarrubias, who generously shared family documents and introduced me to other family members; Rocío Vinaver, who invited me to be her houseguest, provided letters, documents, and photographs, and her most intimate remembrances; Mimi Muray Levitt, who has been generous with her time and has given permission for the use of many wonderful photographs taken by her father; and Blair Paltridge, who used his innate sensitivity and well-earned expertise to prepare the photographic layout for the book.

I am especially grateful to Elena Poniatowska, whom I have had the pleasure of knowing, and whose sensitive and comprehensive interviews for *Novedades* with so many of Miguel's contemporaries contribute enormously to what we know of the artist today.

Many others deserve special thanks for having made time for personal interviews or informative telephone conversations:

In Bali, I Gusti Alit Oka Degut, Anak Agung Ngurah Gedé Sumatra, Anak Agung Gedé Mandera, Fernando Blanco, Anak Agung Gedé Sobrat, I Gusti Madé Sumung, and Ni Ketut Reneng.

In Mexico, Jorge Angulo, Raúl Anguiano, Sol Arguedas, Guillermo Arriaga, Luis Aveléyra Arroyo de Anda, Bil Baird, Zita Basich, Elisa García Barragan, Arnold Belkin, Conchita Dávila de Buelink, María Luisa Cabrera de Block and her daughter Malú Block, Daniel Brenman, Paz Celaya, Román Piña Chán, Alejandra Rico, Luis Covarrubias, Dr. Ester Chapa, Bertha Cuevas, José Luis Cuevas, Ruth and Leon Davidoff, Columba Domínguez, Carlos Espejel, Enrique Félix, Carmen López Figueroa, Gabriel Figueroa, Beatriz Flores, Víctor Fosado, Andrés Henestrosa, Alfa Henestrosa, Cibeles Henestrosa, Fernando Gamboa, Mathias Goeritz, Yolotl González, Esperanza Gómez, Elena Gordon, Eli Gortari, Josefina Lavalle, Ernesto González Licon, Tina Martin, Alberto Misrachi de Soni, Anna Misrachi, Columba Moya, Elías Nandino, Eric Noren, Dolores Olmedo, Nieves Orozco Field, Frederick Field, Guillermina Peñalosa, Vidya Peniche, Antonio Pineda, David Ramón, Rosa Reina, Carlos Rivas, Arturo Romano, Daniel Rubín de la Borbolla, Vilma Ruiz, Beatriz Tames, Manuel Ortiz Vaquero, and Arnoldo Martínez Verdugo.

In the United States, Eulogio Guzmán Acevedo, Michael Coe, Dorothy Cordry, Jeanette Bello, Katherine Dunham, Gordon Ekholm, André Emmerich, Al Hirschfeld, Lucas Hoving, Mae Hutchins, John Huston, Melanie Kahane, Bruce Kellner, Robin King, Rachel and Stan Knoblock, Frederick Field, Gordon Onslow-Ford, Sono Osato, Ruth Page, Ruth Lieb, Stanley Marcus, Nancy Oakes (the Baroness von Hoyningen-Huene), Ethel Smith, Muriel Porter Weaver, and Lucien Weil.

My research has taken me to many archives and libraries. A special thanks to these institutions and their representatives for providing material from their collections: Walter Brem, director of the Bancroft Library at the University of California in Berkeley; Lucía García-Noriega of the Centro Cultural Arte Contemporáneo in Mexico City; Norton Owen, director of the Limón Institute; Rona Roob, museum archivist at the Museum of Modern Art in New York; Genevieve Oswald, curator of the Dance Collection at the New York Library of Performing Arts; Ronald Ian Reicin of the Ruth Page Foundation; Steven L. Schlesinger, secretary of the John Simon Guggenheim Memorial Foundation; Darwin Stapelton, director, and Harold Oakville, archivist, at the Rockefeller Archives in Tarrytown, New York; the Evergreen House Foundation in Baltimore, Maryland; Barbara Tenenbaum, specialist in Mexican culture at the Library of Congress; Eniko Singer de Name, director of the Library, Universidad de las Américas, Puebla, Mexico; the Schomburg Center for Research in Harlem; and the Theatre Collection at the Museum of the city of New York.

I would also like to thank Lorraine O'Grady and Vanesa Krasner, special friends, who have encouraged and sustained me over these many years.

I am indebted and deeply grateful to my personal editor, Doris Ober, for her commitment and arduous work with me over the years. Her close scrutiny and skillful editing of the text along with her encouragement, patience, and understanding were vital to the success of this project.

On February 13, 1992, this book was contracted with the University of Texas Press. I owe a special acknowledgment to my editor there, Theresa May, the assistant director and executive editor, for her support and optimism and a heartfelt thanks to Carolyn Cates Wylie and to Laurie Baker, who had to do battle with my manuscript and unruly footnotes. To Zora Molitor and all those others behind the scenes at the University of Texas Press, I likewise offer my sincere gratitude.

Grateful acknowledgment is made to the following people for permission to reprint previously published text.

1. Jeanette Bello for use of poem in Olmec Notebooks.
2. María Elena Rico Covarrubias for the use of a MC corrido.

Grateful acknowledgment is made to the following people and organizations for permission to reproduce the photographs that appear in this book.

1. Center for Creative Photography for Edward Weston photographs, pp. ii, iii, 40.
2. Elin Elisofon for Eliot Elisofon photograph, p. 153.
3. Mary M. Gregory for Donald Cordry photographs, pp. 112, 124, 157.
4. George Eastman House for Steichen photograph, p. 16.
5. Evergreen House, The Johns Hopkins University for photograph of panel, p. 84.
6. Mimi Muray Levitt for photographs by Nickolas Muray, pp. xv, 31, 39, 119, 154, 160, 167, 170, 184, 187, 228, 232.
7. George Vinaver for Vinaver photographs, pp. 201, 206.
8. The Mexican Museum in San Francisco, photographs taken by Art and Clarity, color section.

INTRODUCTION

From the time of its independence from Spain in 1821 until the dictator Porfirio Díaz assumed governorship in 1877, Mexico operated under two emperors, several dictators, and a variety of presidents and provisional officers—an average of one new government every nine months. During the Porfiriato, as it is called, which lasted more than thirty years, the capital's population doubled, approaching half a million.

At the time, Tizapán was a quiet village twenty-five miles outside of Mexico City, a desert oasis of flowers and trees, open-air markets, and rambling colonial homes. Miguel and Rosa Covarrubias made their home here, at Number Five Calle Reforma. It became a well-known address in the 1930s and 1940s to both native and foreign artists of all disciplines. Many believed this period was Mexico's artistic Golden Age, and Number Five served Mexico City's intellectual and artistic membership as a gathering place much the way the Algonquin Hotel served New York's, or Virginia Woolf's home served London's, or Gertrude Stein's did Paris's.

A place of fascination for its visitors, Number Five was authentically Mexican, filled with the history of Mexico in an extraordinary collection of art that ranged from pre-Hispanic sculptures—work of the Olmecs and Aztecs—to Diego Rivera. The rooms were spacious, with floors tiled in big squares of burnished terra-cotta, and ceilings made of thatched palm and wood beams, and they were full of the color of Mexico—red brick and Taxco silver accenting whitewashed walls, brightly striped serapes draping chairs and sofas, yellow Talavera pottery exploding with red Aztec tiger lilies or deep purple bull orchids. The rooms were as expansive and colorful as their inhabitants: it was a place for passionate conversation, for new ideas, for planning, for laughter, for hope.

Today the splendid oasis that once flourished here is gone, along with its lush gardens. Tizapán is now a part of the larger metropolis of Mexico City, part of a population nearing twenty-five million—the largest city in the world—with

enormous social, economic, political, and physical problems compounded most recently by the crippling earthquake of 1985. The once grand city has fallen on very hard times. Its buildings are crumbling, its streets are clogged with traffic, the air is suffocating—on some particularly bad days around the Zócalo, the city's main plaza, birds fall dead from the sky.

Number Five still stands, but there is nothing left to remind one of its occupants, of the fabulous objects with which they surrounded themselves, of the friends who gathered there, or of that productive and creative age in which they lived. To recall that time, there is perhaps no better subject for biography than Miguel Covarrubias, one of the most versatile men in the artistic and cultural history of Mexico.

I first met Rosa and Miguel Covarrubias in New York City in 1940. They had come for the opening of "Twenty Centuries of Mexican Art" at the Museum of Modern Art, a show that Miguel had helped produce. During their stay, my mother, Artemisa Calles, the youngest daughter of the ex-President of Mexico, Plutarco Calles, gave a party for them at our apartment on Fifth Avenue. I don't exactly remember Miguel or Rosa on that occasion—I was seven years old at the time—although I do remember the party.

My mother was a Spanish classical dancer who had performed with the celebrated Spanish dancer, Argentinita, in the thirties in New York. In 1940 my mother was just beginning her own dance company. She counted among her friends many interesting artists and many mutual friends of the Covarrubiases. Among the guests that night was the photographer Nickolas Muray, one of Miguel's most intimate friends, who had just completed a series of publicity shots for my mother's new venture. The painter Rufino Tamayo and his wife Olga were other longtime friends of Miguel and Rosa who came. I remember Tamayo playing the guitar for us that night, with everyone singing raucous Mexican *corridos* and songs from then-popular musical reviews. I also remember a wonderfully handsome classical Hindu dancer, Uday Shankar, visiting from India; and Sima Leake, an orphan from the Soviet Union whom Isadora Duncan had taken under her wing and taught to dance. The Peruvian writer César Falcón was there, and many of my mother's other bohemian friends.

Over the years I saw the Covarrubiases occasionally in Mexico when we visited family there, but it was not until 1962 that I became close to Rosa. She was widowed by then, but she still lived in the magical house that she and Miguel had shared in Tizapán. She was no longer the extraordinary beauty she had been, but she still dressed extravagantly in ethnic costume, her dark hair pulled back in a chignon embellished with colored ribbons or some exquisite ornament she had found in some remote, exotic place.

She was also still a master chef. I was fortunate to attend many of her famous luncheons, which were celebrated as much for her fascinating guests as for her fantastic menus. Once I sat between the Mexican painters Roberto Montenegro and Jesús Ferreira, and once between the actress Dolores del Río and architect/ designer Buckminster Fuller. The architect Luis Barragan was another frequent visitor. I remember one especially riotous gathering during which he and the

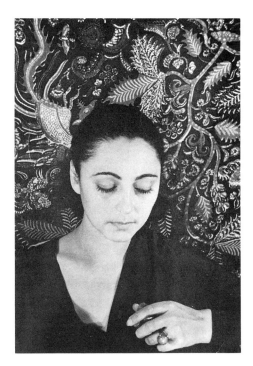

LEFT: *Rosa, October 30, 1932. Photograph by Carl van Vechten.*

RIGHT: *Miguel Covarrubias at work, 1938.*
Photograph by Nickolas Muray.

Mexican historian Edmundo O'Gorman (brother of the muralist Juan) made us practically cry with laughter over biting stories about some well-known society matrons, emphasized with exaggerated facial imitations and hand gestures. The last luncheon I attended was in the late 1960s, for the popular American actor Rock Hudson, whom Rosa liked enormously.

In the early 1960s, I was living in Pasadena, California, and I saw Rosa whenever she came to Los Angeles to stay with her close friend Margo Albert, a delightful Mexican actress who had married the American actor Eddie Albert. Whenever Rosa was in residence, Margo made her feel at home by throwing her own lively luncheons and inviting some of Rosa's friends, many of whom had some connection to the movies or theater, like the actress and scriptwriter Mary Anita Loos. Others were longtime friends, like Bernadine Fritz, whom Rosa had known since the 1920s.

When I moved to San Rafael, California, Rosa came to visit me twice, and it was there that we began to talk about the life she had shared with Miguel. From then on, whenever I returned to Mexico, Rosa continued to elaborate on her history. We would tour the house at Tizapán, stopping in front of any of the remarkable works of art that filled it, and Rosa would tell me where each piece came from and how they had come by it, and perhaps another memory would attach to that recollec-

tion, and another event would be recounted. I began to feel very much connected to Rosa over this time.

In 1970, when Rosa died, I had not seen her for over a year. She had appointed Luis Barragan to be the executor of her estate, and he asked me to assist him in making an inventory of everything she left behind—from such personal things as her clothes, photographs, correspondence, and household items to furnishings, books, folk art, and paintings. This exercise, along with the stories Rosa had shared with me, gave me further insight into the two remarkable people you will meet in the pages that follow.

My friend, the scholar of Mexican culture Tomás Ybarra-Frausto, encouraged me to write this biography. I had Rosa's address book, and in 1984 I began calling her friends in the United States, Mexico, and Bali. It was only after meeting with these people, extraordinary people themselves, that Miguel's story and his character began to take precedence over Rosa's personal history. I regret not having known him as well as I knew Rosa. Many of the people I interviewed used the word "genius" to describe Miguel, whether they were speaking of his accomplishments as a caricaturist, illustrator, writer, anthropologist, archeologist, museologist, collector, stage and costume designer, or dance administrator, for he excelled in all those areas. It became clear, the deeper I dug into his history and the more I learned of his life and work, that his friends had not exaggerated.

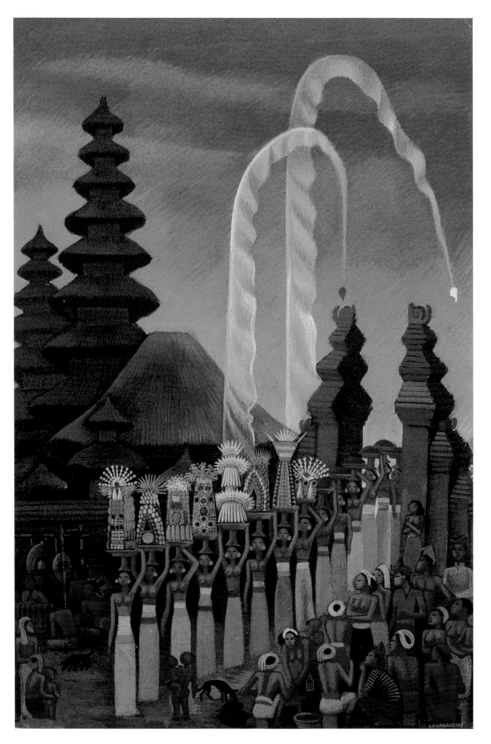

Procession of women with offerings at a temple in Bali
(gouache by Miguel Covarrubias).

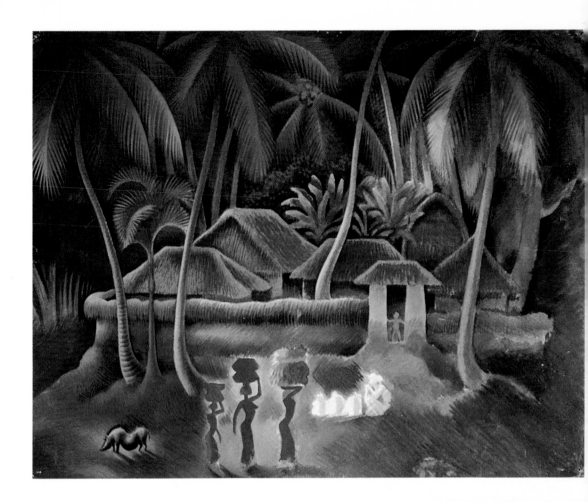

Village in Bali,
ca. 1934
(Miguel Covarrubias
Collection of the
Mexican Museum,
San Francisco).

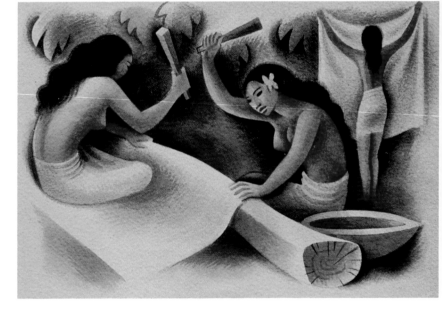

Women Washing,
Bali, ca. 1932
(watercolor by Miguel
Covarrubias, courtesy
María Elena Rico
Covarrubias and Harry
Ransom Humanities
Research Center, The
University of Texas at
Austin).

Illustration by Miguel Covarrubias for the book Batouala *by René Maran, 1932 (courtesy María Elena Rico Covarrubias and Harry Ransom Humanities Research Center, The University of Texas at Austin).*

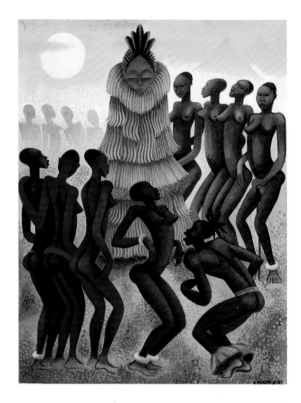

Caribbean Dance, the Malecón, Havana, Cuba, *1928 (gouache by Miguel Covarrubias, courtesy María Elena Rico Covarrubias and Harry Ransom Humanities Research Center, The University of Texas at Austin).*

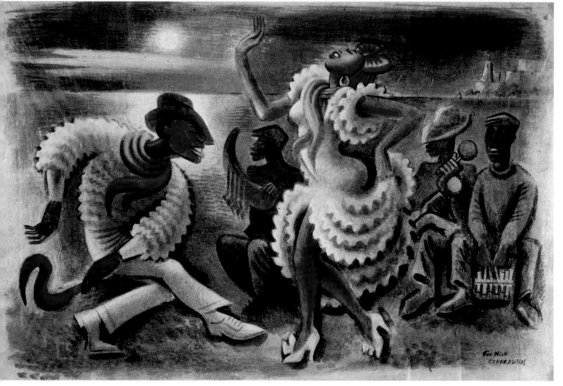

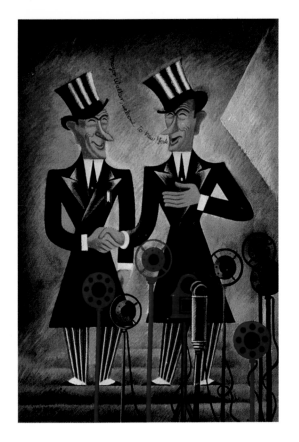

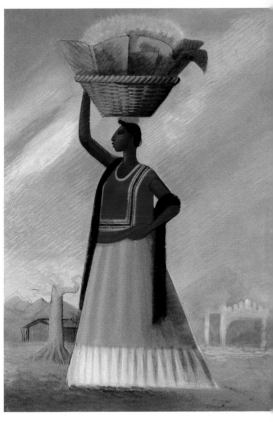

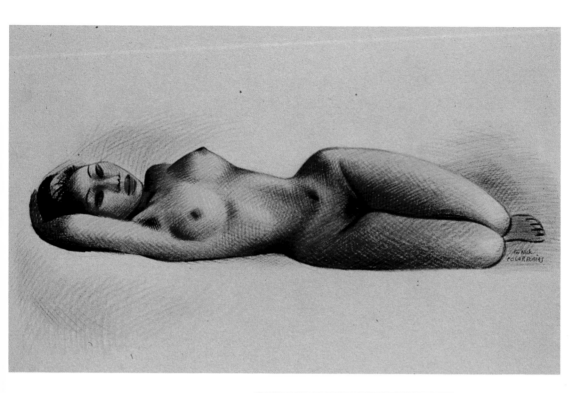

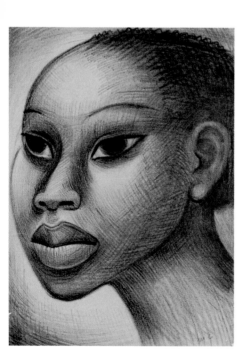

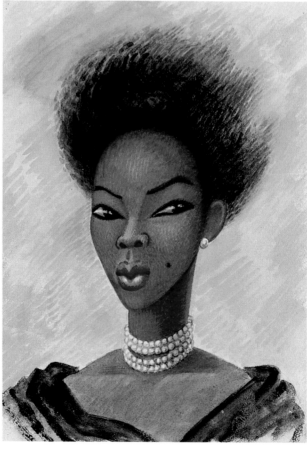

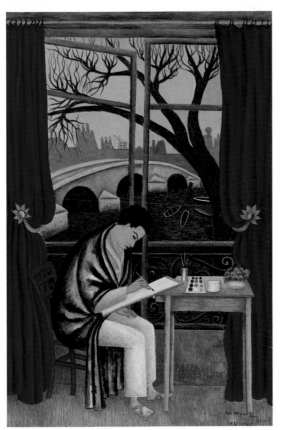

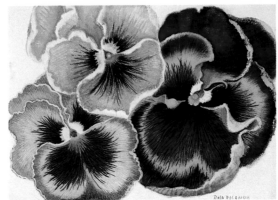

ABOVE, Pansies *(by Rosa Covarrubias, Mexico City, ca. 1945).*

BELOW, Child with Doll, *ca. 1947 (gouache by Rosa Covarrubias, Miguel Covarrubias Collection of the Mexican Museum, San Francisco).*

ABOVE, Miguel in Paris, *1928 (gouache by Rosa Covarrubias, Miguel Covarrubias Collection of the Mexican Museum, San Francisco).*

BELOW, Seashell *(by Rosa Covarrubias, Mexico City, ca. 1945).*

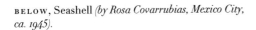

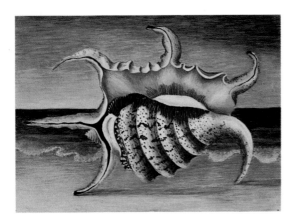

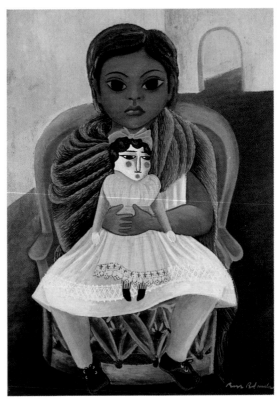

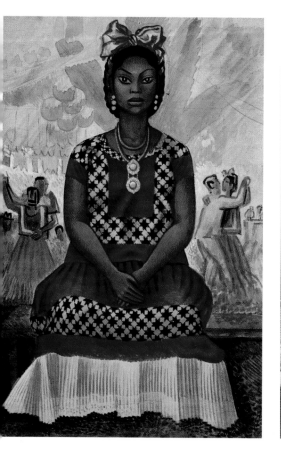

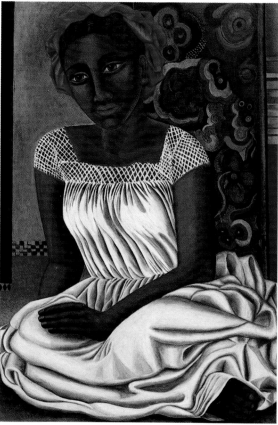

Tehuana *(gouache by Miguel Covarrubias, courtesy María Elena Rico Covarrubias and Harry Ransom Humanities Research Center, The University of Texas at Austin).*

Cuban Woman, *ca. 1928 (gouache by Miguel Covarrubias).*

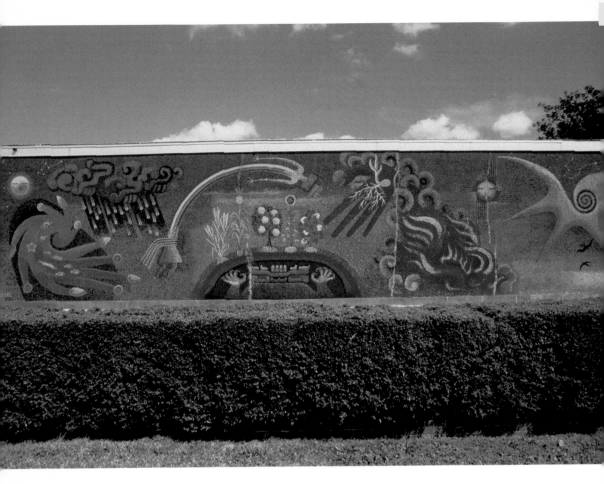

Miguel Covarrubias, Genesis, the Gift of Life, *mural in glass mosaic, 1953–1954. Commissioned by Peter and Waldo Stewart to be displayed on the Stewart Building in Dallas, Texas, the mural is based upon the Indian concept of the four elements, from left to right: water, earth, fire, and air (or sky). In 1993, Comerica Bank–Texas made a generous donation to restore and move this spectacular mural to the entrance of the Dallas Museum of Art's Museum of the Americas.*

COVARRUBIAS

The peculiar genius of Miguel Covarrubias was born of his cultivated background, a natural gift for drawing and a refined and effortless beauty of manner, form and style entirely his own. In sum, an originality that made him one of a kind.[1]

J BEGINNINGS (1904–1923)

osé Miguel Covarrubias was the firstborn of Elena Duclaud, whose French and Spanish parents lived in Mexico City, and José Covarrubias Acosta, whose parents were from Jalapa, Veracruz. Miguel was born in Mexico City at one o'clock in the morning on 22 November 1904 in his parents' house at 1237 Presidente Street. At that time, Mexico had been governed for twenty-four years by Porfirio Díaz, under whose dictatorship the rich had gotten richer and the poor much poorer.

José Covarrubias, Miguel's father, was a civil engineer, one of the privileged class who had prospered with his government. He was a cultured and well-respected man in Mexico City's scientific and political communities, valued for his competence, intelligence, and virtuosity. He enjoyed the trust of six different presidents in the course of his distinguished career.

In 1903 Díaz had appointed Covarrubias to a commission that studied Chinese immigration in Mexico, then assigned him to direct the restoration of national monuments in Guatemala in 1906, named him sub-director of the Post Office in 1907, and a consultant for new national immigration laws being formulated in 1908.[2]

But Díaz cared more for expediency and personal power than he did for history or his nation and more for the present than the future. From this self-serving position, he did inestimable damage to his country. Opening up the mineral and petroleum wealth of Mexico to foreign interests may have been his greatest abuse. Díaz was committed to ingratiating himself to foreign, especially European, power brokers and during his long reign tried his best to replace what was Mexican with what was European. This extended most notably to art and architecture. Perhaps it was an attempt to deny his own ethnicity; although he claimed Spanish blood and used face powder to lighten his dark skin, Díaz was a Mixtec Indian.[3]

Even what is commonly held as Díaz's greatest achievement, the railroads he laid across the country, "followed no plan, formed no system, and instead of being projected for development of the country, had been the product of private interest and accident," according to José Yves Limantour, Díaz's own secretary of treasury.[4]

In the end, the Díaz regime was so corrupt that whatever strength it once possessed had finally rotted away. Its overthrow in 1910 by Francisco Madero, an honorable if naive revolutionary, was accomplished fairly swiftly after troops sent to suppress the Madero upstarts joined them instead.

During Madero's short-lived presidency, José Covarrubias was promoted to Post Office director, and then sub-secretary of communications. After Madero's assassination, Venustiano Carranza took office and found time to decorate José Covarrubias for outstanding service to his country (and to send him a congratulatory birthday telegram on 8 March 1920, one month before his own administration collapsed).[5]

Adolfo de la Huerta completed Carranza's term, serving as interim president for six months in 1920, and in that time he founded the country's National Lottery, to which he appointed José Covarrubias as director. Covarrubias held the post for the next twelve years under President Alvaro Obregón and his successor Plutarco Calles, and it did much to establish Covarrubias's reputation of impeccable honesty. In the early 1930s a columnist commented on it: "Not only was the lottery an admirable philanthropic institution . . . ," he wrote, but "from peons to polo players, Mexicans swear by its honesty, are universally confident that everyone's chance is the same, and that a winning ticket is as good as currency. Such a reputation reflects primarily the character, integrity, and long record for public service of the Lottery director, Ing. Don José Covarrubias, father of Miguel Covarrubias, the caricaturist."[6]

The columnist didn't know how far José Covarrubias's integrity went. Miguel's father would not even permit any member of his family to play the lottery, lest eyebrows raise; and he refused or returned all gifts that were given to him during his directorship.[7]

José Covarrubias was a rare commodity in government—honorable and dedicated—and his skills were far more than bureaucratic. He wrote as well and frequently contributed to Mexico City newspapers, publishing articles about sociological and agricultural problems. He was a great promoter of agricultural reform; his book *The Rural Problem in Mexico* was published in 1917. He was an earnest man who cared deeply about humanity.

He was also hardworking. He taught courses in drawing, topography, and geography at the National School of Engineers, and in 1921 he added architecture to his teaching curriculum. He redesigned the west facade of the National Palace, the seat of Mexican government, and built several Mexican Art Nouveau private houses and apartment buildings in the fashionable Colonia Roma district. One of these houses, an excellent example of the style, still stands on the corner of Guanajuato and Mérida streets.

By avocation, the elder Covarrubias was a gifted amateur painter—a copyist whose work includes an excellent reproduction of Jean-Léon Gérôme's neoclassic *Young Greek: A Cock Fight* (the original of which hangs in the Musée D'Orsay). Perhaps José Covarrubias's most ambitious work was a large bay window in the family dining room, painted to resemble stained glass, depicting scenes set in Tahiti.[8] (Both pieces demonstrate Díaz influence, which placed more value on the European style and the art of other cultures than one's own. Díaz's worst sin may really have been the theft of his people's cultural esteem.)

From his earliest years, Miguel also showed an aptitude with pen and brush. His father taught him to draw and encouraged him, and most Saturdays the two worked companionably side by side in José Covarrubias's studio.

Jose Covarrubias had two sisters and three brothers. His brother Miguel, after whom the young Miguel was named, served as Minister of Foreign Affairs in London and business attaché to Germany, Belgium, Holland, Norway, Sweden, and Russia in the course of his distinguished career. He was appointed ambassador to England in 1921 and ambassador to Paris in 1924, where he died. Many years later, Miguel commented, "I came from a family of diplomats, but I was not one of them." He boasted of having thirty-seven cousins, "all prominent in the arts or politics."[9]

Most of the cousins were from the Duclaud side of the family. Miguel's maternal grandfather Amadeo Duclaud had immigrated to Mexico to work for a French bank that ultimately failed; but by then the young Frenchman had fallen in love with Elisa Fuero, a daughter of Spanish aristocracy, whose sister, Carolina de Unda y de Equia, had been Queen Isabel II's maid of honor, whose first cousin was the respected art collector Baroness de l'Angers, and whose father was the celebrated General Carlos Fuero, decorated for bravery in the Juárez revolution. Amadeo and Elisa's grandchildren numbered more than thirty.

Miguel's paternal grandparents came from Jalapa, Veracruz, Mexico. His uncle Julio, an amateur photographer, and aunts Lala (Alejandra) and María, never had children themselves, and the three of them lived together in one of the Art Nouveau homes their brother had built at 55 Mina Street. From the moment of Miguel's birth, the two aunts were devoted to him. They told him stories and engaged him in playacting and in games. They overfed him and showered him with gifts and treats. As he got older, they sewed fanciful costumes for him. Miguel posed for his uncle in a Spanish soldier's uniform with cap and gold braid, in a pierrot costume, as a Zapatista.

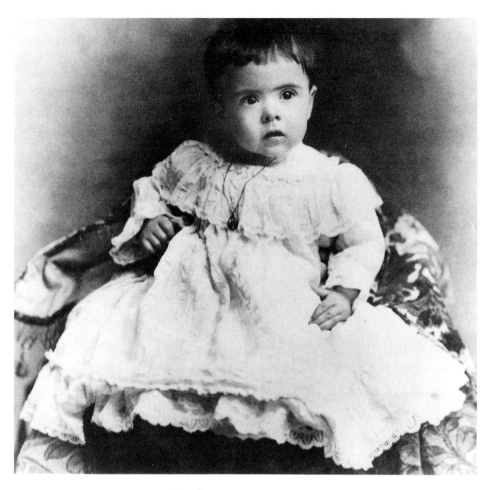

Miguel in 1905.

Miguel developed diabetes as a child, which earned him great compassion and even more attention. As he aged, he tended to ignore the fact of his diabetes. He was too much alive, too busy to accommodate illness, and he didn't care much for denying himself his little pleasures, like the sweets he loved.

Meanwhile, Miguel's immediate family grew to include three brothers and two sisters, the youngest, Luis, fourteen years younger than Miguel; but none of the others was so coddled as Miguel.

The Covarrubias's upper middle-class status guaranteed the children the best schooling. Miguel attended the Horace Mann School, the Alberto Correo School, and a French preparatory school run by French priests. He did not like school very much. He referred to the French preparatory as his *sentencia*.[10] He objected to the rules, which were too restrictive for his taste, and he established a reputation as a prankster. At thirteen and fourteen he frequently played hooky. Miguel had discovered local theater and far preferred watching rehearsals in progress to sitting bored in class.

His dissatisfaction reached crisis proportions when a scrap with one of his clerical teachers ended in Miguel's striking the priest with a stick and fracturing his skull. Though the details have been forgotten, everyone agreed it was an accident, but Miguel was mortified by the incident and insisted he could not go back to school. His parents indulged him in this, and at the age of fourteen Miguel ended his formal education. Later he asserted that part of his success was a result of his lack of academic training, which left him free to develop his own style rather than be compressed into someone else's.[11]

José Covarrubias found his son a job as a map draftsman at his place of employ, the government's department of communication. The work—filling in outlines on architectural plans—was no fun. Miguel would rather be reading *El Globo*'s gossip column or perfecting his tango, which was one of his passions. But this first job ultimately instilled in him a fascination with mapmaking. Later he would create maps out of a "desire to eradicate boundaries between people," as one art historian has pointed out.[12]

Luis Covarrubias recalls that Miguel "amused them all at the office":

> *He was always very cheerful and made them laugh with his mischievous antics and his wonderfully expressive face. He loved to tell funny stories, and he knew how to tell them so he had everyone in stitches. The painter Antonio "El Corcito" Ruiz became one of his best friends. They sat with their desks very close to each other. Instead of working on the charts, Miguel would draw these amusing caricatures of the bosses. Their bursts of laughter would always get them into trouble, but, in the end, Miguel was always forgiven.*[13]

Shortly after their father was named director of the National Lottery, Miguel's brother Luis recalls that they moved into a grand house next door to the lottery offices on the Paseo de la Reforma, considered one of the most beautiful boulevards in the world.[14] The Paseo is a wide two-mile-long avenue that stretches from near the Alameda, Mexico City's central park, to Chapultepec Park, where Maximilian's castle still overlooks the city.

Maximilian, the archduke of Austria who became emperor of Mexico, did much to import the flavor of France to Mexico when he assumed charge of the country in 1864. Mexico may have the emperor's influence to thank for Díaz's conversion to the European way. Maximilian had directed the construction of the grand boulevard where the Covarrubias family now lived; he was responsible for the parade of tall shade trees along its length, its parallel promenades, gardens, and horse trails, and the occasional glorietas, or circular gardens, that flowered along its path. The Alameda was his design, as was the renovated Chapultepec, once Montezuma's fortress, then a summer residence for Spanish viceroys, finally the imperial residence of Maximilian and Carlota.[15]

Little more occurred by way of beautification of Mexico's capital city until the last years of Díaz's reign, when he introduced statues and stone benches to the Paseo and monuments among the glorietas. Díaz also erected several of Mexico's national buildings, among them the Venetian/Florentine-style Post Office, several schools, and a memorial to himself—the National Palace of Fine Arts, or Bellas Artes, as it became known. This was a neoclassic structure designed by the Italian Amado Bori at the beginning of the century. Its theater was constructed of Carrara marble with an immense dome of glazed and gilded tile. Not much remained of Aztec influence in the modern Mexico City of the early 1900s.

The Covarrubias mansion was typical of the era's elegant French pretension that Díaz had favored. A statue of Charles IV along the Paseo stood staunchly in front of the house. In the 1920s the writer Marcet Haldeman-Julius recalled visiting Miguel there:

> One passes into a trim little lawn, full but not overcrowded with shrubs and flowers. The door opens into a pleasant reception hall from which a wide stair ascends. . . . To the right a door led into quite a large room in which slender brocaded furniture, graceful in line, was formally arranged. Paintings were on the wall, and the room was a veritable bower of glorious fragrant flowers. Quick to notice what anyone was observing (the slightest move is not lost upon him), Covarrubias said at once: "It is my mother's birthday." (I met her later. A young-looking woman, very French in appearance, was my swift impression. In contrast to her son, she seemed quite fair.)
> "And the paintings?" (For I took them to be the work of one hand.)
> "Are my father's."[16]

Luis remembers his older brother as a popular teenager. Miguel had his own room, where (through the keyhole, for he was not allowed to intrude) Luis observed him, intent at his drums, and his friends, other young men with horns and guitars, including "El Corcito" in apache dress (the European version of bohemian-style in that day), jamming—often until the early hours of morning. Occasionally Doña Elena, Miguel's mother, invited the boys for a meal—she was a cook of great reputation.[17]

Mexico City's bohemian section, crowded with theaters and small cafés, was called the "Streets of Night" because it came alive at night. Miguel had discovered theater there while he was still in school; one of his favorites was the Lyric, a vaudeville theater. He was a true *Ricardito*, a person who attends rehearsals for the pure pleasure of it. He was befriended by actors, comics, singers, and dancers, some quite famous, such as the comedians Roberto Soto, called Mexico's Charlie Chaplin, Delia Magaña, Leopoldo Beristáin, and Cantinflas, and

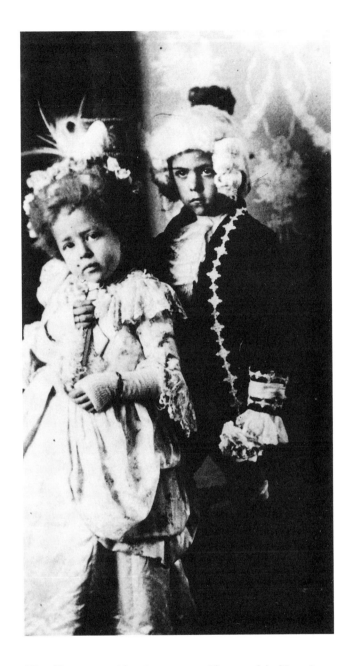

Miguel in costume with a sister, ca. 1912. Photograph by his uncle.

dancer Lupe Vélez, the queen of the *tanda,* an hour-long musical review that combined folk music, dance, and vignettes illustrating Mexican street life and character.

Miguel was such an enthusiast that he took a job as an usher so that he wouldn't miss a performance. During intermissions, he walked up and down the aisles and through the lobby, making hasty sketches of theatergoers that he would use later in caricature.

Miguel had played with this form previously. One of his earliest caricatures, drawn when he was ten, is a self-portrait of a bucktoothed boy with his pants around his ankles, sitting on a potty. Later it became Miguel's habit to sign a book dedication or a piece of correspondence with a hasty caricature of himself. Now he was influenced by José Clemente Orozco's bold, sensual drawings and by the woodcuts of the famous revolutionary caricaturist José Guadalupe Posada, who was called "engraver-to-the-people." Spending so much time in the theater district, Miguel ran into Ernesto García Cabral, a popular artist whose caricatures appeared daily in Mexico City newspapers, and Guillermo Castillo, also a caricaturist, just beginning his career. Orozco, Posada, and Cabral were the three best-known artists working in caricature at that time.

The form enjoys a rich tradition in Mexico, illustrating as it does the hard-to-capture essence of *vacilada,* an ironic, raised-eyebrow attitude or point of view that is considered an aspect of Mexico's cultural temperament.[18] As an art form, caricature is thought to have evolved from pre-conquest times out of the whimsical terra-cotta statuettes of early Mexican Indians. It gained enormous strength by virtue of its use in political commentary in the nineteenth century, perhaps because in Mexican politics at that time there was so much to comment on.

When he was not at the theater, Miguel would likely be found at *Los Monotes* ("Big Monkeys"), a café owned by José Clemente Orozco's brother where the walls were covered with quick drawings and caricatures by the great Orozco (*monotes* also has the connotation "doodles"). At day's end, this is where Mexico City's intellectuals, writers, artists, and hangers-on congregated to enjoy fresh tortas and chicken tostadas with or without chipotle chile, to share with one another new works and to gossip, laugh, and drink. On any given evening one might meet the painters José Clemente Orozco, Diego Rivera, Manuel Rodríguez Lozano, or young Abraham Angel, who died in 1924, just a year older than Miguel. Raoul Fournier was a medical student at the time and a regular at *Monotes.* Soon other writers and artists gravitated to the café—Jorge Juan Crespo de la Serna, Lupe Marín, Rufino Tamayo, Manuel Maples Arce, and the distinguished poet José Juan Tablada made it their meeting place.

It was fertile ground for a budding caricaturist. Miguel, a young boy still in short trousers, full of spirit and enthusiasm, with sketchbook and pencil in hand, stopped in nearly every night to observe the late arrivals. And, of course, everyone noticed him noticing them.

The writer Elena Poniatowska published a series of interviews with friends of Miguel in 1957. They remembered him "burst[ing] through the door like a spirited team of horses," and proceeding directly to a table in the far corner, sketchbook and pencil in hand. Dr. Fournier described a face "like a child's without a single hair on his chin, all round. He wasn't precisely fat, but he hadn't quite lost his baby fat." Miguel did love to eat—his "pastries and biscuits washed down by cup after cup of hot chocolate made from three glasses of milk," as Fournier recalled.[19]

"He reminded one of a small boy," Poniatowska wrote, "his pockets filled with the fruits of life, which he would abandon without a second thought to grab what was going by."[20]

According to the journalist and poet Manuel Gutiérrez Nájera (known as "Caballero Puck"), Miguel "gave one the impression of having just escaped from kindergarten." Puck recalls thinking at the time that "no one would make a better advertisement for the latest North American drink to arrive on Mexican soil than Miguel with his cheeks filled with food!"[21]

If all this wasn't enough to attract attention, Miguel busied himself by endlessly sketching the café's patrons — on napkins when he ran out of paper. "There he sat," Puck reminisced,

> *a young boy with a busy pencil and big brown eyes fastened on a likely subject about to be immortalized: it might be Lydia, the redheaded waitress with arms à la Ruben . . .; the constitutional revolutionary and opera star Castro Padilla with his falsetto laugh; or Romanones, the adventurer and night-wanderer who ended up sleeping in hotel garrets, talking nonsense, and hooting like a mad owl.*[22]

Everyone who went to *Los Monotes* was sooner or later a subject of Miguel's illustration, and nearly all his subjects made friends with him. He was particularly appreciated by the painters and writers of the New Wave, the postrevolutionary artists who would become Mexico's brightest stars over the coming decades; and, being much younger than them, he became their mascot. Diego Rivera was one of the New Wave—Miguel took lessons from him around this time—and Luis Hidalgo, a caricaturist who worked in wax, was another. It was Hidalgo who nicknamed Miguel *El Chamaco*, "The Kid," because he was the youngest member of the group, and the nickname stuck with Miguel all his life.[23]

The young Covarrubias became known as one of the *Niños Terribles*. Miguel Lanz Duret, Carlos Noriega Hope, and Eduardo Elizondo were the other precocious *niños*. The four of them produced a weekly magazine, *El Ilustrado*, advertised as a magazine with spirit, which would have shocked a more conservative society. Its "spirit" was decidedly anti-establishment.

Raoul Fournier remembers that his peers also

> *wanted to start a newspaper at the University of Mexico that would inspire a school revolution and a purging of our professors. We were so idealistic. We wanted to reform everything—teaching methods and social and artistic reforms. We called the newspaper* Cáncer *because of the word's negative connotation! We asked Miguel to donate some caricatures of our professors. . . . We were thrilled when he said he would.*[24]

The desire for reform was in the air—all the young, creative voices cried for it—and had been since 1910 when Díaz was finally ousted. A decade had passed, and little had improved for the people. By now the cry for reform was very loud. It would herald a renaissance in Mexico.

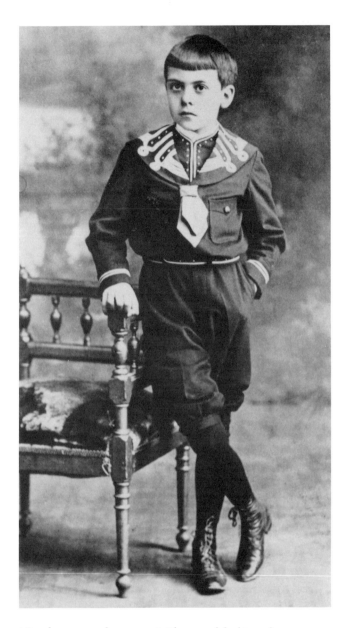

Miguel as a young boy, ca. 1915. Photograph by his uncle.

\mathbf{M}iguel's first published caricatures appeared in October 1920 in *Policromías,* the student magazine of the National University of Mexico in Mexico City, which gave him the cover as well—a pen and ink of an elegant couple done in the lacy style of Aubrey Beardsley. That December, *Zig Zag,* a weekly magazine devoted to theater, books, poetry, art, and reviews of bullfights, included a drawing of the painter Roberto Montenegro by Miguel. Its next issue

featured a series of Miguel's caricatures of gallery-goers attending the opening of a Montenegro exhibition. Among those depicted are the socially prominent La Marquesa Cassati and El Marqués de San Francisco, the guitarist Andrés Segovia, and the painter Gabriel Fernández Ledesma. Two years later *El Heraldo* ran Miguel's satirical interpretation of some of Mexico's reactionary politicians.

However, it was not until the group of drawings that appeared in several issues of *La Falange* that Miguel seemed to have found his own witty but never cruel style. The most noteworthy of these were the portrayals of Diego Rivera and Manuel Rodríguez Lozano in the January and July issues of 1923. From then on Miguel's caricatures—of the poet Tablada, the comedian Nelly Fernández, and Roberto Montenegro, to name a few—appeared in many of Mexico's other newspapers and magazines. As he became better known, his drawings were syndicated throughout Mexico, Cuba, and South America.

Miguel was recognized "from the time he was a child," according to director and playwright Carlos Solórzano, for his "great capacity for drawing and great sense of irony and good humor." But Miguel was not "a spontaneous caricaturist like Ernesto García Cabral and most others," another dramatist and director, Adolfo Fernández Bustamante, insists. "Miguel would study his types. He would first trace his designs, then polish, refine, and stylize them."[25]

What set Miguel apart even more from the other caricaturists of his day was his focus on the positive. Daniel Cosío Villegas reviewed Miguel's work in 1923 for the newspaper, *El Mundo*, and made that distinction. He pointed to a drawing of a particularly unattractive *zarzuela* dancer who was popular at the time:

> *Far from accentuating the inferior qualities such as her skinniness, he has exaggerated certain good features of the dancer, bettering her, yet making fun at the same time. Because of this quality, Miguel's caricatures are not "denigrating" but "uplifting." That lift is passed on to the viewer and makes us feel that all of us, some less, some more, are all the same. We are human.[26]*

Miguel admired everything about his older cousin Diego Covarrubias, who had been born and raised in England and gone to Stoneyhurst—especially his education and the smart way he dressed. The younger Covarrubias now traded his short pants for English-style suits, polka-dot ties, a fedora worn at a rakish angle, and an antique ring. His circle of friends grew to include Fernández Bustamante, the diplomat and poet Maples Arce, painters Carlos González, Ernesto García Cabral, Roberto Montenegro, and Adolfo "Fito" Best Maugard.

Together Fito and Miguel cut a swath through Mexico City's night life in the early 1920s, at *Los Monotes*, at the *Café Volador*, at the theater where musical revues were very popular. Best Maugard remembers Covarrubias as "a very headstrong and impetuous boy. He started coming to my studio when he was just sixteen [Best

would have been 34 then], and we became good friends."[27] Miguel loved the *corridos* (musical revues); guitar music, especially the *jarana* with its peculiar sound of scratched glass; *zarzuelas* (Spanish light opera); ethnic variety shows with regional customs and costume; Mexican folk dance; and Mexican comedy.

But neither Miguel, nor Fito Best Maugard, nor their other friends were totally frivolous. In fact, Best Maugard, considered one of the most original personalities of the era in Mexico, became an important figure in Mexico's artistic renaissance with his participation in the reform movement that distinguished President Obregón's new regime.

When Alvaro Obregón took office in 1921, he was determined to rebuild a demoralized Mexico. Like Mexico City's intellectuals, he believed reform was the key, on nearly every level, to restoring Mexico's pride in itself. The nationalist movement initiated an interest in native art and overlapped into new programs of education. One of Obregón's first and perhaps finest acts as president was to name José Vasconcelos, a scholar and philosopher, to the post of minister of education.

Vasconcelos was an idealist imbued with the revolutionary spirit. He took his position in the government very seriously. He was charged with educating the people, but he would give them more than an education. He believed he could return to Mexico its stolen birthright. He believed that the country could find its essential personality that had been paved over, Europeanized, by reacquainting itself with the Mexican Indian and his culture. Vasconcelos chose Adolfo Best Maugard to be his assistant in promoting those formal open-air art schools whose progressive curriculum now had the government's full approval and support.[28]

To teach contemporary Mexicans the symbolic and conventionalized art of their ancestors, Best Maugard expanded the popular open-air schools, whose emphasis had been on folklore, toys, and popular art, to include the line drawing and color appreciation employed by Mexico's primitive artists. Miguel joined the brigade of painters who volunteered as teachers within the new educational system, along with "El Corcito" Ruiz, Abraham Angel, and Rufino Tamayo, among others.

Miguel told a reporter that he learned from the children he taught, because they drew without prejudice. "They don't try to copy from Nature—they create from within themselves."[29] The painter, poet, and writer Gerardo Murillo (or Dr. Atl, as he was known) took a much stronger position:

> *I have seen children's drawings . . . in Paris, Rome, Wash-*
> *ington, and California. The majority are simply and purely*
> *infantile drawings. . . . But the children of Mexico draw and*
> *paint with great intuition of volume and color, and their*
> *productions are on the plane of true works of art.*[30]

These were days of renewal, days of great optimism that seemed to fire a creative energy among Mexican artists such as had not been seen for centuries. "Off the scaffolds these painters also taught in the schools, explored the market places, the villages and churches, and all the other national art museums," wrote Anita

Brenner in *Idols behind Altars*.[31] Young artists now rebelled against using the European masters as their model. The New Wave looked within itself, just as the Mexican children had done, and found beauty and passion where they had perceived crudeness, and value where they had thought themselves debased. The renaissance had begun.

It was not just the year of renaissance in the arts. Mexico's centennial anniversary of independence from Spain also occurred in 1921. Free now from their own government's repression and from the past ten years of turmoil and revolution, Mexicans were ready to celebrate. Fito Best Maugard received that plum assignment—to organize an appropriate event to mark Mexican Independence Day that centennial year. He enlisted Miguel as a collaborator to produce *Noche Mexicana*. It was the first such spectacular public relations event ever attempted in Mexico—later the celebration was referred to as muralism, sung and danced. As to the dance, *Mexican Folkways* noted nearly ten years later: "Still remembered was the Jarabe [it became the national dance] that Adolfo Best Maugard arranged for 300 couples on the night of his *Noche Mexicana*. It was the first time in the history of aristocratic Chapultepec Park that a folk dance was performed within its precincts."[32] (It was also Miguel's first experience designing theatrical sets.)

The festivities in the park were centered below the castle, in front of Chapultepec Lake. There were stands of regional food and folk art throughout the park. Celebrants entered through a high arch embellished with Best Maugard's folk-art motifs and felt as if they entered a different world. And it was their world. Indian tribes in native costume from everywhere in Mexico came to be "presented" to a wildly appreciative audience. There was regional music and dancing and fireworks. The most popular attraction was a giant papier-mâché volcano, modeled after the volcano Popocatépetl, which simulated a fiery eruption that reflected in Chapultepec Lake.

Two hundred thousand people attended—every foreign ambassador, all of Mexico's highest society, and Mexico City's citizens, rich and poor. The people talked about it for years afterward.

The times were like a fan to the flame of great artistic movement—travel was accessible as never before, communication was possible as it never had been. Released from years of repression, the creative spirit soared in Mexico at the end of the revolution. In 1922 Dr. Atl, Roberto Montenegro, Rufino Tamayo, and Miguel began work on an exhibition of Mexican arts and crafts, another first of its kind that would travel to Los Angeles and then Argentina and Brazil. It took two years to complete, and it attracted huge crowds.

Also in 1922, Miguel and Alfonso Caso constructed a major exposition of Mexican folk art. Though Caso was only eight years older than Miguel, he was even then a role model for the younger man. Caso was already an accomplished linguist and ethnologist; he would become one of Mexico's most revered archaeologists and renowned discoverers.

By now Miguel had begun to form his own collection of folk art; some of his pieces were included in the show. The young artist's appetite for collecting rivaled his appetite for pastries and biscuits. In the early 1920s, his two favorite pastimes were Sunday excursions to *El Volador*, the antique bazaar, followed by five-o'clock tea at Fito Best Maugard's.

Luis recalls that his brother began collecting artifacts from the Colonial and pre-Columbian periods, using the earnings he received from the publication of his caricatures, but very quickly expanded his collection to include dozens of eighteenth-century stoles, long, narrow, embroidered silk shawls worn by priests and bishops during that period; richly decorated Indian trunks made of wood; and scores of lithographs and engravings that evoked an aristocratic past. More often than not, the antique dealer Salas allowed Miguel to pay in installments, so extensive were his purchases. Soon he required additional space for his collection and rented a room downtown on Donceles Street. The young artist was impetuous and his interests changed rapidly. The room underwent continuous transformations as old pieces took a second shelf to the new.

> *[Caballero Puck] remember[ed] the room in which he stored these antiques, as well as hundreds of little apocryphal idols from Teotihuacán [southeast of Mexico City, where the Aztec ruins are located]. Soon he tired of these five cartons of idols and started collecting gold embroidered cloth and statues of enamelled saints. One day he said to me, "I am tired of these old sticks of wood and moth-eaten fabrics. I'm going to throw everything out the window and have Amero decorate my room so I can start over."[33]*

Perhaps it was in the same spirit of renewal that Miguel began dreaming of New York and talking about it with his friends. The United States held huge attraction for the budding artists of the day. Rejecting the European influence as outdated and inapplicable, they looked north and found a novelty and vitality that seemed to speak to them directly. Many of Miguel's friends planned to see for themselves what the new world offered—Fito Best Maugard and their friend the composer Carlos Chávez were both leaving—and New York was everyone's preferred destination.

One night in 1923, over coffee with José Juan Tablada, Miguel's dreams began to solidify. They had met three years earlier at *Los Monotes* when the poet had found himself subject to the intense gaze of a boy still in short trousers. Tablada had been impressed and encouraging. Now sitting together at another popular meeting place, *Café Madrid*, he talked to Miguel about New York City.

Tablada had been banished after a disagreement over political policy during de la Huerta's short presidency. It was a fortuitous exile. Tablada had bought a bookstore on Fifth Avenue, named it *La Latina*, and stocked it with Spanish-language books, and it had become the creative center for Latinos in the city.

Tablada encouraged Miguel again on this evening with more than compliments for his work. He applied to his friends General José Álvarez and Genero Estrada, the latter the minister of foreign affairs and once ambassador to Spain and the former a writer and diplomat with similar political clout, to sponsor the young artist. Impressed with Miguel's artistic promise and his recognition by older artists, Estrada arranged for the government to provide Miguel with a Pullman train ticket to New York and a six-month living allowance.

*We loved the city with its amazing skyscrapers,
and our life in Greenwich Village, which made
us feel as if we were reliving the Golden Age of
Paris. It was the epoch of Picasso, Stravinsky,
the Russian Ballet, Jean Cocteau, James Joyce
and Scott Fitzgerald. We slept very little.*[1]

M THE TWENTIES, PART ONE (1923–1924)

iguel could not have had a better mentor than José Juan Tablada, whose artistic and nationalistic sensibilities and devotion to art did much to promote Mexico and Mexican artists in the post-Revolutionary 1920s.[2]

Tablada was dedicated to negating America's prevailing stereotype of his countrymen as gun-wielding bandits or lazy good-for-nothings—notions popularized by current movies such as *The Greaser's Revenge, The Gringo, Barbarous Mexico,* and *The Martyrs of the Alamo*. In the twenties, other contemptuous stereotypes came into vogue, focusing on difficulty with the English language. Lupe Vélez, the "Mexican spitfire," later built her career on malapropisms, playing off that presumed disability. Tablada's means were to assist the best and the brightest of Mexico's artists in making international names for themselves. For every drunken Mexican desperado that appeared on the silver screen, Tablada brought along another talented actor or musician or painter whose work would make a deeper impression than the celluloid. Pedro Rubín, who appeared in the musical *Río Rita*, actors Ben Hur-Baz and Gustavo Silva, and artists Matías Santoyo and Luis Hidalgo all benefited from Tablada's generosity.[3]

By now Luis Hidalgo had taken a studio on 48th Street and Fifth Avenue which, like Tablada's bookstore, was a popular gathering place for New York's Mexican visitors. Hidalgo had become quite successful, and his wax figures of prominent political and theatrical personalities were much sought after. (He memorialized, among others, American President Coolidge, Mexican Presidents Obregón and Calles, French premier Clemenceau, Charles Lindbergh, Charlie Chaplin, Carl Van Vechten, Frank Crowninshield, Helen Hayes, and Katherine Cornell in *Theatre Arts* and other magazines.) Like Tablada, Hidalgo was a generous beneficiary to his colleagues just starting out.

Combined with Hidalgo's success in particular, Miguel's own achievements over the next several years served to convince the Mexican government of Tablada's extraordinary value to their national image. Beginning in 1927, Mexico began a policy of pensioning worthy artists, and Tablada became known as their "Minister without portfolio."

M iguel arrived in New York in the summer of 1923 with the euphemistic title of attaché to the Mexican consulate. His mission was to do his best to make his country proud. He spoke only a smattering of English, but he had the address of the McAlpin Hotel, which catered to Spanish-speaking tourists. He also had Tablada's telephone number and several letters of introduction from Genero Estrada to various New York acquaintances.

He unpacked and, as Marcet Haldeman-Julius chronicles, immediately "engaged a waiter who spoke Spanish to take him to Tablada's address [an apartment in Forest Hills]. They journeyed thither in the subway—another new experience for Miguel—only to find that the poet had gone to the country for his vacation. Undaunted, Miguel made his way back to Grand Central Station and took a train to Woodstock."[4]

The McAlpin Hotel was Miguel's only false start. When he arrived at Tablada's Woodstock home, he was introduced to Octavio Barreda, who was on assignment with Mexico's consular corps to New York. Coincidentally, one of Miguel's letters of introduction from Genero Estrada was addressed to Barreda, asking him to look after Miguel until he found a job.[5]

"On our return to the city," Barreda recalled, "I took him to live in my apartment on 14th Street. When we arrived, he discovered that [the poet and critic] Luis Cardoza y Aragón, Fito Best Maugard, Carlos Mérida, and Carlos Chávez were already living with me. In fact there were always three to five Mexicans staying with me."[6]

When the elder Covarrubias learned whom his son's roommates were—these older, more experienced men, in particular the twenty-six-year-old Barreda who apparently had a reputation as a carouser—he wrote to Miguel expressing fatherly concern. To which Miguel replied, "I believe that you are mistaken about Barreda. He is one of the best, well-behaved boys that I have met." Miguel went on to report on his own progress: "Tablada and I have plans to write a book and publish a newspaper on art." And his mentor had mentioned him in print, in the

newspaper *International Studios.* "You see," wrote Miguel, "I have only to wait to be discovered."[7]

It was not a long wait. One of Tablada's first calls on Miguel's behalf was to Sherrill Schell, a well-known artist-photographer and travel writer, whose special interest was Mexico. Schell was first enchanted by the young man and then impressed by his work. He assumed the role of agent and began introducing Miguel around.

On 12 September 1923, Schell called his friend Carl Van Vechten, a versatile music critic for the *New York Times*, esoteric novelist, and with his wife, actress Fania Marinoff, a tenured member of New York's sophisticated "Smart Set." Van Vechten was another dedicated advocate of artists and the arts. He was Gertrude Stein's greatest promoter (and later her literary executor), is credited with a revival of appreciation for Herman Melville in the 1920s, and became a key player in the Harlem Renaissance just beginning.

A meeting was arranged. Miguel looked "just out of the adolescent stage," Van Vechten remembered. "So shy, indeed, that he immediately began to bombard me with a volley of quite unrecognizable English." Miguel's portfolio contained drawings of Mexican celebrities, only one of whom was familiar to Van Vechten. Nevertheless, "I was immediately convinced that I stood in the presence of an amazing talent, if not, indeed, genius."[8]

The critic got on the phone, "and for the next few days I made appointments for him to meet H. L. Mencken, Waldo Frank, Avery Hopwood, Eva Le Gallienne, and a great many others. I also introduced him to Ralph Barton who, with unselfish admiration for the rare gifts of this rival caricaturist, rendered him invaluable aid and encouragement."[9]

Barton, William Cotton, and John Held, Jr., were the day's most popular caricaturists, and caricature was very popular at the time. The devil-may-care, tongue-in-cheek twenties encouraged a cultural attitude not so far from that elusive *vacilada* prized in Miguel's own country. F. Scott Fitzgerald called the period the Age of Satire, and it was an age to which Miguel could relate, even without much English.[10]

"As soon as Covarrubias had drawn a few local faces," Van Vechten recalled, "I invited him to join me one day for lunch at the Algonquin. . . . From that moment he was launched . . . one glance at his drawings sufficed to exhibit indelible proof of his prowess."[11]

He began to work immediately. His first drawings sold to the magazines *Shadowland, Screenland, Modes and Manners, Current Opinion,* and the *Nation,* and the newspapers *World,* the *New York Tribune, Herald,* and *Evening Post, New York Evening,* the *Telegram Brooklyn Daily Eagle,* and the *Los Angeles Daily Times.* He designed a series of large paintings for the set of *Fashion,* a revival of an 1849 hit for the well-loved Provincetown Players spoofing the 1840s' "modes de Paris."[12]

"From the beginning," Van Vechten remarked, "I was amazed at [Miguel's] ability to size up a person . . . at once: there was a certain clairvoyance in this. . . . Speaking English imperfectly, a newcomer to this country, frequently he was actually ignorant as to whether his model was actor, painter, or author. In spite of

this handicap, or because of it, his caricatures almost invariably go deeply behind the mere sculptural formation of the face."[13]

The writer Witter Bynner had had a similar reaction to Miguel's talent when he, D. H. Lawrence, and Lawrence's wife, Frida, met Miguel "in a sort of Greenwich Village cafe on the Calle de la República de Cuba" in Mexico City that November. (Miguel must have made a trip home to reassure his family of his continued moral and physical health.) Bynner recalled: "We were looking around when our eyes were caught by a row of small, striking watercolors hanging unframed on a back wall. They were mostly Mexican types, expertly painted in flat bright colors: children, vendors and bricklayers. We went to the wall and studied them, exclaiming over them."[14]

A waitress pointed out the artist, who "happily gave each of us one of his watercolors." Although they saw much of one another during Lawrence's visit, Miguel did not learn that he was a "celebrity" until years later, and then he remarked to Bynner that he regretted not having made more sketches of the author. In *Journey with Genius*, his book about Lawrence, Bynner writes: "Though he had not seen [Lawrence] again after the year of our meeting, this regret was no sooner spoken than he sat down and nimbly drew a caricature from memory, extraordinary not only as a caricature but as likeness. It has more Lawrence in it than most of the photographs."[15]

In New York, Miguel's rare talent soon came to the attention of Frank Crowninshield, publisher of the trendy *Vanity Fair*, which (with *The New Yorker*) kept track of what the smart crowd was up to in the city. Both magazines appealed to a kind of snobbishness in their readers, at the same time engaging in stinging parodies of pretension and elitism. Caricature was the perfect illustrative form. Both magazines also published some of the best writers of the day—when Miguel became a contributor to *Vanity Fair*, he joined a distinguished crowd that included Dorothy Parker, Clare Boothe Brokau, Robert Benchley, Robert Sherwood, the artist Rockwell Kent, and photographers Cecil Beaton, Alfred Stieglitz, Edward Steichen, and Man Ray.

Miguel's first work for *Vanity Fair* appeared in the 24 January 1924 issue. It included an illustration for an article entitled "The Higher Aesthetic of the Neck Tie," by the radio commentator Heywood Broun, and a page of celebrity portraits by Miguel, including one of Ralph Barton—who responded in the same issue with a caricature of Covarrubias. Subsequent issues that year featured Miguel's pen inscribing politicians, theatrical artists, and members of New York's literati, in full- and double-page spreads of five, six, or seven portraits each.

Miguel was as fortunate in the patronage of Van Vechten and Frank Crowninshield as he had been in that of Tablada. Tablada had escorted the young artist to the threshold of a new country. Van Vechten had swept him into society's drawing rooms, and the elegant and genteel Crowninshield assured him a warm reception. These latter two were the movers and shakers of their day, and their implicit confidence in Covarrubias spoke volumes.

On 13 March 1924, Miguel had his first show, an exhibition of caricatures—the originals of those that had appeared in *Vanity Fair*—at the Whitney Studio Club.

Mrs. Payne Whitney decorated her gallery with Mexican folk art for the occasion, turning a bright painted wooden trunk into a music box as a centerpiece for Miguel's work. The Whitney Club catalogue announced with barely concealed pride, "Covarrubias has gained world wide fame and it is indeed satisfying to us to be able to offer our patrons signed original works by this artist at only five dollars each!"[16] It was a huge success, in a way Miguel's "coming out" party.

Tablada reviewed the event for *El Universal* in his column "Nueva York día y noche," noting that Miguel's "caricature of Calvin Coolidge was 'high treason,'" but that "certain caricatures of Covarrubias are of 'high magic.'"[17]

"High magic" was an apt description for the times, as well. Although it was the era of Prohibition, everyone carried a hip flask in his pocket, danced the Charleston, and partied until dawn. "It was the time of the lost generation of American writers and artists converging in two main centers, Paris and Greenwich Village," Octavio Barreda recalled in his 1957 conversation with Elena Poniatowska. "We were part of this group. There wasn't a dull moment in our lives."[18]

Although Miguel was having some success, he spent his money as fast as he earned it on clothes and entertainment in those early years. Barreda remembers they "were often faced with a desperate need to survive," and necessity bred various moneymaking schemes. A series of musical recitals was one, featuring songs by Carlos Chávez performed by Lupe Medina, with Rufino Tamayo on the guitar. Miguel also tried his hand at various musical compositions. He loved to invent personalized *corridos,* emotionally charged songs that recorded affairs of historical or political import and even affairs of the heart—not unlike modern American country and western ballads. (Tata Nacho was the recognized master of the art in those days.) Miguel and Tamayo frequently entertained their friends and one another with witty or simply silly *corridos.*[19]

A new friend of Miguel's, Harry Block, then a senior reader for the publisher Alfred E. Knopf, came up with the idea for a Mexican orchestra—bound to make money, they all agreed. Tamayo was designated conductor, and he decided what instruments each would play: he took the guitar; Chávez (or Chavinsky, as Miguel called him), the piano; Block (the only non-Mexican member of the band) played mandolin, while Barreda (Barredowsky) covered percussion with a frying pan. Miguel's friends nicknamed him *"Botelloncito de Guadalajara"* ["the fat little bottle from Guadalajara"], because he sweated a lot and was so nervous." Miguel attracted nicknames. In addition to this one and *El Chamaco* from his days at *Los Monotes,* friends who wrote to him from Mexico sometimes addressed their letters to the "Marquis of the Curvacious Blondes," a play on his name: *corvo,* meaning "curvy," and *rubio,* "blonde."[20]

Concerts, performed in Barreda's apartment, sometimes ran until two o'clock in the morning—which was about as much as his neighbors could take before they began banging on the walls for quiet. The orchestra did not live up to Block's financial hopes, but it attracted pretty women and lots of friends, and its entertainment value alone made it a worthwhile enterprise.

Barreda, Chávez, and Miguel also collaborated on a fantasy theatrical piece— a marionette show called "Love's Dilemma, or The Astounding Miracle of the

Apparition of Our Lady of Guadalupe," for which Barreda wrote the script, Chávez the music, and Miguel fabricated sets and costumes. The piece was performed at Tablada's home; the audience included some potentially valuable contacts as well as the usual friends. In fact, the directors of New York's Theatre Guild, for whom Miguel would later work, were in attendance on this night.[21]

Moving to fashion-conscious New York City did much to enhance Miguel's already-inflated sense of style when it came to clothes. Now he acquired silk shirts with matching ascots and handkerchiefs. Fito Best Maugard shared this affectation for dapper dress, as Barreda recalled: "You cannot imagine how they looked, or what kind of a life those two led. They personified the Dandy and were bonafide personalities of the Twenties."[22]

The two young men decided to take an apartment together on Beale Street in Greenwich Village. "Since they had no money for furniture," Miguel's brother Luis remembered, "they solved the problem by painting the chairs and sofa on the walls, to the amusement of everyone invited to their apartment."[23]

Miguel need not have lived at near-poverty level if he had been less generous with his money among his friends, but he had his priorities, even then. Since Miguel and Fito were never sure that their artistic endeavors would cover their rent every month, they took jobs as elevator boys—in a building where several chorus girls lived. The girls would come home late after their evening performances, often with gifts of champagne and baskets of fancy food from wishful admirers, which Miguel and Fito were invited to share. The elevator was abandoned, and the tenants complained, but the parties were worth it—although not to the landlord, who fired the boys in fairly short order.[24]

By all accounts Miguel was plump and terribly shy (not to mention that he was nervous and perspired a lot), but he possessed a charismatic personality that dazzled new acquaintances, and he seemed to have a particular appeal for women. Fito Best Maugard was also something of a ladies' man—they were a team, but they were not inseparable. The night that Fito met Rose Rolanda (she changed her name to Rosa much later), he was on his own. He had been to a musical revue on Broadway in which she was a featured dancer and had been introduced to her after the show. Several days later he invited her to the Beale Street apartment to see some of his drawings and perhaps pose for a painting. To his great surprise, she agreed to come.

Unfortunately for Fito, Miguel was home when Rose arrived, and Best Maugard recalls that when the two looked at one another, he knew instantly that he no longer stood a chance. Afterward he told friends that this was the danger of rooming with someone like Miguel, because the girls always fell in love with him.[25]

Rose's father, Henry Charles Cowan, was the son of a Scottish immigrant who had settled in Springfield, Illinois, and then moved to California with his wife and son, where he was stationed in the army in Los Angeles. Henry's mother died when he was sixteen, and his father gave the boy into the safekeeping of a friend, Sylvester J. Cook, an architect known for the French-style

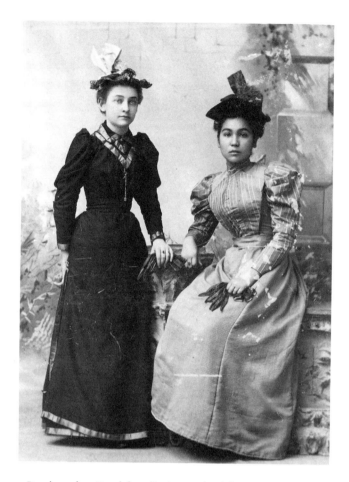

Rosa's mother, Guadalupe Ruelas, on the right.

mansions he designed in Los Angeles's Dougherty district, and his wife, known to the children as Grandma Cook.[26]

There was another child in residence when Henry arrived. She was twelve-year-old Guadalupe Ruelas, who had been born in Azusa, California, to Mexican parents. She had also lost her mother, and her father had returned to Guadalajara to work. Henry and Guadalupe became childhood sweethearts and eventually married in Grandma Cook's house with her blessing. Rosemonde was their first daughter, born 6 September 1895; eighteen months later, Mae was born.[27]

Cowan worked as an engineer with the Los Angeles water department, and the family moved into a "company" house on ten lush acres of land just beyond the corner of Compton and Slaussen avenues, outside the city limits. Here Rose and her sister learned from their mother how to keep productive vegetable and flower gardens, to gather wild mushrooms, and to harvest nuts from the trees. The girls had to walk a mile to school together, which Mae remembered as being less than pleasant. Rose was bossy, often bad-tempered, according to her sister, and insistent on having her own way. When she was crossed, she took out her anger in loud rages that

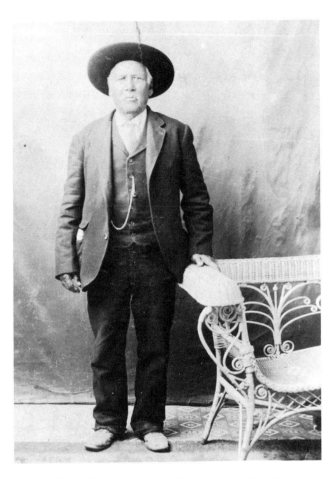

Rosa's grandfather, Guadalupe Ruelas. Photograph by F. E. Brouer.

frightened the more timid Mae and made her dread the daily ritual. She was relieved when Rose graduated to the Manual Arts High School and took the trolley.

Academically, Rose was an average student, but she had a gift for sculpture and excelled in physical education. She was also an extraordinary beauty, with a classic profile, long arms, delicate hands, tapering fingers, and a strong, muscular body. She had unusual eyes: they were dark, but shot with yellow, like an exotic cat. Her eyes mesmerized. Fernando Gamboa, Mexico's premiere museologist, who became an intimate friend of Miguel and Rose in the 1940s and 1950s, likened her eyes to "phosphorescent stone with scintillating golden points."[28]

Rose took gymnastics lessons from interpretive dancer Marion Morgan, who encouraged her to study dance. When Rose was not immediately enthusiastic, Miss Morgan promised that a knowledge of dance would benefit Rose's work in clay modeling—the young woman was already using dancers as models.

Dancing did more than that, revealing in Rose an inherent sense of rhythm and drama. With her huge energy and strong personal confidence, she was able to express her creative self in this new art. Choreography became as natural a means

Rosa's father, Harry Cowan, ca. 1890. Photograph by E. M. Davidson.

of that expression as dance; soon costume design became another. And Rose became a personality at school. Everyone noticed her, and she basked in her classmates' admiration. (It was not so for Rose's more introverted sister, who was always Rose's sister, never Mae, and "That didn't set too good!" as Mae put it. This was true even two years after Rose had graduated—a fact that still bothered Mae seventy years later during my interview with her.)

The year after her graduation in 1915, Rose apprenticed with Marion Morgan for a summer session in interpretive dance at the University of California at Berkeley, which culminated with a performance in San Francisco.[29] At the end of 1916, Morgan chose six of her three hundred students to come with her to New York where she would launch the Morgan Dancers. Again, Rose had to be persuaded. Even after the troupe arrived in New York, she admitted, "While I was rehearsing, I was still only mildly interested in dancing. After the first appearance on a New York stage, however, it was all over. The germ bit me and bit me hard."[30]

Miss Morgan enrolled her girls in dance school in New York, paid their tuition and room and board, and set high standards. She believed that diligent application

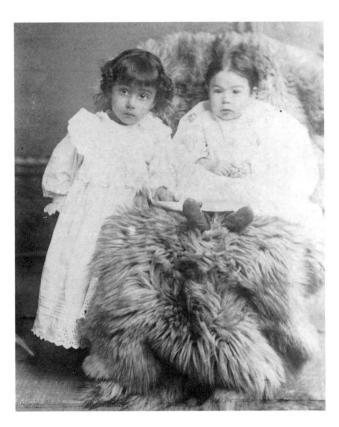

Rosa with her sister, Mae.

would earn each of them a cultural base and the good manners necessary for social status. Each must have some musical training. (Rose studied piano.) Miss Morgan also believed in fresh fruits and vegetables, fresh air, lots of water, and no makeup (bad for the complexion). Curfew was ten o'clock.

There was little time for romance, and dates would be chaperoned in any case. "We have no time nor inclination toward midnight suppers, dance halls and moonlight drives," a Morgan dancer explained to a reporter. "We work too hard. If we are to succeed, we must maintain our rigid regimen and be content with the loss of some things that to others might seem terrible." For their performance work, the girls received a salary of thirty dollars a week. To earn extra money for clothes, Rose found time after classes and between performances to teach dance herself.[31]

Interpretive dance had been in vogue in California since the turn of the century. The Morgan-style dance shared much with the dance Isadora Duncan popularized, although Miss Morgan's second-in-command, Josephine McLean, made it clear that "We were the first barefoot dancers in vaudeville in this country. Yes, we started before Isadora Duncan and her dancers." The Morgan girls used pantomime to enhance their performances, and Miss Morgan considered it a requisite that her girls "live their parts." Miss McLean explained that "they must

*Rosa (far right) in the Girls' Fancy Dancing Class, The Manual
Arts High School, Los Angeles, February 1913.*

forget [who they are] and become for the time being at least the characters they are
portraying. . . . Complete oblivion of self is the one thing that makes the Morgan
dancers different. Marion Morgan has striven for that and succeeded, and that is
why they can appear in the semi-nude and not offend."[32]

Since the troupe took its dance themes from classical Greek and Roman
stories, Miss Morgan required that her young women be well versed in Greek and
Roman mythology and knowledgeable about the mythologies of other exotic
countries. "I particularly like tall girls for classical dances," she told a reporter,
"because they look more like the statues of the ancient figures that I am bringing
to life." She called her girls "my California poppies . . . golden poppies."[33]

They performed at social teas and soirees at such fashionable hotels as the
Waldorf Astoria. They gave dance recitals at private estates on Long Island. The
troupe's first professional stage engagement was in a vaudeville production called
The Lilac Domino at the Palace Theatre, which was on the B. F. Keith circuit for
musical comedy. Rose began performing solo in this show and traveled with it
throughout the United States and Canada. She far preferred the solo performance
and told a reporter several years later, "You must think about what you are trying to
be. I originate all my own dances. Some idea in my head trying to express itself
through my body. That is why group work wasn't for me. It didn't allow for growth."[34]

The Twenties, Part One

27

Arnold Genthe and many less famous photographers left a visual record of Miss Morgan's California poppies interpreting Hellenic art. *Vanity Fair* published photographs by Maurice Goldberg of the dancers arranged dramatically under an oak tree, and Baron de Meyer's image in *Theatre Arts* showed them on a bank overlooking a river. The mood was neoclassically romantic, à la Maxfield Parrish.[35]

It was while she was a member of the Morgan Dancers that Rose changed her name from Cowan to Rolanda, after a distant relative on her mother's side. Rolanda was more theatrical, she thought, and better suited to her dark-eyed look. Over the years Rose continued to make adjustments in her name, from Rose to Rosa, and from Rolanda to Roland.

She left the Morgan Dancers in 1918 to join the Broadway cast of Sigmund Romberg's *Over the Top* at the 44th Street Roof Theatre, starring Ed Wynn and Adele and Fred Astaire. Rose brought her own troupe of ten "Russian" dancers with her to perform neoclassical dances which became the hit of the show.[36]

The move must have been wonderfully liberating to the headstrong twenty-two-year-old, whose "uncommon grace and charms" immediately caught the attention of theatergoers and critics. Her star began to rise. Two years later she was featured with Anna Pavlova and Martha Graham in a *Vogue* article on dance.[37]

During the run of *Over the Top*, Rose had also come to the attention of French film director Maurice Tourneur. He was the head of production for Paragon Studios in New Jersey, and he commissioned her to choreograph and perform dance sequences for several of his films, including *Monte Cristo, Jr., Bluebird, Prunella, Woman,* and *The Glory of Love*, which made the director's reputation as "Poet of the Screen." Although married and in his early forties, Tourneur could not resist the charms of this stunningly beautiful younger woman who shared his interest in symbolic art.[38]

It was an important affair in Rose's life — and Tourneur's, to judge by this love poem (written upon receiving some photographs of her), which Rose kept among her most prized possessions.

Her Pictures

And all the radiance of the Sun is there,
In these dear pictures — the Lady of my love.
Beggared I was and sad until the treasure-trove
Of her sweet thoughtfulness uplifted my despair.

Always within my heart I held her image fair
But now it showers its blessing from above
And in her eyes I read the glory of her love
And mark God's fingers in her glorious hair.

In a note attached to the poem, Tourneur had written, "All I feel I may not have set down. My heart is thine. Because thou has brought me near to the Divine, I worship thee with my Soul and at thy feet I kneel."[39]

Rosa with the Marion Morgan Troupe, New York, ca. 1918.
Photograph by Lumière.

Tourneur moved to Los Angeles. Soon after, Rose decided to visit Los Angeles herself, ostensibly to see her family. Every morning, she borrowed her father's car to make the drive to Burbank where, she told her father, she was working. (She had made him buy a new Chandler because his old car had embarrassed her. Appearances were important to Rose.)

Henry Cowan didn't altogether trust his oldest daughter. She had come back from New York with a high-and-mighty attitude, and she always had been willful. Cowan made a point of recording his mileage before Rose took off in the morning and again when she returned home. He never did find out that she and her lover drove to the beach at Ventura more mornings than not or, if Tourneur could spare the day, to Santa Barbara. Tourneur's chauffeur always adjusted the Chandler's odometer before Rose drove back home.

Rose's mother died unexpectedly in 1920. Not long afterward Mae, who had already married and begun what would be a large family, invited Rose to come back to Los Angeles for a visit. Their father picked Rose up at the train station, and before taking her to her sister's home, he took her to his house to meet his new wife. It was the first that Rose had known of his remarriage, and she was enraged—not only at the fact of it, but at her father's insensitive way of breaking the news. She threw one of her familiar tantrums and left his house. She never forgave him and never communicated with him again.

Rose and Mae stayed in touch after that, but only sporadically and superficially. Rose would send her sister theater programs from her shows and photographs and

mementos from her travels abroad, but there was never any personal communication between them. Later, on occasions when Rose and Miguel passed through Los Angeles on their way to the Far East, they sometimes stopped to see Mae. Mae and her husband Harry would chauffeur Rose and Miguel around town and then share a dinner with them aboard the ship on which they would sail the next day. The shipboard suppers were always a thrill for Mae, but more often than not, Rose did not bother to call.

Mae believed that Rose was ashamed of her middle-class American family. Rose had always felt superior to them. Now that she had traveled and lived in New York and was beginning to be noticed, it seemed to Mae that Rose wanted to distance herself from her family. Very few of Rose's friends even knew that she had a sister or anything else about her background. In fact, Rose was purposely vague about her origins. Some people thought she was an American Indian, some guessed that she was an Eastern European Jew, some thought she was Latin. Rose encouraged such speculation; it added a bit of mystery to the exotic persona she liked to promote.

In 1921 she joined the cast of *The Rose Girl* at the Globe Theatre, and on opening night she stepped out on stage wrapped in a short gold silk sarong, with tropical flowers in her hair, holding aloft a pair of Samoan goldsticks. The choreography was her own, with a kind of jazzed-up East Indian flavor. She had "syncopate[d] the rhythm just for a lark. . . . [and] turned a poetic Nautch [a style of dance popular in the twenties] into a mad, abandoned gypsy number."[40] Rose played the goldsticks by striking them together while she danced. She astounded the audience, whose applause stopped the show.

Before the year was out, she had joined the cast of Irving Berlin's *Music Box Revue*, and she took the goldstick dance with her. After one of these performances, a parcel post package containing a fire extinguisher awaited her backstage, with the note: "Keep this handy. You are liable to blow up any minute."[41]

The *Revue* was a perfect showplace for Rose's remarkable beauty and talent. Aside from the Samoan stick dance, she choreographed several other pieces for it. In one she appeared as a cigar personifying a good smoke, probably a take-off on Kipling's vogue line, "A woman is only a woman, but a good cigar is a smoke." She was the fountain in a dance called "The Fountain of Youth," and she sang and danced with a male chorus in a number called "Wondrous Midnight Eyes," which suited her well and brought the house down.

She was radiantly happy with such response. She clipped and saved almost every review (although she clipped without a thought for dates or even the names of the newspapers in which her notices appeared). She kept *Theatre Magazine*'s comment about the "young American of great individuality who danced with an abandon that seemed almost delirious" and famous critic Alexander Woollcott's report—"The most enthusiastic and spontaneous approval went to an uncommonly spirited dancer named Rose Roland, who looks like Madame Rachel [a famous French dramatic actress of the day] and treads her measure delightfully."[42]

As the *Music Box Revue* played on and continued to wow audiences, Rose added new dance numbers using Egyptian and Far Eastern folk dance for inspiration. She

Samoan "Goldstick" dance in Rose Girl, *1921.*
Photograph by Nickolas Muray.

was frequently partnered with the black dancer Chester Hale, her counterpart in physical beauty and power of expression. Together they performed "like the show itself, something a bit bigger and better than other dances," according to *Theatre Magazine*. The caption of a photograph taken for the article of the two of them by Nickolas Muray likened them to "a fine modeling in marble and bronze from the hands of a master."[43]

There was great camaraderie and generosity of spirit among the *Revue*'s cast members which extended outside their own ranks. With other young women in the cast, Rose was part of a society they had dubbed the Ha-Ha Club, which on one occasion honored one of their biggest fans, humorist Robert Benchley, who wrote on theatrical subjects and who had glowingly reviewed the show for *Life* magazine. In appreciation, the club invited the portly Benchley to a special all-he-could-eat dinner at Rose's Greenwich Village apartment on Irving Place.

Benchley wrote to Rose afterward, thanking her for the meal served "in such a munificent fashion last night. . . . I hope that you will believe me when I say that no one was ever so nice to me out of a clear sky before, and that my first impulse was to cry a little from sheer gratitude. My next impulse was to see if it couldn't be arranged so that I could marry the entire club membership."[44]

In 1921, in addition to shows six nights a week, plus matinees, Rose participated in many benefit performances for various charities. Director Lee Shubert featured her as "artist of the day" for that year's Metropolitan Opera Equity Show—a distinct honor, for other participants were such stars as Ethel and John Barrymore, Norma Talmadge, the elder Tyrone Power, George Arliss, Helen Hayes, Lynn Fontaine, and Alfred Lunt.[45] She performed with Fontaine and Lunt again in the American Legion's Victory Ball that year on the eve of Armistice Day. New York's elite, the Vanderbilts, Paynes, Whitneys, and Burdens, produced it. The theme was America, and in one historical pageant Rose represented Pocahontas, Alfred and Lynn were Bohemia, and Eva La Gallienne was the Spirit of a Nation Reborn.

Rose also continued to train: she studied technique and toe dance with Frank Vaeth and creative dance with Carl Randall, who later became her dance partner. (Nickolas Muray photographed them for *Vanity Fair*.) And she continued to practice her choreographic skills and costume design, taking lessons from Robert Kolloch, who would design her costumes when she worked with the Ziegfeld Follies just two years later. She used all the skills she was polishing in an allegorical ballet entitled the "Dance of Life" for Lois Weber's film *What Do Men Want?* Rose chose the music for her numbers, as well: that of such modern masters as Saint-Saens, Rimsky-Korsakov, and Tchaikovsky, quite avant-garde for the period.[46]

The *Music Box Revue* production costs were an unheard of one million dollars, but the show proved profitable wherever it went. During the two years Rose worked with the *Revue*, the company traveled to Boston, Philadelphia, Cleveland, Detroit, Chicago, and St. Louis. In Philadelphia, a local critic noted that "Rose Roland is more of a dancing sprite than a human being. She seems poised for flight, ready to join the pagan elves that haunt the woodland depths." Of her South Seas number, another reviewer commented on "the lithe young dancer . . . in Javanese regalia. . . . Aztec blood is said to flow in the veins of Rose Roland. Certainly she has a fusion of warrior-like force and grace in her manner, evocative of the old Indians."[47] Rose must have loved the suggestion of Aztec blood.

Audiences were similarly struck in Chicago (where Rose acquired a persistent suitor, the writer and cartoonist Gene Markey). The *Chicago Sun* wrote, "There is a dark skinned, lithely muscular, exceptionally graceful, glossy haired dancer who fascinates the audience. She was gaudily but very sparsely dressed." Another Chicago reviewer mentioned "her remarkable brown-hued body (of which she shows a generous portion—the gods be thanked!). . . . She uses her arms in a wildly exquisite way which captivates one. It would be worth ten dollars a seat to me."[48]

The venerable modern dancer Ruth Page, herself from Chicago, saw Rose dance during this run and remembers in particular her "extraordinary stage presence."[49]

During these exciting years in the early 1920s, Rose established a warm friendship with the precocious painter-designer George Heppenstall, a young genius (one year older than Miguel) whom Rose had met when he was a student at the Academy of Fine and Applied Arts in New York. He included paintings of Rose among those in a one-man exhibition of his costume designs in Pittsburgh and used another of her on his Art Nouveau–Oriental-style Christmas card in 1921. He called Rose "the most wonderful model I ever had."[50]

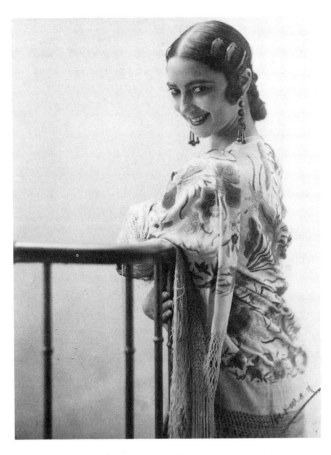

Rosa as a Spanish dancer, New York, 1922. Photograph by Herman.

Heppenstall died in 1923 at the age of twenty after a nine-day bout with pneumonia. His death hit Rose very hard. She had suffered the loss of her mother—and for most purposes that of her father—but she had no experience with losing so close a contemporary and friend as George. Travel may have been a welcome distraction. That same year, she left the *Music Box Revue* to tour with the Ziegfeld Follies in Europe.

A reporter interviewed her aboard ship, just before sailing. "First I'm going to England to dance," Rose told him. "Then I hope to visit Italy because I want to collect Venetian glass before going to Paris to dance in that beautiful city."[51]

She proceeded to expound earnestly on her art:

> *A dancer's brain is not in her feet. You've got to think about your work and what's more, the audience has got to be made to feel that you are thinking. If you are supposed to be a gypsy, or a lily swaying in the wind, or any of the things that one might think of, you must behave as any one of those things would behave.*

I think one should be a psychological dancer, which
would have sounded even more strange a few years ago. But
everybody thinks more today than they would have before. I
suppose the war and everything that came afterward did it
for us, but it is an unescapable truth. For my own part, I
never dance spontaneously. I've tried to make myself clear in
my dancing as another person will try to express himself with
a pen, or a brush, or his voice. I originate all my own
dances.[52]

At age twenty-eight, Rose took herself and the dance very seriously.

She was a smash in Europe. French fashion designer Paul Poiret called Rose's "the perfect type of classic beauty, and the most interesting personality of anyone I have ever seen and worked with."[53] This from a man who knew most of the famous beauties and interesting personalities of the day.

When Rose returned (with a German shepherd) from her year abroad, she entered what was perhaps the period of her highest success, if judged by level of recognition. Artists sought her out: Winold Reiss painted her in a richly embroidered Spanish shawl with an ornamental hair comb and a fan in her hand; William Pogany used her exotic look for a series of decorative panels; and the Mexican Amero (whom Miguel had wanted to redecorate his studio-apartment back in Mexico City) made a splendid black-and-white painting of Rose. She also appeared in *Vogue* modeling hats by Mercedes. As might be expected, many of the day's caricaturists found her a most appealing subject: Luis Hidalgo did one of his satiric wax sculptures of her. I. Randall, Gene Markey, Wynn Holcombe, and Ralph Barton all drew her for magazines and newspapers.

Not too much later, Rose appeared on the cover of a magazine from Río de Janeiro, which pleased her because it promoted her image as a successful Latin woman in New York. She was still eager to create a more interesting past for herself.[54]

Meanwhile, she joined the cast of Jay Kaufman's and H. Mankiewiez's *Round the Town*, starring Jack Haley and Gloria Foy, and her list of admirers grew. Among them was the eccentric and brilliant Avery Hopwood, America's most prolific — and profitable — playwright of the day. Wynn Holcombe included "Avery Hopwood and his passion flower Rose Rolanda" as one of his *Forty Immortals*, a series of panels used as backdrop for the *Music Box Revue*, still going strong on Broadway.[55]

When he began to court Rose, Hopwood was forty years old, and he declared that he had "started to live the greatest romance that had ever entered his mind." They announced their engagement on 17 March 1924 — they would be married "over the air" in a special radio broadcast while Hopwood sailed the high seas on the *Aquitania* and Rose remained in New York with *Round the Town*, whose cast members would be Rose's witnesses.[56]

Among their close friends like Van Vechten, it was common knowledge that it was all a publicity stunt. Hopwood had been engaged to three young women at once before he met Rose, and besides, he was a known homosexual. But it was a

great lark, just the kind of antic the public of the twenties enjoyed, and it came as no particular surprise when the wedding never took place.

From the moment of their announcement, Hopwood had "preserved a sphynx-like silence." When asked why he called off the engagement, he said, "The thought that I might have to look across the breakfast table at the same beautiful face for a period of five to fifty years has made me stop! Look! Listen!" Nevertheless, Hopwood and Rose remained good friends until his sudden death four years later.[57]

After the final performance of *Round the Town*, Rose joined Kaufman's *Manhattan Mirrors* for a short run. It was after one evening performance of this show that she and Fito Best Maugard were introduced and just days later that she met Miguel.

[Miguel Covarrubias] is one of an increasing colony . . . of young men—almost absurdly young men—who have accomplished large things at a ridiculous degree because they have known what they wanted to do and have been able to do it.[1]

F THE TWENTIES, PART TWO (1924–1929)

ito Best Maugard went back to Mexico in 1924, and that summer Miguel made a quick visit home to see his parents.[2] When he returned to New York, he moved in with Harry Block and at the same time began to look for studio space with another young artist, Al Hirschfeld, to whom Van Vechten had introduced him. They found a rental in the old World Tower building on 42nd Street.

"Miguel influenced me more than I did him," Hirschfeld told me in an interview in 1985. "At the time, I was more of a painter and a sculptor, but I was fascinated and very admiring of his way of drawing. His technique consisted of elimination and simplification. When I turned to caricature, I remembered the lesson I had learned from him."[3]

Hirschfeld also remembered that Miguel spent little time at his drawing board, preferring "to be out where the action was. He wanted to be with people. . . . After being only a few years in New York, he knew everybody in the literary world, in the arts, in the theater, in the ballet and all other allied arts. He also knew the Vanderbilts, the Whitneys, and the Rockefellers; the wealthy of the city."

Miguel had been taken up by New York's intellectual and artistic upper class,

"and he suddenly found himself in the position of one of the most indulged youths in that city," according to the biographical almanac "Who's News and Why."[4]

"A rendezvous with him at a cafe was invariably stimulating," Fernando Gamboa remembered.

> *All of his friends and colleagues commented on his enthusiasm, and on his ability to manifest his ideas artistically. Inundated by the rush of ideas in his head, he spoke in a broken, stuttering voice, as though there was not enough air. In this breathless fashion, he jumped from one subject to another, regaling friends with his new projects, the latest gossip, a hilarious joke, or advice.*[5]

Miguel, Hirschfeld, and Alexander King became close friends in the twenties. King was an author and illustrator who worked for *Vanity Fair* as well as the publisher Limited Editions, with whom Miguel would also establish a long-term relationship. King's reputation was that of a *bon vivant* with a stinging wit, a true "character" among New York's elite. Another good friend was the painter Fletcher Martin who had a home in Woodstock where Miguel, arriving for a weekend visit, once encountered a naked woman climbing a tree.[6]

Miguel and Hirschfeld also saw a great deal of the playwright Eugene O'Neill, who shared their love of swing and jazz and often went club-hopping with them. They frequented The Cookery on Second Street, and the Savoy, Deuces, Baron's, Wilkin's, and Small's Paradise in Harlem.

"Once Miguel became involved with the Harlem Renaissance, he had a good reason for never being at the studio," Hirschfeld reminisced. "If you wanted him for something important, he could be found uptown attending some performance or sitting in a nightclub busy making hundreds of sketches. Some of these would later turn into marvelous paintings."

It was Van Vechten, who had written much about Negro blues and American jazz, who introduced Miguel to Harlem very soon after the young man's arrival in New York. A whole new world opened to him then—as if he had stepped through the looking glass, from the sharp, bright surface of Manhattan's upper crust into a place where the focus was on "soul."

It was not an entirely unfamiliar world: Harlem was a first cousin to Mexico City's bohemian section, where Miguel had grown up. Both were gathering places for intellectuals, artists, and personalities of the day, and during the period in which Miguel knew them, both were centers for a renaissance of spirit that had to do with cultural rediscovery, with a search for the elemental self. And in both cases, rediscovery was assisted through a renaissance of creative art, in particular folk art. For blacks in the 1920s, folk art communicated as blues, jazz, spiritual song, and dance, and Miguel was there to record it.

But it was not his style to be the detached observer. Miguel began to make friends—with singers Ethel Waters and Florence Mills, writers James Weldon Johnson, Zora Neale Hurston, and Langston Hughes whom Miguel met at the short

story writer Eric Walrond's home. Miguel also became a good friend of W. C. Handy, who was the first black blues anthologist to be published in the United States, "commencing a revolution in the popular tunes of this land comparable only to that brought about by the introduction of ragtime," in the words of musicologist Abbe Niles.[7] These were the components of New York's Negro intelligentsia—a set as smart as any in Mr. Crowninshield's or Mr. Van Vechten's crowd and vibrant with color. Miguel was fascinated. He made drawing after drawing.

The December 1924 issue of *Vanity Fair* featured eight studies of blacks whom Miguel had observed at Negro revues and cabarets in Harlem. "Enter, the New Negro. . . . ," *Vanity Fair* proclaimed, "Exit, the Coloured Crooner of Lullabyes, the Cotton-Picker, the Mammy-Singer and the Darky Banjo-Player, for So Long Over-Exploited Figures on the American Stage."[8] These were the first drawings of Afro-Americans ever published in that magazine; Eric Walrond provided captions in black folk dialect.

Seventy years later, the language makes us cringe, but the piece was not meant to patronize. While caricatures are frequently disrespectful, Miguel's never were; while most are rarely dignified, his always were because he looked to capture the essential dignity of his subject. "Enter the New Negro" was a genuine if ingenuous effort to show respect and to dignify the Afro-American.

Ever on the lookout to promote his protégés, as well as an end to racial stereotyping, José Juan Tablada spoke of these drawings in his column for *El Universal* under the headline, "Miguel Covarrubias, the Man Who Discovered the Negroes in the United States: Beauty Where No One Has Seen It," praising Miguel for looking beyond current stereotype, claiming, "All of a sudden there is a new image of the Negro, all due to the pencil of Miguel Covarrubias."[9]

Vanity Fair continued to write about the "New Negro" in articles about black music and art and occasionally featured stories and articles by black writers. Miguel's illustrations of blacks also continued to appear in *Vanity Fair* and elsewhere. Among the Smart Set in New York, it became chic to visit Harlem. Here was a place where the straight-laced could loosen up; here was emotional release and a kind of celebration in which most Anglos had little practice and less experience.

One Hundred and Thirty-third Street was sometimes referred to as Beale Street after New Orleans's Beale Street, famous for good jazz. It was one of the best places to celebrate, in Miguel's opinion, and one might find him somewhere on the block—at The Cat and the Saxophone, The Kit Kat Club, Small's Paradise, Leroy's, or The Last Jump—on almost any given night. There, pencil in hand, at a small table, with friends or alone, he sat sketching singers, dancers, musicians, actors, writers, painters, poets, entrepreneurs, and other miscellaneous patrons "on a sketch book which soon no longer had any blank sheets, on match boxes, on napkins, and on anything else he could find," as Hirschfeld remembered.

Soon there were collaborations. A landmark book for the Harlem Renaissance appeared in 1925 with three of Miguel's pieces. Called *The New Negro,* it expanded material that had appeared in a special issue of *Survey Graphic,* edited by the

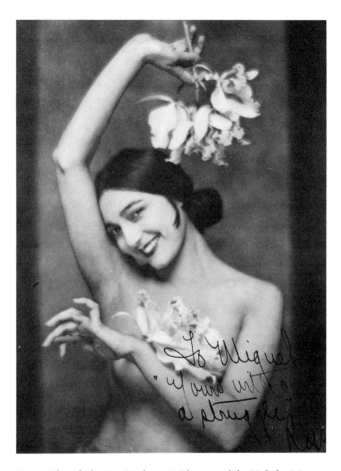

Rosa with orchids, New York, 1926. Photograph by Nickolas Muray.

brilliant black educator and author Alain Locke. (At that time Locke was the only Afro-American to have won a Rhodes scholarship—which remained the case until 1967.) It was a major anthology of stories, articles, and poems demonstrating "the dramatic flowering of a new race spirit . . . among American Negroes in Harlem," primarily illustrated by Winold Reiss.[10]

Another Van Vechten match in 1925 put Miguel, as jacket illustrator, together with Langston Hughes for the young writer's first published book, *The Weary Blues,* which Van Vechten had been instrumental in selling to his publisher, Knopf. Langston had been unsure about using caricature for the cover, afraid that the style might be offensive or denigrating, as some caricature surely is, although NAACP leader Walter White (who had initiated Van Vechten into the Harlem scene) reassured Hughes in a letter: "I hasten to extend to you my warmest congratulations on the acceptance of your book of poems by Knopf. It is certainly great to have a forward by Van Vechten and have Covarrubias to do the jacket. I was delighted when I heard it." But in fact, after the book's publication, the elder poet George M. McClellan, who also wrote to congratulate Hughes on his poetry, added that he had cut out of the cover "that hideous black 'nigger' playing the piano."[11]

Miguel and Rosa, ca. 1927. Photograph by Edward Weston. Collection of Rosa Covarrubias, © 1981 Center for Creative Photography, Arizona Board of Regents.

Miguel had portrayed an angular, black, blues musician astride his piano for the cover, and Hughes and Knopf were pleased. "I liked your jacket for my book immensely," Hughes wrote to Miguel, "and I think it the best pictorial interpretation of my *Weary Blues* that I have ever seen. . . . You are the only artist I know whose Negro things have a 'Blues' touch about them." And Hughes included several new blues poems. "I hope you like the poems well enough to try some drawings for them, too," he went on. "If *Fine Clothes to the Jew* ever becomes a book I would be very proud to have your drawings as a part (and perhaps the best part) of it."[12]

Miguel also illustrated W. C. Handy's *Blues*, published in 1926, which Heywood Broun called "the most beautiful book I have yet seen." Langston Hughes reviewed the book for the black journal *Opportunity,* offering Handy, Abbe Niles (who wrote the introduction), Covarrubias, and Albert and Charles Boni (the publishers) "a bouquet of blue flowers," and effused, "The Covarrubias illustrations alone would be worth the price of the book." James Weldon Johnson thought so too. He concluded a long and generous appraisal of Handy's anthology for the *Saturday Review of Literature* by saying that Covarrubias's illustrations "alone make the book worthwhile."[13]

Miguel presented Rose with a copy of *Blues* dated 10 May 1926, in which he drew a likeness of her, dancing, with a rose between her teeth and a Spanish comb in her hair and wrote: "To the Gringa contortionist (add to that she is dark-skinned), who inspired me to do the negro drawings!"[14]

By this time, Rose and Miguel had become a serious item. "There was a palpable communion of spirit between them. She was an essential part of his well-being. They were not only lovers and friends, but collaborators," *Excélsior* reflected many years later. Rose loved the night life and the Harlem scene as much as Miguel did, although her performance schedule did not permit as many evenings out as Miguel enjoyed. Except for matinees, however, most afternoons were free, and when Miguel had money (he still had not learned to save), he treated them to tea dances at the Plaza Hotel, or they dined out, both being attracted to exotic foods. "We had the habit of going to restaurants that featured ultramar dishes [Asian seafood]," Rose recalled for Elena Poniatowska.[15]

Rose was a true gourmet; within several years she would become revered for her mastery of these exotic dishes. She recalled her introduction to Chinese food in an unpublished article she wrote many years later, entitled "The China I Knew":

> *William Alfred Barr, the renowned collector of Chinese art [he founded the New York Museum of Modern Art in 1929], and Arnold Genthe, Isadora Duncan's photographer, used to take me to a Northern Chinese restaurant near Columbia University, to Port Arthur in Chinatown, and to Lum Fong's third floor on Canal Street where I learned there were other kinds of food besides Chop Suey and Chow Mein.*[16]

Rose and Miguel discovered that they knew many of the same people and shared many of the same interests. Dance was one of those interests, and theater had been Miguel's first love. With director Lee Simonson's encouragement, Rose had no difficulty enlisting Miguel as a set designer and Miguel's friend Tata Nacho as composer of the music for a sketch for the Garrick Gaieties called "Rancho Mexicano," in which Rose would star. (The Gaieties used Rose as their program cover girl for this piece.[17]) Miguel, of course, was not entirely inexperienced in theatrical design, having created sets for the centennial *Noche Mexicana* in 1921, not to mention his more recent fabrications for the marionette show, *Love's Dilemma*.

"Rancho Mexicano" attracted serious attention. Albert Carroll reviewed it for the *New York Times:*

> *There is bright hope for our theatre in the person of a new designer, Miguel Covarrubias. For such people as are nourished by the Southwest, its sun-scorched ferocity and subtlety and elimination and its eternal symbol, this artist will have meaning. His scene before the pulque shop shows a new kind of strength. It is raw and bonafide and without pretti-fication. It is much too good to be picturesque. It has, more-over, a direct sense of the dramatic and a sharp, hot power.*[18]

For the show, Rose braided her long hair with red, white, and green ribbons, wore a big sombrero that tied under her chin, and lived up to her reputation as a

sizzler. Afterward, *The New Yorker* ran a Ralph Barton cartoon captioned, "Every Thorn Has Its Rose: The trees may all be dying in Central Park, and many of us may be paying alimony—" Barton wrote, "BUT—We can still watch Rose Rolanda dance in the brim of a sombrero every night at the Garrick Gaieties, and that is something for which to postpone a sailing to Europe."[19]

For Rose, it was a shining moment. At the opening night party, a society columnist noted: "Living up to her name in a vivid scarlet frock with roses on one side of her hair, Rose was seen chatting with Miguel Covarrubias at a table with Arnold Genthe, Fania Marinoff, and Carl Van Vechten."[20] The evening meant so much to Rose that she kept the red dress all her life.

With this experience of set and costume design fresh in his mind and his frequent attendance at Harlem clubs, it was natural for Miguel to become interested in designing for one of the black musical revues he so enjoyed. Van Vechten promoted that idea by writing that he was sure Miguel "would seize such an opportunity [to stage a black revue] gratefully."[21] Soon enough the opportunity presented itself in the shape of Caroline Dudley Reagon's *La Revue Nègre,* the first jazz musical to travel to Europe with an all-black cast. It opened in Paris in 1925.

Miguel had created a backdrop of "boldly painted watermelons in electrifying colors, some whole and some sliced," spilling out of huge cornucopias on either side of the stage. Van Vechten was in Paris during its run and wrote to his friend, the book critic Hunter Stagg, that the revue was enormously successful. "Papers such as the *Figaro* devote two serious columns to it, comparing the music to Stravinsky and the dancing to the Russian Ballet. And Josephine Baker, the leading woman, is now the best kept woman in Paris with a house on the Avenue du Bois de Boulogne!"[22]

Josephine had been plucked from the chorus line of Eubie Blake's *Shuffle Along,* a revue that had opened on Broadway in 1920 and ushered in a vogue of Negro singing and dancing. Except for being a little less loud and much less provocative, the musicals that played downtown, on Broadway, were very like the ones uptown, in Harlem. When the sensational "La Baker" came onstage at the Théâtre Champs-Elysées wearing a girdle made of bananas, the audience went wild. In her memoirs, she recalls that show that made her a star and "the baroque decor, all yellows, blues, pinks and oranges, and the extravagant costumes." *La Revue Nègre* was the hit of the 1925 season, and according to Baker's biographer Patrick O'Connor, Miguel's work "made a great impact on Parisian designers and illustrators, including Paul Colin" who did numerous posters and drawings of the performer.[23]

Meanwhile, Miguel continued to make his mark as an illustrator/caricaturist at home. *The New Yorker* published his likeness of the Metropolitan Opera's director, Giulio Gatti-Casazza, in February 1925, after which Miguel became one of their regular contributors.

In March Miguel exhibited a collection of drawings of blacks at the New Gallery. That same year he contributed the only colored illustration in Alfred A. Knopf's book, *The Borzoi,* a record of Knopf's twenty-five years of publishing. (The illustration was of Blanche, the publisher's wife and vice president of their firm.

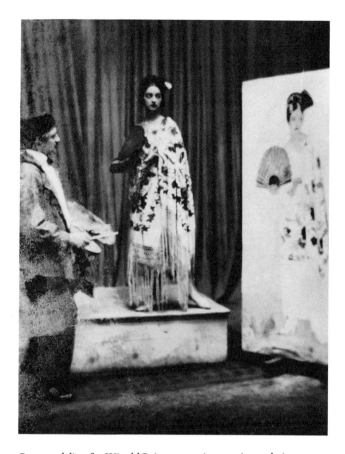

Rosa modeling for Winold Reiss, a prominent painter, designer, and architect, 1922.

Fifteen years later, when Hughes revised his very popular, very successful *Weary Blues* for a tenth edition, it was Blanche who insisted Knopf not use Miguel to illustrate it, because he couldn't be trusted to meet their deadlines. *Weary Blues* eventually saw eleven editions.)

Knopf published Miguel's first book, *The Prince of Wales and Other Famous Americans,* in the summer of 1925. The Prince of Wales, the quintessential eligible bachelor, had long been a hero of Miguel's. The book, bound in handmade batik, contained sixty-six caricatures of notables (not all Americans by any means), including politicians, writers, artists, musicians, and athletes. Many of these had run previously in *Vanity Fair*.

Ralph Barton reviewed the book for the *New York Herald Tribune:*

> *Covarrubias arrived in New York a little over two years ago, at a time when we were on the point of exploding with our own importance. He began at once to giggle at us. . . . It has done us good. To be seen through so easily by a boy of twenty, and by a Mexican, a national of a country that we*

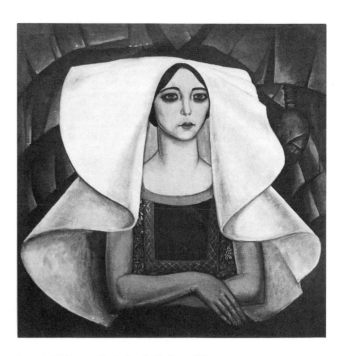

Rosa in Tehuana. Painting by Roberto Montenegro, 1927.

Statuette by Hidalgo of Rose Rolando in See Naples and Die.

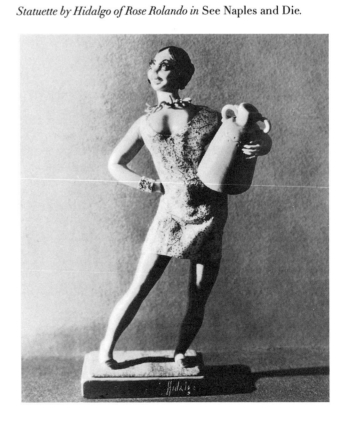

> *have been patronizing for a century or two, an outlander*
> *and a heathen, it was a bitter pill to swallow. . . .*
>
> *Some of the drawings in this book are good. The rest are*
> *superb. They are all vastly and seriously amusing and will*
> *stand being looked at a thousand times, so full are they of the*
> *meat that caricatures should be full of.*[24]

Life magazine later remembered that *The Prince of Wales and Other Famous Americans* had "set America laughing and lifted Covarrubias to the pinnacle of United States cartoonists."[25] The next year, 1926, William Faulkner and the silversmith artist William Spratling (who became a lifelong friend of Miguel's) published *Sherwood Anderson and Other Famous Creoles*. This book of caricatures (now a literary curiosity) was dedicated "With Respectful Deference to Miguel Covarrubias" as well as "To All the Artful and Crafty Ones of the French Quarter."[26]

In November 1925, Miguel held a one-man show at the Dudensing Gallery in New York, with many of the originals from *The Prince of Wales*. Before the year was out, he had finished a book jacket for Lawrence Houseman's *Trimblerigg*, published by Albert and Charles Boni and Donald Friede, and had agreed to an arrangement with these publishers similar to the one he had with Crowninshield at *Vanity Fair:* to produce a to-be-determined number of books for them over a certain number of years.[27]

Miguel continued to participate in the theater scene, designing a poster for Gilbert Seldes's *The Wisecrackers* and the sets and costumes for Shaw's *Androcles and the Lion*, starring Claire Eames and Edward G. Robinson, who also became a close friend. Covarrubias was an interesting choice for *Androcles*. Sherrill Schell reviewed it for the *Boston Evening Transcript*, describing it as "Shavian Rationalism Dished Up in a Mexican Sauce."[28] *Theatre Arts Monthly* loved it:

> *Here again Covarrubias exhibits his uncanny power of satire*
> *and penetration. The opening scene is a jungle of tropical*
> *intensity and luxuriance in form and color, and the extrava-*
> *gant humor of Bernard Shaw's lines is paralleled by the*
> *audacity of the young Mexican's challenge to eyes habituated*
> *to realistic conventions in the theatre. The Covarrubias*
> *settings mark an exultant liberation from the dogmas of*
> *realism. There is gaiety in these settings, yet a gaiety*
> *disciplined and defined by the atmosphere of comedy.*[29]

The *Daily News* agreed: "About the production, one must proclaim the scenery of Miguel Covarrubias. It is all of a hectic humor, startling, prodigiously irreverent, a very high-jinx of backdrops which kick the heels for Art with-a-Roman-A."[30]

But *Theatre Magazine* thought the sets were "weird": "The weird backgrounds of Miguel Covarrubias, we can let these pass with the pious hope that Shaw never sees them."[31] Nevertheless, Miguel continued to work for the Theatre Guild. His next assignment was to design sets and costumes for *The Four Over Thebes* by Aeschylus.

Rose's contract with the Garrick Gaieties expired at the end of 1925, and she did not renew. Early in 1926 at Maurice Tourneur's behest, she flew to Puerto Rico, where she choreographed and performed the dance scenes for *Aloma of the South Seas,* starring Gilda Gray and William Powell.[32]

Rose returned to New York newly devoted to Miguel, and that summer he took her to Mexico to meet his family—an audacious act, considering that he and Rose were traveling as a couple and this was conservative, Catholic Mexico.

His family was gracious, but his friends were enchanted. That summer the photographers Edward Weston and his Italian girlfriend Tina Modotti were also in Mexico, and they became Miguel and Rose's frequent companions. They traveled as a foursome that summer, chronicling their visits to Indian villages and recording the craggy landscapes they traversed, and one another, in hundreds of photographs. It was Weston and Modotti who taught Rose how to use a camera, and it became her newest and longest-lasting form of artistic expression.

Miguel showed Rose off to many of his other friends, among them Diego Rivera, who was enraptured by her beauty and painted the first of several portraits he would make of her over the years.[33] When Miguel's friends begged her to dance for them, Rose was not shy. She used Diego's studio for her performances.

Miguel and Rose stayed in Mexico City at least a month that summer, long enough for Rose to entrance just about everybody and to teach a master class for advanced dance students. Miguel met with Marcet Haldeman-Julius, who interviewed him for Haldeman's popular *Quarterly*. (The interview was published in January 1927.)

Afterward, they arranged to continue traveling with Roberto Montenegro and Manuel Horta to Veracruz. From there Miguel and Rose went by boat to Cuba. They arrived with introductions to all the "right" people in Havana from all the "right" people in New York and were immediately taken up by the editor José Antonio Fernández de Castro and the novelist Alejo Carpentier. Knowing that Miguel and Rose loved cabarets, their new friends took them to local nightclubs that rocked with the rumba and the *son,* the music of bongo, timbales, guiro, maracas, and claves.

Knowing their passion for ethnicity, these friends introduced Miguel and Rose to a Cuban cult which practiced ritual voodoo, whose Nañigos, dancer-priests, spoke a dialect called Carabali, and whose ceremonies, Miguel was convinced, "gave birth to the delirious music of young Harlemites who Lindy-hop, Truck, and Suzie-Que at the Savoy . . ." as much as to "the swanky orchestras of Duke Ellington, Cab Calloway and Louis Armstrong who 'swing it' in white ties and tails." Miguel wrote later, "Cuban music is the only music that reflects the lazy intensity of the warm climates, the palm trees, cobalt skies, ultramarine blue of the sea, and the blinding white, the pale pink and blue of the blocks of houses on nonchalant Havana—the only music in the world that really sounds tropical." He recorded everything in sketches; he had promised Frank Crowninshield to send back drawings of subjects that attracted him. A series of Cuban "dens and denizens" ran the next summer in *Vanity Fair.*[34]

From Cuba, Rose went on to Europe, but Miguel returned to New York briefly,

perhaps for work-related reasons—his *Negro Drawings* would be published in 1927. He and Rose reunited in Paris in September.

Miguel continued to chronicle his travels, returning with a set of caricatures called "This Is Really Paris: Its Types, Terrors and Temptations," a set that was a commentary on "Personages of Paris," and a third on "An Assortment of Tourist Types to Which a Venturesome Voyager is Always Exposed." They ran in *Vanity Fair* in 1927 and 1929.[35]

Miguel and Rose looked up Edward Steichen and Man Ray in Paris, both of whom were working there at the time and both of whom asked Rose to pose for them. Steichen had photographed her in New York previously, but the picture he took of her in Voulanges, France, during her visit there is perhaps the most beautiful of the many thousands that exist of this extraordinarily beautiful woman. Back home, Man Ray used to compete with Miguel for pretty women, engaging in mock fights over who saw one first, to their own and any bystander's amusement. But Rose was something different; the older man didn't even make a pass.[36]

Again, the creative cream of the city—in this case the crème—made them welcome: Gertrude Stein, Andrés Segovia, Henri Matisse, sculptor Constantin Brancusi, film director Marc Allegret, Russian set designer Laironov Gontcharova, writers Ella and Luis Aragón, André Gide, and Marc Chadourne. Miguel and Rose lived in Paris for the rest of 1926 and 1927 at the Hotel Excélsior. With Miguel's encouragement and playful instruction, Rose took up painting, and they made watercolors of one another on rainy afternoons. One of her first was of Miguel seated in front of a table in his blue pajamas with a blanket over his shoulders, working on a painting in their room. (This was how he always loved to paint, and he always wore blue.) Rose was astonishingly good, although Miguel sometimes corrected her backgrounds, which he thought too flat.[37]

In September 1927, Alexander and Nettie King moved to Paris (Nettie worked for *Life* magazine and became Miguel's agent within the magazine industry), and the two couples traveled together to North Africa. Miguel sought out indigenous French black men and sent illustrations to *Vanity Fair* from Fez, Morocco, Algiers, Tunesia, Tripoli, and points east. His fascination with the Negro continued, as with ethnic art. Wherever Miguel traveled he collected art, masks, costumes, figurines, toys, pottery, and jewelry. Africa was no exception.

Back in Paris in December, just before returning to the States, Miguel showed some of his European gouaches to a very receptive audience. Then in New York at the end of February 1928, coincidental with *Vanity Fair*'s publication of his North African illustrations, the Valentine Gallery opened a show of Covarrubias's gouaches with "familiar dance themes full of syncopated rhythms, lusty and burlesqued, in the manner that this artist has so deftly made his own."[38]

Miguel had returned from his travels far better known than he had been before his year and a half abroad, his reputation having soared with Knopf's publication of *Negro Drawings* in 1927. The book contained a laudatory preface by Ralph Barton, attesting that "Covarrubias's drawings . . . need merely to be looked at to be understood. To draw as Covarrubias draws, one has only to be born with a taste

for understanding everything." And he asserted, "As we look at the drawings we are aware that they bear the stamp of genius."[39]

"Barton," it was noted by Archie Green for *J. E. M. F. Quarterly*, "was proud that he, Van Vechten, and Crowninshield were the first to send up huzzas when Covarrubias appeared in New York, and likened his work to the Cro-Magnon incised drawings in the caves near Altamira." Adding his own huzzas, Crowninshield contributed the introduction to *Negro Drawings*, proclaiming Covarrubias "the first important artist in America . . . to bestow upon our Negro anything like reverent attention—the sort of attention, let us say, which Gauguin bestowed upon the natives of the South Seas."[40]

Negro Drawings was widely and internationally reviewed and highly acclaimed. The critic Walter Pach believed that Covarrubias was especially suited to the task of making "the dark happy people live before us, [of regarding] them with an eye of such deep understanding" because, "In the land where he was born, primitive passion, religiosity and heroism are to be found on the streets of the modern Capital side-by-side with the most recent products of invention and culture. And so it was natural for Covarrubias to succeed in portraying the men and women who evolved the Cakewalk and the spirituals."[41]

Reviewer Henry McBride was less analytical, writing that "The gifted young caricaturist has all Harlem in his debt. . . . He has missed nothing apparently, from the 'jazz baby' and chocolate-hued 'Sheik' to the impassioned 'blues singer.'"[42] The black writer Countee Cullen did not agree that Miguel had missed nothing, but Cullen was still complimentary, if somewhat constrained:

> This young Mexican has an uncanny feeling for the comical essence behind those characters that he chooses to portray; he does not choose to portray all, however, apparently finding his most interesting types in the cabarets. He is especially successful in capturing the illusion of motion. . . . The entire stage section teems with action. Even in the still life drawing, jazz instruments, the various orchestra pieces seem about to blare forth a rhythmic cacophony of their own accord.[43]

Miguel's contribution to the Harlem Renaissance is justifiably arguable. While he intentionally challenged old stereotypes, he unintentionally begat new ones. Nevertheless, his work is significant for documenting the emergence of the new spirit that rose out of Harlem in the twenties, a spirit that he understood and frankly admired and wanted to learn more about.

Miguel had spoken to Marcet Haldeman-Julius about his Negro drawings when they met in Mexico the previous summer. "I don't consider my drawings caricatures," Miguel had said. "Most of them are studies. They are—well, they are drawings. A caricature is the exaggerated character of an individual drawn with satirical purpose. These drawings are done from a more serious point of view."[44]

Miguel had indeed become a serious artist. After the publication of *Negro Drawings*, the *Encyclopedia Britannica* listed him among the "wonders" of black-

LEFT: *Rosa in the film* Aloma of the South Seas, *1926, Maurice Tourneur director.*

RIGHT: *Rosa, Miguel, and Nettie King in Carthage, 1927.*

and-white artists.[45] At about the same time, he made the acquaintance of Charlotte Osgood Mason, a wealthy Park Avenue patron of the arts who counted among her protégés Langston Hughes, Zora Neale Hurston, Alain Locke, and the painter Aaron Douglas.

Hughes recalled his first meeting with Mason:

> *I found her instantly one of the most delightful women I had ever met, witty and charming, kind and sympathetic, very old and white-haired, but amazingly modern in her ideas, in her knowledge of books and the theatre, of Harlem and of everything then taking place in the world.*
>
> *She had been a power in her day in many movements adding freedom and splendor to life in America. . . . She had been a friend of presidents and bankers, distinguished scientists, famous singers and writers of world renown. . . . Famous people from all over the world came to see her.[46]*

The Twenties, Part Two

Rosa and Miguel with Eugene O'Neill and André Gide
along the Quai Montebello.

In spite of that enthusiastic review, the "Godmother," as Mason liked to be called by her beneficiaries, could be difficult and demanding, and she had some ideas that would surely be considered racist today. For instance, she believed that "the most significant manifestations of the spiritual were found in 'primitive child races' such as Indians and peoples of African descent whose creative energies had their sources in the unconscious."[47]

On the other hand, Mason's attraction to ethnology was one that most of her artists shared, and all of them were grateful for her support. Certainly Miguel's art demonstrated his deep interest in racial types and the anthropological sciences, an interest that would grow deeper and wider in the years to come; and perhaps Mason can be considered a catalyst for that growth, for she soon took up his cause. Hurston recalled that:

> She was Godmother to Miguel Covarrubias and Langston Hughes. Sometimes all of us were there. She had several paintings by Covarrubias on her walls. She summoned us when one or the others returned from our labors. Miguel and I would exhibit our [work] and Godmother . . . would praise us and pan us according as we had done.[48]

Miguel was no less drawn to the live stage than before, and it was during this period that he completed the art design for several ethnic ballets for Adolph Bohm — Mexican- and West Indian-style — which he had discussed previously with Haldeman-Julius, who had written then, "Steeped as he is in the love of color, he is enthusiastic over the ballet because it gives him a large canvas on which to paint his fantasies." Haldeman-Julius also noted at the time that:

> he is at this moment collaborating with Tata [N]acho . . . on a ballet with Zapotecan motifs from the Isthmus of Tehuantepec. He speaks warmly of the artistic feeling of Indians. "Theirs is a religion of color," [Covarrubias] explained. "Even their cooking is colorful. They will walk miles" — and his tone grew tender — "literally miles, holding a little bouquet of flowers."[49]

Miguel's travels in Europe had not affected his status as a serious player on the New York social scene. The popular Ethel Smith, remembered for her hit song "Tico Tico," but also an accomplished organist who married Ralph Bellamy, recalled Miguel in the late twenties:

> I first saw him at Nick Muray's apartment-studio at 129 MacDougal Street. Miguel had done a series of advertisements for Nick's portrait studio. . . . Later, we all belonged to a group known as the "Society of the Classic Guitar." Segovia was our honorary president, and we held some of the monthly meetings at Nick's studio. We played guitar, talked endlessly, and ate too much. Above all, we laughed a lot.
> There were always interesting people at Nick's. Carl Sandberg, the poet, and I often played guitar together. Ben Grauer, the NBC commentator was another favorite of mine.

However, I must tell you that no matter who was at Nick's, Miguel was the one who charmed us all. Of course, he never missed the opportunity to capture someone with his devilish pen.
He was a wonderful caricaturist. I remember one he did of Clark Gable, which Nick had hanging in the dining room. Every time I was there, I found myself standing in front of the drawing mesmerized. In my opinion, Miguel would have been famous with just this one caricature. It is still as clear in my mind now as it was the very first time I saw it.[50]

But not everyone was as charmed by Miguel as Ethel. Muralist José Clemente Orozco, whose work had influenced the young Covarrubias at *Los Monotes* in Mexico City, was now living in New York under considerable financial hardship, and he was envious. Orozco wrote bitterly to his friend, the artist Jean Charlot, of Miguel's Valentine Gallery show early in 1928:

[Covarrubias] . . . sold more than $3000 worth, he exhibited the originals of the drawings he makes for Vanity Fair. Each drawing was sold for $300, that is, for more than Picasso's which only cost $250. . . . He is earning a mint of money.[51]

Miguel began preparing an exhibition of Mexican "Applied Art" for the New York Art Center, which opened in March 1928 after having been delayed twice by revolutions in Mexico. It was an important show for him, dedicating him to the idea of introducing Mexico to the city and country that had received him so warmly. That dedication grew with time. The anthropologist Andrés Medina noted that while "Miguel always searched for the exotic, for what was uniquely part of whatever Indian culture he was studying, it was in order to make that culture known to the world, and to preserve it as an expression of human creativity and plasticity."[52]

More and more, Miguel's focus was directed toward his roots. It had not escaped him that the most acclaimed piece in his Paris show had been the portrait of a Mexican Indian servant. Like his friend, the Austrian painter and decorator Winold Reiss, and many other artists and intellectuals working in New York and abroad at this time, Miguel was motivated by a sense that ethnic traditions were being lost in the rush of the twentieth century. These artists hoped their work would contribute to the survival of culture under modernization.

Tablada, meanwhile, was doing his part. In 1928 his book of poems, *La feria*, was published with illustrations by Matías Santoyo, George "Pop" Hart, and Miguel, who contributed seventeen bold black-and-white stamp-size woodblocks with Mexican motifs. This was the book about which Miguel had written to his father when he first arrived in New York. Miguel was also preparing illustrations for another of Tablada's books, *La Babilonia de hierro*, which would be published the following year.[53]

Perhaps because they were inspired by the combination of his work at the Art Center and his association with Tablada, Miguel and Rose decided to visit Mexico

earlier than usual in 1928. They spent much of their time on this trip with Diego and his new lover, twenty-year-old Frida Kahlo. This was the summer they met the writer Andrés Henestrosa and museologist Fernando Gamboa, who would become Miguel's close friends and collaborators over the years. In an interview in 1987, Gamboa still recalled how Miguel looked then: "He had the air of a man who had triumphed." Earlier, speaking to Elena Poniatowska, Gamboa called Miguel and Rose "the happiest couple that Mexico contemplated in New York in the '20s and '30s."[54]

Henestrosa remembers that the intellectuals of the day, the artists and writers and other creative bodies of Mexico City, frequently congregated at the Ulises Theatre on Mesones Street. The theater was experimental and took its direction from an artistic and literary crowd, including Jiménez Rueda, Gilberto Owen, Xavier Villaurrutia, and Celestino Gorostiza. They produced plays by Cocteau, Shaw, O'Neill, and Vildrac that were considered very avant-garde.[55]

The theater had been founded by Antonieta Rivas Mercado and María Luisa Cabrera. María Luisa, nicknamed Malú, was the daughter of Luis Cabrera, a famous Mexican writer and lawyer, who along with Tablada, Alvarez, and Estrada had been instrumental in helping Miguel come to the United States. (Harry Block would marry Malú in the 1930s.) Malú's friend Antonieta was a beautiful young patron of the arts who published some of her colleagues' work, including the book *Los hombres que dispersó la danza* by Henestrosa. In 1931, at the age of thirty-three, Antonieta took a gun with her into the cathedral of Notre Dame in Paris and committed suicide.

During that summer of 1928, Miguel and Rose spent time with Tina Modotti (who had broken up with Weston by now) and met up with the young Japanese-American artist Isamu Noguchi, whom Rose had known in New York. Noguchi was in Mexico City to work on a mural in the Rodríguez Market along with the American Greenough sisters, under the tutelage of Diego Rivera. Each was to execute his or her own mural in the market.

Another fortuitous meeting that summer was with an adventurous young Austrian count, René d'Harnoncourt, who worked for the American businessman Fred Davis. Davis had opened a folk art shop in Mexico City some years earlier—it was one of the first of its kind and became one of the most important stores to stock the best of Mexican popular art. It also became the meeting place for Mexicans interested in rediscovering their cultural heritage.[56]

D'Harnoncourt, at six-feet, six-inches tall and weighing two hundred and thirty pounds, was "perhaps the most picturesque invader since the conquest;" the day he first met Davis, "he wore a black bowler, riding boots, and a checkered coat obviously not tailored to his measure."[57] He had arrived in Mexico in 1922 with eleven dollars in his pocket and a taste for graphic art. Five years later he was working for Davis, in the thick of the art scene in Mexico. It was he who organized the first important shows for Rivera, Orozco, and Tamayo in 1927.

D'Harnoncourt met Miguel when Davis asked Miguel to do a caricature of René, which appeared on the cover of "Mexican Sundays" in the *Sonora News*. The two men became close friends, and later, collaborators.

Miguel wearing a sarape and "charro" hat. Photograph by Herman.

The year 1928 was particularly productive for Miguel. Back in New York, he illustrated *Meaning No Offense* by John Riddell (a pseudonym for Corey Ford, a book reviewer for *Vanity Fair* and one of the Smart Set), for whom Miguel would eventually illustrate three books of parody—the last of which was dedicated to him and Rose—and with whom Miguel would collaborate on *Vanity Fair*'s "Impossible Interviews" in the 1930s.[58] Miguel also tackled Theodore Canot's *Adventures of an African Slaver* (being reissued by the Bonis), which provided Miguel the opportunity to examine African history and expand his knowledge of African arts and customs. In this, like many of his contemporaries in other parts of the world (Picasso, Modigliani, Brancusi, Klee, Miro, Moore, Stieglitz, Tzara, Aragón, Elouard, Breton, and Diego), Covarrubias was pursuing an almost physiological need to understand, to experience, and to integrate primitivism in art.

The same year, that master networker, Van Vechten, put Miguel and Taylor Gordon together. Gordon was a countertenor touted by New York's elite crowd for his Afro-American spirituals, as well as his extroverted and ingenuous character. In 1928 Van Vechten arranged a concert for the young man at Carnegie Hall, to which Miguel was invited. On Van Vechten's advice, Gordon wrote a flamboyant folk-autobiography, *Born to Be*, in which he chronicled his early youth and confronted the issue of racial prejudice and its effect on him; Miguel did the illustrations. *Born to Be* was published at the height of Gordon's popularity and

social success, but it met with mixed reviews, as did Miguel's illustrations, on the grounds that "they caricatured Negroes." Melvin P. Levy of *The New Republic* thought they were the best caricatures he had seen; certainly Gordon did not fault them, writing to Van Vechten that "the drawings were the hit of the season for those who have seen them." But the pace-setting black journals *Crisis* and *Opportunity* found parts of the text demeaning, and the *News* proclaimed that Miguel's illustrations looked "like geometrical figures rather than human beings."[59]

In 1929 Miguel met the as yet unknown John Huston, who had arrived in New York that year with a script under his arm based on the "Frankie and Johnny" legend. Huston had written his version of the story as a puppet show for a young puppeteer named Ruth Squires, who persuaded Sam Jaffe to compose some incidental music for it. The show debuted at a party that George Gershwin hosted and for which the famous composer performed Jaffe's score.

The production was written up in the *New York Times*, where Charles Boni read about it and was inspired to pair Huston with Covarrubias to collaborate on a book. The result, published in 1930, is a richly illustrated collection of various versions of the well-known song, including Huston's and thirteen others. One reviewer declared: "This book is not a Huston book: it is a Covarrubias book. There is very little that can be said in words of Mr. Covarrubias' illustrations. To describe them requires both line and music. They should be seen to be sung."[60]

After their collaboration, Huston recalled:

> *I saw [Miguel] frequently. He initiated me into a kind of life in New York I had not known before. A life full of fascinating people and forays into little prohibition clubs. We often went to Harlem together. I don't know which one of us was more taken with the dancing and music. . . . Speaking of which, I first saw Rosa when she danced in the Gaieties. She was a real hit—a wonderful dancer.*[61]

The year 1929 marked Rose's last appearance on stage, in an extravagant comedy in three acts by Elmer Rice entitled *See Naples and Die*, starring Claudette Colbert and Frederick March. (March remained a lifelong friend.) That summer, Harry Block and Miguel gave up their apartment together, and Miguel and Rose took off on Miguel's annual visit home. This time they stopped en route in Taos, New Mexico, a just-burgeoning artist colony then, to visit the heiress Mabel Dodge Luhan, "The Empress of Mabel-town," as she was called, "because of her penchant for dominating local goings-on." Mabel loved to surround herself with interesting people, and there, in that summer of 1929, Miguel and Rose saw Witter Brynner and met Georgia O'Keeffe, who became a close friend of Rose's over the years. They also met Georgia's traveling companion, Beck Strand, whose husband (the photog-

rapher Paul Strand) had worked in Mexico. Miguel was taken by Georgia and did a wonderful caricature of her for *The New Yorker* that ran the same year, captioned "The Lady of the Lillies."[62]

Once in Mexico, Miguel was almost immediately called away to the Fine Arts Museum in Guatemala City—the Mexican department of education had asked him and Montenegro to organize a show of Mexican grade school children's paintings and sculptures based on the national open-air techniques.

Miguel returned to find Rose entertaining Orson Welles and Dolores del Río, who were vacationing from the States, where Dolores had begun her movie career. She was one of Mexico's most beautiful women, and she would become one of its brightest screen stars, adored by millions there and in the U.S. Like many of her contemporaries, she was devoted to advancing Mexican themes in her films. Gabriel Figueroa, one of Mexico's premier film directors, recalled that they felt "it was up to our small group to leave our mark on Mexican film, as it would be for Miguel and the dance in the 1950s." Dolores became one of Rose's closest friends, and Gabriel Figueroa said of her, "[Dolores] instilled in all of us a kind of mysticism."[63]

That summer of 1929, however, was less mystic than comedic. Del Río, Welles, and the Covarrubiases spent several evenings together at one or another colorful *carpas*. These were a popular form of staged comedy in Mexico, which Miguel described some years later in an article for *Theatre Arts Monthly:*

> . . . a canvas tent, often walled in by detachable wooden panels, a gaudy small stage with bizarre painted drops, lit by a single naked glaring electric bulb. . . . The "house," simply rows of homemade hard benches, is generally packed with a most colorful crowd, an amazing variety of types, workers, Mexican apaches, soldiers, Indians from the country, proletarian women with their babies in their blue rebozos, side by side with overdressed city girls and white-collared men of the middle class.[64]

Colorful drama was not confined to Mexican theater among the young, sometimes radical, intellectual friends to whom Miguel and Rose had become attached. Tina Modotti, for instance, was in very dramatic trouble in 1929. Miguel and Diego and Frida (who were married that summer) all wrote letters on Tina's behalf when she was accused of having murdered her lover, the Cuban revolutionary Julio Antonio Mella. Modotti was acquitted; her lover's assassin was never discovered.[65]

While in Mexico that same summer, both Rose and Miguel found a local outlet for their work in Frances Toor's magazine, *Mexican Folkways*. Its January–March 1930 issue featured a series of mask reproductions and notes written by Miguel, Fito Best Maugard, Alfonso Caso, and René d'Harnoncourt. Miguel had been collecting Mexican masks for several years, and he wrote: "All peoples who have lived close to the earth have used masks. In primitive civilizations, ritual masks are sacred and

Rose Rolando in Rancho Mexicano *routine of Garrick Gaieties, 1925, sets and costumes by Miguel Covarrubias.*

possess magic. . . . The Mexican maskmakers reveal the same plastic vigor which is to be found in African and Oceanic sculpture. Their masks are equally important and comparatively unknown." The same issue of *Mexican Folkways* ran a reproduction of a painting by Rose entitled, *The Dance of the Shepherds*.[66]

Miguel still saw René d'Harnoncourt quite often. D'Harnoncourt was currently engaged in his first major assignment as curator—an exhibition of Mexican arts for the American Federation of Arts. It was scheduled to open at the Metropolitan Museum of Art in New York in December 1930 and to tour North America for two years. It was an important show that combined primitive and modern pieces. The folk art was loaned by some of the most prestigious collectors of the day: Dwight W. Morrow, Fred Davis, Jorge Enciso, Frances Toor, William Spratling, and d'Harnoncourt himself. Miguel also contributed eleven pieces from his personal folk art collection to the show, and d'Harnoncourt used five of Miguel's paintings in the exhibit's Modern Painters' section.[67]

When it closed in 1932, ex-president of Mexico, Plutarco Elías Calles, praised the exhibition for "making known to our people and to foreigners the real spirit of our aboriginal races and the expressive feeling of our people in general in beautiful traditions."[68]

W hile they were still in Mexico in the summer of 1929, Miguel received a letter from Blanche Knopf rejecting the illustrations he had prepared for Van Vechten's soon-to-be-published *Nigger Heaven*. Apparently Van Vechten had hated them; in a letter to Fania Marinoff written soon after he had seen Miguel's drawings, he confessed, "The drawings were terrible, and I'm actually relieved he is out of it. I never thought he could do it."[69]

We have no explanation for this turnabout by Van Vechten, who had always been Miguel's champion. Perhaps the friendship had suffered over sides taken when Ralph Barton and his wife Carlotta divorced in 1926. Miguel and Rose considered Barton's treatment of Carlotta a travesty and never forgave him. According to Van Vechten's biographer, Bruce Kellner, "In 1927 in Paris, Rose and Miguel publicly cut Ralph Barton, without explanation," while Van Vechten managed to remain friends with both Ralph and Carlotta.[70] (Carlotta married Miguel's old friend, Eugene O'Neill, in 1928.) It is not likely that Van Vechten doubted Miguel's ability to produce good work. His comment, "I never thought he could do it," may mean he did not believe Miguel could meet Knopf's deadline. Miguel was beginning to establish a reputation for tardiness. In any event, the rejection suggests a change in the offing.

Certainly, great change gripped all of America as the twenties ceased roaring. With the disaster on Wall Street and the country entering its Great Depression, even Harlem had lost some of its appeal for the Smart Set. An era had ended, and the one beginning looked far less promising. Back from his sojourn in Mexico, Miguel was struck by the difference. New York seemed ugly, overly commercial, and more demanding than ever.

CHAPTER 4 *In some ways Covarrubias was a man out of his age. The typical thought of his day took mathematical or statistical form rather than the pictorial form which was his, and incidentally the Renaissance, way of expressing thought. But he typified the best in 20th century humanism: its fascination with the visual arts, its openness to other cultures, and its desperate and doomed struggle to preserve the humane traditional societies against technocratic commercialism.[1]*

THE THIRTIES, PART ONE (1930–1932)

On the Saturday night before Easter in 1930, Rose and Miguel's most difficult decision was whether to go to a minstrel show on Broadway or to see Arturo Toscanini conduct the last program of the season at Carnegie Hall. They settled on the symphony.

They next day they joined the throngs on parade down Fifth Avenue. Rose wore a midnight blue silk dress and a tiny close-fitting hat with the brim turned away. She looked as if she had stepped out of the pages of *Vogue* magazine. Miguel was fitted out in his best Prince of Wales style. It was an elegant crowd, as always, and elegantly dressed, but the newspapers observed that this year's finery was more subdued than usual. The predominant colors were blacks, whites, and grays.[2]

Under the gay face of it, the city was feeling uneasy: the depression was on everyone's mind, and it had been reported that the Communists were organizing a march and a rally for May Day, ten days away. There had been trouble at a Communist demonstration in March, and the party president, William Z. Foster, had been arrested. Now, in addition to the Communist contingent demonstrating for Foster's release, the Veterans of Foreign Wars were also planning a march and rally, and both were to end up at Union Square.

There was considerable tension in the mayor's office that seemed to have touched the crowds on the street. No one was sure what would happen. In fact, although a thousand police officers, a machine gun squad, and tear gas were on call for the May Day demonstration, the 100,000 participants caused no problems. The Communists who marched were mostly women and children; they wore red sashes, and the men wore red neckties. Afterward, relieved police commissioner Whalen declared: "The day was well spent. Everyone had his respective say."[3]

May Day might as well have been centuries away, as far as Rose was concerned, however. April 24 was the day for which she was waiting, when she would become Miguel's wife.

Nettie and Alexander King had offered their rustic, Abraham Lincoln–style log cabin in Kent Cliff, Putnam Valley, New York, for the wedding. Kent Cliff was a romantic woodland of oak, walnut, and chestnut trees, lakes, rolling hills, and meandering streams. It became a much-loved retreat for Alex and Nettie's friends, people like Van Vechten and Fania Marinoff, Al Hirschfeld, Heywood Broun, Alexander Woollcott, and the humorist George Kauffman. The publisher Pat Covici liked it so much, he bought the property next-door.[4]

By the time of Rose and Miguel's wedding, Alex had designed extensions for the house and added sunporches and an attic with a back staircase. The place took on an Abraham Lincoln-in-Wonderland appearance. Inside, they stretched parchment over the walls, and Alex painted a fantastic jungle filled with huge, distorted tigers and other wild creatures amidst a dark, bright, ferny greenery.[5]

Rose left for upstate New York the day after Easter, while Miguel remained in the city to finish an assignment for *Vanity Fair* and to attend Charles Lindbergh's inauguration of the airmail route between Central and South America and the United States for Pan American Airlines.

Many years later Rose recalled that she stayed at Kent Cliff's Old Country Inn during the days preceding her wedding. From the window seat in her room facing toward Farmer Mills Road, she could see a small lake; but she spent most of those days with Nettie engaged in wedding preparations, cooking and baking up a storm for the small group of friends who would come up with Miguel from the city on Thursday.

The day before the wedding, Rose went for a long walk alone through the countryside, and she gathered huge bunches of spring flowers for the house. That night she did not sleep well. She awoke very early on April 24, raised the shade on her lake-facing window, and was horrified to see that it was snowing.

It broke all records for New York's coldest April 24th. She never forgot it.

Miguel had done an advertisement for the piano manufacturers Steinway and Sons the previous year that won the National Art Directors' Medal for painting in color. The cash prize that came with this award would enable him and Rose to take an extended honeymoon.[6] A beautiful book of photographs of the remote Indonesian island of Bali by Gregor Krause published in 1926 inspired them to see the place for themselves, and both Alexander King and

*The home of Alexander and Nettie King in Kentfield, N.Y., where
Miguel and Rosa married in 1930.*

"Godmother" Mason recommended it with such superlatives that Miguel booked
passage on the freighter *Cingalese Prince* for a six-week voyage that would end there.
Claudette Colbert and her husband, the stage actor Norman Foster, accompanied
the honeymooners. The two couples traveled through the Panama Canal, across
the Pacific Ocean, and down the China Sea, stopping at Yokohama, Tokyo, Kobe,
Shanghai, Hong Kong, Manila, Madagascar, Java, and finally Bali.[7]

At each one of these ports, much to Miguel's embarrassment, a host of
reporters waited to interview him. In Manila the journalist Corazón Grau reported:
"Caricaturing is not the only interest of this celebrated man. He paints, and just
now is working on primitive subjects. By primitive subject he means people who
have not been influenced by Western culture."[8] Miguel took refuge in his sketchpad
and in language studies. He hoped to be able to speak a little Malay, Bali's official
language, by the time they arrived, and he found a Javanese sailor on board who
would tutor him.

Bobby Burnes, head of the Dutch-owned K. M. P. steamship line, was aboard
during this crossing, and he took an interest in the attractive foursome. He
promised them a Dutch guide and his own Balinese driver and, when they were
settled in the Dutch-run Bali Hotel in Denpasar, arranged a cocktail party for them
where they met most of the important foreigners living in Bali at the time. There
were several, and soon others would arrive: among them were the Australians Mr.
and Mrs. Pattinson, he a minister, she a musicologist; Adrien Jean Le Mayer, a
Belgian painter who married the great Balinese dancer Ni Polok; Theo Meier, a
Swiss painter; the Dutch painter Rudolf Bonnet; Colin McPhee, the American
musician and writer, and his wife Jane Belo, both doing research on a book about
Bali; the English writer Vicky Baum; and the German painter Walter Spies.[9]

We do not know how long Claudette Colbert and Norman Foster stayed on in Bali—perhaps a week. Miguel and Rose had planned on three months, but they knew they were not getting a true picture of the island in their Dutch-influenced hotel in the city of Denpasar. "As we became more and more familiar with our new life, and our ears grew accustomed to Malay, we made friends among the Balinese," Miguel recalled later. "We were already weary of the stolid prudishness of Dutch hotel life, and since we could not afford the high rates much longer, we looked for another place to live."[10]

They found that place with their very first Balinese friend, I Gusti Alit Oka Degut, whose family compound was situated in the tiny village of Belaluan just outside of Denpasar (now a part of Denpasar, which became Bali's capital city in 1953). I Gusti's family were Hindus, like most Balinese, but of the third royal warrior caste (the Wesya caste)—I Gusti was the son of a former king of Bali; he was a draftsman and carpenter by trade, a drummer by avocation, and the leader of Belaluan's prestigious gamelan orchestra.

The household was fairly prosperous. An old servant and a cook cared for I Gusti, his wife, child, and two widowed aunts. When Miguel and Rose joined the compound, they acquired a houseboy named Dog, a Javanese cook recommended by the mailman, and a chauffeur called Nase, who promptly broke the self-starter on the decrepit Chevrolet Miguel had bought for 800 florins from Bobby Burnes, who was returning to Holland. The manager of the Hotel Bali loaned the Covarrubiases two beds, two chairs, and a table.[11]

Within a few weeks, Miguel was able to converse fairly well in Malay. From the questions Miguel asked, I Gusti soon realized that his guests were not ordinary tourists. Miguel in particular seemed to have an extraordinary curiosity about everything, especially the Balinese culture. It was a lovely coincidence that Belaluan was one of the island's cultural centers at the time and that I Gusti could introduce him to the best-loved artists of the day—the dancers, musicians, painters, mask-makers, silversmiths, and puppeteers of the region.

The news spread rapidly through Belaluan and neighboring villages that there were friendly, inquisitive foreigners living at I Gusti's compound. The Balinese are themselves friendly and inquisitive; soon it became common for dozens of visitors to gather at the Gusti Alit Oka Deguts' to meet the newcomers, to talk, and to play music. Often they brought gifts of fruit and sweets or floral offerings to bless the Covarrubiases' house. Visitors were welcome, and there were many occasions when the resonant round sounds of drums and cymbals and metallophones—xylophone-like instruments with bronze keys—echoed through the night and into the dawn.

Miguel and Rose were profoundly affected by the island and developed a deep enthusiasm for the Balinese lifestyle, which struck Miguel as the opposite of the living he had been doing lately in New York. Life in Bali was simple, natural, highly spiritual, creative, and aesthetic. According to John Selby in his column "Literary Guidepost": "It seemed to [Miguel] that Bali was one of the few remaining graces still in existence, possessing the best elements of civilization lost to the mechanized Western world—a world which for him had taken on many aspects of Eliot's 'Wasteland.'"[12]

There was more that attracted: Miguel was himself both genial and gregarious, like the Balinese. He was immediately comfortable with and admiring of their simple nobility, good nature, serenity, and gentility. His particular brand of *la vacilada* had much in common with the sometimes bawdy humor of the islanders, and the slapstick comedy of Balinese theater was reminiscent of the *tandas* of Mexico—so on a very personal level, he felt a deep response to the place and the people.

Miguel threw himself into the Balinese life. I Gusti remembers accompanying the artist to nearby villages and temples, to festivals and all-night shadow puppet plays, and to tooth-filings, the Balinese rite of passage out of puberty. And he remembers Miguel's interest in seeing everything—cockfights, a house under construction, farmers in the fields, and women planting rice in the brilliant green, stepped rice fields—"the receding man-made terraces, like flights of gigantic stairs, [that] cover the hills and spread over the slopes and plains."[13] Everywhere these sights were recorded in sketches, and the information Miguel had gathered that day was carefully recorded. If he had questions, he took them to I Gusti, and his notes were expanded.

"I never tired of answering him because he cared deeply about our culture," I Gusti told me. "He understood everything there was to know about Bali. I have never forgotten the brother from far-away Mexico: dark-skinned Miguel with the laughing brown eyes, who looked every bit as Balinese as the next man dressed in a *kamben* with a flower behind his ear. To us he seemed to have a Balinese soul."[14]

Rose accompanied Miguel on many of his excursions, but she also pursued her own interests, food being a major one. Miguel wrote:

> *Balinese food is difficult for the palate of a Westerner.*
> *Besides being served cold always, food is considered*
> *uneatable unless it is violently flavoured with a crushed*
> *variety of pungent spices, aromatic roots and leaves, nuts,*
> *onions, garlic, fermented fish paste, lemon juice, grated*
> *coconut, and burning red peppers. It was so hot that it made*
> *even me, a Mexican raised on chilipeppers, cry and break out*
> *in beads of perspiration. . . . Most Europeans, used to beef*
> *and boiled potatoes, simply cannot eat Balinese food, but on*
> *the other hand no Balinese of the average class can be*
> *induced even to touch European food, which is* nyam-nyam
> *to them—that is "flat and tasteless."*[15]

Rose enjoyed visiting the outdoor marketplace by herself, discovering exotic fruits, vegetables, and herbs she had never seen, engaging the vendors in conversation, asking for the names of foods she did not recognize. After making her purchases, she liked to linger at the market, photographing the women and their wares. The Javanese cook taught Rose how to prepare the Indonesian dishes for which she became well known in later years in Mexico, and Dog was a willing pit digger when Rose was learning to make barbecued pork and turtle.

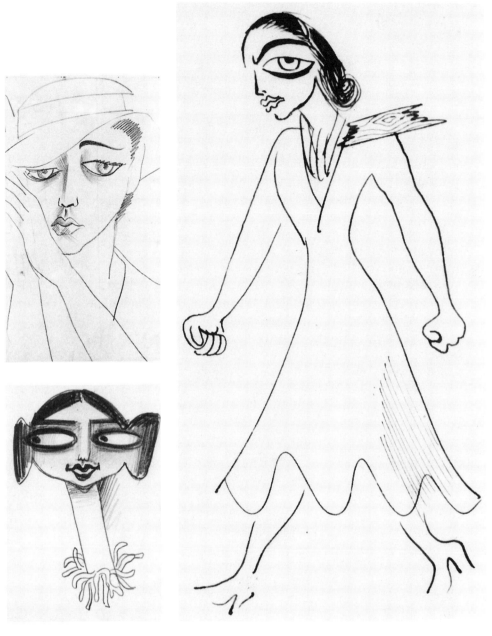

Drawings of Rosa by Miguel Covarrubias, one expressing anger.

Balinese dance, though, was of the most interest to Rose, and her passion for it was shared by Miguel. He wrote:

> *Dancing [in Bali] has developed to a standard of technical perfection that makes of it a difficult science, requiring years of special physical training and practice. . . . Sound and gesture become one, definite movements ruled by the most rigid discipline. The excellence of a performer does not depend only on his skill, but also on his personality, his emotional intensity, and the expressiveness of his features.*[16]

This was a philosophy of dance to which Rose had adhered in her own career; but she was astounded by the way dance was practiced here. Children commonly began their study of the art at age three; by age six they could perform movements and roles frequently more challenging, physically and emotionally, than those of adult dancers. And the costumes were fabulous: ornate gold and flower-tipped crowns, elaborate gold-leaf gowns—Rose must have been reminded of the silk sarong she wore dancing the Samoan goldstick dance in *The Rose Girl* nearly ten years earlier.

The makeup and masks were also fascinating—much like caricature in their broadly exaggerated style. And every gesture and every bit of adornment had a particular significance that Rose learned about as she watched and listened and asked. Her interest in dance attracted new visitors, especially the youngest of Balinese dancers. They danced for her, and she for them, and they were fascinated by the modern and interpretive demonstrations she made for them, by the way she moved her body. The children came every day; according to Gregor Krause in *Bali Erster Teil,* "they left only to go to bed."[17]

Rose loved them. At age thirty-five, she had obviously made the decision not to have children of her own, and she may have felt some regret. Certainly she spent a great deal of time with the youngsters of Belaluan, playing with them, learning their games, teaching them games she remembered from her own childhood, and photographing them. Anak Agung Ngurah Gedé Sumatra, I Gusti's son, remembered Rose with affection. She gave him his first set of paints and for a time gave him lessons. He became a drummaker in Denpasar.[18]

Ni Ketut Reneng was another talented Balinese with fond memories of Rose and Miguel. Reneng became one of the island's most revered dancers, once decorated by President Sukarno, but was a girl when the Covarrubiases lived in Bali. She spoke to me about them in 1985:

> *I loved Rose and Miguel very much, and they loved me. While they were in Bali, we visited each other nearly every day. I remember once when I hurt my ankle, Miguel gave me a massage. He liked to watch me dance and could sit for hours drawing while I rehearsed.*
>
> *Rose and Miguel were fascinated with the very hand-*

*some Mario, a masterful dancer, creator of the Kebyar dance
(still talked about today) with whom I fell in love. I was very
shy and confused by my feelings. They were touched by my
innocence and tried to help me. Mario was the love of my life,
but for many reasons we were never able to marry. Rose took
many photographs of me and of Mario. Some of these are in
[Miguel's] book.*

*Rose was like a mother to me. I was very young then.
We liked to cook together, and I taught her many of the steps
of our dances and dressed her in native costumes. It was easy
to teach her because she understood everything about cooking
and was herself a dancer. She looked beautiful in our
Legong costume.*[19]

Anak Agung Gedé Mandera was among Bali's most celebrated drummers, who frequently visited Denpasar from his village, Peliatan, about an hour away, to play with I Gusti's orchestra. Mandera recalled that he, I Gusti, and Miguel loved to tell stories and that he and Rose occasionally competed to see who could cook the best meal. "All of us, even in those days," he said, "were a little bit too fat because we liked food too much."[20]

The drummer commented on Miguel's appreciation for their music, especially the drums, which had been his instrument in the "Mexican orchestra" that Harry Block had instigated in their bachelor days in New York in 1923. Mandera's drums would start Miguel's foot tapping and fingers snapping, and then it was all he could do to remain sitting on the sidelines — pretty soon he had joined in the frenzy of music making. Mandera composed a gamelan piece for Miguel and Rose, which Miguel recorded. "In return, Miguel played Mexican melodies for me on his guitar," Mandera remembered. "Both Rose and Miguel were very musical. Never a week went by that they didn't come to Peliatan for our weekly dance and music performances. I often recall those happy days with them."[21]

The Covarrubiases' Bali experience was greatly enhanced by their friendship with the painter Walter Spies, "Bali's most famous resident," as Miguel referred to him. "I had admired and cut out reproductions of his paintings of Russia [in 1923] . . . never thinking he was to become one of my closest friends."[22]

Spies was a fascinating character, "familiar with every phase of Balinese life," in Miguel's words, living in the village Campuan in the center of Bali near Ubud, in a house he called his "Water Castle" because of the river that ran past it. "We roamed all over the island with Spies," Miguel wrote, "watching strange ceremonies, enjoying their music, listening to fantastic tales, camping in the wilds of West Bali or on the coral reefs of Sanur."[23] On one camping trip with Spies in West Bali near Pulaki on the beach, alert for crocodiles and wild cats, they discovered a white tree full of black monkeys that Miguel would translate into a fine black and white gouache. It was through Spies that Miguel met the island elders who would share with him the customs of daily life, the meaning of ceremonial dances, the rules of caste, and the

intricacies of witchcraft and religious ritual, while Miguel asked questions and made notes and sketches that would ultimately become a book to change his life.

Time has a different value in Bali. The three months Miguel and Rose had thought to spend there became nine. At some point during this period Miguel spent one month in Shanghai, perhaps to gather material for Marc Chadourne's book *China*, which Miguel was illustrating with twenty-eight drawings.[24] Though there are no notes on that visit, it must have had a profound effect on Miguel; he became deeply interested in China, in all aspects of its culture — its art, politics, society, language, even its penmanship.

Later, while Harry Block was editing the English translation of *China* for Knopf back in New York, Chadourne came from Paris to visit Rose and Miguel in Bali, and the three of them, plus Spies, attended a cremation ceremony, no doubt one of many that Miguel and Rose saw during their stay.[25] Miguel devotes an entire chapter to this ritual in *Island of Bali*.

Spies's Campuan village and its neighboring villages were devoted to hospitality and culture, in particular, painting, which Spies influenced profoundly during his many years on the island. (Other villages might specialize in gamelan, as did Belaluan, or mask making, or silversmithing.) Hans Rhodius and John Darling noted in *Walter Spies and Balinese Art* that "hundreds of Balinese artists called at 'the house of the meeting of the waters'" to attend the painting classes he conducted.[26] Miguel commented on Spies the painter:

> *He was temperamental when he went into seclusion to paint, he would work incessantly for months on one of his rare canvases, great pictures that made the Balinese exclaim: "Beh!" with their mouths wide open in astonishment.... He paints dream-like landscapes in which every branch and every leaf is carefully painted, done with the love of a Persian miniaturist, a Cranach, a Breughel or a Douanier Rousseau.[27]*

Spies invited Miguel to teach. It was the perfect environment for introducing techniques from the Mexican outdoor art schools that incorporated landscape and daily life as subject matter, and Miguel was happy to oblige. Years later Pearl Buck observed that a definite Covarrubias style had been assimilated into the work of several of his Balinese students. Anak Agung Gedé Sobrat, one of Bali's most respected painters, remembered exchanging drawings and paintings with Miguel. "He taught me a great deal about painting," Sobrat said. "Very often he would walk me home to Padang Tegal, my village in Ubud. He never stopped talking about art.... Miguel even used one of my paintings in his book about Bali. I am very proud to have been his friend."[28]

Another friend was the Balinese painter I Gusti Nyoman Lempad. His son, I Gusti Madé Sumung, was a teenager during Miguel's visit to the island and remembered Miguel as the liveliest of all his father's comrades:

[Miguel] was always laughing, telling stories and playing jokes. He would make any one of us feel lighthearted. He seemed to have boundless energy and got to know the inside of our minds. Everyone on the island knew of him. Just ask any of the old people today, their eyes will light up and they will talk about him with affection.[29]

It was a mutual affection. Miguel had to search hard for something negative to report about Bali—but he did find it:

The roads are particularly infested with miserable dogs, the scavengers of the island . . . that bark and wail all night in great choruses. The Balinese are not disturbed by them and sleep peacefully through the hideous noise. The curs are supposed to frighten away witches and evil spirits. . . . Such dogs were undoubtedly provided by the gods to keep Bali from perfection.[30]

Except for dogs, Miguel found life in Bali and the people of Bali wonderful. "No other race," he wrote, "gives the impression of living in such close touch with nature, creates a complete feeling of harmony between the people and the surroundings."[31]

As an artist he was deeply appreciative of the level to which art involved every member of the community, that it was an extension of creative expression recognized in every one, and not only an elite, self-conscious few. Miguel saw Balinese art translated into rituals and festivals; he saw it as the basis of Balinese culture. "A Balinese feast is a pageant that would have made Diaghilev turn green with envy," he wrote. "Men in bright silks wearing krisses of gold and rubies; women in yellow, green and magenta silks and brocades, crowned with flowers of beaten gold and carrying on their heads fantastic pyramids of fruit and flowers, the offerings to the gods."[32]

As a man, he was enchanted by the idyllic beauty of Bali's women, who were entirely free of self-consciousness. They were as "stately and graceful as goddesses," he told one journalist. "Tawny-skinned, with dark glowing eyes, proud red mouth, erect bearing." They were ideal models.[33]

But Miguel was perhaps most interested in the island elders. He wrote:

When I could speak fair Malay, I discovered it was not enough. Malay was the trade language between Balinese and foreigners, spoken mainly by the new generations of the towns, so I started to learn a little Balinese to be able to understand the most interesting people of the island—the older men and women—but just then we had to leave our new home to return to America.[34]

It was then spring of 1931. Miguel and Rose did not go directly home, but to Europe, visiting Naples and Paris, where they saw their old friends Elsa and Louis Aragon, Gertrude Stein, the producer Marc Allegret, the sculptor Constantin Brancusi, Paul Morand, Lee Miller, Man Ray, and the modern composer François Poulenc. Miguel reports that he and Rose also met friends from Bali participating in the Colonial Exposition in Paris in the categories of dance and music "that were the sensation of the exposition. With them I continued to study the difficult Balinese language, because I had then and there made up my mind to return to Bali as soon as possible. I had some random notes, and Rose had taken hundreds of photographs."[35]

Speaking with Miguel and looking over his notes and sketches and Rose's photos, Miguel's friend, André Gide, encouraged him to write a book about the island.[36] Miguel didn't need too much urging but he knew he had much more to learn before he had sufficient material and understanding to fill a book. He was resolved to return to Bali.

Miguel began transforming his sketches into gouache and oil paintings on the crossing home that winter.[37] They would become part of a one-man show of thirty-two Balinese pieces at the Valentine Gallery on 18 January 1932. Diego Rivera wrote the foreword to the show's catalogue, which read, in part:

> *Bali, of all lands perhaps the least mechanized and the most civilized, held [Miguel] for months in its marvelous web. Now he has returned, bringing with him admirable objects, the works of artists of earlier civilizations. They form a background for his own work, yet he sees them with the vision of America, transforming them into a new beauty of his own.*[38]

The show surprised, and for the most part pleased, the critics. The *New York Post* reported that the surprise was that "the artist [had] quit caricaturing. He became a straight painter. . . . It is an interesting phase in a career that has hitherto been concerned with the gayer aspects of life. At any rate, it is impossible to think we have said good-bye to the caricaturist forever."[39]

Some subtle shift did seem to have taken place in Miguel, and it showed in his work. He had gone from a maker of drawings to a maker of paintings. From this time on he exhibited regularly, and he regularly received awards for his paintings.

Edward Alden Jewell, perhaps still trying to categorize the work as the caricature he was used to in Covarrubias, wrote:

> *These paintings no doubt contain elements of satire but Covarrubias seems to have been principally interested in plastic problems, spiced with tropical manners. While a well-considered plasticity is always to the fore in the designs, and while native traits are entertainingly, not to say convincingly reported, the pictures often resemble costume plates*

more than freely imaginative reactions on the part of the
painter. . . . While there are eloquent pieces in the exhibition,
all the same these images do not greatly stir the beholder.[40]

Enough beholders were stirred, however, that Miguel felt secure in committing himself to write a serious book about Bali, and he applied for a Guggenheim grant for support, using Alfred Knopf, Frank Crowninshield, Mrs. Charlotte Mason, the art critics Henry McBride and Walter Pach, and the producer and art patron Irene Lewison as references. In the meantime, he continued to work. In 1932 he illustrated René Maran's novel *Batouala,* a scathing attack on French colonialism that had won the Prix Goncourt in 1921 in Paris. (To some collectors of Miguel's work, these illustrations are among the most beautiful he ever made.) He also continued providing material for *Vanity Fair.* Crowninshield was especially enamored of Miguel's Balinese paintings and featured them whenever possible. In May 1932, three of these illustrated an article by Paul Morand entitled, "Bali, or Paradise Regained."[41]

Miguel and Rose took a one-week vacation back to Cuba. On their return to New York, Miguel received word that he had been awarded a Guggenheim Fellowship for creative work in painting in the Dutch Indies. The terms of the grant would support him from 10 August 1933 through 10 August 1934. Miguel wrote immediately to Walter Spies to give him the good news, and Spies sent his reply by return mail: "Not only am I longing to see you again, but [so is] every Balinese you know."[42]

*His book about Bali is extraordinary. He made
the book simple, very simple. It is easy to under-
stand. Not like a snake, no, no. . . . He was wise,
very wise. He knew everything, even our inner-
most thoughts. He wrote his book not only with
his two eyes but with the chakra in his heart.
His book had soul. Not like today. We buy an
egg. It looks like an egg but inside it is not
an egg.[1]*

B THE THIRTIES, PART TWO (1932–1937)

efore the end of 1933, Miguel had participated in an exhibition
of the fellows from the Guggenheim Foundation in New York, and he had seen his
fine black-and-white illustrations for Frank Tannenbaum's *Peace by Revolution* in
print. All was well: Miguel was well exhibited, well published, and well married—
Rose was his "domestic Tangera, his true sculpture, his everyday Rose, his intense
and sensual flower," as Elena Poniatowska poetically put it.[2] And there was another
stay in paradisical Bali in the offing—when Miguel got into trouble with one of his
staunchest supporters, Frank Crowninshield.

Things could not have been better between them, or "Crowny" more well
disposed toward Miguel up to this time. Miguel and the saber-tongued Corey Ford
had just launched a series for *Vanity Fair* entitled the "Impossible Interviews."
Later, Ford wrote:

> *It was my great good fortune to have Miguel assigned to the
> series as illustrator. Miguel was one of America's most
> penetrating and ruthless caricaturists, a quiet little Mexican*

*with the dimpled face of a cherub and innocent brown eyes
that were as misleading as Dorothy Parker's demure smile.
Miguel carried a concealed dirk in his sleeve, which he used
with deadly effect.[3]*

Each "impossible" illustration portrayed two well-known personalities in an imaginative and highly unlikely conversation. "The way [Miguel] translated character and personality . . . conveyed a story," Melanie Kahane, wife of radio commentator Ben Grauer, told me. "Miguel was a total innovator in the field of caricature. He documented an absurd and frivolous period."[4]

The first "impossible" duo were Mahatma Gandhi in conversation with the evangelist Aimee Semple McPhearson; others juxtaposed John D. Rockefeller with Josef Stalin, Greta Garbo with Calvin Coolidge, and so forth. The Smithsonian's director, Bernard F. Reilly, Jr., described the interviews much later in his introduction to *Miguel Covarrubias Caricatures*: "Every detail of a person's appearance conspired to reveal the central truth of his or her character. The participants are so thoroughly and immutably in character that their pairing becomes comic."[5]

The series, Ford's captions and Miguel's caricatures, was an immediate hit. Crowninshield would have been beaming. And then Miguel sold *Harper's Bazaar* some illustrations for an article about the Japanese, not considering that Crowninshield might care. Miguel's illustrations appeared everywhere in the thirties—*Life*, *Time*, *The New Yorker*, *Theatre Arts*, and *Fortune*, to name a few. But Crowninshield recently had obtained an editorship at *Vogue* (in addition to his work at *Vanity Fair*—Conde Nast owned both publications). *Vogue* competed with *Harper's Bazaar*, and Crowny did care, very much. Ultimately, the *Harper's Bazaar* illustrations were withdrawn. Miguel must have conceded to Crowninshield's insistence—he was too valuable a friend to lose over a drawing or two. (Later, in July of 1937, Miguel's cover for *Vogue* won an Art Director's award for Best Magazine Cover of the year.)

In fact, Crowninshield had, not too much earlier, recommended Miguel to his friends John and Alice Warder Garrett, for what promised to be a challenging and lucrative free-lance assignment.

Garrett was a bibliophile, numismatist, philanthropist, and career diplomat—he had held various posts under four presidents, to the Netherlands, Germany, Venezuela, France, and Luxembourg. He was currently ambassador to Italy, posted in Rome. His wife Alice was an intellectual, very well versed in art, who shared her husband's philanthropy. The couple maintained a twenty-six-acre estate in Baltimore, with an impressive Italiante house which grew and changed over the years to fit the needs of its occupants. In 1922, for instance, Alice had had a small private theater installed in the north wing, to serve as a showplace for a Musical Arts Quartet she supported. The Russian artist, Leon Bakst, whom she had met in Paris during Garrett's duty there, did the interior of the theater. In 1933, the servants' rooms were converted into space for artists-in-residence. These rooms became known, collectively, as the "Genius Wing."

As the number of Mr. Garrett's rare books grew, a library and reading room

were added by the architect Laurence Fowler, and Alice decided to commission an artist to decorate the reading room's eight wooden panels and lunettes. She had turned to Crowninshield, who was a frequent and reliable art advisor, and he had persuaded her to use Miguel.

The panels and lunettes, intended to represent the posts Garrett had held, were removed from the walls and sent to Miguel at the Barbizon Plaza Hotel in New York, where he and Rose usually stayed when they were in the city. Between February and April 1933, Miguel completed three panels and then took six weeks off to visit Mexico, promising Fowler, who was supervising the project, that he would recommence his work in residence in Baltimore on his return.[6]

Miguel's trip to Mexico that spring coincided with his family's move from the village of Tizapán on the outskirts of Mexico City, to a rented house on Rhin Street in the Cuauhtémoc Colony, which they occupied while they looked for something closer to the center of the capital. Miguel's father had given up their grand house on the Paseo de la Reforma when he resigned from the lottery in 1932 after a stormy relationship with then President Pascual Ortiz Rubio. (Rubio renounced the presidency that same year.)

Miguel's next correspondence with the Garretts' architect is dated in August, again from the Barbizon Hotel, indicating that the Rome panel was on its way, along with preliminary sketches for the remaining pieces, and a reminder that in ten days Miguel was embarking for a year-long trip to Bali. It is uncertain whether Miguel completed the lunettes in Bali or in the United States when he returned; what is known is that when Alice Warder Garrett returned from Rome and walked into the library, she was taken aback by the panels' strong tropical colors, typical of Miguel's palette, and she asked him to tone them down. The result is a body of work very different from what the connoisseur of Covarrubias's art is accustomed to seeing, although it is stylistically familiar: Miguel personalized his nationalistic representations with women in Dutch caps and gauchos on horseback, for example, and incorporated identifiable monuments or buildings to help the viewer recognize a particular capital city. He also did an exquisite screen of bold floral design for the Garretts—without compromising his palette—which did meet with the couple's approval. (As far as we know, Miguel only did two screens in his life: one shown in the Valentine Gallery exhibition on 27 February 1928, entitled "Celestial Bodies," and this one for Alice Warder Garrett.)

By the time Rose and Miguel left for the Far East, his relationship with Crowninshield seemed to be repaired. Miguel carried a letter of introduction from the publisher, which called Miguel "a distinguished artist who has, for the past ten years, been the chief artist on *Vanity Fair*'s editorial staff. He is to do drawings and paintings for us in the East, sending us his work by occasional steamers during his year's absence from New York."[7]

However, by December they were on the outs again. Miguel had done a caricature of Ernest Hemingway for *Vanity Fair*'s "Private Lives of the Great" series, inspired by Max Eastman's review of Hemingway's new book, *Death in the Afternoon*. Eastman had wondered in print whether the author's masculine pretensions "suffer at times from that small inward doubt, and led to a literary style

Rosa in Bali, 1930. Photograph by Miguel Covarrubias.

. . . of wearing false hair on the chest." Miguel had drawn Hemingway in a leopard skin loincloth, sitting atop a mountain of stags' horns, fish, and the skulls of bulls—his kill—while he applies a hair-growth tonic to his chest. Crowninshield thought the drawing was in bad taste and refused to publish it. When Miguel discovered this just before Christmas in 1933, he wrote to Crowninshield to sever his relationship with *Vanity Fair*.[8]

On February 5, Crowninshield's reply caught up with Miguel in Bali, refusing his resignation, declaring, "You are *Vanity Fair*'s brightest jewel."[9]

Miguel and Rose sailed for Bali on 3 September 1933, again aboard the *Cingalese Prince,* with its first stop in Panama City. This time they took longer to arrive at their final destination, hoping to see more of the Far East than on their last voyage. We do not have a complete record of their adventures on this trip, but it was surely an adventurous journey for a young couple in the 1930s. However, Miguel did keep note of his itinerary and his intentions: to travel aboard a French cargo steamer from Panama City over several weeks, stopping in the

Miguel in Bali, 1933. Photograph by Rosa Covarrubias.

Marquesas, Tahiti, the Cook Islands, Raratonga, and Fiji, then transfer to a smaller steamer, the *Tofua*, making a round-trip voyage with three stops in New Hebrides, Suva, and Samoa. In Samoa, they would transfer to the local mailboat and visit Noumea in New Caledonie, Fak Fak in New Guinea, Raboul in the Solomon Islands, and Ceram in the Moluccas, as well as the islands of Alor, Flores, Sunda, Sumbawa, Lombok, and Java. In Java, the sultan, Nogoro, arranged a special performance of dance and music for them at the royal palace. The next stop was Bali.[10]

Denpasar was full of tourists, so Rose and Miguel accepted Walter Spies's offer to share his home for several months. Situated there, they would meet most of the distinguished foreign visitors to Bali, who came to pay their respects to the island's most famous resident. Barbara Hutton and Charlie Chaplin were also guests of Spies that year, and Spies did two portraits of the heiress while they were there. Mrs. Pattinson was back from Australia and went to live again in Pedang. The actor Jack Mershon and his dancer-wife Katherine visited. Katherine had been a director at Ruth St. Denis's famous school of dance before she married Jack. Now she operated (and supported) a medical clinic on the island.

Rosa seated with Balinese woman on the steps of Covarrubias home in I Gusti compound, Denpasar, Bali, 1931.

Eventually Miguel and Rose moved back with I Gusti Alit Oka Degut's family. I Gusti had remarried, but when his first wife heard that the Covarrubiases were in Bali again, she returned to the compound in Belaluan to live with them as well. Miguel recorded this about his return to Belaluan:

> *Our dear friend Siloh Biang, Gusti's first wife, had fought with Sagung, her rival, and had run away to her mother, but our return brought Siloh Biang back. She preferred to remain with us in our part of the house rather than with Gusti and his new wife, and we often had to act as mediators in their family quarrels. . . . Some of our old friends had died, others had married or moved away, and the little dancers who only left our front porch to go to bed at night had grown into serious young women of thirteen or fourteen years of age.[11]*

As before, visitors gathered at the house and placed floral offerings at the doorstep to make Miguel and Rose feel welcome.

Once settled, Miguel went to work in earnest, resuming his daily language lessons with both a teacher and a translator to help him decipher the books and manuscripts that his research uncovered. Miguel conceived the book he would write in three parts: he would address the worldly and the spiritual sides of Bali,

and he would try to tell its future. His intention was to "collect in one volume all that could be obtained from personal experience by an unscientific artist, of a living culture that is doomed to disappear under the merciless onslaught of modern commercialism and standardization."[12] He would create a thorough, and thoroughly accessible, anthropological treatise, but the voice he used would speak to scholars as well as lay people, to a tourist as well as a Balinese. He would consider geography, history, and culture. He would explore sociology, politics, and justice in discussing the community. He would examine labor and the economy, family life, language, cooking, dress, art, dance, music, rites and festivals, magic and medicine, death and cremation.

As for illustration, he did not intend to stint there, either. The book would be heavily illustrated with his own drawings and Rose's photographs of Bali—its beaches and rice fields and forests, its flora and fauna, its festivals, temples, markets, and people. (Ultimately Rose's contribution consisted of one hundred and fourteen photographs. The book contained over ninety black-and-white drawings in line and wash by Miguel, including a three-page fold-out topographic map, several drawings by Balinese artists, and full color reproductions of five of Miguel's paintings.)

Miguel seemed to be the ideal author for such a book: he was irresistibly drawn to exotic cultures, and for him, "no people are more beautiful, no landscape more seductive, no race more lofty in spirit" than the Balinese.[13]

The kind of research required to produce *Island of Bali* was active. Miguel followed processions of Balinese to temple celebrations, sketching the intricate "kbogans," towering structures which women carry on their heads. These pyramids of fruits, flowers, and cakes are offerings of sustenance to the temple gods, can be seven feet high, and sometimes weigh as much as fifty pounds.

Miguel attended dance rehearsals as religiously as the dancers. He was increasingly fascinated by dance. In studying Balinese forms of dance, he made a drawing of every separate step and gesture that is part of the Balinese choreography. "Miguel insisted that even the smallest gesture of a hand or the tilt of a head be accurate. He was a perfectionist. I respected him for this," the dancer Ni Ketut Reneng remembers. And Anak Agung Mandera, the drummer, agreed: "Miguel's drawings of the dance are wonderful," he said. "Just by studying them you could become a good dancer."[14]

Every aspect of *Island of Bali* shows a similar attention to detail as the pages that illustrate every gesture and movement in a particular dance. And every subject is illustrated, if not with a drawing, then with an anecdote. It is possible to open the book to almost any page and be drawn in, as in the discussion on "Social Order":

> *It was surprising to discover the extent to which the question of rank obsesses so simple and democratic a people as the Balinese. In our house every time Gusti came near, everyone scrambled down the veranda steps to place themselves at a level lower than his. Once in Ubud we received a visit from two little girls, high-caste dancers of ten. They were to spend*

the night in the house . . . and a servant was appointed to watch over them; when they heard he was to sleep in the attic, twenty feet up, they snatched their pillows and ran upstairs, not to be defiled a second longer by an inferior located above them. They preferred to sleep on a hard bench rather than in the bed made for them, while the poor servant had to sleep on the floor. Once we visited a high priest, who invited us to remain for lunch; when the food came he apologized for having to ask us to sit down, because, he said, "the gods would not like it" if he, a Brahmana, placed himself at a level lower than ours.[15]

After a year away, with many hundreds of pages of notes containing such stories as these, hundreds more of details on home life ranging from house construction to the four ways to prepare a festival dish of sea turtle, scores of sheets of illustrations from floor plans to kitchen utensils, over a thousand of Rose's photos, and an eight-millimeter film they had shot, it was time to think about returning home.

First, however, they would visit China again. They stopped in Hong Kong and Canton (Guangzhou) and from there went to Shanghai to see their friends Bernadine and Chester Fritz (of export-import fame). Miguel probably knew the Fritzes through his publishers, the Bonis; Bernadine had once been married into that family.

An invitation to spend time with this much-admired couple was a real prize, as was a visit to their luxurious home, the Sassoon House, where guests sailed in gaily decorated boats across the lake at sunset, sampling Chinese wines and gastronomic delicacies as they went. The Covarrubiases stayed with the Fritzes for a month, visiting restaurants and antique dealers and making side trips to Soochow (Suzhou) and Peking (Beijing).

Years later, Rose penned a dreamy recollection of this trip to China, especially their time in Soochow:

Our days were spent visiting the homes of famous poets, painters, musicians, and writers, seeing temples, eating in restaurants, on boats, and in private homes. We traversed all the canals on a red lacquer houseboat, gliding under the bridges and watching the river traffic. We wound in and out of the moon gates of the romantic house of Chang Lang Ling, crossing a broad band of blooming lotus over a white stone bridge to enter the white-walled . . . whitewashed house of winding corridors, secret rock gardens, pools, tea houses and feathery trees of a thousand Chinese paintings.[16]

The memoir describes bamboo forests, ancient temples, gardens "ablaze with peonies," and the shops, in particular the snake shop: "veritable walls of glass boxes

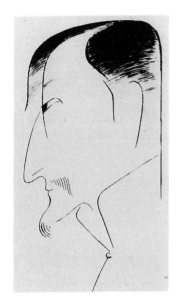

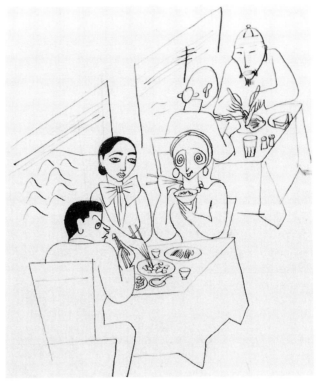

L E F T : *Sinmay Lau, the host of Rosa and Miguel at a picnic in Soochon, 1933. Drawing by Miguel Covarrubias.*
R I G H T : *On board the dining car in China, 1933. Drawing by Miguel Covarrubias.*

placed one on top of the other, housing the writhing occupants whose destiny is on the banquet plate of a discriminating gourmet." But Rose's warmest memories in this essay have to do with the food.

> *In all the years that followed I would think of Soochow and my Chinese friends, all of us seated around a large circular table piled high with steaming crabs. . . . Scissors, hammers, tweezers all went to work to crack, cut, pull and extract the juicy meat from the tender shells, after which we dipped the delicate morsels in vinegar and chopped ginger. Nobody said a word, but it was the noisiest dinner party I ever attended. Everybody was shameless; one of the Chang boys ate fourteen, the record for the day.*

They picnicked one day, and Rose wrote:

> *I can't resist telling what we ate. . . . So here they are, the cold preliminaries: candied walnuts, Chekiang ham, shirred*

The Thirties, Part Two 79

*eggs, roasted sparrows, raw crabs in wine, bean curd,
mushrooms in oil, cold boiled chicken, gizzard sliced thin
with sauce, mushrooms stuffed with shrimp paste, sliced duck
and raw shrimp. . . . Following these appetizers came some
hot dishes: small white shrimp paste with petals of ham and
chicken, bamboo shoots with greens, bird's nest soup, four
kinds of dumplings in elaborate shapes . . . whole duck in
soup, crabs in red sauce, whole chicken with onions, Chinese
cabbage with white sauce, pigeon eggs, bamboo pith from
Szechuan cooked in mushroom soup, pig in soup, baked fish
with sweet and sour sauce, rice, pomelo, melon seeds, and
mint, hot wine, and at the finish toothpicks!*

Rose's appreciation shines through her list. She was a sensualist for whom taste, smell, and sight could be satisfied in food. She learned to cook many of the exotic dishes she tasted in China and gained an international reputation among her friends for her culinary skills.

Miguel and Rose set about for home on a freighter that would take fifty-eight days via Java and Nova Scotia to reach New York. As was his custom aboard ship, Miguel worked. On this voyage, he completed six paintings and wrote three chapters of *Island of Bali*, in spite of strong winds and heavy seas. Several years later a journalist interviewed Covarrubias about his facility in such circumstances, and Miguel responded, "Always have I made it a point to work while traveling, whether on train or ship. In fact, I work better on shipboard than on land. Whenever possible, my traveling is done on cargo boats, for I prefer to travel on them. When on a freighter I feel more a part of a ship." The journalist noted that "to combine one's work with worldwide travel seems to many an ideal existence, while to be able to work better on ships than anywhere else is an art which few have developed."[17]

Miguel and Rose arrived back in New York in December 1934. As usual, they checked into the Barbizon Hotel, where Alfred Barr, by now director of the Museum of Modern Art, met them, eager to hear about their trip. Barr introduced them to his friend Salvador Dali, who was in the city for a one-man show at the Julien Levy Gallery.[18]

Miguel and Rose planned to spend Christmas in Mexico, but first Miguel had to make his requisite visit to Godmother Mason. It was a ritual that she summoned her protégés for a full report whenever they returned from a working trip. Although she was not well, this was still the case, and Miguel's visit took place at New York Hospital.[19]

Mrs. Mason was pleased by what Miguel showed her: the rough draft of the manuscript so far, some of his illustrations, the film he and Rose had shot, and many of Rose's photographs, which especially moved her. "I want to speak of Rose's photographs," she wrote. "They are most amazing in their quality. She has

Miguel on a trip to China. Photograph by Rosa Covarrubias.

caught and reproduced forms in nature and human life that are believed to be impossible in the photographic mode."[20]

On Christmas day, Miguel had several new paintings delivered to Mrs. Mason's hospital room. As her health worsened, she wrote to him again:

> *I can only think of you, this grey-weathered day as the embodiment of flaming truth, moving forward on the earth, with such a broad sweep, that all evil vibrations fall asleep on their wings of bad impulses. I do pray and hope that the light of your creative impulse form some fresh expression of your spirit on either canvas or paper day by day. . . .*
>
> *The fulfillment of this dream in you is ever present with me. Ah, Miguel it is a terrible sorrow to the old Godmother that she cannot work with the dear Godchildren as in the old days but, either here or Beyond, my spirit will brood about you and pour the old fire still upon you. Eternally the morning star in my own creative world will call you to action.[21]*

That January, while Mrs. Mason brooded over Miguel's creative brilliance, *Vanity Fair* celebrated it, publishing color reproductions of five of the paintings he had completed aboard ship, with the caption: "These paintings support the Chinese proverb 'A picture is worth ten thousand words.' Few men know Bali—indescribable gem of the Dutch Indies—better than Covarrubias, who gives us these five glimpses of its enchanted life."[22]

There would be far more than a glimpse when *Island of Bali* was completed and made public. Much of 1935 and 1936 would be devoted to writing and culling and shaping the raw material and detailed notes and illustrations that Miguel had brought home with him. And two years does not seem a very long time, considering the volume Miguel produced:

> . . . *a finely executed masterpiece, a scholarly study magnificently illustrated by an artist who showed true genius as writer, draftsman, and painter. It demonstrated his painstaking research, his accurate marshalling of facts, and the ordered results of keen first hand observation. The result was worthy of a trained ethnologist, but with the feeling and sympathetic understanding that might only be expected from one of Balinese birth. An extraordinary feat when one realizes that Miguel was only twenty-six when he first went to live in Bali.*[23]

Island of Bali had been well heralded: the "glimpses" of Miguel's Balinese art had been leading up to the book for the two years he worked on it, beginning with the illustrations in *Vanity Fair*. The Brooklyn Museum added Miguel's painting, *Balinese Dancers,* to their January 24–March 15 "The Dance in Art" exhibit[24]; then *Theatre Arts Monthly* carried a special issue on "Theater in Bali" in August 1936; and *Asia* magazine excerpted *Island of Bali* in six separate issues and used two of Miguel's Balinese paintings on its covers in April and June 1937.

Both the piece in *Theatre Arts Monthly* and the excerpts in *Asia* attracted a great deal of attention among the literary-minded, especially in New York. John Martin, dance critic for the *New York Times,* noted with surprise and pleasure that "Theatre in Bali":

> *[W]as a most extraordinary departure from the usual procedure of magazines in general and of* Theatre Arts Monthly *in particular. . . . Covarrubias is happily an artist, and this sets him almost spectacularly apart from the majority of writers on anthropological aspects of the arts. . . . Indeed the August* Theatre Arts *becomes at once required reading for the dance world.*[25]

Vanity Fair's last issue (before its 1983 resurrection) appeared in February 1937, with Miguel's painting of the Balinese dancer Ayu Ktut as its cover, an honor for Miguel and a demonstration of Frank Crowninshield's continuing regard.

Meanwhile, interest in Bali continued to grow, even before Miguel's book was published. *Life* magazine did an illustrated story entitled "Mexican Covarrubias in Dutch Bali" for its 27 September 1937 issue; and the next month a fashionable New York department store held a party in honor of Miguel, advertising "Bali Comes to Franklin Simon."

The store went all out. Inside, they carried fabrics and beach ensembles, shorts, evening gowns, and daytime dresses that Miguel had designed with Balinese motifs. Gamelan music wafted through the high-ceilinged rooms, and the press who covered the event received a special viewing of Miguel's eight-millimeter film of the island. Naturally, Miguel did the windows as well. His backdrop for three mannequins in "Palm Beach" evening dresses featured a Balinese girl swimming. Rose contributed an intricate temple offering to the display. She kept one of the evening dresses all her life and would occasionally take it out to show visitors. It was designed from an abstract "Tjili" figure representing the Rice Mother in Balinese culture, symbol of fertility, beauty, and seed.[26]

Miguel's illustrated magazine articles, his exhibitions and drawings, and the Franklin Simon promotion all contributed to a Balinese craze in New York City that persisted through the 1930s. By the time *Island of Bali* appeared in mid-November 1937, that craze was at its peak. No wonder the book was an instant best-seller. Even before its appearance in bookstores, Alfred Knopf had to order a second large printing to satisfy demand. Its first run consisted of 6,000 copies; the second printing added 5,000; and a third printing of 3,000 was necessary by February 1938.[27]

The reviews were nearly all raves. The *Colorado Springs Gazette* commented on the writing in particular and Miguel's "fast-moving style that never falters even when the author touches—which he does lightly—on purely anthropological and archeological subjects." The *Waukesha (Wisc.) Freeman* reported on Miguel's extraordinary suitability for the task:

> *Only through the sympathetic eyes of an artist could he have penetrated so deeply into the spirit of the dance, theatre, music, handicraft and sports of Bali; and only a man of learning in anthropology could have understood and recorded its religion, family life and economic and political organization.*[28]

The *Nation* called it "a lively and handsome work. . . . Furthermore, it is a sound piece of scientific work and a real contribution to knowledge. It will probably be the standard English work on Balinese culture for years to come." (Indeed, it still is.) And the *Herald Tribune* declared: "A superb piece of reporting of anthropological and artistic understanding as you will find in a dozen campusfuls of pompously scientific work."[29]

Reviewers (and readers) responded to the four fundamentals that characterize all of Miguel's written work: his interest in everyday life, the historical-anthropological perspective with which he interpreted everyday life, his extraordinary knowledge of ethnic people, art, and culture, and the ability and facility to make

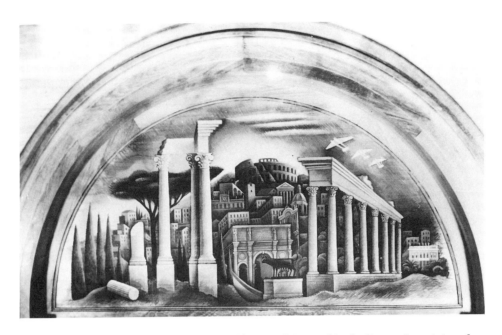

Lunette mural by Miguel Covarrubias for Garrett Commission of Evergreen House Library, Baltimore, 1933. Courtesy of Evergreen House, The Johns Hopkins University.

the researcher and the aesthete compatible. Writing much later, Terence Grieder categorized Miguel as:

> [T]he heir to all those nineteenth century artist travelers, such as Reyendas and Mark, who specialized in pictorial costumbrismo, or the painting of local customs and human types; or of Stephens and Catherwood, who together described in words and pictures the typical life of Central America, although Covarrubias was a better artist and writer than his predecessors.[30]

What was new about Covarrubias and his book, Grieder believed, was Miguel's "sense of urgency": "Nothing suggested to Reyendas, Mark, or Stephens and Catherwood the imminent disappearance of the life they recorded. Even in his illustrations, Miguel was conscious that he was engaged in salvage ethnology."[31]

Perhaps the highest praise for *Island of Bali* came from the Balinese themselves. Miguel's host, I Gusti Alit Oka Degut, would not have understood Grieder's references, but he did know that "Miguel lived with the Balinese. We learned to love and trust him, and because of this we revealed ourselves to him. For us his book is the most important on the Balinese culture because he understood the significance of the spirit of our culture, as well as its deepest mysteries."[32]

Fernando Blanco, a Catalonian painter called the "Dali of Bali," who went to Bali in the 1950s, also spoke of Miguel's achievement with great admiration:

*This man was able to penetrate Bali as no other
foreigner, including many of those who lived and worked in
Bali for longer periods than Miguel.* Island of Bali *is the
bible of Bali. This great, great book, this informative book
with its wonderful stylized illustrations is superb because
Miguel with his Mexican eyes and soul was* touched*. I who
have lived here for over twenty years and am married to a
famous Legong dancer, whenever I need some concrete
information, I refer to Miguel's book.*

*Where did Miguel get so much ability? He didn't have a
Ph.D., not even a high school diploma, yet he excelled in so
many fields. Have you ever considered that Miguel was
divinely inspired?*[33]

Pearl Buck did not think so, although she allowed, "There is scarcely a question about Bali which is not answered here. . . . At times it seems a scholar's work rather than an artist's. And then the artist emerges to make us see a line, a color, a flash, which a scholar would never see." Still, she found the book "curiously passionless. . . . Covarrubias obviously loves his subject," Buck wrote, "but it is an artist's love of the body of a beautiful model. It is not the way in which Byron loved Greece, so that he threw himself into her life and lost his own."[34] She went on:

*Covarrubias remains himself, and he sees Bali out of his own
eyes, and not out of any spiritual transfiguration. Greece
made Byron tridimensional at last — it rounded his life and
art and gave him completion. But as an artist Covarrubias
was already complete, and Bali has not added depth to his
work so much as scope. His writing therefore has the
technique of his painting — color and line and style, but the
surface is flat.*[35]

No one else found it so. Whether he achieved spiritual heights is surely arguable, but there is no doubt that what Miguel accomplished in *Island of Bali* "lifted him to a loftier artistic peak as a writer," as the *Sun* (New York) noted in its review.[36] Furthermore, the book established Covarrubias as a serious student of anthropology and forever changed the direction of his life and work. Even as he accepted the accolades that *Island of Bali* brought him, he had already gone some distance in that new direction.

CHAPTER 6 *One of the axioms of contemporary thought is that the world is divided into two parts, one developed, the other underdeveloped, which were also the new and the old. This discovery was largely made during the 1920s and 1930s. How old were the traditions of the "undeveloped" societies and what were the sources of those ancient traditions? These questions began to fascinate Covarrubias.*[1]

THE THIRTIES, PART THREE (1935–1939)

iguel's parents' search for a new house in Mexico City ended on Zamora Street, where they moved at the end of January in 1935.[2] They kept the house at Tizapán, however, which they continued to visit on weekends, and offered Miguel, as the oldest son, its use as a homestead.

The timing seemed fortuitous. Miguel must have thought his work on *Island of Bali* would benefit from the relative peace he could find in Mexico, as opposed to Manhattan's frantic pace. New York seemed more and more demanding of his time and company, and for Miguel, demands were hard to resist. If Crowninshield wanted another illustration, or a reporter wanted an interview, or Van Vechten wanted to introduce Miguel to a new writer, or Mrs. Mason wanted to see him, or there was a party at Nick Muray's that conflicted with a deadline, Miguel hated to disappoint. Moving may have seemed easier than refusing. And besides, maybe it was time to go home.

Not that there wouldn't be distractions in Mexico; Miguel had many close friends in his own country, both Mexican and American. In fact, Harry Block had just moved to Mexico that same year. Block reminisced, "If I came to this

magnificent country of Mexico, it was because Miguel got me interested. I came to love Mexico so much that I stayed to live."[3]

Miguel and Rose moved in stages, around a hectic schedule, and it was quite late in 1935 before they were in residence at Number Five Calle Reforma in the small village of Tizapán—Aztec for "Village of Flowers"—and Rose was unpacking the rare and wonderful relics that had been Miguel's art collection when he was a young man.

How much peace this move engendered, however, is hard to say. When one looks at what Miguel accomplished in 1935 and 1936, which included his writing the massive *Island of Bali*, the impression is overwhelming. He continued to paint and exhibit. Early in 1935, two of his paintings, an oil entitled *The Bone* and a gouache called *Río Tehuantepec*, showed at the Carnegie International Exhibition of Modern Painting in Pittsburgh, Pennsylvania. Ninety-three painters participated in this prestigious show; Orozco, Siqueiros, Mérida, and Covarrubias represented Mexico.

The Bone depicted a man in a black suit and hat with white shirt and tie, seated on a green wicker chair, his hands crossed and resting on a black umbrella. In Spanish, another meaning for "the bone" is "an easy government job." The Carnegie Institute purchased *Río Tehuantepec* in November for $300, a good price in those days.[4]

While the Carnegie Exhibition was taking place, Miguel took Rose for the first time to that primitive region in Mexico's southeastern territory called the Isthmus of Tehuantepec. This was the country whose religion was one of color, as he had put it to Haldeman-Julius in 1926. This place had inspired Tata Nacho to collaborate with Miguel in the twenties on a Tehuantepec ballet, as well as the very *Río Tehuantepec* then hanging in the Carnegie Exhibition.

Tehuantepec had fascinated Miguel for years, as it did many of his contemporaries. In 1922, the idealist Vasconcelos, who had breathed a cultural pride back into Mexico as Obregón's minister of education, sent Diego Rivera to Tehuantepec, and "Rivera came back . . . shaken into simplicity by all he had seen and experienced."[5]

Miguel had surely seen Diego's fresco of Tehuantepec, created for the ministry of education in 1923. It is not known when Miguel first visited the isthmus, but he told a reporter for the New York *Sun* in 1938 that he had been there at least twenty times—he had visited Alfonso Caso's excavation at Monte Albán in Oaxaca in 1932—and he would make many more trips there during the 1940s. He wrote:

> *I was attracted by its violent contrasts—its arid brush, its*
> *jungles that seemed lifted from a Rousseau canvas; the*
> *Oriental color of its markets . . . the majestic bearing and*
> *classic elegance of the Tehuantepec women walking to*
> *market . . . with enormous loads of fruit and flowers on their*
> *heads, or dancing the latest "swing" tunes, barefoot . . . in*
> *magnificent silks and wearing gold-coin necklaces worth*
> *hundreds of dollars.*[6]

Tehuantepec was Mexico's own Bali, and it appealed to Miguel as Bali had.

Miguel and Rose were back in Mexico City on 7 March 1935 for the opening of the first contemporary Mexican art gallery, established by the distinguished Amor family. Miguel's work was shown, along with that of the rest of the very best: Frida Kahlo, Federico Cantú, María Izquierdo, Xavier Guerrero, Tina Modotti, Timaji Kitagawa, Roberto Montenegro, Anna Beloff, Alice Rahon, Carlos Mérida, Diego Rivera, José Clemente Orozco, and David Alfaro Siqueiros.[7] (1935 was an important year for art and artists in Mexico. After the Amors' opening, the League of Revolutionary Artists and Writers and Taller de la Gráfica Popular [Workshop of Popular Graphic Art] opened the Espiral Gallery, and María Asúnsolo, who became Rose's most constant friend, opened the GAMA [Galería Artística de María Asúnsolo] Gallery.) Later that same March, Miguel showed in New York's College Art Association show, in which *Río Tehuantepec* appeared again, along with two of his drawings of Mexican women.

The next year his award-winning *Lindy Hop* traveled in an important show called "America Today," sponsored by the American Artist Group Incorporated. The show visited thirty American cities, and Miguel's entry was so popular that the AAGI produced a lithograph of it, which sold very well.[8]

On the book scene, Miguel saw his second project for Limited Editions, a reprint of Herman Melville's *Typee*, released in 1935. In an unusual and highly original move, Miguel had had a Chinese merchant in Bali send him one hundred sheets of tapa cloth to bind each copy for the publisher's First Edition subscribers. Soon after *Typee*'s publication, J. B. Lippincott published Zora Neale Hurston's fine book about Afro-American folklore, *Mules and Men*, with a four-color cover by Miguel—his involvement in the project had been instigated by Godmother Mason.

Hurston remained a friend of the Covarrubiases for over ten years. She wrote of them:

> *I value Miguel and Rose for old time's sake. Long before they were married, we polished off many a fried chicken together. Along with Harry Block, we fried "hand chicken" and settled the affairs of the world over the bones. We did many amusing but senseless things, and kept up our brain power by eating more chicken. Maybe that is why Miguel is such a fine artist. He has hewed to the line, and never let his success induce him to take to trashy foods or fancy plates.*[9]

Miguel was indeed a success—"No one can imagine to what degree Miguel was famous in New York," Malú Block reminisced. "It was something incredible. Everyone knew him, and he knew everyone." And this was at a time when most artists in the United States and Mexico were surviving only by the good offices of government programs. (In fact, when George Biddle proposed what became the Works Project Administration and Federal Arts Program to his old classmate, President Franklin Delano Roosevelt, Biddle held up President Obregón's policy for Mexico's artists as his model.)[10]

Roosevelt took Biddle's advice. By 1935, the WPA/FAP was in place with comprehensive work programs that elevated art by bringing it "down" to the level of the masses while it provided jobs for artists during the recovery period after the Great Depression. It was the democratizing of art, the dispossession of it from elite patronage only. With its special focus on collective creativity, WPA art was particularly beneficial for muralists and artisans: post offices, hospitals, schools, and libraries were embellished with sculpture, murals, posters, and crafts.

The period empowered art, it did not attempt to ennoble it. In America, for the first time, art assumed an aspect of social commitment. Painters like Thomas Hart Benton, Grant Wood, and John Steward created a visual narrative of everyday life in the American heartland. Others, like Ben Shahn, William Groppa, and Jack Levine explored the darker underside of American life with images of class struggle and political corruption. Miguel predicted "that out of the W.P.A. [would] come the renaissance of American Art. And that as soon as the American artist ceases aping European art, he becomes what he should be: a representative of the life which is about him. This is true both in the United States and in Mexico."[11]

In Mexico the idea of social commitment among artists was decades old, and artists were more insistent and political about their commitment than were their counterparts in the U.S. In 1922, for instance, Diego Rivera had headed the Syndicate of Revolutionary Painters, Sculptors, and Engravers of Mexico, whose manifesto read in part:

> *In the present epoch of exasperated class struggle, of imperialism oppressing our people, our native races and peasants, there exists, for intellectual producers and for workers in the painting craft conscious of the historical moment, no other way but to affiliate with each other in a manner disciplined by the struggles of the revolutionary proletariat.*[12]

Several of Miguel's friends and colleagues were members, including David Siqueiros, Xavier Guerrero, and José Clemente Orozco, all promoting "works of revolutionary art" that would support "Mexico's popular classes in their struggle . . . ," at the same time dedicated "to destroy[ing] all egocentrism, replacing it by disciplined group work, the great collective workshops of ancient times to serve as models."[13]

When he moved to Mexico in the mid-thirties, Miguel joined the League of Revolutionary Writers and Artists, which included many of the same crowd: Frida Kahlo and Diego Rivera were members, as was Xavier Guerrero. The league's purpose was to unionize artists and provide communal projects for them.

Another group, founded in 1937 by three communist artists, Luis Arenal, Pablo O'Higgins, and Leopoldo Méndez, also attracted Miguel's support. Called Taller de la Gráfica Popular, it was designed to employ large groups of artists of the so-called second and third generations of the Mexican school of painting and to produce new forms of popular art while it upheld established forms of critical art, like the

calaveras of Posada (satirical graphics that use an image of a skeleton to parody and comment on social issues), and the *volantes* (printed broadside on brightly colored paper, combining satirical verse and images).[14]

In his own graphic images, Miguel let cultural and historical themes dominate over the political, allowing the satire of his caricatures in particular to speak for political intent. But he was a great promoter of Mexico and of nationalistic art. In an interview in San Francisco in 1938 he maintained:

> *Real art can no more be a monopoly of one country than man can seclude himself on an island and expect to picture humanity. For example . . . out of the Spanish conflict [the civil war of 1936–1939] has come the beginning, only the beginning to be sure, of a great art. The Republican government has realized that once art is in the hands of the people then art flourishes.*[15]

Living in Mexico, at least some of the time, reaffirmed the bond Miguel had with his family. Since the house in Tizapán was spacious enough, his parents continued to use it as a retreat from the hubbub of the capital city. They spent every weekend there until illness forbade it, whether Miguel and Rose were in the country or not. And when Miguel and Rose were traveling, his mother and father wrote to keep in touch. Several letters survive. In one, the elder Covarrubias confides his disappointment over not being able to interest a publisher in his latest book on Mexico's rural problems.[16]

In another, his mother wrote to "Micaelito" in New York urging him to get enough sleep.[17] Miguel had not been well; he seemed always tired, and tiredness depressed him. Part of his business in New York in December 1935 was to consult with a specialist in tropical diseases.

The diagnosis was malaria, contracted, no doubt, during his travels in the tropics. The diagnosis did little to slow down Miguel. Though the disease ate away at his energy, he would make no concessions to it. He was in New York again in February—the purpose of this visit may have been to negotiate a new contract with Crowninshield for work with *Vogue*. Of course, while he was in the city he and Rose visited Harlem. They went with Frank Tannenbaum (for whom Miguel had illustrated *Peace by Revolution*) and his wife, Jane Belo (whom Miguel and Rose had met in Bali where Jane was researching a book of her own), to a service of Father Divine, a charismatic black cult leader who dressed in furs and preached from a throne. His disciples were said to dance themselves into trances, which greatly interested Miguel and Rose, who had seen a similar kind of ecstatic dance in Indonesia and Cuba. They were so impressed, they made a special trip to Philadelphia to see the preacher a second time.[18]

In March, the same month that *New Theatre* sported a Covarrubias cover of Charlie Chaplin, Miguel was in Chicago for the opening of the Fifteenth International Exhibition of Watercolors at the Art Institute of Chicago. Sixteen of Miguel's

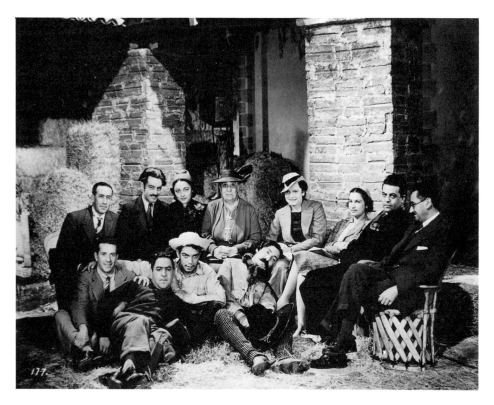

Miguel and Rosa on the set of Así, Es Mi Tierra, *Arcady Boytler, dir., 1937. In back row, at left, Luis Barrerro and composer Ignacio "Tata Nacho" Fernández Esperón. Below Rosa, Cantinflas; to his left, Manuel Medel.*

gouaches from the *Impossible Interviews* he did for *Vanity Fair* were shown, along with twelve from *Batouala* and one ink drawing. He had a gallery all to himself "filled with opaque watercolors . . . which combine the elements of good drawing, strange yet beautiful color, interesting design and broad humor. Covarrubias is a veritable pictorial rover," proclaimed *Art Digest*.[19]

At the beginning of April 1936, Miguel and Rose were back in New York, this time to attend the opening on April 15 of a "protest" exhibition entitled "War and Fascism" organized by the American Artist Congress at the New School for Social Research. It was a powerful show with participants from around the world. Miguel was flattered to find his work hanging next to that of Daumier, whom he particularly admired.[20]

However, this honor did little to comfort Miguel in the face of the news he received from home just days after arriving in New York. His father had died on April 9.

José Covarrubias had been ill for some time, but no one had believed his death was imminent; in fact, he had seemed much improved at the time of Miguel's departure for the States. Miguel was not able to get back to Mexico for the funeral. Perhaps he could not find a flight leaving New York in time—air travel was still in

its infancy in the mid-thirties, and schedules were sporadic at best and dependent on railway connections. A flight to Mexico might take days from New York. (Miguel hated to fly, in any case.) He was broken up over the news and kept in close touch with his mother over the next month.

The correspondence that remains from Miguel's mother indicates that José Covarrubias's estate would be probated and that Miguel had written from New York to ask what price she would put on the Tizapán property, which included the lot on which the main house stood, a second parcel that would become Rose's bedroom, and a third consisting of the front garden—about a square city block in size. "Since it's for you," his mother wrote, "and as I don't remember what your father spent on the house improvements before he transferred it to you, I think if you give me $5000 for the property that will be sufficient."[21]

He could pay her monthly. "When this has been paid," she wrote, "the property will be put in your name. I have spoken to your brothers and sisters and they agree with this plan." She ended the letter, "And to you my adored Micaelito, I send lots of kisses and love from your little mother who adores you and misses you."[22]

When Miguel and Rose returned to Mexico in May, it was to a home of their own—their first—and they plunged into making it truly theirs. The house was adobe and brick, whitewashed inside and out, with cool terra-cotta tile and brick floors.

Miguel undertook major reconstructions, adding a large studio for himself on the house's second story and a detached bedroom for Rose that faced the spacious Mexican kitchen. The kitchen was, figuratively, Rose's studio, and Miguel ultimately added a second, more modern kitchen to the house for her. "I must have complained a lot," Rose wrote later, "because one day when I returned from one of my periodic trips to New York I was surprised by a completely equipped, shiny white new kitchen including the gadgets that make cooking an easy pleasure."[23]

Outside, their acreage also grew. They purchased additional parcels from their neighbors, including a good-sized plot from Ismael Celaya, whose daughter Paz came to work for the Covarrubiases and eventually became their housekeeper. The Tizapán property had two productive wells, and Rose may have felt some nostalgia for the rich garden her mother had kept when Rose was a little girl, for her gardens were extraordinary, profuse with flowers and shrubs of both native and exotic varieties that Rose collected, nurtured, and tended herself. The house was always filled with fresh flowers in big clay bowls, and the kitchen with baskets of fresh vegetables and fruit.

Miguel must have devoted most of the rest of 1936 to work on *Island of Bali,* except for trips he made with Diego on Sundays to Tlatilco. These had become something of a ritual after he and Rivera heard rumors of treasure having been found at a small brickyard just outside of Mexico City.

"'Tlatilco' is a name well known to everyone with an interest in Mexican art and archaeology," wrote Michael Coe in his book *The Jaguar's Children.* (Tlatilco means "where things are hidden" in the Nahuatl language.) Coe went on:

It was applied by Miguel Covarrubias to an extensive Pre-Classic village site . . . on the northwestern outskirts of Mexico City. In ancient times Tlatilco was a very large community, or cluster of communities. . . . It was discovered through the operations of brickyard workers. There is a strong correlation between Pre-Classic village sites and brick factories in Mexico. Over many generations the clay used by early peoples on the walls of their huts became deposited in such concentration that it could be exploited for brick-making in modern times.[24]

Now, as the laborers broke up the earth for its rich, useful clay, they were finding small vessels and figurines thought to be pre-Hispanic.

"Curious," Miguel wrote, "we went to the brickyard to determine if the finds were genuine because collecting 'archaic' figurines and implements has been a hobby of ours of long standing. Astonished by the beauty of the objects and acknowledging their authenticity, we soon realized that there was no better hunting ground for the purpose than the great holes of the brick factories."[25]

In the first days, in the excitement over this discovery, Miguel and Diego visited the brickyard two or three times a week, but then "going to Tlatilco with a pocketful of change and returning with an archeological puzzle or with an artistic surprise became our weekly habit."[26] The brickyard workers came to look forward to these regular visits, which augmented their meager wages. They were happy to stop shoveling when they encountered resistance in the ground and to dig out the ancient pieces with their hands as Diego and Miguel had requested. After a while, on occasion, one of the laborers would show up at Miguel's or Diego's home with a particularly interesting find. The two artists enjoyed an unspoken competition for the most unusual pieces.[27]

One very rare piece, one of the first that Miguel had purchased from the region, was a headless torso of a Chaneque-type figure that he found for sale at a pulquería in Iguala, about an hour from Tlatilco, where the Indians exchanged, for a glass of mescal, the little idols they uncovered while digging. "I acquired a number of very strange archeological objects [at this site]," Miguel wrote, "fat little idols with extraordinarily mongoloid characteristics and thick unpleasing lips. [The rounded torso with its head missing] was an exceptional piece because of its realism and the skill with which the black serpentine was carved and polished."[28]

Even more extraordinary was the day eight years after this purchase when, in honor of Miguel's Saint's Day, Diego presented him with a box of earth in which he had buried the black serpentine head that belonged to the idol from Iguala! The piece was "a round face in the form of an avocado," and had "puffy eyes, swollen cheeks and a strange mouth. It was the mouth of a monster; that of a child or a dwarf born without the lower jaw, showing the trachea carved in a realistic manner."[29] Diego had had no idea that Miguel owned the other half of the Chaneque figure. It now resides in the Museum of Anthropology in Mexico City.

"Later," Miguel reported, "I found another similar piece in Veracruz carved out

Miguel, Rosa, and unidentified man in front of The Economy of
the Pacific, *one of six maps painted for the World's Fair on
Treasure Island, San Francisco, 1938.*

of basalt that seemed to represent a deaf man." That figure, now world-famous, is
cupping its ear with its hand. "Still another find was a superb and rare serpentine
figurine from Tlatilco that a worker brought to my house from the brickyard. It was
unlike anything I had seen before."[30]

As Michael Coe reports, "Covarrubias quickly realized that here was a find of
the greatest importance: a site with demonstrably pre-classic pottery and figurines,
associated with objects that were surely Olmec." Tlatilco, it became clear, was an
ancient burial site. The burials consisted of "extended skeletons accompanied by
the most lavish offerings, especially figurines which only rarely appear as burial
furniture in Formative Mexico. . . . The potters of this village made ceramics which
are among the most aesthetically satisfying ever produced in ancient Mexico."[31]
Eventually, approximately three hundred and forty burial sites were uncovered.
Many more had been inadvertently destroyed by brickworkers.

Over the next years, Miguel wrote:

> *[T]housands of expressive figurines representing a variety of
> subjects, such as mothers, children, warriors, ball players
> and priests were being uncovered at the site. Of those more*

Miguel and Antonio Ruiz together working on designs for the World's Fair murals, 1938.

than two hundred complete figurines came out of Tlatilco in a most varied range of styles. A general assumption was that these figurines were ritual objects of an agricultural fertility rite.[32]

Miguel must have hated to leave Diego alone in their hunting fields during these early days of discovery, but he took a trip to New York in the fall of 1936 to attend the Heritage Press publication party for a reissue of William H. Hudson's *Green Mansions,* which he had illustrated, and while he was there, Frida Kahlo wrote to say that without Miguel "there are no more reunions in Misrachi [a popular bookstore/gallery in Mexico City]. No more long conversations in the Concordia, Regis, Prendes, etc. [all fashionable restaurants]. Hurry back before the Revolution starts. Everybody will be a General because hunger is general."[33]

By the beginning of 1937, Miguel's Bali manuscript was in the hands of his publisher, freeing him to redirect his attention to illustration and painting. One of his more compelling projects that year was to

illustrate a Limited Editions publication of Harriet Beecher Stowe's *Uncle Tom's Cabin* for the Heritage Club. The Limited Editions Club produced small print runs of exquisite volumes of special literary merit. Its founder and director, George Macy, also headed the Heritage Press and among these three entities produced about a dozen books each year.

Uncle Tom's Cabin had a special significance for Miguel. He worked with his old friend Harry Block on the book, and Block recalled in a note to Limited Editions Club subscribers that when George Macy first raised the possibility of Miguel's taking on the job, Macy "was startled by the light that had come into Miguel's eyes." According to Block, Miguel's godfather had told Miguel "that [Miguel] was born for the sole purpose of illustrating *Uncle Tom's Cabin*, that this was the guiding goal in his life" and "that no one, not his wife, not the most beautiful girls in Bali, mattered so much to him as the opportunity to illustrate this book."[34]

Uncle Tom's Cabin may have been a guiding goal, but it did not occupy Miguel exclusively. In March he showed *Marquesan Scene, Three Bathers,* and three *Impossible Interviews* in the Sixteenth International Exhibition of Watercolors at the Chicago Art Institute. Apparently these works caught the attention of an executive of the Container Corporation of America, one of the first innovative packagers in the United States. The company was equally innovative in self-promotion and launched an advertising campaign for its products in the late 1930s, an unheard of idea at the time in the paperboard industry. Miguel was the first artist the company contacted for a series that would have a "United Nations" theme, for which each artist would provide an image to represent his or her native country. Miguel drew an Indian woman from Tehuantepec carrying a Container Corporation box on her head and a pail in her hand. He continued to provide the Container Corporation with graphics through 1947.

Miguel was frequently solicited for commercial art, and although he was handsomely paid for such work, he didn't enjoy it—commercial clients were too demanding, especially of time, Miguel's rarest commodity. He found it easier to say no to these jobs than to most others. He was persuaded in 1939, however, by the Hawaiian Pineapple Company to do a black-and-white illustration which earned a distinctive merit award that year from the Art Director's Club. He was honored again for a Dole ad in 1945. (He also won a distinctive merit award for an illustration of Japanese politicians for *Fortune* magazine in 1945, a prize for which 6000 artist-illustrators competed.)

In May 1937 Miguel participated in the Brooklyn Museum's Ninth Biennial Exhibition of 200 Water-Colors, and he helped select other Mexican artists to participate, including Emilio Amero, Jean Charlot, Carlos Mérida, Carlos Orozco Romero, José Clemente Orozco, Diego Rivera, David Siqueiros, Rufino Tamayo, and other, lesser-known, painters.[35]

Meanwhile, from Tizapán, Miguel wrote to Nick Muray about his plans to journey again to the peninsula of Tehuantepec. His next book was taking shape, and the shape was Mexico. "I shall remain in Tehuantepec most of the summer until the rains chase me away," Miguel wrote. "I hope you will visit me either at Tizapán or in Tehuantepec."[36]

The two men had established a very close relationship over the more than ten years of their friendship.[37] Nick, one of New York's leading photographers by then, had become Miguel's confidante in matters he could not discuss with anyone else—especially not with Rose. His infidelities fell into this category.

Although their marriage was still a collaboration of love and work (Rose managed and promoted Miguel as an illustrator), the times, their society, and perhaps Miguel's own particular *machismo* encouraged flirtations. Rose remained his muse and life-partner, but in the mid-1930s, he was apparently involved in an affair with a photographer whom Muray knew. In another letter to Nick that year, Miguel wrote:

> *Because of the mention of our photographer . . . I couldn't*
> *show Rose your letter with all the news of the apartment. . . .*
> *I hope [it] is still available when I come to New York.*
> *However, I am not sure how would it work to have one's wife*
> *so near. . . . If you have any more news and you feel like*
> *writing, do so, not to Zamora 36, but care of my brother. . . .*
> *It is safer. The battle with Rose on the subject is well dead*
> *and forgotten and I would hate to revive it, not so much for*
> *myself as for our frightened photographer.*[38]

Miguel's photographer probably had good reason to be frightened. Rose's rages had terrified her sister Mae when they were girls, and Rose became absolutely wild when she was jealous. She was also forty-two years old to Miguel's thirty-three; it is not unlikely that she worried about losing her beauty to age. She was still astonishingly beautiful, however, and was herself inclined to romances outside of marriage (perhaps inspired to some degree by Miguel's extramarital liaisons). Carmen López Figueroa, a friend of Miguel's since their childhood, remembered that:

> *All the men were jealous of Miguel because Rosa was so*
> *beautiful. She was not only intelligent and sophisticated, but*
> *witty and fun to be with. She had many admirers among*
> *their group of male friends. Over the years, Rose had a few*
> *harmless flirtations with the likes of [Mexico's Minister of*
> *Education] Moisés Sáenz, [artist and anthropologist] Jorge*
> *Enciso, [the poet] Xavier Villaurrutia, Marc Chadourne*
> *[author of* China*]. . . . After their little affair, Villaurrutia*
> *[who was known to be homosexual] sent Rosa a book,*
> Queen of Hearts. *She led Miguel on a string.*[39]

On the other hand, Carmen López Figueroa also had a fling with Miguel. So did Nettie King.[40]

It is not known whether Nick Muray managed to visit Miguel and Rose in Mexico that summer. He was not with them when they set out in June with a fairly

large group on a week-long study expedition to the Tehuantepec Peninsula. Dr. Atl and Roberto Montenegro went along; so did the attorney/diplomat Narciso Bassols and the young newspaperman (future poet, dramatist, essayist, and gourmet) Salvador Novo. The group was "accompanied by thirty-five horses and their six grooms, eight soldiers, a very nice lieutenant, and a group of muleteers, who carried the equipment and provisions."[41]

Miguel kept a record of the adventure:

> *The first day we rode twelve hours on horseback. No mean thing when you think neither Rosa . . . or myself had ever ridden before this more than three quarters of an hour. We slept on cots in an abandoned church. We were so stiff and sore we couldn't sleep, which was bad because the next day was even more grueling. We rode for fourteen hours, making our way slowly over the mountains towards Tehuantepec.*
>
> *The trip was not without a few disasters. First, Montenegro fell off his horse. He had not started out with the group but caught up with us in Oaxaca. He arrived with a young impertinent reporter, Salvador Novo, who annoyed everyone. [Novo later became a well-loved friend of Miguel and Rose.] We rode on until one of our horses sickened and fell dead. . . . When we [stopped] three more horses died.*
>
> *We rested for several nights at the* Hotel La Perla *in a charming village near a river. When we went down to the river bank, we found women bathing and playing in the nude. Like all Tehuanas they were coquettish, friendly, candid, and unembarrassed by their nudity. Much like the Balinese.*
>
> *Bassols was so taken with the villagers, he promised to order the construction of a theatre in their town, and further promised to send basketball equipment for their school. He did this as soon as he got back to Mexico City.*

The convoy visited Juchitán, Córdoba, Orizaba, Planta de Tuxpango, and San Gerónimo before arriving at Tehuantepec. Toward the end of the journey, the group learned that Lázaro Cárdenas, Mexico's current president, was purging government offices of those Callista ministers who had remained both powerful in government and loyal to former president Calles. (Calles himself, and several of his ministers, had been exiled the year before, in 1936. Calles found refuge in San Diego, California.) Mexico had seen five presidents in office since Calles's term in the late 1920s.

Narciso Bassols had remained loyal to Calles and would soon renounce his political post. It was a great loss to Mexico. Miguel believed Bassols was the most valuable administrator the country had; Bassols cared for the people and under-

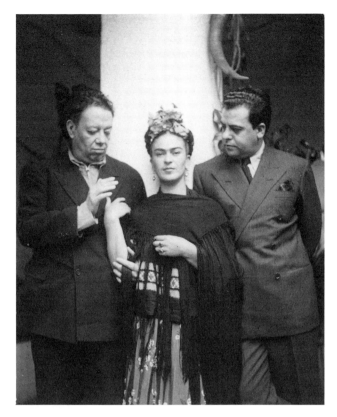

Diego Rivera, Frida Kahlo, and Miguel.

stood the Mexican Indians' plight in particular, for they suffered the most from the unstable government.

The summer in Tehuantepec convinced Miguel that he had found the focal point for the book he wanted to write about Mexico and the countries south of Mexico: this place "situated in the strategic center of an area where very probably man first evolved on the American continent from a nomadic barbarian into a highly civilized sedentary agriculturist."[42]

Not only did most Mexicans know nothing of this region (most Mexicans had more knowledge about foreign geography than that of their own country), few people anywhere did. But that would not be the case for long, Miguel knew, and soon traditional life in that very primitive place would be displaced and then lost forever. It was the same fear he harbored for the paradisal Bali; it touched a sense of duty in him to recover the past before it was lost, to record what was against what would be.

"Once I had begun to scratch the surface of this country and to realize the complexity of its endless facets and problems, the need for further knowledge became imperative," Miguel wrote. "I was driven to delve into ancient chronicles of the Isthmus, to read local histories, to argue with archaeologists, economists, politicians, labor leaders, peasants, landowners, market women, and traveling

salesmen." *Mexico Art and Life* noted: "Anthropology and archeology which began as a hobby for Covarrubias now became his art and work."[43]

Finding the time to research his subject and to make that record, however, was a problem. The end of 1937 was taken up almost exclusively with the publication of *Island of Bali*, although Miguel did manage to design a cover for a souvenir program on behalf of the Chinese Women's Relief Association of New York while he was there in November.[44] In February of 1938 he was in New York again to inaugurate an exhibition at the McDonald Gallery of contemporary Balinese paintings, "an art exuberant and delicate, with a refinement not generally associated with the simplicity of the tropical primitive," for which Miguel chose the artists and the specific pieces to be shown. He also wrote the catalogue.[45]

Also at the beginning of 1938, Miguel was working on a series of caricatures for *Fortune* magazine, which would be entitled *Radio Talent*, to appear in the May issue. The drawings attracted much admiration. Popular radio commentator Walter Winchell said, "An orchid to Covarrubias for his caricatures . . . ;" and Frances E. Brennan, art director for *Fortune*, begged Miguel to do a cover for the magazine. "I will be very sad," Brennan wrote, "if you find that you cannot paint the cover for me. I have thought about it so much that it has now become a vital contribution toward the success of the story." Brennan was referring to an issue devoted to "Mexico in Revolution," with illustrations by Diego Rivera and Carlos Mérida. Miguel did paint the cover for that issue, published in October 1938.[46] That same year he won the Art Director's Club Distinctive Merit Prize honoring his surrealistic *Beach Scene* cover for the July 1937 *Vogue*. *Beach Scene* was shown at the Seventeenth Annual Exhibition of Advertising Art at the New York Art Center in 1938.

Uncle Tom's Cabin, with Miguel's illustrations, came out in 1938 as well, and Miguel was in New York for its debut. If that work fulfilled the sole purpose of Miguel's life, as his godfather had predicted, it did not disrupt his lifestyle; his notes for that time record evenings out with Eugene O'Neill, Clare Boothe Luce, Zora Neale Hurston, Nick Muray, Walter Pach, Alan King, Bil Baird, Pierre Matisse, the photographer Marion Moorhouse, and Alain Locke.

We know Miguel was still in New York on 22 June 1938, because he made a note of going to see the Joe Louis–Max Schmeling boxing match, "the battle between democracy and fascism," on that night at Yankee Stadium with Rose, Andrés Henestrosa, and Langston Hughes. Afterward, the four friends drove up to Harlem to celebrate Louis's symbolic victory. People were dancing in the streets, and Joe Louis's brother chose this night to inaugurate his beer house. Henestrosa recalled, "We all drank a lot of beer. As everyone got drunker and more raucous, Langston turned to me and said, 'Let's get out of here before an act of cannibalism occurs. I am not in any danger but you, with your white skin, might be eaten by the blacks.'"[47]

It was hard for Miguel to get started on *Mexico South*, hard to break out of the round of parties he and Rosa enjoyed, hard to turn down interesting new offers for interesting new projects. One of these projects presented itself in a telegram from Philip Youtz, director of the Golden Gate International Exposition, inviting Miguel

to participate. This world's fair was to be held on Treasure Island in San Francisco Bay from February 1939 through the end of the year.[48]

Ray Lyman Wilbur, president of Pacific House, explained why Miguel seemed the perfect choice for consultant:

> *He was selected as the one who could make visual the idea of the Pacific area, not only with the imagination and skill of a great artist, but with an understanding of the verities and needs all people held in common. He was seen as an ethnologist and anthropologist, subtle and sensitive to the unrecorded past of unknown peoples, with a humorous, penetrating perspicacity of contemporaneous life, and with a wide knowledge of the governmental forms and trade relations of the moving forces that bind people together or sever their relations.*[49]

Miguel met to discuss the world's fair specifics in Washington, D.C., with his old friend René d'Harnoncourt (now Alfred Barr's assistant at the Museum of Modern Art), Frederick Vanderbilt Field, an Asian specialist (the fair's theme was "The Pageant of the Pacific"), and Moisés Sáenz. Would Miguel, they wanted to know, produce a series of decorative pictorial maps relating to the theme?

Miguel really wanted to work on his Mexican book, but this was a plum assignment. René encouraged him to accept it. René himself would be supervising a comprehensive exhibit of past and present North American Indian art and life for the exposition. He had been appointed full-time general manager of the Indian Board in Washington, D.C., in 1937 and by now was quite knowledgeable in that field. Back in Mexico, Moisés Sáenz also urged Miguel to say yes, insisting that the maps would be "an educational depiction of sociological truth through art." The premise appealed to Miguel; he said yes.[50]

There were to be six mural maps of the Pacific Rim (four 15-feet-by-24-feet, two 9-by-13 feet); Miguel conceived them as six mini-lessons in anthropology, illustrating the region's flora and fauna, the people of the various nations, and their economies, art, transportation, and habitations. His travels through Asia had given him a broad understanding of these subjects, and inveterate note-taker, sketch-maker, and photographer that he was, he had copious personal records of the Pacific Rim. Still, he did not consider it enough, and he entered into an intensive research study program with several prominent anthropologist/scholars.[51]

Miguel worked on the project in San Francisco. The Golden Gate International Committee provided an apartment at the Plaza Hotel on Union Square for him, Rose, and two assistants, one of whom was his old friend Antonio "El Corcito" Ruiz. Miguel began with two outline maps in which the Pacific Ocean was the center of the world and proceeded to both refine and define, but with a "facetious disregard for realistic relationships," according to one reviewer.[52]

The result was "a modern tapestry of joyful color and form, sharp and precise in concept."[53] In typical Covarrubias style, the peoples' mural used representa-

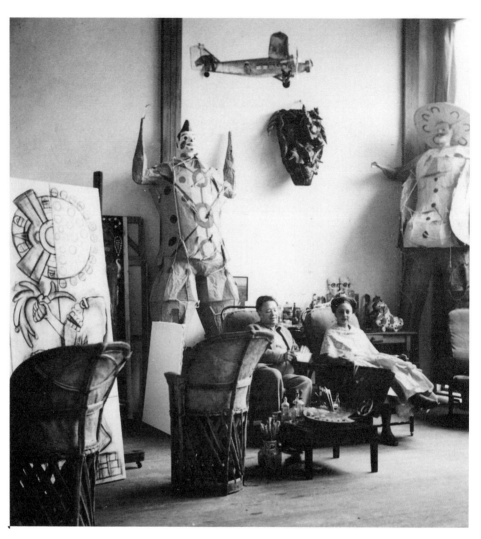

Rosa and Diego in Rivera's studio, resting during the portrait session for the painting at right.

tional characters such as the agrarian revolutionary Emiliano Zapata outfitted in a familiar *charro* costume for Mexico and, for North America, a plump East Coast business executive with a cigar in his mouth and a voluptuous Hollywood starlet in a bathing suit and goggles. A jellyfish trailing pink feathery tentacles, kangaroo, tiger, and panda are some of the Pacific Rim's representative animals. Animal skins, coffee beans, flax plants, rubber trees, and oil derricks stand for various economies, and transportation is illustrated with a canoe, coach, and camel.

If the illustrations showed a facetious disregard for reality on Miguel's part, the technique he used to protect them from the erosion that a world's fair crowd might cause did anything but. Mural maps were traditionally made of plaster. Miguel invented for the Pacific House walls a kind of fresco in a flat duco lacquer with a nitrocellulose base. He diluted his medium with lacquer thinner, added pure dry

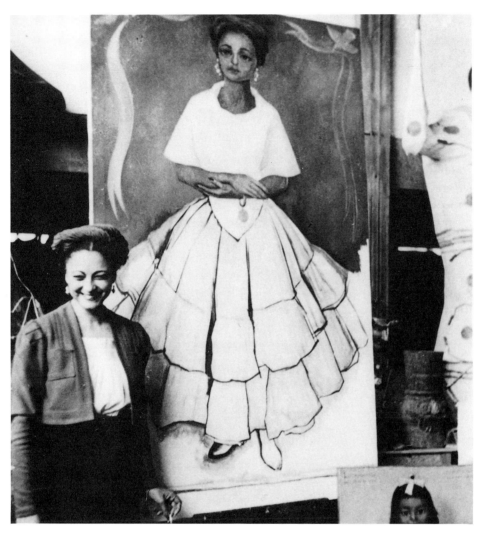

Rosa beside Diego Rivera's portrait.

pigment to it instead of watercolor (fresco is usually done wet on wet), then applied that combination to his masonite panels. Each brush stroke embedded particles of color into the lacquer; when the piece dried it was hard and water resistant, the color sealed inside a clean, clear shield.

But Miguel wasn't sure whether the technique would work; the chemistry involved in creating a durable fresco is complex even when one follows standard procedures, and his was not a standard procedure. About a week into the project, Ruiz decided to have some fun. He climbed up the ladder and pretended to pull off a small island, then turned and called down to Miguel that the technique had failed, the system was no good. Miguel looked up, horrified. When Ruiz saw how miserable he looked, he took pity and confessed it was a joke.[54]

The system did work, creating a permanent, washable surface that was

impervious to normal wear and tear. Today five of the six original murals are displayed at San Francisco's waterfront trade center. The mural entitled *Art and Artifacts* is lost.

When the show opened, the critics were lavish in their praise, responding to a technique that linked human beings through time and space, that focused on common characteristics and essential human concerns such as clothing, housing, transportation, and environment. *Fortune* magazine recognized that "not only are the mural maps first rate works of art, but the research job behind them is prodigious. They are unparalleled in the way in which they combine education, decoration, and entertainment, providing painless instruction to the public." Eugen Neuhaus, in *The Art of Treasure Island,* tried not to be dramatic: "Without being dramatic, the total effect is gay, even exhilarating, full of fascinating information that is often quaintly humorous." MacKinley Helm, in his book *Modern Mexican Painters,* concluded: "Covarrubias has just about summed up his special interests and proficiencies as a plastic artist with these murals."[55]

Miguel's visit to San Francisco coincided with a parade protesting Tom Mooney's imprisonment. Mooney was a union activist allegedly framed for a terrorist-type bomb attack in San Francisco in 1916. He received a conditional pardon in January 1939, not long after this demonstration for him, and a full pardon in 1961, at which time he was released from prison.[56] The Irishman became a cause célèbre in the city—everyone with a political opinion turned out for the Tom Mooney parade. Miguel's notes indicate that he marched with his friend "El Corcito," Rose, and Dr. Paul Radin, author of *Indians of South America.*

Miguel's political ideas had been formed early, one might say at his father's knee. José Covarrubias had stood firmly on the side of personal freedom, and from his vantage point in government, he understood the corrupting influence of political power on civil rights. He spoke of such things to Miguel when Miguel was a boy, and he wrote:

> *What makes men weak and inferior, what makes them fearful and without initiative is oppression and poverty. The cruelty of conquerors from every epoch is that by abusing their power, they take from the people their rights, including the freedom to choose the manner in which they earn their living and their right to be satisfactorily compensated for their work.*
> *When the environment is one of freedom, every man is free and prospers but, when the contrary is true, the atmosphere is one of slavery and everyone is in danger of falling into chains.*[57]

Miguel's father strongly supported agrarian equity. He had been a consultant to President Carranza on Carranza's revolutionary 1915 program for reform, of which agrarian reforms were the priorities. The program promised to do whatever

was necessary "to establish a regime that will guarantee the equality of all Mexicans among themselves." Proposed agrarian laws favored:

> [T]he establishment of small properties; the dissolution of the large estates; the return to the villages of the lands of which they have been unjustly deprived; . . . laws that will improve the conditions of the peon, the worker, the miner, in general the proletarian classes; . . . political reforms that guarantee the application of the Constitution . . . [58]

Unfortunately, Carranza was more interested in his own faltering political career than in rural reforms. The program did revive his popularity and extend his future in government for a period, but it did little for the Mexican working class or for the Indians during what was left of Carranza's administration. (By 1920, the tide had turned against him again, and Carranza fled the presidency; he was shot to death in a stable as he slept. Obregón succeeded him.)

Carranza may have had a hidden agenda, but it is certain that José Covarrubias did not. He was wholeheartedly pro-Constitution and pro-Indian; he considered the native Indian Mexico's most precious resource. He passed along this fervor to his family. Miguel had grown up part of the privileged class, but his father had made sure that his children would never feel superior to anyone because of it.

Miguel's ideology had his father's imprint, and as he matured, it gained the influence of his bohemian and intellectual friends, as well as the influence of a society of extremely talented creative artists. In Mexico in the 1920s, the politicization of art was a veritable trend, and by the 1930s, the art collective had gained political status and social approval. To be an artist was to be political.

After Miguel's death, Octavio Barreda spoke to Elena Poniatowska about Miguel's politics:

> It is easy to explain Miguel's evolution toward socialism. He returned to Mexico during the time of President Cárdenas. After being away from Mexico for so long, he walks through the slums, he talks to the Indians, he visits the remote areas of Mexico and, little by little, he becomes so much a part of the Indians that he feels that he is one of them. Not because of intellectual beliefs, but based exclusively on aesthetics, because he feels tenderness for the disinherited. He carries his socialism in his blood and it is more sincere and heartfelt than that of others. He is not a cerebral like the majority. He loves the utensils the Indians use, the black pots, the objects from Oaxaca.[59]

Miguel became known for that "tenderness for the disinherited." The distinguished museologist Daniel Rubín de la Borbolla used similar words in remembering Miguel:

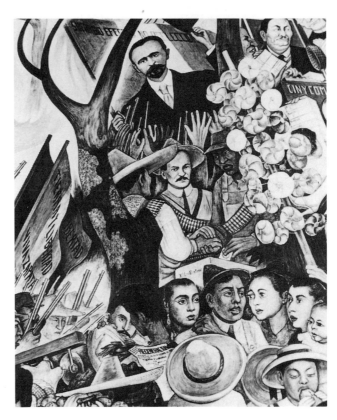

Rosa's face appears in Rivera's Hotel del Prado fresco, 1948.

He turned towards something more vital [than wealth], a
deep love for and interest in mankind. He always felt a
special love for the disinherited. His success could not mar his
deep feeling and support for noble human causes. He
rebelled against social injustices; he was loyal to his social
and political convictions, which he expressed freely. He
fought with all the power of his individuality for any cause
he considered just.[60]

Certainly, living in Bali had reinforced for Miguel the Mexican socialist ideal for collectivism over egocentrism. In *Island of Bali* he wrote, "Unlike the individualistic art of the West . . . the anonymous artistic production of the Balinese, like their entire life, is the expression of collective thought." In Bali, the artist's "only aim is to serve his community, seeing that the work is well done when he is called to embellish the temple of the village, or when he carves his neighbour's gate in exchange for a new roof or some other similar service."[61]

Miguel admired such artistic motivation above all else, on a political as well as personal level. One sees his efforts to emulate those principles of service to a

community or a people in his ethnically focused work, and his desire to "see . . . the work is well done" in his nearly obsessive perfectionism that often interfered with such mundane matters as a publisher's deadline.

In the thirties, Miguel's intense relationship with the Balinese culture—as a student, an artist, a lover, and its chronicler—shaped his personal political landscape and separated him to some degree from the path his Mexican cohorts chose. If one wanted to pin a political label to Miguel's lapel, it might read "Cooperativist." He described the system in detail in *Island of Bali*, where all activity "is managed, not individually, but communally, with every active member having a vote and a voice in every enterprise."[62]

> *Instead of the familiar exploitation, enslavement, and economic inequality imposed on the population by a ruling class of aristocrats or bureaucrats so often found in countries where the government is centralized in individuals, in Bali we find an economically independent majority that is truly democratic because every representative villager, regardless of his caste or his wealth, is an active member of the village council with an equal voice in village affairs and with equal duties.*[63]

Miguel was sophisticated enough to appreciate that a system which worked in "a compact nation of [just] over one million hardworking, cultured people living in a deeply rooted, well-coordinated form of agrarian socialism" might not work in a nation whose demographics were vastly different.[64] But he knew that a similar system had flourished since pre-Conquest days among the native villages of Mexico, and he saw cooperativism as a basis for positive change or as an element that might be applied either socially or politically elsewhere.

Miguel's support for unions, their collective looking out for its members, appealed to this sensibility, and so of course he marched with the thousands for that sacrificial unionist, Tom Mooney, in San Francisco in 1938.[65]

Not long afterward, journalist Lou McLean interviewed Miguel at Miguel's studio on Bush Street. Outside of the observation that "Covarrubias has the happiest demeanor of any man I have ever met," the interview's focus was decidedly political. "First of all," McLean began, "just who is Covarrubias? Mexico's great caricaturist is a union man and a progressive. . . . When he was still a kid, he earned his living as a caricaturist in Mexico City. It was only on progressive papers and periodicals expressing progressive changes that he found an outlet for his avid love of expressing life in Mexico in the color so loved by his countrymen."[66] McLean probed for Miguel's feelings about art in the Soviet Union, to which Miguel replied "with the gestures and excitement of a child receiving a toy. . . . 'The magazine presentation, the children's books, and the caricatures in the poster medium as well as magazines and newspapers are among the best in the world. And in many cases Soviet caricature topped the world's best.'"[67]

Miguel was eager to get back to Mexico and to resume work on *Mexico South*, but he took two weeks after finishing his murals to experience San Francisco before going home. He wrote to Nick Muray in April:

> *I am finally back in Mexico and in the process of recovering from my San Francisco experience. I arrived a complete wreck in every imaginable way as my last two weeks in San Francisco were about as hectic as you can imagine, plus the job of checking out the city, plus the natural and very human desire not to leave some leaves unturned, that in the tension of the work I had been too busy to attend to. I didn't go to bed for two solid weeks so you can imagine my condition.*[68]

Over the next few months, when Miguel had recovered, he and Rose set out twice for the Isthmus of Tehuantepec on fact-finding missions, exploring villages and interviewing villagers. They went both times with Andrés Henestrosa and two sisters, Alfa and Nereida Ríos, all of whom had grown up in the sizeable village of Juchitán, Tehuantepec's eastern neighbor and traditional enemy. On both trips, the five travelers stayed with the Ríos sisters' parents. Nereida began teaching Miguel to speak Zapotec, the indigenous language of the Oaxacan people, and Andrés introduced him to the region's ethnology.[69] (Andrés and Alfa later married.)

Another isthmus excursion during Miguel's research phase of *Mexico South* was to Veracruz, across the isthmus from Tehuantepec, on the Gulf of Mexico. He usually made a party of these jaunts. María Asúnsolo, "the most admired beauty in Mexico" and a cousin of Dolores del Río, recalled one such party, when the group "filled two Pullman cars. There was [the poet] Villaurrutia, Montenegro, Dr. Atl with his friends Náhui Olín [Dr. Atl's lover] and Paul Morand [a French writer who contributed to *Vanity Fair*]. . . . , Another time I went to Juchitán with them and the painter Chávez Morado. We saw Olga and Rufino Tamayo while we were in Oaxaca. Rufino played the guitar and sang for us."[70]

In the meantime, Alfred Knopf executed a contract with Miguel to publish *Mexico South*, which would have a similar format as *Island of Bali*. Publication was set for the fall of 1941.

Miguel resolved to work exclusively toward that deadline and to avoid distraction, and he did fairly well until his old friend, conductor/composer Carlos Chávez, and his new friend, the journalist Salvador Novo, came to him with an animated film project and asked him to be a partner with them in producing it—they wanted his ideas for the script and his animated art for the film. It would be such great fun. Miguel couldn't say no.

The film was called *The Creation of the World*. It was the story of earth, air, fire, and water, personified as four playful gods who create the world and everything in it.[71] The three novice filmmakers turned to ancient American creation myths for source material and collaborated on a workable script. Chávez, whose orchestral work was well known in Mexico for its nationalistic themes, would compose the music.

Miguel's mentor, the *indigenista* Alfonso Caso, took a look at what the young men had done and was very enthusiastic. "It is not good, it is very good!" he told Chávez and encouraged them to pursue it. Heartened, Chávez wrote to Walt Disney, whom he knew, to see if Disney would be interested, and he discovered that the filmmaker was already working with Leopold Stokowski on a feature that would become the revolutionary movie *Fantasia*. The stories and their styles were too similar. The three friends abandoned the project, no doubt concluding that whatever the ethnic origin, great minds run in the same direction.[72]

By now it was the end of 1939. Miguel turned back to his work on *Mexico South*. In order for Knopf to publish the book in the fall of 1941, his completed manuscript was needed within a year, and there was still a great deal of research left to do. Furthermore, Miguel was in dire need of funds—he couldn't continue to support traveling back and forth from the isthmus out of his own pocket.

In the past, whenever Miguel's bank account had dwindled, he had turned to caricature or illustration, which he could always sell to one or another New York magazine. This time, however, he calculated what the loss in time devoted to new projects would be against the money he could earn, and he concluded that he could not afford the exchange. On December 28 he wrote to Henry Allen Moe, director of the Guggenheim Foundation: "I am including a tentative outline of the book on Southern Mexico . . . on which I have been working for about a year and a half. The work is well under way, and I am dedicating the entire year of 1940 to its completion."[73] What he needed most, Miguel explained:

> is to have freedom to travel in the areas involved in this study, to dedicate all my time to the organization and actual writing of the material obtained, to continue my study of the Zapotec language, to obtain native informants, and to make drawings, paintings and photographs without having to maintain connections with New York magazines and publishers from whom I derive my income.
>
> I will be in the field by the second week of January of the coming year, as I must take full advantage of the dry months. I have until August to undertake certain trips and visit certain places that become impractical during the rainy season. The Guggenheim Fellowship I was honored with before was of invaluable assistance and made my book on Bali possible. I sincerely hope that I may be considered again.[74]

CHAPTER 7 *One of Miguel's most defined traits was his*
devotion to Mexico and its people. His deepest
love, his most passionate concern, and the best
of his creative spirit was reserved for Mexico.[1]

M THE FORTIES, PART ONE (1940–1942)

iguel had one outstanding obligation beyond *Mexico South*, and that was to George Macy, director of the Limited Editions Club, for whom Miguel was to illustrate Bernal Díaz del Castillo's book, *The Discovery and Conquest of Mexico*. It was a job that Miguel had been thrilled to get. Harry Block recalled:

> *Miguel and I worked on ten or twelve books together. Before he agreed to illustrate* Batouala, Typee, *and* Uncle Tom's Cabin, *Miguel always said there was a book that he would prefer to do, and that was* . . . The Discovery and Conquest of Mexico. . . .
>
> *Since none of us had heard of it before, it could not be considered one of the well-known classics. Each time we told him this he flew into an amiable rage. He tore his hair and stamped his feet. We were guilty of abysmal ignorance. We learnt from Miguel that it is a book second only to Cervantes'* Don Quixote *in Spanish literature in lasting merit and charm.*[2]

However, Miguel did not feel particularly pressed to supply those illustrations; Macy had scheduled publication for summer of 1941 — there seemed to be plenty of time. It was very early in 1940, as Miguel was plotting how to proceed with the work on *Mexico South,* when he took on another obligation. This was at the request of Alfred Barr, who called to ask if Miguel would participate with René d'Harnoncourt in the organization of a Mexican exhibition for the Museum of Modern Art to open that May. Nelson Rockefeller, president of the museum at the time, announced that the exhibition would "cover the entire range of Mexican art from archaic times through the period of great Indian cultures, through the Spanish Colonization and including material up to this date."[3] Covarrubias chose the name for the show, "Twenty Centuries of Mexican Art," and Barr gave him the directorship of the modern art section.[4]

When Miguel accepted, Rockefeller wrote his thanks, acknowledging Miguel's other obligations: "It will make all the difference in the world to the Exhibition and while I know it means a real personal sacrifice to you I can assure you that it is of tremendous importance to the ultimate success of the show."[5]

The correspondence, preserved in the Rockefeller archives in North Tarrytown, New York, gives a behind-the-scenes portrait of how the show was assembled, and in particular, how crucial Miguel's role was to its success from its inception. He and Rose drafted a long telegram that Nelson sent to Ramón Beteta, Mexico's subsecretary of foreign relations, extolling the importance of the exhibition to Mexico and soliciting government cooperation.

Monroe Wheeler and John E. Abbott were Nelson's attachés to Mexico, acting as overseers and advisors. On February 2, Abbott wrote to Nelson:

> *I'm a little worried about Miguel, who is somewhat sore. . . .*
> *[He] has had to spend much more time than the rest, really*
> *imperiling a lot of personal friendships, actually neglecting*
> *his own contracted work, and all the help he has gotten from*
> *Caso is one peso a day for a helper. We should try to think*
> *of something for him.[6]*

Wheeler also reported on developments. On March 6 he noted that "Miguel Covarrubias . . . always comes staggering under a new load of pictures to be included in his section."[7] On May 1 Wheeler wrote about Mexico's May Day celebration: "The effect is that of a general strike; literally no one is allowed to work." Then he outlined the status of the exhibition catalogue:

> *Miguel Covarrubias had scarcely begun his stupendous work*
> *of examining all the available work of seventy-odd modern*
> *artists and selecting representative examples of each; most of*
> *them had no telephones and were hard to locate; some*
> *imposed rigid conditions, such as being allowed to make their*
> *own choice, or that their work be hung in a particular*
> *manner, or that they be represented by the same number of*

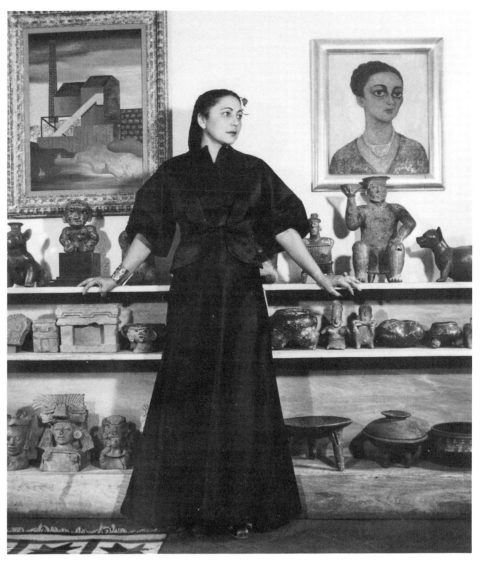

Rosa in front of the Covarrubias collection of pre-Hispanic art. Diego Rivera's portrait of her hangs on the wall. Photograph by Donald Cordry.

pictures as certain other artists, etc. Others did not want to be in the exhibition at all. But it is a great tribute to his patience and diplomacy that, in the end, he obtained the cooperation of every artist he approached, so that we probably have the most representative group of contemporary Mexican art ever to be shown in the U.S.

Some days things went well, but here every unusual effort seems to be followed by periods of inertia which it is futile to combat. . . . In Mexico, time lurches on. As Miguel says, "It doesn't pay to be on time, because nobody else is."[8]

Rockefeller came to know Miguel and Rose during the mounting of the show, and he was charmed by them, especially by Rose, whom he enlisted in the project as a collaborator with Roberto Montenegro in the "Popular Arts" section that featured crafts, furniture, pottery, and toys—things that Rose was beginning to collect on her own. She spent that winter assisting Montenegro in gathering material from private collectors and regional museums. She and Rockefeller wrote to one another frequently from this time on. It became a correspondence of affection and confidences, and it lasted more than twenty years.

Miguel's friend Carlos Chávez was also a key player in the museum show. Chávez's program traced Mexico's musical development from ancient times through the colonial period to the present. "It is the first time we have presented the music of people as an integral part of its artistic culture," Rockefeller noted. "We confidently expect that this experiment . . . in combining music with the visual arts will provide the general public with as comprehensive a view as possible of the varied expressive forms contributing to the monument of Mexican culture."[9]

Their friend and colleague, the Mexican scholar and anthropologist Daniel Rubín de la Borbolla, considered Barr's choice of collaborators to be brilliant. He knew d'Harnoncourt and Covarrubias, "[whose] teachers were craftsmen and artists from many countries; [whose] experience was gained in museums, work-shops, marketplaces, village roads or in collectors' houses," would fashion a show devoid of pretension. But many Mexican artists were resentful. Miguel had been away for nearly twenty years, as far as they could tell. "What does Covarrubias know about Mexican art today?" they asked. "He is never here, and besides he isn't Mexican."[10]

Miguel defended himself: "Having lived outside of the inner artistic circles of Mexico but still retaining friendly relations with the various groups of artists, I felt I could be more objective and could do greater justice to the artists. Someone else, . . . being part of the local artistic politics, may have turned the exhibition into a vehicle for personal aims."[11] Ultimately the exhibition itself proved the naysayers wrong.

But all of this exacted a severe toll on Miguel. Perhaps a month before the show opened, he wrote to Nick Muray outlining his work load:

> *I can really say I have never been so busy in all my life; here is a sample:*
>
> *1. The organization of the G. D. Mexican Exhibition which took every minute of two months and the details of which I am still struggling with.*
>
> *2. The preparations of my section (Modern Art) for the catalogue.*
>
> *3. My own book* [Mexico South] *which has suffered heavily.*
>
> *4. A drawing for* Vogue *of the opening of the Exhibition with about 5o people in it. [This had become a regular feature in* Vogue, *called "New York's Favorite Opening Nights."]*

The walkway from the house in Tizapán to the living quarters.

5. *The arrangement of a great reception of all the workers, women, etc. . . . for the frustrated flight of Ya Ching. [The extraordinary Lee Ya-Ching was supposed to have flown from China to Mexico, but she never received permission from the Mexican government to land on their soil, hence the "frustrated flight."]*

6. *Attendance and extra official work at the 1st International American Indian Congress which is just over.*

7. *George Macy's book.*

8. *And last, to help John Steinbeck and Herbert Kline to make a film in Mexico. He arrives tomorrow.*

If after reading this you don't weep for me you have no pity in your heart.[12]

The terrace where Rosa held her luncheons.

The letter concluded that Miguel would arrive in New York on May 5 or 6 for the exhibition's opening on May 14, "not alone, as the Rockefellers invited Rose." And he ended by asking Nick to give his love "to Helen, to Mai Mai [Sze], to Mam [Blanche Knopf], etc."

"Twenty Centuries of Mexican Art" consisted of over one thousand objects which had come packed in 2,800 boxes (insured for nearly $400,000), the largest shipment of art ever to cross an international border. It went by train from Mexico in three box cars with a detachment of troops to guard it up to the border. There the guard duty was taken over by two Texas Rangers, who rode in the caboose during the day and slept on top of the box cars at night.[13]

Meanwhile, Miguel and Rose flew to Manhattan, to stay at New York's Barbizon Hotel as usual. The Barbizon was a favorite of Mexican visitors, and on the inaugural night of "their" show it was packed with friends from home. A mood of

great excitement and anticipation reverberated throughout the hotel as residents prepared for the event. (Lucien Weil, a friend of the Covarrubiases, wrote: "Many important people from Mexico came for the opening. The women stood like Goddesses decked in gold. It was something to behold.") Tina, one of the young Misrachi daughters, remembers how beautiful her mother and Rose looked that evening: Rose wore her hair pulled back from her face in a tight chignon, and both women wore exotic Mexican jewelry designed by Bill Spratling; Rose's featured a spectacular pre-Columbian carved jade face that Spratling had hung as the centerpiece of a necklace.[14]

The opening party honored those prominent Mexicans who had come for the show, among them Ramón Beteta, Mexico's minister of culture; gallery owner Inez Amor, who had come by ship with the Misrachi family; Clemente Orozco; the art historian Manuel Toussaint; Alfonso Caso; and of course Chávez and Montenegro. Miguel's illustration of the event for *Vogue* seemed to include everyone: representatives from the silver screen, such as Greta Garbo, Katherine Cornell, Hedy Lamarr, and Edward G. Robinson, as well as artists, photographers, and socialites like Edsel Ford, John Hay Whitney, Mrs. William Paley, and Nelson Rockefeller. (The next day Miguel and Rose joined the Rockefellers in Tarrytown for a celebratory luncheon.)

From all accounts, the show fulfilled Rockefeller's wishes for it. Art critic Henry McBride wrote:

> *The true wealth of Mexico is not in the gold that may still be down there nor in the oil wells nor in the haciendas, but in the instinctive and yearning love of beauty that lies deep in the hearts of its peasants. It is impossible to look upon the primitive arts and the folk arts of that country without falling instantly in love with the people who produced them.[15]*

Interestingly, the only negative criticism on record came from a reviewer writing for the *New York Times* society pages about the modern art section, in which one of Miguel's own pieces, *The Bone*, was displayed, as well as Rose's gouache entitled *Tehuanas*, and *The Two Fridas*, by Frida Kahlo, whose work the *Times* reviewer considered "some of the most ghastly surrealist conceptions ever shown in New York."[16]

Upon his return to Mexico, Miguel found word from the Guggenheim Foundation granting his request for support during the coming year, promising that a check would be forthcoming.[17] Miguel raced out of his house with the letter and made the rounds of his friends, starting with Harry and Malú Block, to share the news. The Blocks introduced him to other visiting friends, Donald and Dorothy Cordry, who were living in publisher Frances Toor's apartment in Oaxaca while Donald pursued his anthropological studies of the local Indians and added to his growing primitive art collection. Miguel and Donald, sharing such similar interests, became instant friends.

Miguel wrote to the Guggenheim Foundation to thank them, to explain that his timetable had changed as a result of the museum show, and to assure them that "although the preparation for this exhibition has been strenuous and has taken practically all my time, it has been excellent preparation for my future work."[18]

Rose wrote to Nelson thanking him and his wife Mary for their post-opening garden party. Rose and Miguel planned a trip to Tehuantepec, Veracruz, and La Venta in Tabasco in June and July, and she promised to "keep my eye out for interesting folk art to add to your collection."[19]

Miguel resumed work on *Mexico South* with vigor. He made another fact-finding trip to Tehuantepec in June and stayed through July. (Rose sent a postcard to Nelson on 19 July 1940: "Miguel writes, draws frantically all day long and I take pictures."[20]) Miguel met the Indian revolutionary Juan Paxtián on this visit and wrote about him in his chapter "Land, Politics and Sudden Death":

> *Juan Paxtián . . . is a rare example of a leader of men who has controlled thousands, who has held offices that could have made him rich, yet remains a simple, modest peasant whose obsession is the unity of his people as the means to end the stupid warfare and useless bloodshed.[21]*

"But life is not all politics and social problems," as Miguel wrote in another chapter. He saw many joyful celebrations during those months and attended numerous feast days for one or another patron saint. By August, back in Tizapán, he had reams more notes and sketches. He also had two fabulous ancient masks that he presented to the Cordrys, along with an invitation for the couple to join him and Rose in Tehuantepec in September, when several more significant festivals that he wanted to include in his chapter on fiestas would occur. The new friends were happy to accept.[22]

On September 15, the eve of the anniversary of Mexico's independence from Spain, Miguel records:

> *The mayor of Ixtepec [old San Gerónimo] appeared on his balcony at exactly eleven p.m. to wave the flag and shout "Viva México!". . . .*
>
> *On the streets below, boys paraded with torches and lanterns on poles while the drunks tried to dodge a* torito, *a bull of bamboo and papier-mâché carried on a man's shoulders, spouting jets of fire from its arsenal of fireworks, a bull more dangerous perhaps than one of blood and flesh. There were marching soldiers, a sight always dear to the* istmeños *[locals] and floats—truckloads of city girls in rich regional costumes. There was a great ball that night, and the*

Antonio Ruiz, Alfa Henestrosa, and Miguel. Photograph by
Nickolas Muray.

city hall glittered with dusky beauties, gold-coin necklaces,
military uniforms, and the dark serge suits of the ixtepecanos.
Outside, soldiers with drawn bayonets kept the mob at bay
while the handsome barmaids did a rushing business.[23]

While Miguel attended fiestas and weddings and burial processions, he did not
work on the illustrations for *The Discovery and Conquest of Mexico*, which was to have
been in George Macy's hands the previous May, at the time of the big museum
show. Now, late in 1940, it was clear to Limited Editions that the book would not
be ready by summer 1941. Macy had to notify his subscribers. Nor was Miguel
anywhere near finished with his research for, let alone the writing of, *Mexico South*.
Knopf was not pleased, nor, surely, was Henry Allen Moe at the Guggenheim
Foundation.

But the deeper Miguel went into Mexico, the more he discovered about its past;
and the more he saw of its past, the more profound became his understanding of
the people, their culture, even of the land, and he could not stop there but must
go further still. In fact, it was nearly impossible for him to stop as long as there was
more to be discovered—and there was always more to be discovered. Miguel was
driven ever deeper into his subject by a passion that sounds quite clearly in the
concluding pages of *Mexico South:*

The Spanish conquerors came to Mexico avid for treasure, with eyes only for gold, and they massacred, pillaged, and burned the villages that resisted them. Filled with contempt for the culture of the Indians, and moved by a fanatical zeal, they burned manuscripts, smashed statues, leveled cities and monuments. . . .

Seldom has a whole culture been so thoroughly wiped out. Even the memory is lost of the science of a people who had invented and used a calendar based on direct astronomical observation, far more accurate than the Julian calendar then in use in Europe. Everything was forgotten—the craftsmanship of a race of artists who carved jade exquisitely, who cast delicate ornaments of gold and wore rich clothes of woven cotton and mosaics of the tiny feathers of hummingbirds; the enterprise and architectural skill of the builders of great stone cities. Their descendants today, after four centuries of slavery, exploitation, and debasement, have no inkling of their glorious past, hardly connect the carved jades, painted pottery, and stone sculptures turned up occasionally by a plow or washed out of the hillsides by the rains with the remote people, their people, who made them.[24]

Miguel's desire for his book in progress was to reacquaint his people with themselves, to give the gift of identity and self-worth and the attendant respect which this would engender—as Vasconcelos had wished to do in the early days of Mexico's renaissance. Miguel would settle for no less than that, no matter how long it took.

Many clues to the past that Miguel sought survived in the extraordinary culture still alive in Tehuantepec and southern Mexico, and beginning in 1938 many more clues were unearthed throughout the peninsula as a result of the first large-scale archeological excavations in that area. For Miguel, archeology was the natural companion of anthropology, and it satisfied that need in him to dig deep, to discover meaning, to bring to light what was hidden, as no other science could.

Miguel's fascination had been stirred by his intimacy with the brickyards at Tlatilco, but in the past four years he had seen that place become the great hunting ground for collectors. Within a short time of Miguel's and Diego's own discoveries, their competition came to include many of their peers: the surrealist painter Wolfgang Paalen (who later employed Miguel to continue to buy for him); Jean Charlot, a French painter who was part of Mexico's muralist movement; André Breton, the surrealist French writer; the English sculptor Henry Moore, and others.[25]

By 1938, "so many treasures were being found every day that it didn't pay the brickmaker to make brick," Miguel wrote. After two years, the merchandising of Tlatilco had become a process of indiscriminate and unofficial digging by profi-

teers who could collect up to the equivalent of sixty American dollars for burial offerings, small clay figures, and vessels, or ten dollars for a whole human skeleton. This was a considerable sum for a day laborer, who normally earned less than five dollars a day. As a result, of the two hundred burial sites that have been identified in the area, sixty were plundered and dispersed by those first collectors and speculators. Miguel had taken to sleeping out in the brickyard to defend it against looters on his visits there.[26]

Miguel had learned a great deal since his first trips to Tlatilco: to peel layers of earth off a site—"dirt archeology"; to make detailed drawings of the unearthed pieces; to extrapolate from the tantalizing clues a picture of a long dormant culture. With no formal training in archeology, his drawings, meticulous centimeter-by-centimeter examinations of objects executed during visits to archeological sites, museums, and private collections, became Covarrubias's course of study, enhanced by his seeking out more knowledgeable ethnographers and archeological researchers than himself.

Now when Miguel visited Tehuantepec at the very dawn of its own era of excavation, he was both breathless with excitement and concerned for the safety of the place. Recent finds (in 1939) by Matthew Stirling, an American archeologist with the Smithsonian Institution, hinted at a culture not previously known, and Miguel was eager to go there, to the deep jungles of Tres Zapotes, La Venta, and San Lorenzo on the Gulf of Mexico side of the Isthmus of Tehuantepec.[27] At the same time, he was supposed to be writing a book.

Miguel had become a frequent visitor to the National Museum of Anthropology in connection with *Mexico South*. He needed information as well as confirmation, and he found a degree of it there, as well as a mentor, in Daniel Rubín de la Borbolla, the museum's director. Rubín de la Borbolla had been immediately struck by Miguel's knowledge of Mexico's primitive cultures and by the infectious enthusiasm with which he spoke of them. These were precisely the qualities of a good teacher, and the distinguished director soon had Miguel signed on to teach a course on primitive and pre-Columbian art at the museum's School of Anthropology, although Rubín de la Borbolla recalled that "considerable patience and persuasion were needed to help him overcome his stage fright."[28]

It is indeed testimony to Rubín de la Borbolla's persuasive powers that Miguel took on this new obligation—and that he had participated as a delegate in the First Indian Congress in Pátzcuaro, Michoacán, earlier that spring (noted in his letter to Nick Muray, accounting for his time).[29] By the end of 1940, *Mexico South* was still in its formative stages, and *The Discovery and Conquest of Mexico* was still without illustrations.

At the end of December 1940 or early January 1941, Miguel made an arduous trip along the northern coast of the isthmus to finally see the astonishing sights Stirling had been reporting for several years. Miguel wrote of the trip:

Miguel in a chinampas *at Xochimilco. Photograph by
Rosa Covarrubias.*

*Some of the most mysterious and exciting sculptures of
Middle America, certainly belonging among the masterpieces
of world art, lie scattered in the jungle and swamps of the
southern Gulf Coast of Mexico, directly on the Isthmus of
Tehuantepec. These monuments have no precedent, and do*

not resemble any other style of Middle America. They include colossal heads of basalt, powerful and sensuous, admirably realistic; great stelae and enormous altars, with strange personages carved in high and low relief; vigorous statues of snarling jaguars; squat, chubby dwarfs and infants and dignified men, Mongoloid and Negroid at the same time, statues often endowed with the magic breath of life of great art. Some of these are clearly human; others have a fantastic, haunting mixture of human and feline characteristics in varying degrees. It is often difficult to guess whether a given carving was intended to represent a man disguised as a jaguar or a jaguar in the process of becoming a man.[30]

The carvings were ancient, more ancient than the Mayan culture, in Stirling's opinion. Miguel and Stirling believed that they were of the same civilization that had chosen Tlatilco centuries ago for a burial site. They referred to this civilization as Olmec, a coastal culture which had sent feelers south and inland, accounting for Tlatilco and some other isolated sites. (This theory is still a matter of debate among archeologists.) The Olmecs and their "dwarf babies," figures with a strong feline cast, fascinated Miguel, which did not surprise Matthew Stirling, who wrote:

I have been struck by the number of individuals who after becoming involved with a single fine specimen of Olmec art, spent the rest of their careers as Olmec enthusiasts. . . . George Vaillant told me that he first went overboard . . . when the Necaxa jade tigre arrived at the American Museum of Natural History in 1932. He put it in a drawer in his desk and for several weeks used to take it out daily to admire it and to feel it—for there is a tactile as well as a visual appeal to the Olmec jades. I cannot say what particular specimen first caught the eye of Miguel Covarrubias, but he early segregated the Olmec style from other aspects of Pre-Columbian art, and made it a love affair for life. . . . I speak with personal feeling on this subject because the bait that hooked me into a career of Olmec research was a small blue jade mask in the Berlin Museum.[31]

Miguel and Rose stayed at Stirling's camp in the Cerro de las Mesas. The now famous archeologist recalled their visit for a *National Geographic* reporter and commented on Miguel's "detailed knowledge of aboriginal Mexican art . . . and his enthusiasm [that] reinfected all of us." Stirling let Miguel take charge of a digging crew, and Miguel almost immediately uncovered "a deposit of exceptional importance." These were 782 pieces of pre-Columbian jade: ear ornaments, beads, tubes, carved plaques, and parts of human figures that represented "the largest find yet made of the most precious substance known to the ancient civilizations of Mexico."[32]

In Stirling's opinion, "Covarrubias would be known as one of the best-informed men of Mexican archeology and ethnology were it not for his fame as a painter, caricaturist, and writer."[33]

From Stirling's camp, Miguel and Rose continued along the northern coast of the isthmus to southern Veracruz, the Chimalapa Mountains, Oaxaca, and finally Tehuantepec. We know his itinerary because Miguel provided Henry Allen Moe with a detailed account of his trip in a conciliatory letter explaining why he wasn't further along with *Mexico South:*

> *This trip was perhaps the most interesting yet since I had an opportunity to visit parts of the Isthmus that are least accessible.*
>
> *I concentrated on archeological sites and visited the little known ruins of Ciengola, a historical place of first importance and one that has not been studied. I made a map of the buildings there. I also spent a week in Monte Albán with the archeologist Dr. Alfonso Caso.*[34]

At the time of Miguel's visit, Monte Albán's "Tomb 7" had just been excavated, and Miguel made detailed drawings of objects discovered there—five hundred pieces of jewelry made of gold, jade, obsidian, pearl and turquoise—and Rose took scores of photographs.[35]

Later Bertram D. Wolfe described the place in a *New York Times* book review of Miguel's *Mexico South:*

> *Above all it is a painter's land, a land of arid brush and Rousseauesque jungle; of alluring women whose habit of bathing nude in the rivers is as celebrated as their colorful costume and statuesque grace.*
>
> *[Miguel] saw Monte Albán before Tomb 7 was opened, and after its treasures had been revealed; he visited the jungle sites with the monumental heads and stone altars uncovered, flying over slopes that "from the air looked like tightly packed broccoli."*[36]

Moe understood, as Knopf did, that the never-before-seen discoveries that Miguel was gathering for his book would make it all the richer. Miguel concluded his letter to Moe by saying, "I shall spend only a short time in Mexico City, only long enough to organize the material I brought back. I will make only one final trip into Tehuantepec and Chiapas."[37] After this trip, Miguel assured his sponsor, he would have all the necessary material to finish his book. He closed the letter promising the manuscript soon.

There was only one other obligation to meet first, and that was assisting his old pal René d'Harnoncourt, currently mounting over a thousand pieces (some from Miguel's own collection) of "Indian Art of the United States" at the Modern

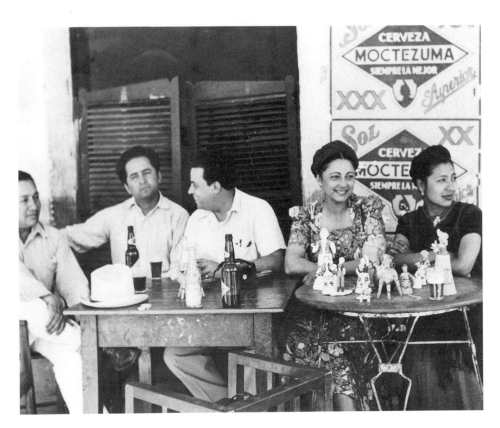

*Miguel and Rosa with Andrés Henestrosa and Alfa, buying folk art.
Photograph by Donald Cordry.*

Museum of Art for a show that would open in 1941. (The preparations took two
years.) Their friend, the puppeteer Bil Baird, helped too, and he recalled building
an erotically explicit Kachina doll that Miguel substituted for one of René's
authentic ones. "D'Harnoncourt didn't notice, and my Kachina was there on
opening night. We all had a good laugh, as the figure attracted a lot of attention."[38]

This show started Miguel thinking about the difference between art of the
Mexican Indian and that of the North American Indian. In the latter case, much had
been preserved and in many places was still in full creation; but in Mexico, "the art
had been pulled up by the roots."[39] Those differences, as well as the similarities,
were almost enchanting in the way they occupied his imagination. One day he
would do something about it.

Meanwhile, George Macy was desperate for the illustrations for *The Discovery
and Conquest of Mexico,* about which he had heard nothing for too long. There was
also confusion about whether or not Miguel had agreed to illustrate *The Good Earth*
and *Aesop's Fables* for Limited Editions. (Macy thought so, Miguel didn't.) Macy
wrote: "If you were only here, you could draw a remarkably fine caricature of a
brow-beaten publisher holding his head in his hands pitying himself. If you find
me living in a hovel on the occasion of your next visit to New York, you will know
that you are responsible for my hard lot."[40]

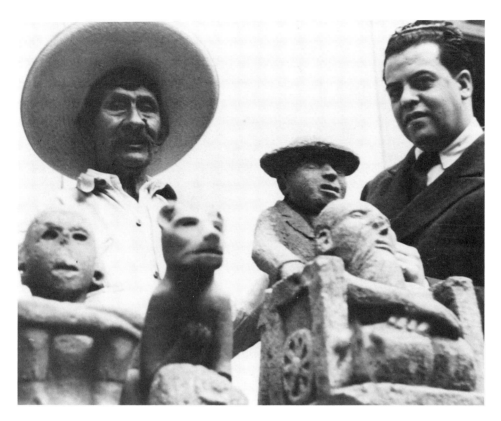

Miguel buying artifacts.

Finally Harry Block took up the cause of the long-suffering Limited Editions publisher, wheedling the illustrations out of his friend Miguel. In an interview, Malú Block said that "[Miguel and Harry] were very much alike. It was impossible for either of them to meet deadlines. . . . The two men were devoted to each other and . . . they would cover up for each other when long distance calls or telegrams arrived from harried publishers and editors."[41]

The Discovery and Conquest was printed in Mexico. When Miguel had delivered his work to the printer, he wrote to Macy, obviously nettled, "hoping you will have at least a nice book to make up for all the trouble."[42] It was far more than a nice book. Harry Block wrote the introduction, and since Limited Editions subscribers had had to wait years for it, Block tried to smooth any ruffled feathers with this explanation:

> *Miguel Covarrubias' dilatoriness could be explained in part*
> *because since his youth when he first expressed interest in*
> *illustrating the book, the world had surrounded him with its*
> *demands. Nearly every day he receives an order from San*
> *Francisco or New York for additional work. He also leaves*
> *Mexico City frequently to take trips into the Mexican jungle*

for his research on Mexico South. *Furthermore much of his time is taken up with the serious study of Mexican art and archeology.*

He can hardly find time for illustrating but, when he does, he gives to these illustrations an authenticity which is remarkable. . . .

Some of the drawings were repeated as many as fifteen times in a patient experimentation to find the right approach and technique; they are based on scrupulous research to insure accuracy and fidelity to the originals, following the general style and color scheme of the Mexican pictorial manuscripts of the 16th Century.[43]

Block was not trying to apologize, just to explain. And with similar forthrightness, he concluded:

This book transcends in excellence any book that has ever come out of Mexico, and one which must rank among our few best. Paper laid and toned, especially watermarked with a design by Covarrubias and the names of Bernal and Miguel. Leather skin of sheep and marbled by hand, this type of work is only done in Mexico.[44]

Block's opinion was shared by Limited Editions subscribers. George Macy wrote an appreciative letter to Miguel, after all they had been through:

The only comments I have heard thus far are summed up in the extravagant statement that most people think it the best book we have ever done. Even if you are not personally pleased to know that the customers are delighted . . . then you ought to be particularly pleased that Mexico is being praised so lavishly, by some Americans, for this cultural achievement.[45]

Meanwhile, Rose was experiencing her own extraordinary cultural achievement, her transformation into a Mexican Beauty Rose. In a way, the Tizapán house and its surroundings became her personal garden, which she shared with objects from earliest Mexico, the rare and ancient pieces that Miguel and she collected. Rose believed the house "was the ideal background for all the primitive art we had the good fortune to collect," adding that "in the good old days when we could travel over the world, we overloaded ourselves with possessions. The storage bills in New York were outrageous, so we were forced to build a house to put them in."[46]

The result was a colonial style, traditional, walled Mexican house, with patios

and Rose's untraditional gardens. (Her friends brought her exotic plants from all over, knowing they would thrive under Rose's green thumb.) Visitors entered through a fantastically lathed gate with a sunburst at the top that Miguel had made himself. An open-air flagstone-floored gallery ran alongside the house under its own thatched palm and wood beam ceiling. Terra-cotta urns of all sizes stood beside the gallery's cantera columns, and a five-pointed tin star became a hanging light fixture at the midway point, where Rose set her spectacular table.

Entering the living room off the gallery, one encountered a world of exotic art. The shelves, already overloaded with Olmec figures, nevertheless received more; cabinets and drawers opened to reveal pre-Columbian jades and necklaces and antique codices redolent with the aura from pre-colonial times. African, American, and Asian idols stood by implacably, members of an international society of totems at home in Tizapán.

A large, low, round table with a giant green pottery *calabaza,* or squash, from the state of Michoacán occupied the center of the room. The chairs, made of leather and wood from Taxco, were modeled after a sixteenth-century design. In the adjoining dining room was a big scalloped window, inset with an iron grille that Miguel and Rose had had copied from the jail in Taxco. In the late afternoon, the grillwork cast strange shadows on the floor. The tables and cabinets were made of local sabin wood, and the sofas were flung with bright wool serapes.

An exceptionally striking and primitive painted tin cabinet filled with silver *milagros* hung near an archway in the living room.[47] On the other side of the room, a dark carved wooden antelope head from the Sudan and a troop of wooden Balinese dancing figures held the corner. And of course there were paintings, by Diego Rivera, Frida Kahlo, Xavier Guerrero, "El Corcito" Ruiz, Manuel Rodríguez Lozano, María Izquierdo, Roberto Montenegro—something from just about every artist Miguel and Rose knew.

If the artful public rooms of the house were Rose's garden, the Mexican kitchen was her flower bed. It had been designed after one that Rose had seen in a house "on my first visit to Puebla . . . the most extraordinary and beautiful house. It was like a glorified birthday cake, pink with white frosting. *Churrigueresque,* 18th century baroque architecture of the most ornate design. . . . And its most original room was a fully equipped Mexican style kitchen."[48]

"I love to cook," Rose explained, "so I wanted the kind of kitchen I could have fun in. I also wanted a setting for all the beautiful cooking utensils I gathered whenever I went near a market place. Many of these were presents made especially for me with my name inscribed, and filled with sentimental mottos of love and remembrance." She hung all of these—molds of every exotic shape, pots of copper and ceramic and cast iron, baskets, skillets, measuring cups and wooden spoons, ladles, paddles, and glazed pottery—on the clean white adobe wall, "as in an exhibition." Her Mexican kitchen was a favorite of photographers. The book *Mexican Homes of Today,* published in 1964, noted that "Rosa's kitchen became a gallery of ceramic art, sometimes sophisticated, sometimes primitive, and always captivating."[49]

Keeping Rose company in the kitchen was a parrot who lived with her until her

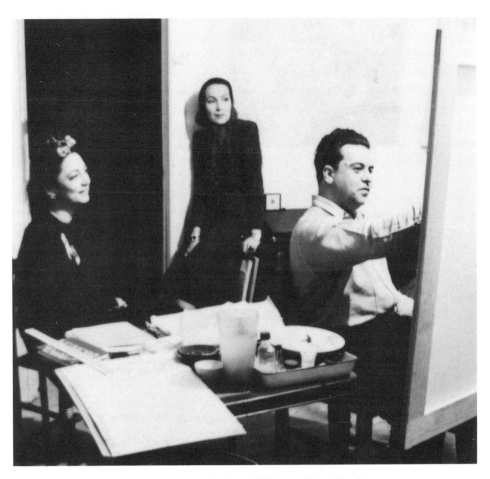

Rosa and Dolores del Río watching Miguel paint.

death and to whom she taught an especially spicy repertoire of English expressions. There was also a Great Dane named Traviata who followed Rose everywhere.[50]

Rose threw herself into learning about Mexican food and food preparation with a fervor akin to Miguel's on a new assignment. She became an expert on the history of Mexican cooking. She discovered and later wrote that "Mexican food is cooked over charcoal since far back. It is found in archeological excavations along with corn, beans and other offerings. In the drawings of the Aztec codices women are grinding corn on the same kind of metates that are still used today."[51] And so she learned to cook slowly in clay bowls and pots on a charcoal-burning stove made of brick and black and white tile that ran the whole length of her kitchen, and she learned how to grind her own corn using the traditional stone metate. Much later she worked on a cookbook and devoted a whole chapter to corn.

The great Mexican actress Columba Domínguez met Rose and Miguel in the mid-1940s when she was a girl of fifteen, and she never forgot the delicacies that issued from that great kitchen. "She was the envy of all the cooks in Mexico," Columba recalled. "Nowhere could you eat meals like the ones Rosa prepared. She

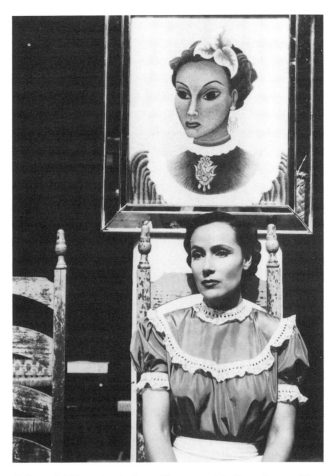

Dolores del Río posing in front of her portrait by Rosa Covarrubias.

knew everything there was to know about food, including some of the more wonderful sentimental customs surrounding the art of cooking. She was truly sensational."[52]

Rose was also opinionated on the subject of cooking and never shy about expressing those opinions. She had this to say to a Mexico City newspaper reporter:

> *As far as I'm concerned, the Chinese are the best cooks in the world, the Mexicans the second, and the French the third. In China and France men are better chefs, but in Mexico we women have a better hand at seasoning.*
>
> *To know how to cook is an art . . . and to prove it to you, I will give you the great dancer-choreographer George Balanchine as an example. He converts his dishes into a delicious and spectacular ballet. You must orchestrate your presentation of dishes by adorning the table with beautiful objects and colors.*[53]

The Forties, Part One

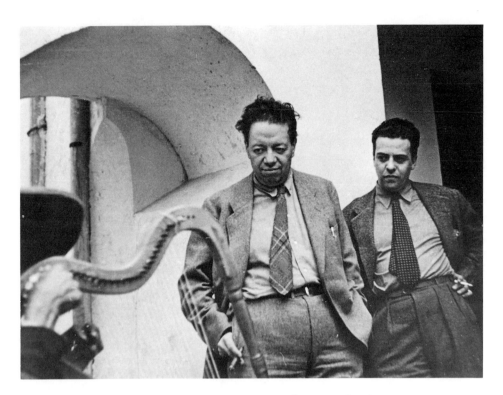

Miguel and Diego Rivera listening to harpist.

Both Rose and her friend George Balanchine took great delight in setting a beautiful table. Balanchine was a frequent houseguest at Tizapán, and the two of them spent hours together in Rose's splendid kitchen. No one who tasted one of Balanchine's Russian dinners would ever forget it. "I grieve for those who really like good food," Rose wrote, "and have never tasted the wonderful food he cooks."[54]

Food was an interest that Miguel and Rose had shared since they dated in the 1920s in New York.[55] Wherever they traveled, to Europe, the Orient, Northern Africa, or the South Seas, they searched out the best restaurants. Rose did not hesitate to ask a chef for a recipe she admired, and perhaps because of her obvious appreciation, she was never refused.[56] To Miguel's pleasure, she never failed to reproduce these exotic dishes. Rose was a truly talented gourmet, and everyone who had the good fortune to dine at her table knew it, including Rose. Miguel told friends that the only thing about which Rose was immodest was her cooking.

Cooking was certainly not Rose's only talent, however. She was an accomplished artist. During her years in Mexico, whenever she woke up inspired, she spent the morning painting. She preferred to paint portraits of friends, children, and Indian women, and she was heavily influenced by her environment and the artistic climate in which she lived and worked. She painted mostly in gouache, sometimes in oil.

"The canvases Rosa did in the Forties burst with the hot colors of the Mexican landscape that surrounded her," wrote one journalist for *Harper's Bazaar:*

> *She had an elegant and primitive style that evoked high sophistication. Her varied sensual arrangements of copper orchids, tiger lilies, butterflies, or her adeptness in expressing the essence of the chocolate-eyed children in festive holiday dress, and Mexican village brides as graceful as Gauguin's South Sea maidens were proof of her ability as an artist.*[57]

Rose painted her first portrait in 1938, of Dolores del Río. It is an extraordinary work, a straightforward head-and-shoulders study in the style of the day, reminiscent of many of Frida Kahlo's portraits, but softer and smoother, not unlike some of Miguel's own exotic illustrations. Dolores is seated in front of a gauzy drapery, wearing a ruffled bodice, with two tropical-looking flowers in her hair and a dreamy, pensive expression. The painting was used as a prop in the film *Derecho de Nacer,* in which Dolores starred in 1952. John Huston was especially taken by the portrait, and he also remembered Rose's "lovely [Mexican Indian] creatures in white," probably Tehuantepec women in their great ruffled *bida:niró,* white pleated lace collars that framed the face and covered the shoulders like a cape.[58]

Rose soon established a reputation for fine portraiture. She did a large oil of the Mexican actress María Félix in a shocking pink Mexican skirt with a *rebozo* around her shoulders. She also did one of the young daughter of English heiress Nancy Oakes, who had married the Baltic-American photographer, Baron Hoyningen-Huene, a friend of Miguel's and Rose's. The portrait of the child, sitting in a chair in a blue dress with blue flowers in her hair, displays a decidedly sulky expression. Nancy Oakes recalls, "The two of them did not get along. I think that explains the expression."[59]

Rose did a self-portrait, as a Tehuana, that was chosen for the cover of *Mademoiselle* magazine in March 1946, and her illustrations of ethnic costumes and accessories for the Franklin and Simon department store appeared in *Vogue.*

Bertha Cuevas interviewed Rose much later in her life, for *Novedades,* and Rose talked about her painting:

> *I am of the neo-figurative school of painting. I rarely exhibit but paint for myself. I must paint what I know and what I like. I paint to delight, to amuse. I capture a curve or a color that surprises the eye. I wish I could say I paint out of deep yearning, crazy passion, but I don't. I paint for pleasure. I don't exhibit in galleries. People who see my paintings in my house and like them buy directly from me.*[60]

Fred Davis had acquired several of her paintings in this way, as had Stanley Marcus of the Neiman Marcus stores, gallery owner Alberto Misrachi, and the architect Luis Barragan.

By the early 1940s, Rose's cultural transformation appeared complete, outside and in. In 1942, *Harper's Bazaar* wrote of her: "Rose Covarrubias is American born, but she has taken Mexico and all things Mexican to her heart; you would never guess she was not part and parcel of her husband's white-sun, black-shadow country — as indigenous as their low, thick-walled house."[61]

Rose delighted in her Mexican home and especially in her authentic Mexican kitchen. She dressed in the Mexican style: "She almost always [wore] black (beautiful and right in that blazing climate), her hair braided with bright yarns and bound tight around her head, or caught in a snood of knotted wool."[62] Her paintings were fabulous Mexican motif pieces. Her friends were Mexican. She was learning to speak Spanish; and since her new friends all called her Rosa, she changed her name. From now on she was Rosa Covarrubias.

His endeavors to penetrate the most profound and genuine manifestations of man's aesthetic expression led him to his great love, pre-Columbian art of Mexico and the rest of America.[1]

THE FORTIES, PART TWO (1942)

Rosa became famous for her parties, and her charming essay, "I Have Two Kitchens," gives us a good idea why. (It also is clear from the essay that Rosa was, like Miguel, a skillful and unpretentious writer in addition to her other talents.) She describes preparations for an outdoor party that must have occurred in the early forties:

> *Montezuma had his fish brought from Vera Cruz by runners, ours is flown in. Food comes by train, plane, truck, muleback, burro, and on the backs of peasants that run along in a steady trot for miles. Preparation begins a couple of days ahead: great baskets overflowing with crisp green vegetables and fruits are bought. The lamb for barbecue comes from a friend's hacienda. Our faces search the sky for those telltale clouds that spell wind, rain, or fair weather, because on bright days the tables are set out under the swaying fronds of the great weeping willow. Rain forces us*

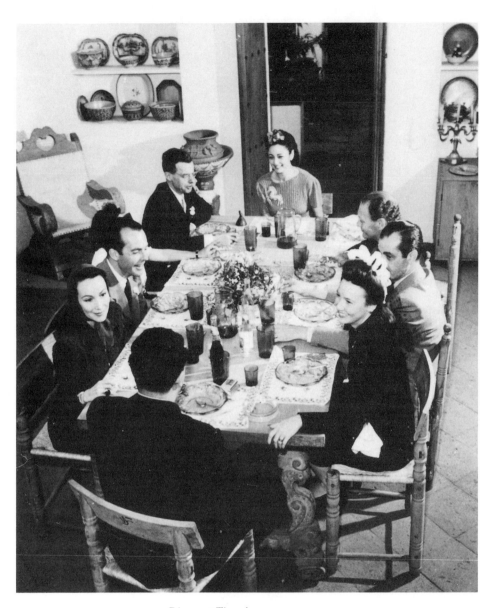

Dinner at Tizapán.

*to the veranda or to the white dining room with a crackling
fire. Outside the tables are spread with roughly woven
striped cotton, or straw mats with tiny animals woven on
top. . . .*

*Inside we always use bright red table cloths or mats,
yellow Talavera pottery dishes and our best citron vaseline
glasses imported from the U.S.A. in Victorian times. The
silver comes from the renouned [sic] Taxco silversmiths
William Spratling, Hector Aguilar and Frederick Davis.[2]*

Spratling was a good friend and promoter of both the Covarrubiases. Later in the 1940s he asked Miguel to paint murals for the four walls of the main cabin of his yacht, called *Pez de Plata*, or the Silver Fish. "Miguel said he would like to do it, but it would take several months," Spratling wrote later:

> *I knew that he needed money and couldn't ask Knopf for any more on his advance [for* Mexico South*]. I told him I was rich, and could gladly pay him in advance.*
>
> *The resulting panels, done in a few weeks, gave the vessel quite an air of distinction. The frescoes were painted in the same style as the great ones he had done for the Pacific House at the San Francisco Fair. Nieves . . . posed for the [Indian] figure. Mary Anita Loos' face was used for the sun.*[3]

Spratling truly loved Miguel. In 1960, years after Miguel's death, he dedicated his book *More Human Than Divine* to Miguel with these words:

> *His long, intimate search and adventures in the aesthetics of ancient American sculpture produced in Miguel Covarrubias an acuteness of insight and an intuitive feeling for the integrity of creative styles that possibly no archaeologist has ever equalled. The artist that was Covarrubias became in the end, beyond doubt, the man with the most informed and clearest vision of his country's artistic past. To him, who for thirty years most constantly shared and stimulated his love of these objects, the author dedicates this volume with warm affection and to commemorate their friendship.*[4]

Spratling was also one of many who recognized Rosa's extraordinary talents. In 1940 he had tried to interest her in his own specialty by offering her a business opportunity in jewelry design. He would pay her ten dollars for every design he used or a minimum of thirty dollars per month and, in addition, ten dollars extra for any of her designs used for his New York line. All of her pieces would be marked with a small die carrying her signed initials. Rosa was enthusiastic and promptly created some handsome bracelets, necklaces, buttons, buckles, pendants, flowers, brooches, rings, and earrings. The two signed a contract, but Rosa's creative efforts never metamorphosed into a business, although in later years, according to Dorothy Cordry, she occasionally designed dresses as well as jewelry for one or another fine shop.[5]

Paz Celaya, Rosa's housekeeper at Tizapán, remembers that William Spratling loved to buzz over their house in his plane when the Covarrubiases had lunch guests. Miguel would run outside and wave to him, and Spratling would dip his wings in salute. Paz was always terrified he would crash into the house, he flew so low.[6]

Presumably, Spratling did not disrupt the barbecue that Rosa continues to describe in her essay: "We need extra help on a party day. We borrow a man waiter

from our friends or from our relatives, and girls in the neighborhood come to help in the kitchen, which buzzes like a bee hive."

Rosa chose her helpers and servers for their classical Indian features and asked them to dress in native costume for her parties. She braided colored ribbons in the women's hair and wrapped the plaits like a crown around their heads.

> *Emilita, the laundress, loves parties and always comes of her own accord, choosing the worst of all jobs: kneeling over the stone metate to grind corn for tortillas or the pungent spices for the mole sauce. Since it is to be sort of a picnic, all the food will be cooked in clay pots and jars. We peel, chop, skin, crack, steam, fry all the ingredients.*

"The tables are set and arranged with flowers," Rosa wrote. She favored Oceloxóchitl (bright orange Aztec tiger lilies) and bull orchids, both from her garden.

> *There is a long table where we will serve the food buffet style. . . . Today it will be a barbecue. . . . The lamb will be cooked buried in a pit in the ground overnight, wrapped in agave leaves, slowly sizzling its fragrant juices. . . .*
>
> *To encourage the appetite, we serve mashed alligator pears with fried tortillas or quesadillas . . . , squash flowers,* huitla-coche *(a corn mushroom), or chopped meat, and delicious Oaxaca cheese, rolled up like a bolt of thick white velvet ribbon. . . .*
>
> *Victor has removed the meat from its steamy under-ground nest. Lola goes to work unwrapping it and removing the bones.*

And Rosa goes on to describe the feast, complemented by:

> *a giant casserole of Mexican rice covered by a pinwheel of succulent sliced fried bananas . . . ,* poblano *chilies under a blanket of clotted cream and gruyere cheese . . . , cooked young leaves of the prickly pear cactus, cut in minute squares and doused in oil and vinegar with rings of tomato, onions, and chopped parsley on top.*

Rosa's guests remember the long buffet table, set under the star chandelier in the gallery and overlooking her famous garden brilliant with bougainvillaea and beds of ferns and succulents collected from around the world. Large, ancient Mexican water cypress, sabin, and willow trees protected the garden from the unrelenting sun, and primitive sculpture undoubtedly kept bad spirits away. "There were two stone serpents' heads peering out of the thick fern foliage beneath

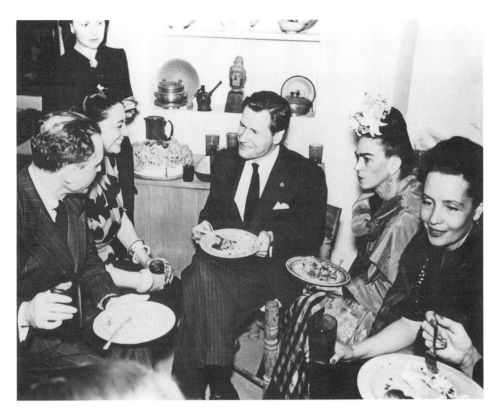

Nelson Rockefeller feted at one of Rosa's celebrated Tizapán luncheons.

the leaves of the banana trees," one visitor remembered, while a large coiled Aztec snake rested between two antique carved wooden crosses, one with a crown of thorns. And Rosa had placed two pre-Columbian pieces, two large seated dogs made of terra-cotta, so that they seemed to stare at her guests as they ate.[7]

María Asúnsolo recalled the exciting atmosphere Rosa created: "Sometimes there were thirty people for lunch. Many of the women dressed in beautiful Mexican costumes which added to the color and exotic ambiance." Frida Kahlo, the model Nieves Orozco, Alfa Henestrosa, and the young actress Columba Domínguez always wore splendid native dress at Rosa's luncheons, and a photograph of Rosa appears in the January 1942 issue of *Vogue* magazine, dressed "for dinner-at-home" in a traditional Tehuana costume—the long white lace petticoats under a colorful embroidered top skirt and blouse and the startling starched lace flounce that is worn like a pleated petal around the face and over the shoulders.[8]

> *Upon entering the garden [María Asúnsolo continued] a*
> *guest was immediately seduced by the atmosphere and the*
> *odors coming from the kitchen. A kind of excitement*
> *prevailed, and everybody was happy.*
>
> *Lunch, which was always a special treat, lasted several*
> *hours. There was much conversation which went on and on,*

much laughter, and throughout many exclamations of awe
and admiration of Rose's superb cooking.

After the meal everyone moved to the garden to have
coffee and brandy under the large willow trees. When the
Russian ambassador, Constantin A. Oumansky, was there,
we played a game he invented, which went something like
this: Because Rosa's guests came from all over the world,
most of us spoke many different languages. He had each of
us write down a word on a piece of paper in the language of
our choice.

While we were doing this, Oumansky would go back
into the house. On his return someone would read all the
words to him [in Spanish]. He would think for a moment,
and then in Chinese, or whatever language the word had
been written in, tell each of us who had chosen which word.
He was never wrong.[9]

Carmen López Figueroa remembered one particular dinner party at Tizapán
for another foreign dignitary, at which Frida Kahlo, who despised anyone whom
she deemed "establishment," fell asleep out of boredom under the table. It was for
this kind of outrageous behavior that her friends loved her. The actress and writer
Mary Anita Loos commented that "Rosa not only found Frida beautiful, but she was
emotionally shaken by her astonishing personality. She identified with her and
they confided in each other."[10]

"Frida used to sew jingle bells in her petticoats," Carmen recalled. "When she
sat down, you could see the bad words she had embroidered in bright colors along
the bottom of her petticoats. She always used bad language. Every other word! She
was her own person. Rosa and Frida were very close for many years."

Reminiscing about another party at Tizapán, Carmen told me:

I recall another time when the great Spanish Flamenco
dancer, Carmen Amaya, was invited to Tizapán. Many
Mexican artists and intellectuals had been invited that night
to come and meet this great personality. In came this rather
ugly woman wearing a long fox coat almost to her ankles.
When she took off her coat and began to move, she trans-
formed herself into something of great beauty. Montenegro
and Villaurrutia both wept.

All during the 1940s, the Covarrubiases were the couple to visit when one
traveled in Mexico, and friends provided other friends with letters of introduction
to Rosa and Miguel, sure of their unfailing hospitality. Number Five Calle Reforma
became for Mexico City's "Smart Set" what Virginia Woolf's home was for the
London crowd, what Gertrude Stein's was for Paris; except the food was inarguably
better at Tizapán.

Columba Domínguez reminisced that "the people I met at Tizapán were the cream of the crop in Mexico: the intellectuals, artists, and show-business personalities of the country. It was a great privilege to have been part of the Covarrubias coterie."[11] Included in this group were Frida Kahlo, Diego Rivera, David Siqueiros and his wife Angélica, Fito Best Maugard, Roberto Montenegro, the Tamayos, Carlos Chávez, actors Arturo de Córdoba and Pedro Armendáriz, and Mr. and Mrs. Wolfgang Paalen (he was a multi-talented, well-travelled Austrian and collector of Amer-Indian art).

By the 1940s, Rosa and Georgia O'Keeffe were quite close. Perhaps to reciprocate Rosa's own hospitality, O'Keeffe invited her to New Mexico to travel with her during a season of American Indian festivals. They visited much of New Mexico and some reservations in Arizona, and Rosa returned to Tizapán with photographs of Indian dances and antique Indian jewelry to add to her own growing collection.

O'Keeffe's biographer, Laurie Lisle, mentions another trip O'Keeffe and Rosa took together to the Yucatán peninsula: "One dawn in Chichén Itzá," she writes, "the two women left their straw-roofed hut and climbed up into a temple, holding on to a chain, to watch the sunrise break over the dense green jungle, which was as wild and wonderful as the sea."[12]

Gabriel Figueroa, Dolores del Río, María Félix, and the singer Carmen Cugat (an aunt of Margo Albert and wife of the popular Cuban bandleader Xavier Cugat) were also regulars at Tizapán, as was Jorge Enciso, a man of great distinction—painter, professor of decorative arts at San Carlos, Mexico's director of the department of colonial monuments, and secretary of public education. Alfonso Caso felt at home at Number Five, as did art historian Ignacio Bernal, journalist Salvador Novo, architect Luis Barragan, writers Alfonso Reyes and Andrés Henestrosa, poets Villaurrutia and Pellicer, María Asúnsolo, Carmen López Figueroa, and "El Indio" Fernández, the colorful actor/film director with whom the fifteen-year-old Columba Domínguez lived.[13]

Columba recalls:

> *Rosa and Miguel liked my type and kind of adopted me as their child. . . .*
>
> *Everyone taught me something, but Rosa more than anyone else. Not the least how to cook. For that "El Indio" Fernández was forever in her debt. First she began by showing me how to buy the ingredients in the markets for Mexican dishes. Not until she was fully satisfied with my ability to cook Mexican dishes, did she teach me how to make some of her great Oriental ones.*[14]

Other beautiful young women felt at home in the company of Rosa and Miguel and their friends, and the presence of these often exotic, exceptional women, usually in alluring Mexican costume, was part of the attraction of a get-together at Tizapán. Flirtations of every degree were rampant. Nieves Orozco was one of the

Rosa and Margo Albert.

great beauties who came regularly to visit. She had modeled for Diego in the mid-thirties. He had introduced her to Miguel and Rosa, and Nieves began to pose for Miguel in 1938. She remembered that "Miguel liked to talk while he was painting. Much more than Diego. It was always interesting to listen to him." Nieves met both her husbands at Tizapán: James Tillet, an interior designer, and Miguel's fellow collector, Frederick Vanderbilt Field.[15]

Alfa Henestrosa also modeled for Miguel. She recalled that "sometimes he worked half a day, and sometimes he was so engrossed . . . that he wouldn't even stop to eat. Often there would be interruptions when scholars from abroad came to visit Tizapán and see Rosa's and Miguel's collections. At other times, friends arrived for lunch, and then they would stop work to enjoy the company."[16]

Another young Mexican beauty was Margo, an actress who went by the single name, had worked as a dancer in Hollywood, and had come back to Mexico in the late thirties to dance with a Spanish troupe called "La Triana." According to Mary Anita Loos, Rosa, hearing that Margo was having a hard time with some of the other dancers, made a pilgrimage to the theater to bring Margo homemade chicken soup backstage with the advice, "Don't take it from these bastards." Margo married the American actor Eddie Albert in 1945.[17]

Mary Anita Loos, niece of Anita Loos (author of *Gentlemen Prefer Blondes* and occasional member of the Algonquin set), was a regular houseguest at Tizapán after being introduced to Rosa and Miguel in the early forties. She and Rosa often sat together in the gallery in white rattan chairs, sewing sequins onto the woolen or

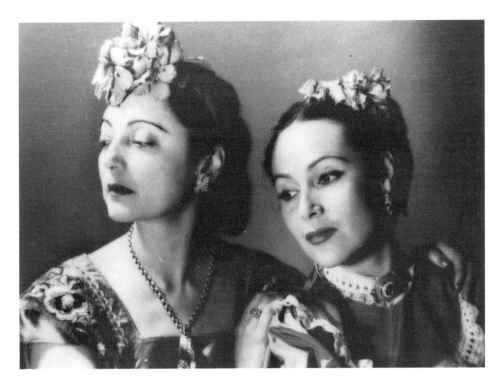

Rosa and Dolores del Río.

velvet snoods that were the fashion of the day, gossiping, and laughing. Miguel called the two of them directors of "The Sequin Society of Tizapán."[18] Mary Anita fell in love with the dashing William Spratling; in 1940 they had gone together to the Mexican Exhibition at the Modern Museum of Art in New York—as had almost everyone else they knew.

Of course friends from New York and abroad visited the house at Number Five: the Hollywood writer Bruno Traven (*The Treasure of Sierra Madre*), who moved to Mexico when he was blacklisted; Amelia Earhart (whom Rosa photographed in a charro outfit); Japanese-American sculptor Isamu Noguchi; Nelson Rockefeller; popular and wealthy socialites Sonny and Jock Whitney; Stanley Marcus; director José Quintero; actors Sam Jaffe and Orson Welles; Martha Graham; Nick Muray, of course; photographers Bob Capa, Gjon Mili, Henri Cartier Bresson, and Eliot Elisofon; Nancy Oakes; Tyrone Power; Marc Chadourne; Luis Buñuel; French actress Suzanne Flon, with John Huston; Merce Cunningham; Katherine Dunham; and Mrs. Pandit Nehru.

If it sounds like a lot of partying, it was. And Rosa did most of the work of orchestrating and producing the gala luncheons, outdoor picnics, and candlelit dinners for which Tizapán became famous; and it was she who planned long motor trips for the grateful guests into the Mexican countryside and visits to a colonial church or pre-Columbian ruin or a marketplace in a mountain village. I accompanied Rosa on several such trips to buy pottery at local markets. She had a wonderful eye for value.

Miguel did not drive. It was usually Rosa who took him to one or another village that he was investigating for his book, and then he would make an immediate connection with the locals. He would be invited to someone's house where he squatted comfortably on the floor. He would ask where they got their hemp, how they made their dyes, who had taught them. He asked about their grandparents. He asked if the family had anything very old among their possessions. Often he took out his pad and made sketches, and sometimes he left with some wonderful addition to his growing folk art collection.[19]

Mexico South was now almost two years late. Miguel had actually turned down a request to illustrate *The Story of the Amazon* by Carl Crow for the Artists and Writers Guild, knowing that to assume another obligation would be insane.[20]

Miguel continued to inspire Rosa's famous jealous tantrums. No doubt his flirtation with Paulette Goddard, which became a brief affair, elicited one. Now, whenever Miguel was away, Rosa became suspicious, and she confided unstintingly and repetitiously to her pet parrot. Adela Fernández, "El Indio's" daughter, wrote in her book that Rosa and Miguel had gone on one of their study trips to Tehuantepec and left the bird with "El Indio" for safekeeping. "All day long, the bird cried out lamentations in English, 'Oh my God, this is too much! So terrible loneliness!' and so forth."[21]

After their trip, when Miguel came to collect the parrot, "El Indio" grabbed him by the lapels and hit him. "Rosa is enchanting," he said, "and if you don't make her happy I'll kill you!" Miguel didn't know what he was talking about. When he found out, he was terribly insulted — to the extent that he returned an unfinished portrait of Columba that he had been working on. But the two made up, and "El Indio" went so far as to throw Miguel and Rosa a second wedding party "in the manner of Tehuantepec."[22]

V*ogue*, in January 1942 (the same issue in which Rosa had appeared "dressed for dinner"), published an excerpt and four color gouaches from *Mexico South* in an article entitled "Women of Fashion in Tehuantepec, Mexico." Presumably the features were timed to whet an appetite for the upcoming book, as such excerpts had done for *Island of Bali* in the year preceding its publication. (In June 1940, when *Mexico South* was first supposed to have been forthcoming, *Theatre Arts* had also done an illustrated piece called "In Place of Theatre: A People's Feast in Tehuantepec.") But *Mexico South* would not be published in 1942, in spite of Knopf's best wishes and Miguel's best intentions.

Miguel always seemed to be behind schedule, but it was never for lack of effort. He worked hard, and he worked long hours. He needed very little sleep — this had been so since his teenage years — and he painted more during the night than the day. When he was writing, he worked until two or three in the morning, claiming there was less to distract him. When Paz came to work at five in the morning, the light was often still on in his studio. She would fix him breakfast and take it to him, and he would get up from his chair, get into his bed, and eat his breakfast there.[23]

Rosa described Miguel's creative style to the great modern dancer José Limón in a letter written in the early fifties:

> *He was quite orderly until he was caught up writing a paper or working on his latest book. Then everything was chaos. He would throw his papers all over; on the floor, on the tables, on the bed. There were piles of articles and masses of books in which he couldn't find what he was looking for. It was a time of crisis.*[24]

So it must have been in the early forties with *Mexico South* in the works, not to mention ongoing visits to Tlatilco and his classes at the School of Anthropology. Rosa reminisced to Elena Poniatowska:

> *Miguel was never satisfied with his knowledge or with his own work. He was preoccupied with learning. He always felt that he could better himself. With his own work it was the same. I saw him tear up drawing after drawing because he wasn't satisfied. He never worried when he was behind schedule with his illustrations or books because, when he did finish them, they were the very best he could do.*[25]

More and more, Miguel's anthropological interests took precedence over his other talents and to an alarming degree over his obligations to his publishers, as well. The definition of anthropology was metamorphosing in these years, as archeological finds spoke of culture and ethnology as well as art—all Miguel's favorite subjects. As he traveled through Tehuantepec researching for *Mexico South*, he became aware that the area had been inhabited by a great Indian culture. The remaining archeological sites were clearly important and not yet extensively explored. Miguel was in the right place at the right time.

Informed of every new archeological find in the Tehuantepec region, Miguel made a point of visiting them all. He spent hours studying each newly discovered piece and by then had developed an extraordinary "intuitive understanding of subject, color, surface treatment, design workmanship and an over-all 'feeling,'" according to Michael Coe.[26]

That intuition and Miguel's artistic sense, along with his curiosity and intellect, would make a profound impact on the evolving science of archeology. His studies of Meso-America would enable him to advance new archeological and historical theories. Andrés Henestrosa believed that Miguel "gave to the archaic cultures in Mexico the importance they so rightly deserve, and to the art of the Indian and that of all 'primitive art,' a universal status."[27]

There were treasures, keys to history, just hours away. It was particularly hard for Miguel to stay away from Tlatilco, only one hour from Tizapán (in the present state of Mexico, toward Toluca), especially as his concern for its continuing erosion by "collectors" grew. In 1942 he petitioned the Institute of Anthropology to launch

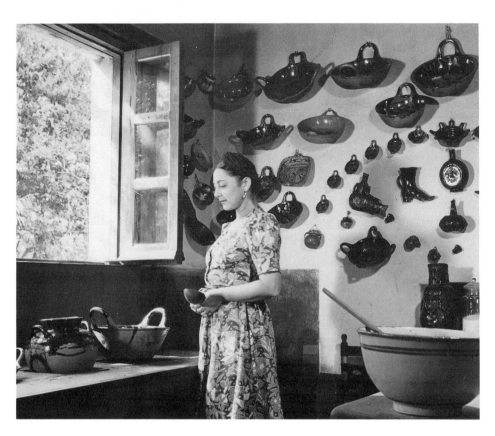

Rosa in the kitchen at Tizapán with her collection of folk ceramics.

an official exploration of the brickyards. They agreed and appointed him director of the project, which would occupy him for the next two years.[28] (The official intervention by the Institute also meant the site was now off-limits to any but personnel authorized by the Institute. In fact, work went on at Tlatilco until the 1970s, and the site remained well cared for, as Miguel had wished.)

Such intensive collaborative work focused Miguel in a way he had not known before. He became a passionate researcher. "He gave to archeology something that it lacked, and that we archeologists could not give," Alfonso Caso recalled for Elena Poniatowska, "and that was an aesthetic perception of form, always correct."[29] Miguel became particularly preoccupied with the culture that suggested itself in the remains of Tlatilco. He was caught in the mystery of the unknown, so tantalizingly present and yet so definitely past; he was nourished by the intellectual inferences one needed to formulate an accurate portrait of this Olmec civilization, its period, its people, its place. It was a process that required exacting considerations and reconsiderations, just right for a man who "was preoccupied with learning," as Rosa had said, and who approached his own art with a similar meticulous consideration and reconsideration.

Some years later, Miguel wrote about his love affair with "this strange culture on which nothing was written":

*I fell under the spell of Olmec archeology in the early days of
its determination, carried away by its tremendous plastic
force. . . . My interest for everything Olmec converted itself
into a true obsession and I began to collect photographs and
drawings of every Olmec piece I could find in museums,
private collections and archeological monographs. It went so
far as to acquire pathological characteristics and now I am
even accused of thanking someone who praises the artistry of
the Olmecs.*[30]

The Olmecs usually worked in basalt for large pieces and in serpentine, quartz, hematite, jade, and jadeite in unusual translucent blue-green and blue-gray colors for smaller figures. Miguel's friend William Spratling understood his passion for his finds. Spratling's own pre-Hispanic collection rivaled Miguel's. He wrote:

*For at least twenty years of our thirty-five years of close
friendship, I had made it a habit of turning over to Miguel
anything outstanding in Olmec sculpture which I had been
lucky enough to acquire. Why? Anything Olmec was more
important to Covarrubias than it was to me. His profound
feeling for form, combined with his increasing interest over
the years in ancient cultures, gave him an enormous advan-
tage over the average archeologist who has always been
dedicated to the stratification of clay, plus measuring and
note taking.*[31]

Frederick Field was another collector in awe of Miguel's acquisitions and frequently a witness to Miguel's enthusiasm when he came into possession of a new piece. "Upon arriving at his house," Field remembered, "we would find him dancing up and down the room, eyes lit up, looking like someone deranged. His excitement was so infectious that we too acted like madmen."[32]

While Miguel oversaw the Tlatilco project and absorbed every nuance of the Olmec findings there, Matthew Stirling and other archeologists working in the Olmec heartland of coastal southern Veracruz and northern Tabasco continued to discover stelae, pottery, and figurines in what they also believed to be the Olmec or "de la Venta" style, as it came to be called. The evidence suggested more and more to Miguel and his colleagues that the Olmecs predated the Mayans, although this was an idea that many archeologists considered heretical. Stirling wrote:

*The Mexican archaeologists, especially Caso, Covarrubias, and
Jiménez Moreno, became very interested in the new discoveries,
and in April and May of 1942 a round-table conference was
arranged at Tuxtla Gutiérrez, Chiapas. . . . One of the
objectives of the conference was to assemble the characteristic
traits then known as a result of the recent excavations.*[33]

The Forties, Part Two

The Covarrubias Hypothesis.

Another objective of the "Second Roundtable Discussion of Anthropological Problems" was to settle the question of who came first, the Olmecs or the Mayans. Every prominent archeologist of the day was there.

Caso, Covarrubias, and Jiménez Moreno presented their conclusions in the first comprehensive definition of Olmec style, a paper entitled "The Origin and Development of the Artistic Style of the Olmecs." It was, according to Coe, "The first full treatment of the Olmec style . . . worked up directly from the sketches that crammed [Covarrubias's] notebooks."[34] The trio defined a culture as having a certain recognizable artistic style and called the Olmec style:

The very antithesis of the formalized and rigid art of the
highlands or the flamboyant baroque of the lowlands of the
Classic period, both overburdened with religious symbolism
and ceremonial functionalism. On the other hand, its
aesthetic ideology is in the spirit of the early cultures:
simplicity and sensual realism of form, vigorous and original
conceptions.[35]

To back up this thesis, Miguel created an illustrated analysis composed of hundreds of meticulous drawings that charted "how during the fifteen centuries from about 2000 B.C. to 500 B.C. one type [of figurine] evolved out of another and different styles crossbred to produce still others." Specifically, he demonstrated the evolution of Olmec werejaguars (fantastic part-man, part-animal figures) into the rain gods of the Tlaloc of late post-classic Mexico. "It is easy to see the transformation of the stripe on the tiger's lip into the nose pendant of the Tlaloc," he wrote, "and the almond-shaped eyebrows or convolutes, which perhaps represent clouds, into the eye glasses of the Tlaloc."[36]

But, in fact, Miguel's chart is considered problematic, according to archeologist Eulogio Guzmán Acevedo, because although the storm god was one of the most important gods to the Mayans and Central Mexicans, it was less important to the Olmecs, who had plentiful rain. Further, Miguel's chart traces the storm god's evolution into four important cultures: Zapotec, Aztec, Teotihuacán, and Maya and, by placing them side by side, portrays them as contemporaneous. Guzmán Acevedo notes that "stylistically, there are closer ties between the Teotihuacán iconography and the Aztec, just as the Zapotec has closer ties to that of the Maya." He believes that ten or fifteen additional charts would fill in the gaps in Miguel's stylistic chronology.[37]

"All of this, however, does not overshadow the admirable insight which Covarrubias had for tracing the evolution and similarity in form in pre-Columbian art," Guzmán Acevedo continues. "This chart is of great importance because it made scholars broaden their horizons, and seriously returned the question of Pan-American religious systems to the limelight."[38]

Based on Miguel's chart, the Mexican threesome (Covarrubias, Caso, and Jiménez Moreno) proposed that:

The Olmecs had originated many of the basic elements of
Middle American civilization, such as jade-carvings,
monumental stelae and altars, stone vessels, glyphs, mirrors
of hematite, as well as jaguar gods of the earth, the rain, and
the sky, which in time evolved into a multitude of gods,
mythical dragons and monsters.[39]

Caso pronounced their conclusion: "This great [Olmec] culture . . . is without doubt the mother of the other [Mesoamerican] cultures such as the Maya, Teotihuacán, the Zapotec, Tajín and others."[40]

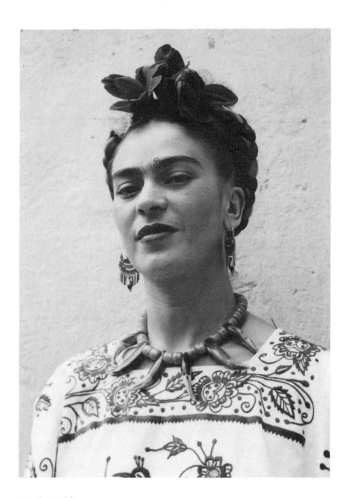

Frida Kahlo.

However, some conferees, led by Sylvanus Morley and J. Eric S. Thompson from Harvard, remained vested in the seniority of the Mayans. In their opinion, the Olmecs were no more than a recent branch of the greater Mayan civilization. To Caso's pronouncement, one of the Mayan supporters shouted from the audience, "If what you say is true then the Maya is the father culture!"[41]

Time has proven the Mexican school correct about the Olmec's antiquity. It is now known that some of the relics which Miguel salvaged from Tlatilco date from 1200 B.C. The conference established five successive cultural horizons in Meso-America, Miguel noted, and he declared that the Olmec would be recognized "as the first horizon" from that time on.[42] It was a victory for the Mexican archeologists, for historical accuracy, and for a once lost culture that could now be classified.

Miguel's fascination with the Olmecs continued throughout the forties, as a collector, of course, but more so as a scholar. In the midst of what seems a maelstrom of other work, he produced another definitive

paper on their art and culture entitled "El arte 'Olmeca' o de La Venta" for the July–August 1946 issue of *Cuadernos Americanos*. He speculated that a continuity of religious tradition may have existed between the Olmecs and the post-classic civilizations, a hypothesis taken up from that point on by many archeologists trying to understand Olmec symbolism.[43] His paper concluded that the Olmecs of the La Venta region practiced an art of great antiquity, not just one of many other local styles, and that the Olmecs had influenced art during the archaic pre-classic horizon, as the scientists refer to it, as well as during the transitional period leading to the classic period, the basis for the Middle American civilization.

Two other papers, "The Political Roots of the Art of Tenochtitlán," and "Tlatilco: The Pre-Classic Art and Culture of the Valley of Mexico," appeared in *Mexico en el Arte* in 1949 and in *Cuadernos Americanos* in 1950, the latter with photographs by the archeological photographer Arturo Romano, a student and colleague of Miguel's.

Of this latter paper, Tomás Ybarra-Frausto wrote:

> *In a creative synthesis full of rich information, [Miguel] articulated his findings within a wide-ranging interdisciplinary focus very uncommon at the time. Starting from aesthetic concerns, moving towards archeology, thence to ethnography, ethnology and history, yet always returning to the archeological data, Covarrubias presented a multifaceted picture of life in the earliest known village settlement in the valley of Mexico. . . .*
>
> *Based on a stylistic analysis of the figurines, he promoted the notion of the co-existence of two social classes in conflict: one belonging to the ancient culture of Zacatenco made up of agricultural workers who during various centuries evolved sophisticated agricultural techniques and ceramic arts. The other group was more urban and sophisticated, perhaps a carrier of Olmec culture. This elite group of artists and priests evolved a more complex culture that later dominated over the agrarian group and laid the basis for the subsequent development of a theocratic system.*
>
> *Beyond his masterful stylistic analysis of the Tlatilco figurines, Covarrubias contributed to the formation of various cohorts of young archaeologists (among them the eminent Román Piña Chán and José Luis Lorenzo). Since excavation and investigation at the site continued until well into the 1970s, various generations of archeological students continued to do their field work at Tlatilco building on the original theories of Covarrubias.[44]*

The eminent Piña Chán had once been a student of Covarrubias, and he too remarked on his mentor's contribution to the collective knowledge of pre-Hispanic

Mexico: "One has only to look at the books written on the Olmecs, several dedicated to Miguel. He inspired those of us he taught." Piña Chán himself, collaborating with Luis Covarrubias and using Miguel's own illustrations, dedicated his book *El pueblo del jaguar* to Miguel in 1964.[45]

On average, 1942 had been a good year for Miguel and Rosa. It was the first year in which they had stayed in Mexico exclusively. It was a year that focused on interiors, identity, and discovery.

But there was also loss. Miguel's mother died of hepatitis in the summer of 1942; she was sixty-three years old. It was a blow to Miguel—to the whole family. Elena Duclaud Covarrubias had been well-loved. She was buried in the French cemetery in Mexico City.

Afterward, Doña Elena's two sisters and her six children with their wives and husbands received the guests and the many family members who came to pay their respects at the house on Zamora Street. Many of Miguel's friends came to stand by him at the reception. Luis Cabrera was there, as well as Alfonso Caso, Carlos Chávez, Jorge Enciso, Harry and Malú Block, Roberto Montenegro, Inez Amor, and Fito Best Maugard. Even the ambassador from the United States, Edward Gatewood Trueblood, came to offer condolences. Doña Elena would have been pleased, and that may have been some comfort to her oldest and favorite son.[46]

It was particularly charming that this man, who knew everything, never passed judgment in a pedantic or ostentatious way. He was a man of rare modesty and scholarly integrity. In his personal order of things, everything reached a significantly greater elevation as a result of this innate quality. Besides a powerful and fresh imagination, his work was founded on strong scientific exactness.[1]

THE FORTIES, PART THREE (1943–1949)

If it appeared that Miguel had found a single focus in his obsession with Olmec art and culture, this was not the case. He continued to collect—his pre-Hispanic pieces filled whole rooms by now—and he continued to sort through artifacts for information and to formulate theory. His work as director of the Institute of Anthropology's project at Tlatilco continued through 1943, but his collecting never stopped. Jeanette Bello remembered that although the Tlatilco collection looked all a jumble—Miguel kept the smaller pieces crowded in velvet-lined cabinet drawers—he "was very meticulous. He had each [piece] placed chronologically. Every one of the figurines was magnificent."[2] At his request, Muriel Porter Weaver spent some days cataloguing Miguel's collection:

As I went along I cleaned each figure. Miguel teased me by saying, "You have washed off all the antiquity." I made a complete card index and glued photographs of each figure on the appropriate card. I worked in the upstairs rooms

which housed his collection, and I left the card index there.
These were all pieces acquired before 1947 and were all of
excellent quality. I completed the index in 1948. Unfortu-
nately, no one knows what happened to it.[3]

But life was not strictly Olmec. In 1943 Rubín de la Borbolla, now director of the School of Anthropology and the School of History, involved Miguel in integrating the study programs for both and signed on Miguel to teach courses in pre-Columbian art, primitive art, and art history, in addition to his ongoing classes in anthropology. Four years later, his teaching credentials would include the creation of a curriculum for a degree in ethnology and an innovative course on museum science and administration, thanks again to Rubín de la Borbolla. (Within a few years Miguel had established museology as a legitimate professional career study.)[4]

Miguel was an unlikely academician, given his very fleeting brush with school, but he is remembered as an inspiring teacher. Arturo Romano told me that Miguel "changed our ideas about Mexican civilizations":

> *Miguel was one of our most stimulating teachers. This in*
> *spite of the fact that he was paralyzed with fear as he stood*
> *in front of his students. He was loathe to begin and often*
> *stuttered. As he lectured, to illustrate what he was describing*
> *he would simply turn to the blackboard and draw: "It goes*
> *something like this. . . ."*
>
> *[He] was very appealing. He put a great emphasis on*
> *the things he told us. He had a remarkable intuition for*
> *hypothesis. Although he did not hold an academic degree in*
> *archaeology, Miguel knew what he was talking about. Very*
> *few teachers had academic degrees back then. They were*
> *autodidactics, but autodidactics who were experts in their*
> *fields of interest.[5]*

Arturo, one of the students who had participated in Miguel's Tlatilco dig, was in on the then new theories regarding the Olmecs. He remembers that Miguel engaged his students in debates in a kind of "think tank":

> *He even went as far as organizing our own small roundtable*
> *that included professors and students alike. He wanted to*
> *clarify our thinking about the Olmecs and make a chronol-*
> *ogy of the figures we and others had found. He relied on our*
> *research and incorporated our findings in his reports. . . .*
> *Miguel gave a lot to his students. He inspired us.[6]*

Miguel loved the roundtable format, but Piña Chán assured me in an interview in Mexico City in 1987 that:

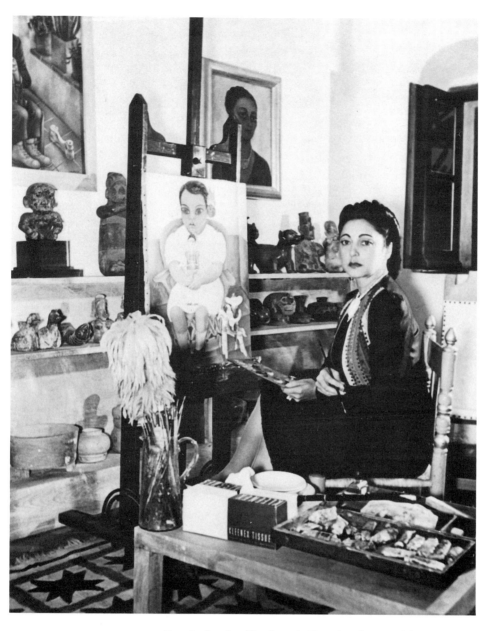

Rosa in the sala *of her home in Tizapán. Photograph by Eliot Elisofon.*

He was not a polemic. If he saw his theories were not accepted amongst a certain group of scholars, he remained silent and became quickly disillusioned. On the other hand, in an auditorium filled with people interested in what he had to say, he would bubble over with enthusiasm expounding on his theories.[7]

The Forties, Part Three 153

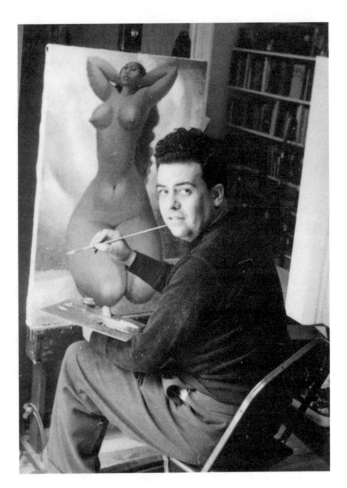

Miguel in his studio. Photograph by Nickolas Muray.

Miguel may have suffered moments of disillusionment, but for Rosa, the whole period of his devotion to academia and of his obsession with the roots of culture, especially Mexican culture, became a period of frustration and growing animosity. She had been his "cape and sword," as María Asúnsolo put it. "If anyone ever criticized or attacked Miguel . . . she defended him like the fiercest bullfighter," and yet now it was she who criticized.[8]

Rosa attended several of Miguel's anthropology classes, sometimes in the company of a friend. "It annoyed Rosa to watch him make these fantastic drawings on the blackboard only to erase them," Mary Anita Loos remembered. "'Why,' she would ask, 'don't you use an easel and paper?'" What she did not understand, according to Loos, was "that teaching was Miguel's way of preparing and finding himself." What Rosa did understand was that their income was jeopardized by his new work. It took Miguel away from fulfilling his book contracts and from what she considered his real talent, illustration.[9]

Rosa nagged that *Mexico South* was still not finished; and given the demands of his other occupations and preoccupations, Miguel's continuing to take on new obligations strikes even a lay observer as compulsive. We can be grateful for this behavior, and at the same time appreciate both Rosa's unhappiness and the frustration of Miguel's publishers. In 1943, Miguel could not refuse the opportunity to mount an exhibition of "Mexican Masks." The Museum of Anthropology would sponsor the work, with Daniel Rubín de la Borbolla, Fernando Gamboa, René d'Harnoncourt, Alfred Barr, Harry Block, Carlos Chávez, Luis Barragan, and Fred Davis as Miguel's co-sponsors. The show would open in February 1944.

Miguel's personal collection of masks had grown considerably since he first wrote on the subject for Frances Toor's *Mexican Folkways* in 1929. Miguel and many of his co-sponsors contributed rare pieces to the show. Miguel loaned masks of stone, white jade, green serpentine, and polychromed wood. Rosa offered a jade mask necklace from her collection (possibly the Spratling piece she had worn at the museum show in 1940) and a wooden mask with crystal eyes and porcelain hands.

At home, Miguel's collection occupied drawers and cabinets and shelves, sometimes several objects deep on the shelves. But for this show, he created space around his masks with vari-colored backgrounds and single spotlights which seemed to magnify each piece. It was an innovative and modern design and received nearly as much attention as the masks themselves. "He demonstrated much audacity and feeling for the modern in his techniques of museum science," wrote Sylvia Navarrete Bouzard, for the *Miguel Covarrubias* catalog, "which changed forever the way exhibitions are mounted in Mexico."[10]

There were other things that kept Miguel constantly behind on *Mexico South* in 1943 and 1944. He couldn't resist a liberal political cause, nor could most of his friends, so there were meetings to attend, speeches to follow, programs to illustrate. In these war years, the Committee of War Relief for Russia was popular among the artist/activists of Mexico City.[11] Rosa was not one of these, however, and she expressed her displeasure. She worried that Miguel's political leanings would hurt their relationship with their American friends. In particular, perhaps, their friendship with the Whitneys and the Rockefellers, especially Nelson Rockefeller.

Rosa and Nelson may have been having an affair during these years. He visited Tizapán in the summer of 1943; Rosa celebrated with a cocktail party one night and an exclusive luncheon on the following day. Carmen López Figueroa reports that they sat together on the piano bench and played "footsie, legsie, and armsie."[12] Nelson stayed for a week in June 1943, and he and Rosa were inseparable for that time. She took him sightseeing and shopping for Mexican folk art to add to his collection, and they visited Roberto Montenegro's studio, where Rockefeller purchased one of the artist's oils.

It is likely that Miguel was present during Nelson's visit, but most certainly preoccupied with work. In any event, Miguel is not likely to have felt threatened by his friend's infatuation with his wife. Men always fell in love with Rosa.

While Miguel's career as an illustrator had been somewhat superceded by his anthropological work, Miguel still earned most of his living as an artist and illustrator, and he continued to be well exhibited throughout the forties—at the Philadelphia Museum's "Mexican Art Today" show in 1943; at the Philadelphia Print Club's "Annual Exhibition of American Lithography" in February 1944; and at the Library of Congress in Washington, D.C., in May 1944 in a show called the "National Exhibition of Prints Made during the Current Year." (Archibald MacLeish was director of the Library of Congress at this time, and he talked Miguel into becoming a consultant to the library's newly founded Hispanic Foundation.) In May 1946 Miguel showed his celebrated lithograph *Lindy Hop* at the Grand Central Gallery in New York and another called *Rumba* at the National Exhibition of Prints at the Library of Congress.

The period saw a boom in art in advertising, as well. In 1943 the De Beers Diamond Consolidated Mines Company launched an ad campaign for which they had solicited the work of various fine artists and for which they created appropriate copy. Miguel submitted a painting of a tropical tree on which was carved "R.R. & M.C." inside a heart. The art and advertising community was charmed. "Without the aid of the text at all one got the whole story," *Art News* effused, "the heart and initials carved on a tree—leading perhaps years later, to an engagement ring."[13] De Beers became a longtime account for Miguel.

Just as Miguel continued to quietly produce and show fine art, he also continued to contribute to the budding commercial art industry, and his resume was impressive—Standard Oil's calendar in 1925; his more recent work for Dole and The Container Corporation; and in the 1950s, his work for the Stephen Lion Company—a South Sea island fabric promotion that Miguel conceived as a luxury book and for which he was paid $2,500.[14]

The year 1943 saw the completion of a decorative wall map of the United States that Miguel produced for the Associated American Artists. Designed for mass production as a teaching aid for school and home use, the original had taken him fourteen months to complete. That the American Artists group had chosen a non-American for this product seemed to require explanation:

> *This famous Mexican artist was selected for this all important commission because only he could make visual and endow with breath, the power, the richness, the humor, the folklore, and the grandeur of the United States of America; for Covarrubias has not only the imagination and skill of a great artist, but has an understanding of the verities and needs all peoples hold in common.*[15]

By the 1940s Miguel's maps hardly needed explanation, however. He had become known for his "unique sensibility" in that form, as Tomás Ybarra-Frausto has said: "Rather than seeing borders as points of division, he envisioned them as a space of contact and communication. Joining ethnological exactitude and artistic originality, he created maps of striking beauty and scientific value."[16]

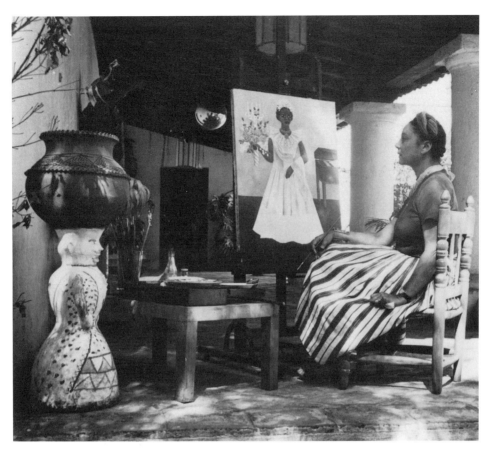

Rosa painting outside in the corredor. *Photograph by Donald Cordry.*

In addition to the map work, "Colarubia," as Miguel was affectionately called by the Henestrosas, provided Andrés Henestrosa with an engraving of Benito Juárez with the Mexican constitution tucked under his arm for Henestrosa's book *Flor y látigo,* published in 1944, about the national hero from Henestrosa's own state of Oaxaca. Also, Matthew Stirling asked Miguel to illustrate a section of an article he was preparing for the Bureau of American Ethnology on "Stone Monuments of Southern Mexico." Stirling wrote that he had "profited greatly from [Miguel's] profound knowledge of the art and archeology of the early cultures of Mexico, in which field he is without question one of the outstanding authorities." Miguel also accepted a commission from *Life* magazine to illustrate the evolution of the operatic story of Carmen, inspired by the drama's current hit on Broadway, "Carmen Jones." Furthermore, George Macy had been in touch, and Miguel had agreed to illustrate Pearl Buck's translation of the Chinese classic *All Men Are Brothers,* by Shih Nai-an, for Limited Editions. Miguel was happy to have another book whose origins were Chinese. Publication was set for 1944.[17]

Meanwhile, Miguel was still musing on North American Indian art and the show with which he had assisted René d'Harnoncourt in New York in 1941. North

American Indian art was virtually unknown in Mexico; Miguel wanted to correct that. Obviously, the person to see was René, by now the acknowledged authority on Indian art and famous for his innovative installations.[18] René was inspired by Miguel's vision, and the two agreed to collaborate on a show that would exhibit North American Indian art in Mexico in March 1945.

Now that the first phase of work at Tlatilco was winding down, Miguel must have felt that he could find the time to do the necessary research for the exhibit. He contacted Henry Allen Moe at the Guggenheim Foundation through the Committee for Inter-American Artistic and Intellectual Relations and secured a subsidy that would allow him to visit collections of North American Indian art in museums and universities in the United States and Canada. The trip would take two months.

Daniel Rubín de la Borbolla had just married, and he and his bride, Sol, decided to join Miguel on what became a combination honeymoon/acquisition trip. Rosa did not accompany them, though it is likely she flew to New York to meet them. The threesome went first to Santa Fe, New Mexico, where they must have stopped to see Georgia O'Keeffe, and then to Albuquerque. Sol recalls:

> *We drove from one place to another, and it started to snow. I was thrilled because I had never seen snow, but it soon turned into a severe storm. You couldn't see out the window, so Miguel got out of the car and walked alongside, directing Daniel.*
>
> *From New Mexico we traveled by train to New York. When we passed through Kansas, the dry law was in effect. It happened also to be New Year's Eve, but Miguel had hidden a bottle of liquor in his compartment, and we were able to celebrate.*[19]

Perhaps it was bad weather that contributed to their arriving in New York forty-eight hours late. Miguel told the Rubín de la Borbollas that he was glad to see such a thing happen in the United States—he considered it scandalous that in "gringo land" everyone always arrived on time for appointments and the telephones always worked.

Nelson Rockefeller threw a party for them all in New York, after which Miguel and Daniel made the rounds of East Coast museums. They went to Chicago next and then to Canada and Alaska. Miguel returned with reams of notes, hasty drawings, photographs, research files, and promises for objects from collections throughout the United States and Canada. (Sol noted, "Both Miguel and Daniel had very good connections and relationships with museum directors, which helped them always to get what they wanted.")

Miguel also persuaded his friends at home to lend pieces to his North American Indian show from their private collections. Alfonso Caso, Donald Cordry, the archeologist and writer Herbert Spinden, and Wolfgang Paalen all contributed. Rosa loaned some choice pieces of her own antique Navajo jewelry, which she had purchased on excursions with Georgia O'Keeffe.

The show was the first of its kind in Mexico and an eye-opener to its audience, who experienced, through the various artifacts' dramatic presentation, an almost palpable sense of the deep, often mystical primitivism that the objects seemed to possess. Piña Chán considered it a demonstration of Miguel's mature talent as a museologist and curator. He remembered:

> By the time he organized this exhibition, all of his innovative techniques had come together. The interior color of the vitrines against which the exhibited pieces or piece stood out, for instance. The lighting, using a simple spot on an object, a matter of focus. Everything was changing: the type of vitrines, the panels, the photo-murals. Everything was revolutionized.[20]

The show started Miguel thinking in terms of the book he could write on American Indian art. Although a new project was the last thing he should have been considering, the idea began to percolate in Miguel's unceasingly creative mind.

By late 1944 it had become clear to George Macy that Miguel was working on something other than Buck's *All Men Are Brothers*. Macy, no doubt with a sinking heart, informed his subscribers in a Limited Editions newsletter that the book would not be available until 1945.

Several months into 1945 he must have wondered if he would have to make a similar announcement again. He wrote to Miguel on April 25:

> Please give me a time that you can definitely meet. Naturally, I am anxious to have the book from you. Actually, I am anxious to have any book from you which you want to illustrate. I consider you a great illustrator, and have had in mind when next we meet to suggest a contract between us by which you would be paid an annual subsidy in return for illustrating a book each year.[21]

But, Macy implored, he had "to feel that you could arrange your affairs so that you could perform the task involved in return for an attractive contract."[22]

Four months later the two men sat down together over lunch and reviewed the titles of the books Macy hoped Miguel could illustrate for him over the coming years. It was a rich list: *The True History of the Conquest of Peru* by William Prescott (not to be confused with Bernal Díaz del Castillo's *The Discovery and Conquest of Mexico*, which Miguel had finally finished for Macy in 1942), *Travels of Marco Polo*, *Travels of Captain Cook*, Sinclair Lewis's *Babbit*, and George Bernard Shaw's *Androcles and the Lion* (Miguel had done the sets for a Broadway production of *Androcles* twenty years earlier).[23] Miguel agreed he would begin work on Prescott's

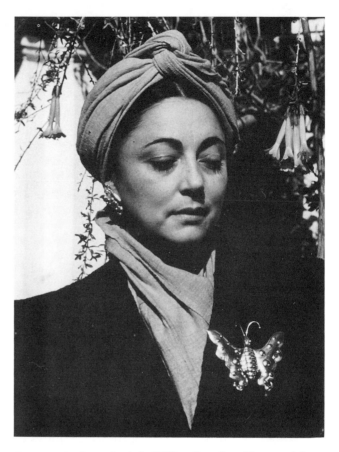

Rosa wearing butterfly pin by William Spratling. Photograph by Nickolas Muray.

True History as soon as *All Men Are Brothers* was finished. Shortly after their meeting, back at Tizapán and perhaps inspired by their conversation, Miguel completed the illustrations for *All Men Are Brothers* and sent them off to Macy in New York.

Mexico *South* was never completely neglected during these years. At home both Miguel and Rosa worked on the illustrative material, his drawings, color plates, and foldout map, and her photographs. (Rosa organized and documented many hundreds of photos she had taken in Yucatán, Veracruz, and Oaxaca as well.) At night Miguel found the time to write. He also made several trips to the States in 1943 and 1944, both with and without Rosa, but always with his *Mexico South* manuscript in whatever stage of development it might be. During these visits he worked with an editor/typist, Rachel Knobloch, wife of Nettie King's brother Stan, to prepare a final draft for the publisher. For Rachel, it was an experience quite unlike any other.

Miguel could not just sit down and begin to work, she recalled.

First you had to play Ping-Pong or shoot darts into the
target in the fireplace. It was very important that Miguel
should win, although he was good-natured if he lost. . . . We
worked for two hours, and then we would stop. He always
had music playing when he worked, and he was never
without a cigarette or a cup of coffee.[24]

Frequent visitors caused interruptions, as well, Rachel told me. Alexander King would stop by, and Miguel would recite some silly off-color joke, to which Alex responded with a scathing critique of the joke itself, the telling of it, the kind of person who would repeat such a bad joke, and so forth.

There was a lot of laughter. "I remember Miguel was always giggling," Rachel said. That giggle was almost a trademark of his; Nettie and Alex's son, Robin King, who was a child when he knew Miguel, still remembers it as "a silly little girlish giggle . . . like the falsetto of a mariachi."[25] Silly, but apparently endearing. Fernando Gamboa described it:

Almost like a vague tic, he would throw his head back,
emit a nervous little half-laugh, and frantically glance at his
wristwatch. His head to one side, lips rounded in a perpetual
smile, he looked like one of his beloved Olmec idols.
 This smile said many things. It expressed his excitement
over a discovery, his approval of an exact idea, delight over
a ridiculous occurrence, pleasure because of a personal
success or someone else's, and even a kind of desperation
over a stupidity or an evil act.[26]

When Miguel came to New York with Rosa, they stayed at the Barbizon Hotel; if he came alone, Nick Muray put him up, and Rachel reported to work at Nick's apartment, a large two-story duplex at 230 East 50th Street. "When Miguel came to New York without Rosa," Rachel recalled, "he would do a lot of playing around."

Rachel was in her early twenties, newly married, and, by her own admission, naive. Nick and Miguel seemed like very sophisticated ladies' men. Rachel and I tried to define Miguel's appeal in our interview. After all, as Robin King described him, "Miguel always seemed a little too fat for the clothes he was wearing. The buttons on his jacket pulled against the cloth. He had a soft face. . . . [But] there was a boyish charm about him that made him beguiling to women." And Rachel remembered that Miguel was shy and easily embarrassed, which might have made him especially sensitive to how others, especially women, felt. "He was incredibly gracious," she told me.

Miguel was also a genuinely sweet man. John Huston saw that, also, and spoke of it many years later:

There was something so dear about him. You really wanted
to embrace him. It wasn't so much that Rosa was the

Rosa with Mary Anita Loos, writer and niece of Anita Loos.

*dominant personality, but Miguel was exceptionally modest.
It wasn't that he was in any way retiring, or in a world of his
own, or secretive, but private. He had his own distinctive
way of looking at things. He was wonderful to talk to. . . .
He had a great sense of humor.[27]*

These qualities appealed to almost everyone who met Miguel, but in these
years, Rachel says, "I remember mostly women coming and going. At the time he
was very much attracted to two Oriental girls, a photographer and a dancer."

We have met the photographer previously, in Miguel's letter to Nick Muray
written several years earlier. The dancer was the ballerina Sono Osato, of Irish,
French, and Japanese descent, twenty-three years old—just the kind of exotic
beauty Miguel appreciated most. They had met in New York in the late 1930s. Later
Miguel painted a portrait of her that appeared on the cover of *Theatre Arts*
magazine. Sono planned a trip to Mexico that summer of 1943, where Miguel hoped
he would see her; but when she went to renew her passport, she was told she could
not leave the country. She was Japanese, and those were times of war.[28]

Miguel with Roberto Montenegro.

In Mexico the war's impact was mainly economic, beginning in the fall of 1939 when Europe went to war, effectively cutting off trade routes with Germany and the substantial import/export business Mexico had enjoyed with that country. Dealing with the United States was far more costly. There was a great deal of anti-American and anti-English propaganda in Mexico during this period, encouraged by numbers of German Nazis in the country trying to negotiate business deals. Sizable numbers of Spanish loyalist refugees and communist sympathizers streamed into the country as well, and in the midst of all this Leon Trotsky was murdered in Mexico in 1940 by a man who had insinuated himself into Frida Kahlo's confidence and perhaps gained access to Trotsky through her. (Three months before, David Alfaro Siqueiros was one of several Stalinists who had tried unsuccessfully to murder Trotsky, for which he was jailed and later exiled. After the assassination, Diego Rivera and Frida Kahlo both came under suspicion for having befriended Trotsky.)

It is likely that Trotsky had visited Tizapán at one time or another, but Miguel was not an activist in the same way his friends were, and he would not have participated in such high-stakes skulduggery even if he were. Rosa would not have allowed it.

Several months after Miguel delivered the original art for *All Men Are Brothers*, Macy returned the reproductive plates for his approval; but Miguel did not approve. He insisted on redoing the art entirely. In a statement that accompanied the book when it finally did come out—in 1948—Harry Block wrote:

> *Nearly any other, having completed a series of illustrations, would have gone on to other work; or would, at any rate, have paid us the compliment of being too much afraid of us to insist that we throw away our expensive reproductive plates.*
>
> *But not Miguel! In a moment of vexation and irritation, he said, "I am not going to be satisfied with these drawings of the Chinese people until I have succeeded in making a series of drawings which might have been made by a Chinese."[29]*

Again, Macy issued a postponement to his subscribers. But at this point, Miguel was very nearly through with *Mexico South* and was devoting his time almost exclusively to its completion. Exclusively, that is, except for another assemblage and installation at the Museum of Modern Art in New York with René d'Harnoncourt, the illustration of the book that would accompany it, and an article he had promised *Vogue* to coincide with the show. This was the "Arts of the South Seas" exhibition that would open in January 1946. By the end of 1945, Miguel was in New York and working day and night, but not on *All Men Are Brothers*.

"Arts of the South Seas," organized by d'Harnoncourt, anthropologist Ralph Linton, and art historian Paul Wingert, was in Miguel's words, "the most important and comprehensive exhibition ever assembled on the subject." Again, the installation was innovative and dramatic. Space and color served to distinguish objects and to connect them. Walls were staggered, removed altogether, or lowered to one-third their original size to allow exciting vistas to open one from another. The walls were "painted in contrasting colors—red, green, yellow and white . . . not merely for decorative purposes, but primarily . . . as symbolic aids to the visitor."[30]

Visitors who rode up the two floors from Manhattan's city streets entered:

> *The dark green of the jungle, the clearing where the sun filters in, the yellow sand color and red rock of the Australian desertland, and the brilliant white light of the coral islands [which] all serve as background for . . . ancestral figures, ceremonial masks, adzes and clubs of jade, bone and carved wood, canoes, combs, jewelry of shell and tortoise shell, and hundreds of other beautiful and fantastic objects.[31]*

Bamboo poles supporting primitive masks stood alongside objects in glass cases. A journalist reported:

> Some objects are seen in dramatic settings of foliage and textured sand with vivid crosslighting, while others are seen in sunnier, more open space. What emerges from the exhibition is the astonishing and inexhaustible fertility of human genius.
>
> ... open vistas from one section to another [were placed] wherever there is a close relationship between objects.[32]

This hugely successful show spotlighted a year of extraordinary achievements. The show had opened at the end of January in 1946, and that fall Miguel had the satisfaction of seeing *Mexico South: The Isthmus of Tehuantepec* in print, four years later than promised, but a larger piece of work than anyone could have predicted.

The reviews were unanimous. Diego Rivera wrote: "Covarrubias gives to his data such simplicity, good taste and literary value, making it so attractive and easy to read, that this work of erudition becomes a tasty cocktail, the tang and flavor of which provoke the urge for a trip to Mexico." The *New York Times*' Charles Poore declared, "This is one of the handsomest books of the year. The color, the grandeur, the misery and the inexhaustible life of Mexico flow through these pages." And another reviewer, Mary Butler, concluded, "[the] book fills a gap in the literature on Mexico by giving us a well-rounded, vivid, objective account of an unrecorded area. It is beautifully planned and printed, carefully annotated, and cannot be too highly recommended."[33]

The book sparked controversy among the ranks of dedicated anthropological and archeological scholars, however, some of whom classified Miguel's work as "romantic," by which they meant unscientific—perhaps because the material was so readily understandable, appealing to the senses as much as the intellect.[34] Miguel was indeed a romantic. A good example occurs in his treatment of the two most popular local *sones*, or cultural anthems, of the isthmus:

> We attempted to have them written down by Zapotec musicians who could read notes, but the result was appalling; all the melancholy delicacy and the wild ad-libs we admired in the local orchestral versions were gone. Instead we were presented with commonplace umpa-pa tunes in which the melodies were recognizable enough, but lacked completely the style and character of the originals. Our friend, the Mexican composer Carlos Chávez, long familiar with the music of the Isthmus, came to the rescue and gallantly wrote arrangements of the songs to transpose the spirit of the orchestrations to the more convenient piano.[35]

Miguel dedicated the book to Rosa. By the end of the fall publishing season, newspapers announced that *Mexico South* had topped sales nationwide among all other non-fiction books in its price range for that season.[36] Also, Knopf signed a new contract with Miguel for the North American Indian book he had been thinking about now for some years. It would be called *The Eagle, the Jaguar, and the Serpent*. Miguel promised to deliver a finished illustrated manuscript in mid-1948.

Meanwhile, he was engaged in what may have been the most rewarding accomplishment of 1946. Miguel's work at Tlatilco had opened a door in his mind that had led him to the Olmec civilization. Now he stepped through another door into history and found himself in the Mezcala River Basin in the state of Guerrero. He believed he had found the Olmec's origins, based on the theory that "among the most important and characteristic Olmec traits are the cult of votive stone celts and the unique development of anthropomorphic stone axes." And this was the case with Mezcala, as art historian André Emmerich points out in *Art before Columbus*.[37]

Miguel opined that "the Balsas River contained the source of Olmec jade in ancient mines that are still unknown, and that a major Olmec site would someday be found in these remote areas." He presented his first paper on the relics found there at the Fourth Roundtable of the Mexican Society of Anthropology, an assemblage of Mexico's great archeologists—Alfonso Caso, P. Drucker, G. F. Ekholm, Ignacio Marquina, W. Jiménez Moreno, Arturo Romano, and A. V. Kidder. His paper was called "Topology of the Industry of Carved and Polished Stone from the Valley of the Mezcala River" and is considered a major contribution to Mexican archeology. It was published two years later in *El occidente de México*.[38] Miguel felt strongly that exploration should be undertaken in Guerrero to broaden the understanding of Mexico's cultural legacy.

Mezcala sculptors distinguished themselves by carving in extremely hard stone with a technique referred to as "polishing stone." Mezcala objects, mostly male figures and miniature facades of colonnaded temples, were carved out of a stone celt and possessed a modern abstract quality and a religious/magical aspect that appealed to Miguel—and many surrealist collectors. The typical piece was an anthropomorphic axe-shaped stone, similar to the "Kunz-axes" found in the Olmec heartland, with incised decorations or a highly polished celt-based votive figurine. Many figures are tied back to back. André Emmerich mentions one such piece in the Covarrubias collection: "Two tiny human figures still tied together and wrapped in the cloth in which they were buried."[39]

In an interview, Emmerich told me that he and Miguel had "invented that name [Mezcala]. I liked it because it encompassed many things—the river, mescalin, magic!"[40]

Not all that Miguel attributed to the Olmec and Mezcala traditions remains viable, but considerable credit is given to him as a pioneer and landmark discoverer of the two cultures. At the conference "On the Olmec Presence in Central Mexico" in April 1987, Gillet G. Griffin of Princeton University opened the meeting with these words: "Covarrubias was a titan, one of the greatest men of Mexico. Everyone who knew him speaks of him with great warmth. This conference pays tribute to him and everyone he inspired."[41]

Nickolas Muray and "Mimi" (Michael Brooke Muray) with her godfather, Miguel, 1943. Photograph by Nickolas Muray.

Poor George Macy, meanwhile, had written to Miguel in June 1946:

> *Now I know it is difficult for you to send me a letter, especially since your letter would have to be an embarrassed one. So I ask you instead to . . . send me a telegram to tell me . . . either that you have actually completed the illustrations for* All Men Are Brothers, *or that you will now agree to push this job aside and turn out the Prescott pictures which ought to be so much easier for you. . . . P. S. Both Nettie King and Ben Grauer, in my house last night, bet that you would* not *send me the telegram!*[42]

Nettie King and Ben Grauer won their bet. Macy sent a telegram himself in November: "Am very anxious for news of your progress. Don't be afraid to tell me the truth because I can stand it and meanwhile I send love to Rose and to yourself."[43]

But Miguel did not respond until early in 1947, when he could say he had once again finished the first phase of the work on *All Men Are Brothers*—the publisher still had to produce plates for Miguel to color. Meanwhile, Miguel had plunged headlong into two new projects, neither of which was *The Eagle, the Jaguar, and the Serpent*.

Until 1946–1947, Mexico's Museum of Anthropology was little more than a warehouse in which ancient objects were stored at random or exhibited in crowded, ill-lit vitrines that measured no more than two meters high. Objects were identified by means of a slip of typewritten paper placed alongside.[44] Daniel Rubín de la Borbolla must have appealed to Miguel's sense of propriety and history to convince him to reorganize the space. René d'Harnoncourt encouraged him and promised to help, and Miguel's students of museology became an eager crew.

Miguel and his crew catalogued everything on exhibit and in storage, which took six months. They arranged all stored pieces by pre-Hispanic culture and divided the viewing halls into permanent and temporary spaces, creating a traffic pattern that would lead visitors from the origins of man, through the settlement of America, and then into Mexico's great old civilizations. Miguel made sure that all available forms of Indian art were represented. Seeing that he had only a few Jaina Island objects, typical of a specific period of Mayan culture, he wired his former student Román Piña Chán in Uxmal to procure some.[45]

Miguel designed cabinets, color panels, and spot lighting to enhance his displays. He used large-sized graphics, maps, photo-murals, and cards for identification. Visitors surged to the museum when it was completed in 1948 (although Miguel continued to work on it until 1954), and he blushed at the praise lavished upon him—for his "global concept" and his modern display techniques, still in evidence at the National Museum of Anthropology in Mexico City today.[46]

New project number two in 1946–1947 was really two separate commissions, both as satisfying as his museum work. The new, very elegant Hotel del Prado, then under construction on Juárez Avenue, had asked Diego Rivera, Roberto Montenegro, the painter and set designer Gabriel Fernández Ledesma, and Miguel to paint various murals throughout the hotel. Miguel provided two large wall maps for the reception area: one of a "traditional" Mexico illustrating the country's "natural assets and the historic points of interest . . . principal structures that survive from early Mexico and from the Colonial Period," the other, "present-day Mexico . . . modern cities tied together by highways, railways and airways."[47]

"He used an unfinished salon in the hotel for his studio," one newspaper interviewer reported:

> It was filled with such things as research books, paints, sketches, jewelry, costumes, a radio, maps and even a cot to take a nap on. There were many different kinds and colors of maps, nearly all painted by the artist in preparation for the mural. There were sketches of mines, of crops, of trains, of mountains. . . . It took him a year to prepare to work on the mural.[48]

Miguel used several assistants in the production, including Doreen Feng (daughter of the Chinese Ambassador), Arnoldo Martínez Verdugo, who worked

on the project for most of 1947, and Miguel's brother, Luis, who began to work almost exclusively for Miguel from this time on. Luis had studied biology in school and earned a degree in that subject, but he had a distinct artistic talent and sensibility as well—he had helped Miguel with the artwork for *Mexico South* and was now assisting with sketches for Miguel's North American Indian book.

I spoke to Arnoldo Martínez Verdugo in July 1992. He commented on how important Luis became to Miguel because the younger man knew his brother's technique so well and could maintain consistency among the several artists working. Martínez Verdugo also remembered that Miguel was suffering severely from an ulcer in those days and had put his faith in a remedy the American actor John Garfield recommended—liquid yogurt.

Martínez Verdugo told me:

> It was very nice to work for Miguel because he was so simpático. We prepared the panels for the murals on the mezzanine while Diego painted his downstairs. Wherever Diego worked, he put up a sign he had painted showing the head of a toad with tears falling from his eyes. This was his "no smoking" sign, which amused Miguel but didn't stop him from smoking. . . .
>
> I especially liked working alongside Doreen Feng. . . . Like Diego, Miguel had many visitors. I remember meeting Xavier Cugat . . . who was living in Mexico with his wife.
>
> Sometimes I would join Miguel and Diego for lunch. Miguel liked to go to a small neighborhood Chinese restaurant that he knew well. He would call the chef, who was his friend, and order special dishes. [Over lunch] Diego and Miguel would argue over who had the best formula for painting frescoes. Once the argument grew heated, and Diego went to test the resistance of Miguel's work by running his thumbnail hard across the painting. Nothing happened! There was not the slightest scratch mark![49]

The finished pieces were nine-by-four meters and hung on either side of the elevator in the hotel lobby—prime positions. Miguel received $500 for each. (They were destroyed in the great earthquake of 1985.)

At the same time, Miguel was painting a third, larger mural, twenty-five-by-six meters, for the bar of the Ritz Hotel, another grand gathering place in Mexico City located near the Zócalo, or city plaza. The painting was entitled *An Afternoon in Xochimilco* and depicts a boatful of Mexican men and women (including the same implacable character featured in Miguel's painting *The Bone*) enjoying the floating gardens of Xochimilco, while a typical American couple photographs them from another *chinampa*—a rectangular craft like an English punt with a cloth cover.[50] (The mural still hangs in the bar at the Ritz Hotel.)

Miguel, Nickolas Muray, and William Spratling. Photograph by Nickolas Muray.

Rosa wrote to Nelson Rockefeller in August 1947 that Miguel was deeply involved in the Tlatilco excavations:

> *Some lovely things are coming out and some horrible*
> *skeletons. Besides all this, Miguel is painting (half the night*
> *included) his maps at the Hotel Prado, illustrating Eleanor*
> *Lothrop's new book called* Throw Me a Bone, *and*
> *Prescott's* History of Mexico, *and the art books from Alaska*
> *to Patagonia [his North American Indian Art book]. I am*
> *working on my cookbook for the Heritage Press.*[51]

Nelson visited Rosa and Miguel at Tizapán that same summer. One afternoon they sat together in the gallery after lunch, and the conversation turned to archeology. Rosa recalled that Miguel told Nelson, "Almost anywhere you put your finger on a map of Mexico, the chances are if you dig there you will meet with success." Rockefeller was skeptical. Rosa got the map, and with his eyes shut, Nelson put his finger on a spot. It was Palenque, a tiny place on the Tabasco border in one of the many unexplored regions of Chiapas.[52]

For Rockefeller it was not a joke. Upon his return to the States, he arranged to put together $20,000 for a three-year program to explore the site, after which,

it was agreed, the Institute of Anthropology and the state of Chiapas would assume the financial obligation to continue. Work began that winter, with a bevy of interested collaborators and consultants, among them Miguel, Alfonso Caso, and Mayan expert Alberto Ruz, who was charged with reconstruction of the pre-Hispanic buildings uncovered there.[53]

To get into the area required forest clearing and road building, but Miguel had been right in predicting success for an archeological endeavor. Palenque turned out to have been one of the premiere sites of the classic Maya civilization. Some temples had already been discovered there, but the area had never been thoroughly explored or excavated until Rockefeller undertook it. Then a complex of temples was revealed, among them the temples of the Sun, the Inscriptions, the Cross, and the Foliated Cross, named for the carved bas-reliefs inside each temple and for the stucco modeling adorning each temple—considered some of the finest examples of Maya-style relief. In 1949, Alberto Ruz lifted some stones in the floor of the sanctuary of the temple of the Inscriptions and discovered a stairway, filled with rubble, that led to a "sumptuous burial chamber" seventy-five feet below. "Inside lay a skeleton of a Maya high priest with a mosaic jade mask covering his face, surrounded by offerings of jewels and jade." The thrilled team of excavators named him Pacal.[54]

Miguel came down to the site only infrequently—in addition to everything else, he had accepted two more teaching assignments with the National Institute, one on pre-Hispanic art and one on primitive art—but Rosa was very involved in the project. (She spent three consecutive summers at Palenque assisting Ruz in the mid-1950s.) She wrote to Rockefeller about her first visit:

> *Will you believe it, this is the first time I've seen*
> *Palenque. I can't tell you how wonderful it is. It is probably*
> *the most impressive of all the ruins, as the jungle closes in on*
> *all sides. Tall mountains form a backdrop and the monu-*
> *ments face a sea of jungle as far as the eye can reach.*
> *Monkeys howl all day long and in the morning toucans and*
> *myriads of other birds play in the trees in front of the camp.*
>
> *It is not easy to work here. The humidity is terrific, but*
> *the small Maya men seem never to tire. A beautiful river*
> *flows in front of the ruins and when work stops, they make*
> *for the river like children at play. . . . Everybody works with*
> *caution of the dreaded Fer de lance and the rattlesnake.*
> *Wasps are in every crevice.*
>
> *I could go on forever raving about the location. All in all*
> *it is proving more exciting than we dreamed, when you first*
> *had the idea to work here.[55]*

Rosa "discovered a palace wall and several small art objects during her explorations" at Palenque.[56] I think she felt, and rightfully so, a sense of pride and pleasure over the actualization of a dream that had been served up for dessert at her own table.

In October of 1947, George Macy had the new plates for *All Men Are Brothers* ready for Miguel to color. Macy wrote:

> *Please be a good little boy now, and color these proofs the minute you get them. I am enclosing a special envelope for that purpose, with an addressed label; I am unable to acquire the Mexican stamps, or I would put the stamps on for you, too! . . . If this sarcasm does not amuse you, possibly you will be moved by the most violent threat I can think of. This is, if you do not let me have the colored proofs promptly, I will have the plates colored by somebody else and published over your name.*[57]

The Pearl Buck translation of *All Men Are Brothers* was received with great enthusiasm early in 1948. (Miguel's friend, the author Lin Yu Tang, wrote the introduction stating that this book was one of four or five Chinese masterpieces.) Miguel had succeeded in "making a series of drawings which might have been made by a Chinese," as he had hoped. Buck wrote to Macy: "What a magnificent piece of production it is! If I had foreseen or been able to imagine any such glorious end to the long and difficult job I began some twenty years ago, it would have lightened my labor, when there."[58]

With the publication of *Mexico South* and *All Men Are Brothers* behind him and the work on Palenque begun, Miguel returned to Tlatilco and the digs that he had overseen for the National Institute of Anthropology earlier in the decade. There was much more to be discovered, and the Institute agreed to undertake a second phase excavation if funds could be found to support the work. Miguel contacted Paul Fejos, director of the Viking Foundation, a United States–based institution devoted to scientific, charitable, and educational purposes, for whom Miguel had designed a commemorative medal in 1947.[59] No one really expected the American foundation to support this foreign project, but it did, and the National Institute launched a full-fledged scientific excavation. At the helm was Rubín de la Borbolla; his second-in-command was Miguel Covarrubias.

This second phase of exploration was a much more extensive operation than the first phase had been, and Rubín de la Borbolla made it an invaluable learning experience for the Institute's students of archeology and physical anthropology, who were thrilled at the opportunity for hands-on lessons and on-site study and collaboration with the highly regarded Miguel Covarrubias. Among these students were Arturo Romano, Román Piña Chán, and Muriel Porter Weaver, who had received a pre-doctoral fellowship from Columbia University in New York in order to work with the Mexican team.[60]

During this phase two dig, Romano devised his innovative system of photography which enhanced identification of archeological finds. Although his method — shooting a one-eighth section of the subject at a time and enlarging these sections

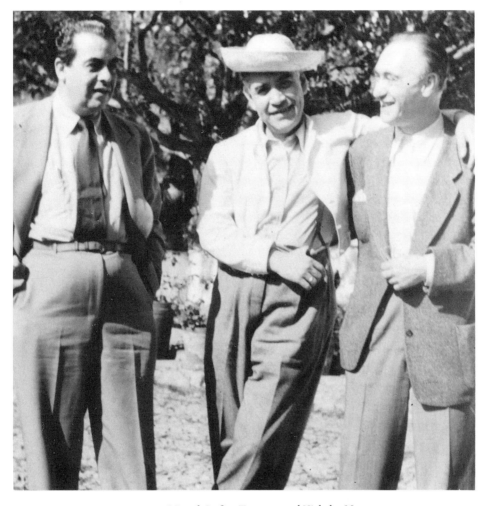

Miguel, Rufino Tamayo, and Nickolas Muray.

for study and detailed comparison—was roundly criticized by other schools of archeology, it proved more successful than previous methods, and it became the standard technique for such study, even among those who had previously criticized it.

Romano spoke to me about those days at Tlatilco. He recalled:

> *We had a little red jeep we nicknamed "The Red*
> *Bedbug." I was fortunate to be able to drive [Miguel] around*
> *because I always learned something important from these*
> *few extra minutes with him.*
>
> *Surprisingly, Miguel always wore a tie and suit. I have*
> *a photograph . . . taken around 1949, showing him with his*
> *eternal smile contemplating a figure from a newly uncovered*
> *site. Miguel is dressed in his grey flannel suit with tie and hat*
> *and the always-present pens in his coat pocket. He also*

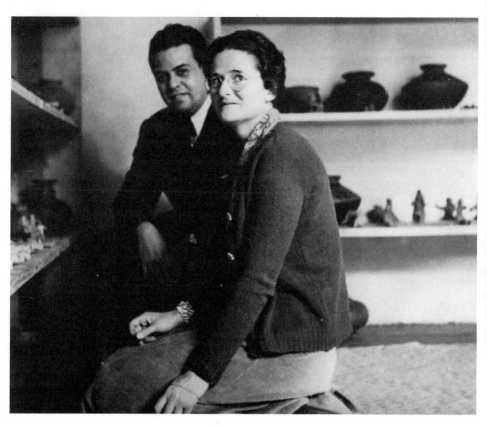

Miguel working on his collection.

carried a notebook with him to make sketches. . . . When he no longer had any pages left, he would draw on any scrap of paper, including napkins at lunch. . . . As students, we fought over these scraps of paper, or eagerly lent him our notebooks. It was a sure way of owning an original Covarrubias sketch.[61]

Miguel is described as shy in his role as teacher, but his enthusiasm over his subject always overcame his stage fright. Vidya Peniche, his secretary in those days, recalled that even after so many years, Miguel still suffered when he had to speak in public. A sheen of perspiration bathed him, and his hands grew clammy. "I would always ask him, 'Miguel, aren't you confident about your subject?' And he would say, 'That's true,' and go out and face his audience. In the beginning his words seemed to stick, but once he began, his ideas ran like a river."[62]

Sometimes Miguel invited his students to Tizapán for lunch to show them objects from his collection which related to the finds they were making at the time. When we spoke in 1987, Romano still remembered a crocodile consisting of three connecting links carved from a single piece of green jade. But this was only one of many exceptional jade pieces and necklaces from Tlatilco that Miguel owned.

Miguel spent much of his time during the late 1940s fending off new obligations, sometimes regretfully, as in the case of his old friend, Ruth Page, who proposed that he design scenery and costumes for the ballet "Billy Sunday," which she was choreographing for UNESCO, to open in Paris.[63]

Miguel had ended his collaboration with *Vogue* in 1946 and would terminate his contract with *The New Yorker* in 1949. He also said no to a children's edition of *Androcles and the Lion* for Heritage Press—he still owed Macy the illustrations for Prescott's *True History of the Conquest of Peru*. And he declined a six-book proposal from Penguin Books.[64] He was offered a summer session teaching post at the University of California at Berkeley and a Walker-Ames Professorship by the University of Washington in Seattle—in fact, his course at Washington, "Ancient Mexico and Central America," was listed in the school's catalogue for 1949. But Miguel never did show up to teach. Nor did he respond to repeated efforts to contact him by a Seattle gallery owner. Melvin Kohler, director of the Henry Gallery, finally wrote to the Container Corporation of America, for whom he knew Miguel had worked in the past. They replied:

> We have had little success in contacts we have made with [Covarrubias] in that he seems to make a point of not answering letters or telegrams. He seems to be a law unto himself. Charlie Coiner reports that we have to be rather discouraging on the possibility of locating Miguel Covarrubias. . . . since Covarrubias has taken up archeology, he has become disinterested in the subject of art to the point where he will not answer letters or give any address. Charlie cornered him several years ago in a hotel and gave him a commission, and had a definite agreement on the delivery of a painting. He has not been heard from since, nor was the painting delivered. Good luck in your pursuit of the elusive Mr. Covarrubias.[65]

The numbers of people whom Miguel "stood up" in this way were becoming legion. *The Eagle, the Jaguar, and the Serpent* was to have been in Knopf's hands by now, and Miguel had been avoiding the eager, and then anxious, inquiries from Herbert Weinstock, his editor there. In December, Weinstock wrote:

> You are a charming fellow, a great archeologist, a great painter, and everything else that is good. But you are one hell of a man to do business with. I don't know even if you are in Mexico, or Bali, or Seattle. We have passed the last date for deliverance of your book. We are, in short, in a mess![66]

Miguel was shaken by the letter and, with uncharacteristic quickness, responded directly to Alfred Knopf:

I feel like a man who has suddenly awakened from a state of hypnosis. . . . I'm shocked that I let it come to this situation. I cannot explain what happened—perhaps overwork, personal problems, economic difficulties. . . . Perhaps it was the result of neglect, repeated over and over for more than four years, until it grew into a complex which I could not overcome.

How many times I have come home with the deliberate intention to write a long feeling letter, then I distracted myself. . . . The more time elapsed, the greater the sense of guilt and the more difficult it became to attend such vital matters as a business letter. Sometimes I rushed to send a wire that would avoid giving explanations, or at worst, I did nothing . . . a form of hiding from myself, to pretend to ignore my sense of shame.

It has been quite painful to realize this. I shall do all I can to organize myself and overcome this complex. . . . I shall immediately attend to the proofs, etc. I hope you and Herbert forgive me, even if I do not deserve it.[67]

However, it would be four more years before *The Eagle, The Jaguar, and the Serpent* saw print.

CHAPTER 10 *He devoted himself to ideas, to works and to
people, with unending generosity. Without a
thought that such unselfishness and enthusiasm
merited acknowledgement or recompense, he was
generous to a flaw with his person. He had the
ability to recognize another's potential, and noth-
ing gave him greater pleasure than to contribute to
the awakening and development of a person's
talent; be he scholar, artisan, popular musician, or
young artist. Because of this he often dissipated
himself to the detriment of his own work.[1]*

THE FIFTIES, PART ONE (1950–1952)

The phase two excavation of Tlatilco had been completed in
1949, and although exploration continued, Miguel's involvement had ceased for all
practical purposes. Now, aside from his teaching, he was free to devote himself
earnestly to Knopf's book; but in early 1950, Trygve Lie, secretary general of the
United Nations, asked him to sit on a four-member board of advisors who would
select art for the United Nation's new headquarters in New York City.[2] Miguel made
a quick trip to Manhattan to participate. Although he did not know it at the time,
it would be his last trip to the United States.

When he returned home, it was with a new dedication to wrap up *The Eagle,
the Jaguar, and the Serpent,* which he was beginning to think of as the first of three
books he could produce over the course of the decade. *The Eagle* studied North
American Indian art: Canada and the United States, including Alaska. A second
book would focus on Indian art of Mexico and Central America, for which he had
already gathered copious material over the years. The third book would be on
Indian art of South America. He considered the project manageable within a ten-
year time frame, as most of the research was already done. He was excited by the

prospect, and he excited Knopf in it as well. They agreed to produce his trilogy, and Miguel resumed his work enthusiastically.

But, alas! Just as he was beginning to make some progress with the writing, Carlos Chávez telephoned with a project which took Miguel off in a completely different direction.

Chávez was then director general of the National Palace of Fine Arts, or *Bellas Artes*, as it was called. This was the monument to himself that Porfirio Díaz had built during the "beautification" phase of his presidency. The neo-classic complex now housed a sumptuous opera house, a concert hall, a museum of popular arts, a painting gallery, and exhibition salons. Its *pièce de résistance* was the famous Tiffany curtain (designed especially for the great stage—at a cost of $47,000—and still in use) patterned after a painting by Dr. Atl, on which Mexico City's two dominant volcanoes, Popocatépetl and Ixtaccíhuatl, glitter in the changing light. Chávez wanted to add an Academy of Dance to Bellas Artes, and Miguel was his first choice for artistic director and director of administration. It was a bold and controversial choice, Luis Covarrubias remembered. "Many were asking, 'How could a caricaturist/painter be given such a position?'"[3]

In fact, the choice was inspired. Miguel understood dance from the perspective of an anthropologist, with a depth few could match. Over the years he had recorded in sketches and in sixteen-millimeter film the ethnic dance traditions of Harlem, Cuba, Bali, Java, Cambodia, and the South Pacific, not to mention dances peculiar to the Isthmus of Tehuantepec, Tuxtepec, Tepostlán, Pátzcuaro, Janitzio, Tajín, and Acapulco. Reading his sections on dance in both *Island of Bali* and *Mexico South*, one becomes aware of Miguel's obvious fascination with the subject and his broad knowledge. He was particularly fascinated by ecstatic dance, in which the dancer becomes entranced and achieves a kind of mystical ecstasy. He had witnessed this phenomenon in initiation rites in Cuba, Bali, and Anam and Tanjam in Southeast Asia. He had seen the evangelist Father Divine evoke it in his revival meetings in the thirties and forties in the United States. In Mexico, the Huicholes and the Coras in the northwest had such ritual dances, as did the Chamulas in Chiapas in the south. Dance was the magic key. Dance could unlock a door to pure spirituality.

Katherine Dunham recalled that whenever Miguel was in New York when she performed, he came to see her; and she saw a lot of him in 1948 when she was in Mexico dancing and teaching. Inevitably, when they got together, their conversation turned to the relationship of dance to spirituality. Miguel, a staunch atheist, found in dance a palatable form of religion. For Miguel, dance was far more than mere performance art.[4] But, of course, it was that too—and staging, dramatic presentation, costume, and design, all talents that Miguel possessed. And what he lacked, Rosa could supply. She was delighted at the prospect. Dance was her métier, where she shone, where she could prove valuable to Miguel in a way she had not felt for a long time.

Rosa had been in charge of Miguel's life once, but that was back in the days when Miguel was primarily an artist. Somehow she had lost control when Miguel became a historical scientist. John Huston told me, "It was a kind of wonder and

something I greatly admired him for, that he was able to forget his painting and devote himself to historical pursuits."[5]

Rosa never really appreciated Miguel's pioneering role in the new science of archeology, and she was resentful of his devotion to the study of anthropology. She was also still in charge of their finances, and she knew one thing for certain: neither archeology nor anthropology paid the bills, and they were suffering financially. His ancient figurines did not contribute to their bank account, nor did his adoring students or his museum shows.

If Miguel would just stick to his books and illustration, life would be so much easier. He was successful there in a way that Rosa understood—he earned money—in fact he was successful in large measure because of her focus and dedication, according to many of their friends. Dorothy Cordry told me, "I envied the way she was able to market his work. Miguel was very disorganized, but Rosa centered him."[6]

But Vidya Peniche told me quite candidly that Miguel "wasn't interested in making money. He lived by the day. For him wealth was to own an anthropological piece that he liked. He used his own art to pay for other art or services—the barter system."[7]

Miguel felt no conflict or problem in the choice of anthropology over painting. His scientific peers noted that he reconciled the two by becoming a scientist with the sensibility of an artist, a graphic designer in the field of anthropology and archeology.[8] But it was a problem for Rosa, who had watched their income decrease every year they lived in Mexico. And still Miguel would "waste his time on eight jerks," as she referred to a group of his students, when he could be earning so much more by painting. She was very tough on him, according to Mary Anita Loos.[9] It was easy for Miguel to live by the day, but Rosa was thinking about the future.

And Rosa's future was gaining on her fast. Rosa celebrated her fifty-fifth birthday in 1950, feeling Miguel's emotional absence more and more. His work possessed him as she no longer could, and Rosa was as jealous of this mistress as she had been of his "little photographer." Chávez's offer must have seemed a godsend. Miguel accepted it in June of 1950.

Miguel entered the world of dance at a time in Mexico when "folkloric" dance and European classical ballet were pretty much all that one saw performed. There had been even less before Vasconcelos rekindled the creative spirit in Mexico in the early twenties, and three hundred couples had danced the Jarabe, the national dance, performed for the first time in Chapultepec Park. Now, some thirty years later, it was clearly time for this art form to flower.

The end of the first six-year civil presidential term in Mexico also occurred in 1950, and President Miguel Alemán wanted his regime to be remembered for its cultural contributions as well as its industrialization of Mexico. Toward this end, Alemán had founded the University of Mexico in Mexico City and since 1947 had supported Chávez's evolving Bellas Artes.[10] This made the timing for innovative work even more auspicious.

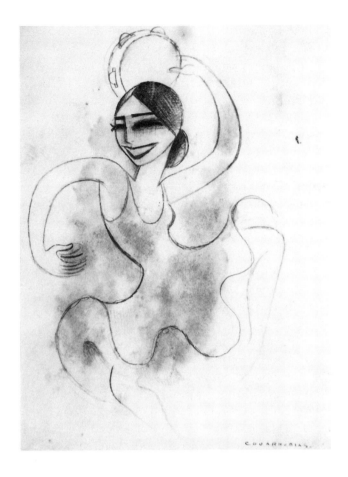

Rosa dancing. Drawing by Miguel Covarrubias.

Miguel came on board with a grand vision: to make the academy a center for the collection and examination of what artifacts and other materials remained of pre-Columbian dance and Mexican Indian dance festivals and to join Mexican dance with the new, essentially Indian, nationalist/revolutionary ideology, just as the muralists and painters had done with pictorial art in the twenties, and as Gabriel Figueroa had done with film in the 1940s. "We both wanted to motivate the use of Mexican themes in our medium," Figueroa told me in 1991.[11]

In addition, as a way of enriching the dance experience of students and audiences, Miguel envisioned a "master company" made up of members of Bellas Artes Ballet, the National Ballet, the Ana Mérida Company, Guillermina Bravo's Company, and the University Ballet—the very best dance companies Mexico City had to offer at that time.[12]

High standards deserved appropriate compensation, and Miguel's budget was generous. Bellas Artes teachers and company dancers received good salaries for the times. Even a beginning dancer could earn a reasonable grant. Miguel persuaded his friend, the painter Santos Balmori, to take on the directorship of the

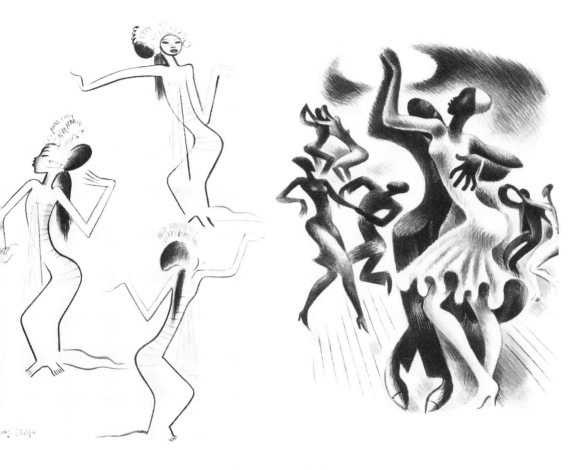

LEFT: *Legong dancers, Bali.*
RIGHT: *The Lindy Hop, Harlem. Drawings by Miguel Covarrubias.*

dance academy, a post Balmori held for seven years. The job description in those early days included administration, set and costume design, poster art, and program and catalogue production — Balmori even wrote librettos when necessary.

In the beginning, Rosa went to the school with Miguel every day, as a kind of efficiency consultant. She sat in on classes to evaluate both teachers and students. She was adamant that the faculty be improved.[13] She also contributed to the structure and organization of a curriculum that would provide dance education in classical and modern techniques and training in body discipline and in choreography.

Rosa's complaints dissolved in the Bellas Artes' classrooms as she began to feel like a participant and a collaborator again, as she had been with Miguel on the Bali book, on *Mexico South,* and twenty-five years earlier on Tata Nacho's "Rancho Mexicano" for the Garrick Gaieties which had made such a stir. The world of dance was where Rosa wanted to live, and for the moment, so did her husband. She secretly hoped that this new involvement would require him to give up teaching at the National School of Anthropology and History.[14] Nevertheless, he managed to continue his work at the school through the mid-fifties.

Meanwhile, late in the summer of 1950, Knopf editor Herbert Weinstock, still begging for *The Eagle*, wrote to Miguel:

> *In going through some old files here in the office Pat Knopf found the carbon copy of a telegram sent to you by Harry Block on February 23, 1929. It . . . reads: "Why don't you answer something. When are you returning?" This indicates that you have not changed in more than twenty years.* [15]

Weinstock was not the only irate editor in Miguel's life. Nettie King represented Miguel's magazine interests and had gotten an earful from *Collier's* magazine regarding Miguel's unresponsiveness. Nettie wrote to him in March 1951 that the publisher was reassigning the job:

> *Honestly, I don't think it is fair for you to keep waiting for the last minute and then bollix up the works. I'm truly surprised that you get me into such a mess. You know I make my living by having the good will of the editors. . . . [I]t shall never happen again, I assure you. If I have another assignment, I will never promise to get it done until you send me word that you are doing it and when I'll get it.* [16]

George Macy was still waiting for Prescott's *Conquest of Peru*, but he did not allow this to affect his warm feelings for Miguel and Rosa, and he invited them to join him and his wife on a trip to Guatemala. They had traveled together before and were compatible companions on the road. They ended up touring Central America, and Miguel took the opportunity to collect new material for his second Indian art book for Knopf, though the first was not yet finished. [17]

Word of the infusion of spirit and opportunity at Bellas Artes spread quickly throughout Mexico City. Within a year three hundred students enrolled where there had been less than a hundred. This was more than the already enlarged faculty could handle. Miguel solved the problem by deputizing three of the academy's most advanced students as teachers—Guillermo Arriaga, Guillermina Peñalosa, and Rocío Sagaón whom Rosa first pointed out to Miguel after monitoring a class in which the girl had danced.

Rocío was an exceptional talent, as Rosa must have seen, and Rosa may also have recognized an image of herself in the dark-haired, dark-eyed seventeen-year-old beauty. Rosa's friends certainly did. María Asúnsolo, Columba Domínguez, and Mary Anita Loos all said the same thing: Rocío could be mistaken for Rosa in any of the photographs of her youth; indeed, she seemed a reincarnation of Rosa. [18]

Clearly, Rosa saw nothing in this shadow of herself that forewarned her of the role Rocío would play in her life, for she took the young woman under her wing.

María Asúnsolo recalled that Rosa "taught Rocío how to fix and adorn her hair, how to dress, and even how to eat; everything but how to dance."

"She made Rocío so perfect," according to Mary Anita, "that Miguel couldn't help but fall in love with her."

The Bellas Artes ballet's inaugural season in September 1950 featured José Limón, one of the foremost modern dancers in the world, who happened to be Mexican and also happened to be a good friend of Miguel and Rosa. Limón had been delighted at the invitation to bring his New York company to Mexico City. He had never danced in his native country; furthermore, Bellas Artes provided a grand stage with full symphonic orchestra, unheard of even in New York in those days.

Although Limón's reputation was impeccable, introducing Mexico City's newest ballet company with a New York City modern dance ensemble was reason for concern. Miguel knew he was taking a risk, and he was vastly relieved when the Mexican public received Limón with open arms. Salvador Novo wrote for *Novedades*: "We owe this splendid season of modern dance to Covarrubias. From the first evening, the lovers of classical ballet were reconciled to the barefoot dancers and the general disaffection for the acrobatic movements of Modern dance."[19]

Limón returned in January 1951 as a guest teacher, dancer, choreographer, and artistic director, and he brought with him his teacher, Doris Humphrey, herself a famous dancer and choreographer, and Lucas Hoving, a member of Limón's company in New York, to teach Miguel's young dancers and students modern dance techniques and choreography.[20]

"Of course we all enrolled in [Limón's] classes . . . ," Rocío reminisced:

> *It was an unbelievable opportunity for us. We took master classes in technique with Lucas Hoving . . . and choreography with Limón. We had classes in interpretive dance as well as classes in music and theatre. In the early afternoon Guillermo Arriaga and I taught the younger students. Rehearsals were held at 4:30, and when we didn't have a performance, rehearsals continued late into the night. Often we worked a ten- or fourteen-hour schedule, but no one complained because we were so caught up with what we were doing.*
>
> *Miguel was aware of the smallest detail. He came to many of our classes and rarely missed rehearsals. In order to awaken our curiosity and to broaden our knowledge, he took it upon himself to take us to museums and exhibitions. He helped us to analyze the paintings.*[21]

Miguel also established the Academic Section for Dancers and Choreographers within the Academy of Dance, with courses in art history, folklore, literature,

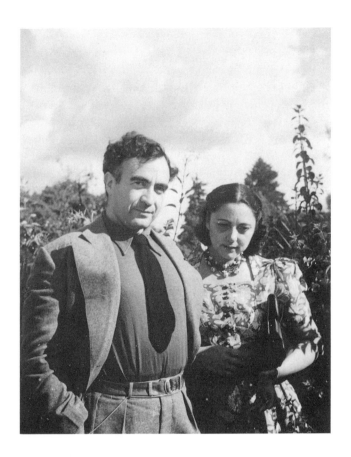

Rosa with Carlos Chávez. Photograph by Nickolas Muray.

poetry, music, lighting, set design, and theater mechanics. Miguel himself lectured on archeology and pre-Hispanic culture.[22] Such a holistic approach changed what it meant to be a dancer in Mexico's macho society. Miguel made it acceptable for young men to take up the art. (Guillermo Arriaga, who taught with Rocío, became one of the most accomplished male dancers and choreographers in Mexico.)

"Miguel invited young writers, musicians, and painters to observe our dancing," Rocío continued. "The presence of these outsiders stimulated the dancers. Many had never seen a dance performance before. It was very exciting and stimulating for them, too, and they learned a lot which later helped them in their professions."[23]

> *Besides the painters and photographers [Rocío recalled] there were also a burgeoning group of young writers and composers who contributed librettos and scores for ballets. Although [Miguel] pushed us to our limits, we never complained. In fact we never missed a class or even arrived late for a rehearsal, because something exciting always occurred when*

he was around. Even if a dancer had an injury or felt sick,
he or she would be there to observe and listen.

Miguel encouraged his students to use archeological and historical sources as the basis for their choreographic experiments. In this way he hoped to instill a cultural veracity to new works. "We worked in an atmosphere of effervescence and excitement," Rocío told me, and that excitement survives in her memories to this day:

> *The extraordinary fact is that Miguel did not discrimi-*
> *nate against any of us. If a dancer had the ability and the*
> *talent, he or she had the opportunity to create a ballet for the*
> *company. Imagine, we were all creating works that in our*
> *wildest imaginations we never thought possible! Miguel*
> *believed that it was more important to have the freedom to*
> *create even if we failed, because only with complete artistic*
> *freedom could great work develop. For me, the most reward-*
> *ing and exciting part of my years at Bellas Artes was being*
> *involved with the development of a work in progress.*
>
> *As choreographers we influenced and enriched each*
> *other. There was a constant exchange of ideas. And as we*
> *were students and teachers at the same time, it was an added*
> *impetus to better ourselves, since we were involved in every*
> *aspect of the school.*[24]

For Miguel, it must have been like inheriting a world populated by enthusiastic, talented, and beautiful youngsters, all receptive to learning and to his world view, all eager to please. He tried to teach them more than dance—he took them on field trips to museums and exhibitions; he gave them a system of human values. "One of the most important things that Miguel taught us was to respect the ideas of each person," Rocío said. "He wanted us to be generous of spirit and not to compete with each other in the negative sense of the word."

Miguel also insisted that every dancer participate in company programs. During their first season, about sixty dancers performed, including seven-year-old Cibeles Henestrosa, daughter of Alfa and Andrés.[25] The Covarrubias sensibility was evident in many of the works that year. As with his other arts, Miguel enriched his creation of sets and costumes with a depth of research. "Los Cuatro Soles" ("The Four Suns"), the ballet which opened the spring season in 1951, was a pre-Hispanic legend for which Miguel had designed the sets and costumes after the Borbonic, Mixtec, and Mendocin Codices (ancient illustrative chronicles of Indian life) and the story of the conquest of Mexico.

Solórzano remembered the sets:

> *The only decorative element is a blue curtain and two back*
> *panels in the manner of* retablo *[miracle paintings]. With his*

*artist's sense of the dramatic [Miguel] got rid of the flashy
effect of lighting. He controlled the depth of the stage by
suppressing all idea of distance, therefore eliminating all
idea of reality. As a result, by the simple use of color and a
trace of two or three decorative elements inspired more often
than not by pre-Hispanic symbolism, Miguel achieved sets
full of poetry and grandeur. The costumes reflect the same
aesthetic moderation: tunics with simple lines, the blending of
hues, and headdresses of Quetzal feathers. He possessed an
exceptional scenic sensitivity.[26]*

Miguel set the tone. The company's musicians, Silvestre Revueltas, Blas
Galindo, Carlos Jiménez Marabak, and Carlos Chávez, unquestionably the master
musical nationalist, and its set designers Antonio López Morado, José Chávez
Morado, Guillermo Meza, Arnold Belkin, Juan Soriano, Leopoldo Méndez, Luis
Covarrubias, and even Rosa, all based their work for Bellas Artes on pre-Hispanic
culture, colonial and folk art, legends, children's stories, and the *retablo*. (Piña
Chán noted that Miguel sometimes mixed pre-Hispanic and colonial elements and
commented on his use of shocking color: "purples, magentas, and yellows jumped
out at the audience."[27]) Much of their work also shows the influence of Mexico's
great contemporary artists, Orozco and Siqueiros.

By the end of the spring season, with the help of government subsidies, Miguel
had also succeeded in establishing dance classes in ten schools in Mexico City
through the Bellas Artes' department of dance. *Dance Magazine* was impressed:

*Twenty . . . graduates of the Academy of Mexican
Dance are busy teaching, training and discovering. But
Mexico is not Mexico City and so the department plans to
expand its educational programs to take in the regional
schools, to bring dance to all the students of the nation.
 As big as this teaching project is, Covarrubias will not
permit it to obscure the program of research, for if Mexican
dance is to grow in content as well as in numbers, the dance
lore of the people must be studied, recorded, analyzed,
codified and passed on to students, performers, choreogra-
phers, critics, historians.[28]*

The magazine also reported on the strides that Miguel had made toward
unearthing and preserving what remained of pre-Columbian Indian dance:

*At present two researchers are at work. One is busy with
pre-Columbian dance material, studying eyewitness
accounts by Spanish invaders of the dancing they viewed
in the land they conquered and investigating those
contemporary folk dances which retain themes, steps,*

*Rosa and a seamstress designing a party outfit. Photograph by
Nickolas Muray.*

*flavors or hints of the dances of aboriginal days. A second
researcher is dealing with Mexican dance festivals,
exploring their folk and ceremonial aspects, their
regional differences and distinctions, their heritages,
their terminologies.[29]*

The Fifties, Part One 187

When José Limón returned home from his season in Mexico, he wrote to Rosa:

> *I have not recovered from the impact of Mexico, and the Covarrubiases. . . . I look out the window on Woodland Ave., an old and familiar sight to me for two decades, and suddenly I am a stranger here and I say "What in the devil are you doing here? Go on home. Go back." You see, Rose, dear, I have always been a torn man. Pulled apart and asunder in many ways by one thing and another and now more than ever the conflict is greater because where at one time I only had dim memories, now I have seen it. And it makes me tremble, because my safe little world is no more. And I have to start all over again.*[30]

The 1951 spring season was followed by a short summer run with Mirnalini Sarabahi and her Hindu ballet as guest performers. Meanwhile, four of the best of the Bellas Artes company accepted dance scholarships and an invitation to perform at the American Dance Festival in New London, Connecticut, and to participate in the summer dance program at Jacob's Pillow in Massachusetts. Sisters Marta and Valentina Castro, Beatríz Flores, and Rocío Sagaón were the chosen dancers. Rosa wrote to Limón: "The angels are frantically studying English. Rocío does very well indeed. The others are real jealous."[31]

Rosa would accompany the "angels" to the East Coast. Miguel, however, was denied a visa by the United States government. Apparently, he had been under investigation since 1943. In that year, his name was included in a report from the United States Embassy in Mexico City to the attention of the secretary of state in Washington, D.C., in connection with the dissolution of the Third Communist International in Mexico, an organization with branches worldwide. The report described:

> *. . . a varied assortment of individual Mexican intellectuals, economists, educators, artists, writers, and social reformers who had at one time or another more or less leaned on the Soviet Union and the III International for support. Among these mentioned were Diego Rivera, David Alfaro Siqueiros, Lic. Vicente Toledano, Narciso Bassols, and Miguel Covarrubias. Some of these individuals may drop their socialism, in view of the circumstances, while others may seek other means of bringing about the world revolution.*[32]

The idea that Miguel might attempt to bring about world revolution *or* give up his socialist ideals was patently ridiculous (as Octavio Barreda said, Miguel "carried his socialism in his blood"), but these were the days of Joseph McCarthy's paranoid

Rosa with Carlos Rivas and José Limón.

ascendancy in the United States, which saw a communist threat behind much that was only creative or forward-thinking—and McCarthy's influence was widely felt. (Al Hirschfeld commented, "Anybody who could read or write was on [McCarthy's] blacklist.")[33]

Miguel's affiliation with his politically active friends, longstanding international friendships, efforts on behalf of both Soviets and Chinese, attendance at rallies, patronage of the "Committee to Help Russia in War" in 1943, advancement of communal art and support of organizations promoting "communism" in art, and his pro-union stance—all guaranteed that "Miguel Covarrubias along with countless other artists and intellectuals [would] fall into the widespread net spread out in all sectors of society to wipe out the 'evil shadow' of political engagement," as the embassy report put it.[34] In fact, the only political party Miguel ever actually joined was the Popular Party in 1947 (it became the Socialist Popular Party in 1952), dedicated to improving the lot of Mexican workers and *campesinos* (indigenous farmers).

North of the border, the busy House Committee on Un-American Activities no doubt had noted that Miguel's name was on the roster of supporters for Lázaro Cárdenas's "Americano Por La Paz" conference in Mexico in May 1951 and that Miguel had also endorsed the "Cultural and Scientific Conference for World Peace," held in New York in March 1949. Both were considered "fronts" for communist goings-on, both attracted an international community of the cultural and scientific elite, and Miguel was surely a member of that society.[35]

Miguel's name would have come up again when the committee painted his friend Maurice Swadesh, a Columbia University professor, red. Swadesh had decided to emigrate to Mexico, but his Russian ancestry caused kinks in the process of acquiring the necessary papers to travel, and then he was notified that his passport would be confiscated. Such tactics struck many of Swadesh's friends as outrageous, and Miguel petitioned against the injustice and used his influence to persuade Mexican authorities to allow Swadesh to enter Mexico, where he lived and worked until his death in 1967. Miguel had attended the "Americano Por La Paz" conference with Maurice, which Rosa had insisted was unwise, but by then the matter of the visa had probably been long settled.[36]

Arnoldo Martínez Verdugo, who had worked with Miguel on the Hotel del Prado murals, was another friend whose political affiliations leaned toward the radical. In these days, he was actively reorganizing the communist youth movement. On 1 May 1952, a rally of students and workers erupted in violence against the troops sent to keep order, and deaths resulted. The police blamed Martínez Verdugo and instigated a search for him. Miguel hid his old friend at Tizapán. Martínez Verdugo told me, "Although Miguel was not a member of any political group, he was supportive of our common cause . . . and he kept a picture of Mao Tse-tung in a place of prominence over his desk."[37]

None of Miguel's alliances would have endeared him to Joseph McCarthy, but denying him a visa seemed to his friends a terrible infringement of rights. John Huston, himself high on McCarthy's list of subversive types, said it was "appalling and humiliating that Miguel could not come to the United States." Rosa was also furious—to a large degree, Miguel's livelihood came from the United States. She feared his inability to travel there would have a potentially disastrous financial effect on them, and she seemed to blame Miguel more than the rabid McCarthy. How was this going to affect their relationship with the Whitneys and the Rockefellers, she wanted to know. Why hadn't Miguel heeded her advice—or his mother's, for that matter? Doña Elena had disapproved of Miguel's politics too. She had once written, "The enormous grief of my old age is that you are a sectarian of the religion of hate."[38]

Miguel had no time to ponder such questions. Since the last time we catalogued his various projects, another had been born and nurtured to the point of blossoming: a new government Museum of Popular Arts and Industries, the brainchild of Daniel Rubín de la Borbolla, for which Miguel was painting a wall-sized pictorial map of Mexican folk art for inside the entrance. The mural/map would be similar to the *Art and Artifacts* map he had done for the San Francisco world's fair in 1939.

The museum, located in the old building of the church of Corpus Christi on Juárez Avenue across from the Alameda Park, had the sponsorship of the prestigious National Institute of the Western Hemisphere Indian and the National Institute of Anthropology and had enunciated its purpose as "compiling and preserving folk art, while developing it as a business."[39]

Vidya Peniche remembers that everyone involved in the project, including Miguel, "took off in all directions" to find Mexican toys, baskets, ceramics, clothing, and jewelry. Vidya accompanied Miguel to Michoacán on one such jaunt. Up to this time, according to Carlos Espejel, who became director of the museum in 1977:

> *No one paid any attention to folk art in Mexico. It was seen as junk for the tourists. Miguel understood that museums are the only way to conserve the past. Sadly, by the time I took over, less than a third of the pieces remained of that extraordinary collection, which had been merged with an outstanding collection of Fred Davis.*[40]

Miguel spent the better part of that year painting his mural. His research, as always, occupied a good portion of that time, and his friend Donald Cordry was a constant advisor in the scholarly aspects of the work. Rubín de la Borbolla and Miguel's brother José, nicknamed Pepe, assisted in processing the voluminous amounts of material that Miguel would synthesize in his map.

To protect the mural, the engineer Ignacio Marquina built a light, second wall to reinforce the one already standing, and it was on this that Miguel worked. (Marquina's foresight preserved the painting during the devastating 1985 earthquake that destroyed the murals Miguel had done for the Hotel del Prado.)

On the scaffold, Miguel's brother Luis assisted, along with Doreen Feng, who had worked with Miguel and Martínez Verdugo before on the Hotel del Prado maps, and the young Pascual Villarreal. "Whenever we worked on a mural," Luis remembered, "we had fun playing jokes on each other and going off for long lunches with friends who came around to visit. Tourists often showed up to see what was going on, and there always seemed to be a stream of pretty girls around."[41]

The museum opened in May with an exhibition of popular art from regions throughout Mexico. Many of the objects on loan came from the living rooms of the museum's sponsors. Miguel and Rosa gave eighteen pieces from their own collection on permanent loan: intaglio painted wooden trunks from Olinalá, large hand-painted wooden plates and a black mask from Uruapan, a mask used in the "old man" dance from Pátzcuaro, two red bracelets, and two red and green necklaces with matching earrings designed as bowls and pitchers.

As for the map, which designated the centers of folk art throughout the country, Tomás Ybarra-Frausto notes that its "playful invention and precise ethnology" make it "scientifically accurate yet accessible to all viewers ... [and] one of [Miguel's] most exuberant and deeply felt" maps. It used five figures from Mexican popular art (a Judas, a skeleton, a straw man, a mermaid, and a devil) as

Rosa with José Limón.

decorative emblems, a stylized moon and sun, and "enchanting drawings of flora, fauna and representative popular types using his recognizable and by now codified techniques of cartographic visualization."[42]

Miguel had wanted to use Rocío's face for the sun, an idea which Rosa had vetoed with some steam, though at the time her jealousy was unwarranted.[43]

Soon after the museum opening, Rosa and her Bellas Artes dancers departed for the States. It was an intensive and impressive summer. Rosa wrote to Miguel that the youngsters were taking "pre-Classical dance with Louis Horst, modern dance with Doris Humphrey, technique with Martha Graham, and kinesiology with Josefina García." They also had a class in dance notation. Rosa had had high hopes that Laban, a kind of shorthand for recording choreographic directions, would be of "invaluable help to us in saving some of the few remaining dance forms which exist among our Indians." Rosa was disappointed. Labanotation was far too complex a science to learn in a class or two.[44]

Bellas Artes wowed New London's Dance Festival audiences: "The legends of Mexico, the diminutive dancers, the brilliant decor, and the colorful costumes enchanted all," noted *Dance News Annual*. One of the best loved of their performance pieces was "Los Cuatro Soles," for which Limón had done the choreography, Miguel the sets and costumes, and Carlos Chávez the orchestration. *Dance Magazine* referred to them as Mexico's new triumvirate, declaring, "The Aztec ballet . . . represented a new peak of accomplishment in Mexican theatre dance and augured still greater accomplishments through the directorial capacities of [Limón, Covarrubias, and Chávez]."[45]

"I'm glad we sent our four girls to New London," Rosa wrote to Miguel early that August:

> *Working together enlightens all of us in many ways.*
> *We have a great advantage. Our Government supports us with a theatre, a large budget, a symphony orchestra, a production department and musical composers and painters.*
> *The children are leaving on the 10th for Mexico filled with gratitude and enthusiasm, and burning with the desire to teach others what they have learned here. I know that you will be very happy and proud of their progression.*[46]

The young dancers were also eager to get away from their vigilant chaperone. Rocío remembered:

> *While we were studying and performing in Connecticut, Rosa left us pretty much alone, but at Jacob's Pillow it was another story. She stayed with us every minute and interfered in everything we did. Although the summer was very productive and exciting, we were anxious to get back to Mexico and be on our own.*

First they stopped in New York City, where Beatríz Flores recalled:

> *Rosa introduced us to many of her friends. I remember a wonderful party in . . . an elegant apartment. There were many people there, perhaps a hundred. Among them were*

some very famous people. I remember being introduced to
President Eisenhower. It was very thrilling for us to have
come so far.[47]

The dancers came back to Mexico without Rosa, who stayed on in New York to visit friends. It might have been better for her had she continued to supervise her young charges, even beyond their return home — but of course that would have been impossible.

Ｏne day, soon after the dancers' triumphant return, Miguel asked Rocío if she had ever been to *La Blanquita*, a Mexico City vaudeville theater, "something I should experience because it might broaden my dance vocabulary," Rocío recalled him saying. And then he said, "If you want, I shall invite you."

> *We went to the theater together. I was fascinated by the*
> *way the chorus girls moved. I had never seen dancing like*
> *this. Everything was going along splendidly, when suddenly*
> *I felt a hand on my leg. I felt the blood rush to my head. . . . I*
> *didn't know what to do or say.*
>
> *Almost without thinking I placed my hand on top of his.*
> *With that simple gesture everything changed! . . . Just*
> *talking about it now, I get excited again. . . .*
>
> *After the show he invited me to dinner, but I had to get*
> *home. He took me to my house, and he behaved very cor-*
> *rectly. He didn't even kiss me goodnight. Of course I couldn't*
> *sleep. I imagine he didn't either.*[48]

They began meeting very early in the morning, "around eight o'clock at the Hotel Prince on Dolores Street for breakfast. We had our coffee and sweet rolls together," Rocío reminisced, "I was always in a rush because I had to get to my English and French lessons before going to dance classes."

These intimate breakfasts were quite chaste. By the time Rosa returned, probably in September, Miguel and Rocío were not yet lovers. For all his experience with women, Miguel was terribly shy about initiating this affair. "He was so timid he didn't dare say anything directly, and of course I was just as shy," Rocío said.

Eventually, however, perhaps in October while Rosa was occupied preparing an exhibition of her paintings for a gallery in Mexico City,[49] Miguel told Rocío he wanted to do a painting of her. She recalled:

> *There was no place to draw at the academy; besides, he*
> *was too shy to draw me in front of the others. He rented a*
> *studio on Paris Street near the Hotel Reforma. While I was*

*posing for him in that apartment, our relationship took a
different turn. . . .*

*[In the beginning, Miguel made] a series of studies. He
was so timid he would never have dared draw me in the
nude. From the drawings he did at the apartment, he
painted . . . two oil portraits of me. . . . He never finished one
of them because being together suddenly took precedence
over my posing for him.*

*He was such a thoughtful, gentle, considerate man. I
have always felt such gratitude that my first sexual experi-
ence was with someone like Miguel. After my second mar-
riage, when I had my daughters, I hoped their first encounter
would be as happy as mine had been. Everything was
delicate, and it mattered to him that you were satisfied.
Miguel was an extremely affectionate and giving man. This
is why his friends were so devoted to him.[50]*

Everyone at the academy and in the company became aware of their affair, and
"even though everyone in our group at Bellas Artes protected and covered for us,
Rosa knew," Rocío told me. "She stopped coming to Bellas Artes. She took a dislike
to all the young dancers, calling us the Ponytail Bunch."

Rosa's world began to unravel as Miguel's relationship with Rocío deepened,
and she would never really recover.

CHAPTER 11 *What a painful decision this was for Miguel.*
Everything that was his life was with Rosa: his
beloved house, his treasures from around the
world, his paintings, his books, and his studio.[1]

I THE FIFTIES, PART TWO (1952–1954)

n 1952, Miguel's *The Eagle, the Jaguar, and the Serpent*
advanced snail-like toward completion, while the Bellas Artes ballet moved in leaps
and bounds under his direction. The 1952 season, both spring and winter, was
strictly Mexican and performed exclusively by Bellas Artes dancers, several of
whom (Rocío included) also contributed their newly acquired choreographic skills.

Among the most popular of the spring season's new works was "El Invisible,"
choreographed by Elena Noriega after a pre-Hispanic myth with Miguel's costumes
and sets—including a monumental temple of Cali and a mythical tree inspired by
the botanical drawings of the Nuttal and Vindobonensis Codices. "El Invisible"
was one of Rocío's favorite ballets: "Miguel made a beautiful costume for my role
in this ballet. I wore a blue skirt with a transparent huipil. My hair was pulled back
into a ponytail, and I wore large wooden pendants and a necklace painted green to
look like jade."[2]

Rosa, however, despised the piece, writing to José Limón: "And as for that
shitty Elena Noriega, you would have vomited to see 'The Invisible.' She stole from
other ballets. 'The Invisible' is a lemon."[3]

"Tozcatl" was another well-received ballet that season, choreographed by Xavier Francis with music by Chávez and sets and costumes by Miguel. For this ballet, Miguel constructed a large pyramid on which the dancers moved up and down, and he based his costumes on those of a deity in the Mixtec Codice.[4]

In this second year, funds for the fledgling company were harder to come by, which only made Miguel work harder to secure them. His secretary Vidya recalled:

> *He would come to the office, make phone calls, and walk back and forth until he had a solution. Often when an idea struck him, he would rush over to Carlos Chávez's office to ask him what he thought.*
>
> *I remember a time when the company was preparing a new ballet, and there wasn't enough money to complete the costumes and scenery. Miguel first went to Chávez for help, but he had no money available. Without a second thought, Miguel then went to [the government] and got the money. With his connections and his enthusiasm, he always managed to get what was needed.[5]*

"If the officials couldn't help," the art dealer Alberto Misrachi told me, why then "Miguel always had a painting to sell. He would go home, get a work of art, and come back downtown here to the gallery [located on Juárez Street across from Bellas Artes]. He would offer us whatever it was, a painting or a series of drawings, and we would buy it. The whole operation would take less than a few hours."[6]

Guillermo Arriaga remembers an occasion when the dance company's government endowment was late, and "Miguel went to Tizapán, took down from his walls three of his favorite paintings, and sold them to Misrachi. He saved the economic situation of the moment. This gives an idea of the love and total engagement that Miguel had for this artistic movement."[7]

According to Vidya, "It was Miguel who insisted on stipends for the dancers so they wouldn't have to take late night jobs dancing in nightclubs and Miguel who would reach into his pocket for tortas for everyone, dancers and technicians, when we stayed late for rehearsals."

For all that it meant to him, as the year neared its end, Miguel stepped down as the Bellas Artes director of dance. Adolfo Ruiz Cortines, the new president of Mexico, would replace Chávez as overall director of Bellas Artes, as well as the heads of the various departments, once the new administration was in place. Miguel arranged a gala performance in mid-November for the visiting German Prince Bernard, consort of the Dutch Queen Wilhelmina (whom Rosa called "that silly old woman" in a letter to José Limón), published a rousing article for *México en el Arte* on the company, and then submitted his resignation to Carlos Chávez.[8]

Rosa was bitter. She believed Miguel could have stayed on under a new director. She wrote to Limón that Miguel had wasted two years of his life mired in an administrative morass, overextending himself to an undeserving company and putting up with criticism, envy, and ignorance. She complained:

He put ballets in the hands of people who will never be able to do a choreography in a million years. You and I know that is the hardest thing to do in dancing. . . .

Honey, why should I go on telling you about these mediocrities anyhow? In another month they will all be lambisconando *[fawning over] somebody else. All the dissention is affecting his health. Miguel has taken all this too seriously for his own good. Everybody says so.*[9]

Chávez responded to Miguel's resignation in a letter acknowledging his friend's "steadfast backbreaking manner of working, your intelligence, your competence and your preparation. Anyone who judges objectively the accomplishments of the Department of Dance during these past two years and a few months will have to recognize a body of work of extraordinary dimensions without precedent."[10]

Indeed, Miguel mounted thirty-four ballets in his two-year stint with Bellas Artes and inspired all those with whom he worked.[11] His insistence that nationalism figure in Mexican dance was unique, and he believed strongly that the "best ballets, since modern dance was developed in Mexico, have been those which drew their inspiration and vitality from the true Mexican spirit."[12] He told Rocío that he thought it "fundamental for a choreographer to have roots, an origin, to create something of worth."

Miguel ushered Mexico into the golden age of contemporary dance, although Rocío does not care for that designation: "It's too grand. What occurred was simply the liberation of a group of people guided and inspired by the marvelous person that Miguel was. It occurred at the time of the rebirth of nationalism and the great pictorial movement in Mexico, which we represented in dance."

Nevertheless, Guillermo Arriaga believes:

Miguel's directorship was the birth of the most significant creative movement in dance in the fifties.

He was the foremost promoter of Mexican dance that the country has ever had. Not only did he arrange to have students go to the United States to study and perform, but before he retired, he made arrangements with his friend Lincoln Kirstein for the Mexican ballet to perform in New York. Unfortunately, as soon as Miguel was gone, the trip was cancelled.[13]

Rocío spoke for many of her colleagues in dance when she said, "Without Miguel, the support, inspiration, and magic were gone. When Miguel left the directorship of Bellas Artes, modern dance in Mexico died"—though the latter is surely an exaggeration.

The painter Arnold Belkin probably did not overstate Miguel's contribution, however, in saying that he had made dance in that period, "more than any other form of artistic expression, the spirit and soul of Mexico."[14]

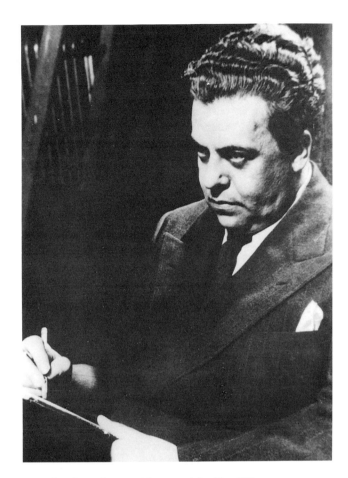

Miguel in the early 1950s. Photograph by Gjon Mili.

Somehow, during Miguel's already full days and nights, he had managed to produce the illustrations for a book entitled *The Art of Dental Mutilations,* about dentistry in pre-Hispanic times, which was published at the end of 1952.[15] Presumably he made headway on *The Eagle* and on the illustrations still owed to George Macy for Prescott's *Conquest of Peru.* Macy was ever forbearing. In fact, in this year he sent Miguel a note: "If ever you are in real need of help and this help is something which I can supply, you can count on me to supply it."[16] Perhaps he had heard of Miguel's difficult situation at home.

Miguel did at least some preliminary work on a bas-relief mural for Stanley Marcus, who wanted a fitting Texas-oriented wall for his department store then under construction. Miguel's archives contain a note in his writing: "This was the first important mural I have done which is not a map."[17] But if Miguel actually *did* the mural, there is no trace of it. Marcus bought one from Tamayo instead, which still hangs in the Neiman-Marcus "Zodiac Room" in Dallas, Texas, today.

Miguel spent the first few months of 1953 organizing an exhibition for the National Museum of Popular Arts and Industries, called "Select Works of Popular

Rocío Sagaón dancing on the ruins of Tula. Photograph by Miguel Covarrubias.

Art," which, he wrote, "derives unconsciously from pre-hispanic sculpture, one of the most vigorous in the world. . . . Folk art is a . . . basic element of the reknown [*sic*] Mexican school of art."[18] And he participated with Bill Spratling and Daniel Rubín de la Borbolla as a judge at the first silverworking competition in Taxco, where Mexico's great silver mines are located.[19]

Miguel had not severed his ties with Rocío when he left his position at Bellas Artes, nor his devotion to or work for the ballet. He contributed toward the rent of an off-campus dance studio on Belisario Domínguez Street, where Guillermo Arriaga created the extraordinary expressionist ballet "Zapata," inspired by José Clemente Orozco's powerful paintings. Miguel designed the sets and costumes for the production, which premiered at the 4th International Youth and Students Congress for Peace and Friendship in Bucharest, Rumania, in August 1953. Rocío starred, and when we spoke, Andrés Henestrosa called her "divine" in the role. "I believe," he said sincerely, "that she was the best modern dancer that Mexico has had."[20]

Rocío. Photograph by Georges Vinaver.

Four of the best of the Bellas Artes company comprised the tour troupe: Olga Cardena, Guillermo Arriaga, Antonio de la Torre, and Rocío Sagaón. The dancers visited Montreal, Amsterdam, Zurich, Hungary, and Poland in a two-month period.

Miguel wrote to Rocío:

> *I miss you and I am lost without you. It was a sacrifice on my part to let you go but it was one of those opportunities that doesn't come along every day. My life is boring and adheres to daily routine. In the morning I go to the museum and in the afternoons to Zamora. Pepe [Miguel's brother] is on vacation and we are working very hard on my book. . . . [Miguel refers to* The Eagle, *which his brother was typing for him.]*
>
> *It is three o'clock in the morning and I am dead beat. I*

miss you and I can hardly wait to see you. I need you and I
think of you all day long. Many kisses, great success, have
fun, and, above all, hurry home.[21]

Miguel's political evolution kept pace with his growth as an artist and his development as a cultural anthropologist. His signature appears in favor of the Stockholm Peace Treaty of 1950, along with those of other artists and intellectuals. (Half a billion people around the world signed.) The congress urged the dismantling and destruction of atomic weapons. Miguel was also intrigued by a gathering in support of the People's Republic of China—his fascination with China had grown since the early 1930s when he and Rosa first traveled there. His ongoing friendship with Marc Chadourne, the China expert, Lin Yu Tang, the brothers Chiang, and others, plus his work on *All Men Are Brothers,* kept that fascination alive. At this pro-China event he made the acquaintance of Dr. Eli Gortari, a young Mexican philosopher and professor just back from China. Gortari recalled:

> *Because of Miguel's longstanding passionate interest*
> *and love for that country, he wanted to learn more about*
> *what I had observed in China. He invited me to have lunch*
> *with him the very next day in one of his favorite but humble*
> *Chinese restaurants on Dolores Street.*
>
> *Miguel was active in organizations that promote East-*
> *West cultural relations. He wanted the Mexicans to learn*
> *about China's theatre, opera, painting, literature, and music.*
> *Above all he wanted to share his prodigious knowledge and*
> *humanism along with everything he understood about China.*[22]

Out of this initial meeting grew the Society of Friends of Popular China, which Miguel chaired during its first year in 1953. By June of 1954, he had published the society's first bulletin, outlining its bylaws and statutes. Its goals were "to promote friendship between China and Mexico" through cultural exchange in the arts and sciences and "to force the recognition of Popular China by the Mexican Government."[23] A little public relations savvy would have suggested a more acceptable verb in connection with their last goal.

PR savvy was clearly not Miguel's forte, and the bonds of friendship between him and his publisher were fraying at this time. On 8 June 1953, Miguel received this letter from Alfred Knopf:

> *Don't you think you continue to put an undue strain on*
> *our old and devoted friendship and loyalty on the part of a*
> *publisher to his author when you consistently ignore our*
> *communications and consistently fail to do what you know as*
> *well as we know is absolutely necessary for you to do if we*
> *are to get on with the publication of your book. . . .*

Oil portrait of Rocío Sagaón by Miguel Covarrubias.

*I regret very much indeed that you persist in treating
me with such lack of politeness and business courtesy. I shall
add that I do not think you would like it if I did the same to
you.*[24]

That Knopf put up with Miguel's consistent failure to deliver on his promises over so many years—that so many people put up with his procrastination, including George Macy, Nettie King, and others—is ironic testimony to how valuable Miguel's work was to them. Those people who knew him understood that Miguel was not purposefully derelict in his obligations. His friends always knew that his intentions were the best, that his enthusiasm inspired an optimism—especially in calculating time—that was often not realistic.

The urgent letters, designed to shame Miguel into action, usually accomplished at least some of their intended effect, making Miguel feel embarrassed and uncomfortable. Unfortunately for his many commercial and artistic suitors, his feelings of guilt inevitably were assuaged or overcome by the lure of the next, newest project.

Rocío may have been similarly alluring. When she returned from the company's two-month tour, she and Miguel resumed their love affair.

Rosa became desperate. She turned her desperation into criticism, and she raged at everything and everyone. Rocío told me:

> *When their relationship began to deteriorate, she found an outlet in criticizing Mexico. She would rant and rave, "The country is filthy, nothing works. The people cannot do anything right; they are stupid and dirty. . . ." She complained about the servants and nagged [Miguel] constantly about domestic problems.*
>
> *Most damaging of all, she no longer tried to improve her Spanish. She would speak to Miguel only in English. This was very distressing to Miguel and put a further strain on the marriage. . . .*
>
> *At the point that I became involved with Miguel, he needed someone who supported him in his interests. Someone who understood and felt his enthusiasms. All of his work involved projects concerning Mexico, and he wanted to share his ideas with someone close to him. . . . I fulfilled that need. . . .*
>
> *[But] Rosa pressured Miguel to stop seeing me. She called him continually at his office and followed him everywhere she could. She even spied on him, creating nasty public scenes, which upset Miguel dreadfully. Because of her relentlessness, we made up our minds to terminate the relationship. As we were saying our final goodbyes, we ended up crying, and once again we postponed the break-up. It seemed as if our good intentions always failed, and because of the on-and-off aspect of the relationship, it was a time of great stress and anxiety for both of us.*

This was nothing compared to the stress and anxiety Rosa experienced as the affair progressed. That spring she wrote to Nelson Rockefeller that the archeologist Alberto Ruz had offered her a job assisting him at the Palenque dig, "which interests me very much as Miguel has drifted away these last two years and I think a vacation would be a good thing for both of us. Personally I am very unhappy and an opportunity of this kind could pull me out of a very unhappy situation."[25]

Rosa tried to overcome her unhappiness. In 1953 she became involved in the Experimental Museum of El Eco, housed on Sullivan Street. The art dealer Daniel Mont and businessman Gabriel Orendain had commissioned sculptor Mathias Goeritz to make El Eco an "emotional building," as Goeritz recalled in Selden Rodman's *Mexican Journal*.[26]

"No two walls were the same height, and none of them were parallel to one another, or at right angles to the floor or ceiling," Goeritz said. The purpose was "to create a functional space, which was strictly ephemeral, where interdisciplinary

happenings could be exhibited or performed." The artists Henry Moore, Carlos Mérida, Rufino Tamayo, and the sculptor Germán Cueto each created some piece or mural for the space.[27]

Walter Hick's black dance company came from New York to perform at the September opening, dancing outside on a patio that supported Goeritz's huge illuminated iron serpent in front of a 450-meter high yellow wall. Rosa designed the dancers' costumes in black, brown, and white, "with a hint of folklore." Musicians played, poets read, and the museum was inaugurated with much fanfare.[28]

Dorothy Cordry recalled that Rosa became more "social" as Miguel withdrew. Rosa had always liked to collect people in the news, and although Miguel had tired of such parties, she now increased her efforts to organize lavish celebrity luncheons. "She also tried to paint and do other creative things," according to Cordry, "but she wasn't anywhere near as disciplined as Miguel. Although she had the talent, she couldn't produce a body of work important enough to fulfill her emotional needs."[29]

Rosa did go to work with Ruz at Palenque, about which she continued to apprise Rockefeller for three consecutive summers, beginning in 1954, but Rosa's financial and emotional difficulties persisted. To make matters worse, Rosa received a letter in October 1954 from her sister informing her that their father had died, and because of their estrangement all these years, he had not remembered Rosa in his will.[30] Although it was she who had severed their relationship over her father's remarriage, the sting was no less sharp. It seemed as if everyone had abandoned her. Her misery increased.

Miguel reacted as he always did when confronted with Rosa's unhappiness. Unable to cure or even face it, he threw himself into work: for the Mexican Society of the Friends of Popular China and for the Bellas Artes company's winter season, designing elegant period sets and costumes for the ballet "Romance." He took on two new book illustration projects: Alfonso Caso's *The Aztecs: People of the Sun* and Ivan T. Sanderson's *John and Juan in the Jungle*, a children's book—Miguel's only children's book. Both were major projects. Caso used forty-two of Miguel's color drawings.[31] *John and Juan* utilized his watercolors of tropical birds and animals: a wonderful macaw, a quetzal, an anteater, jaguars, butterflies, snakes, and monkeys. Miguel's teaching maps of North and South America with the birds and animals common to each region made up the inside cover.

Miguel also continued teaching classes in anthropology, pre-Hispanic art, and museology; his museum renovation was also ongoing.

Nor had he forgotten *The Eagle, the Jaguar, and the Serpent*. Both his brothers were assisting him now, Pepe with the typing and Luis with the drawings. By the beginning of 1954, Miguel had nearly finished what might almost be a final draft.

Miguel finally completed *The Eagle, the Jaguar, and the Serpent*, and Knopf published it at the end of 1954. It was another great success. The *New York Times* called it "a book to be read with excitement, humility and wonder!"[32]

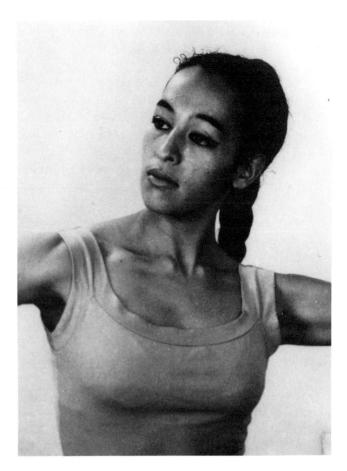

Rocío. Photograph by Georges Vinaver.

The book represented a departure from the intimate and anecdotal style of his previous two books on Bali and Mexico. The approach was now scholarly, the emphasis on history rather than the present since so little of North American Indian culture had survived. The focus was on Indian art, through which Miguel could extrapolate history. This approach had led him to pre-Buddhist China, Malaysia, and the South Seas, where he found similarities with the symbolic artwork of the Meso-American regions. Extraordinary and otherwise inexplicable similarities of odd cultural details could not be explained other than by contact, he thought. The people of one culture had to have somehow visited the culture of the other—and thus was born his theory of the transpacific interaction of cultures— "what he calls the transculturation, the effect of one culture on another," according to a *Time* magazine report on this theory.[33]

The theory was not very popular. Archeologists and anthropologists tended to promote the singularity of their cultures of choice, and they were loath to share credit with any other culture for what they proprietorially considered their chosen culture's art. Miguel's global vision of the world contradicted the indigenousness and nationalism in vogue at the time, and it seemed an audacious assumption.

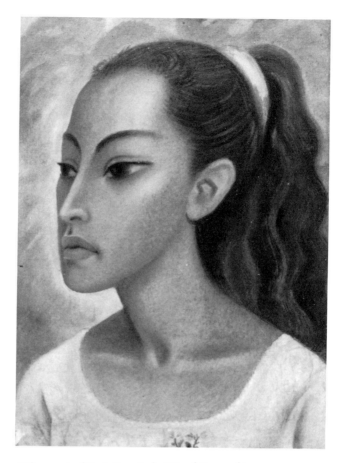

Oil portrait of Rocío Sagaón by Miguel Covarrubias.

"Whether there was indeed any connection in civilized times between the Far East and America is a difficult and tantalizing question," Daniel Rubín de la Borbolla wrote. "[Miguel] may not have been able to present sufficient proof, but his insistence drew attention to these similarities and parallels linking the art of the two continents." Still, insists Rubín de la Borbolla, "the worst that could be said of Covarrubias as a believer in transpacific contact is that he talked too much, knew too much, and felt too deeply."[34]

Critic Holger Cahill reviewed this aspect of *The Eagle, the Jaguar, and the Serpent,* as well:

> *[H]e follows the late Heine-Geldern's theory of an "Old Pacific style" which originated in China probably in the third Millennium B.C. and spread to . . . America.*
>
> *All this has been gathered together into a narrative which is flowing, clear and in harmony with the spirit of contemporary scholarship.*[35]

The Fifties, Part Two

Cahill points out admiringly, "Mr. Covarrubias respects the Indian enough to refer to him as 'native civilized man in America.' He gives short shrift to the term 'primitive,' which has bedeviled art criticism. . . . It is usually a term of denigration."[36]

The book was illustrated with 12 full-color pages, 112 line drawings, and 100 black-and-white photographs. Miguel called it "an apotheosis of Indian art history in the whole continent."[37] *The Eagle, the Jaguar, and the Serpent* may well have been Covarrubias's crowning achievement as an art historian and anthropologist.

The completion of *The Eagle*, which had occupied him for eight years, was the first of many closures that seemed to symbolize 1954 for both Miguel and Rosa. Frida Kahlo had died that summer, and her loss was still difficult for them to assimilate—especially so for Rosa, who had adored the younger woman. Miguel's big work for the National Museum of Anthropology, begun in 1947, ended this year with the installation of the Tlatilco and the South Seas galleries.[38]

But Miguel was surely not at a loss for things to do. He had promised Knopf three books on Indian art and history, and he still had two to go. He still owed George Macy illustrations for Prescott's *Conquest of Peru*—no doubt by now Macy had given up on the other books they had discussed in 1945: *Babbit, Travels of Marco Polo*, and others. And Miguel continued to be politically active. He spoke quite passionately at a celebration of the thirty-sixth anniversary of the Russian revolution at Mexico City's Iris Theatre, where he contrasted the condition of culture in socialist countries to that in the so-called free world, where:

> *Hundreds of writers, artists, musicians are being persecuted, denounced, and imprisoned because of their ideas, when they are not condemned to die of hunger for not being willing to take part in the anti-communist campaign or for refusing to submit to the McCarthy Inquisition. The enemies of the people are afraid that the popular conscience will awaken and, because of this fear, freedom of expression in some countries becomes more radical and more alarming with each passing day.[39]*

Rosa was also becoming more radical and alarming with each passing day. Miguel had dared to speak to her of divorce. Rosa's dear friend María Asúnsolo explained, "Although he feared that Rosa would not accept such a proposal, he reasoned that just asking for a divorce would surely define in Rosa's mind the seriousness of his intentions towards Rocío."[40]

It did more than that. Not long after, Rocío remembered:

> *I accompanied Miguel one afternoon to the office of the Friends of China on Puebla Street, where he was tirelessly*

*organizing a New Year's function for the society. Miguel
wanted me to be on the program, so I invented a Chinese
dance, and he designed a fantastic costume for me.*

*I went to the office that day to help the members address
the invitations. We were busy working in the office when we
heard a knock at the door. I went down to see who was there.
It was Rosa. I stepped back in fear. Not just the look in her
eyes, but the thrust of her body was terrifying! She grabbed
me by the ponytail, violently pulling and shaking me by the
hair.*

*Upstairs the others heard our screams and dashed down
to separate us. Rosa ran to the kitchen, grabbed a knife, and
came towards me. I was terrified. I didn't know what to do,
but luckily our friends were able to wrestle the knife away
from her. Immediately, Miguel took Rosa back to Tizapán,
and Xavier Guerrero took me to my house. Needless to say, I
was a complete wreck.*

Obviously, Rosa was a complete wreck as well. It was not the first time she had
acted out her rage in such a way. Miguel's secretary Vidya remembers one such
occurrence at Bellas Artes: "Rocío was dancing in the title role of a new ballet. The
performance had already started when Rosa arrived by taxi at the theater. She
rushed into the lobby with a pistol in her hand. The guards managed to detain her
in Chávez's dressing room until the performance was over."

Rocío reflected:

*I don't know why we put up with such behavior, except that
I don't believe Miguel had the energy or character to fight
her. He knew that he was weaker than she was, which added
to his grief. On top of that, a horror of confrontations was
clearly the predominant reason why things got so out of hand
and why all three of us found ourselves in a predicament we
could not deliver ourselves from.*

Finally it became impossible for Miguel to concentrate on his work—Rosa was
always screaming at him, or his ulcer was. It became clear to him that he could no
longer live at Tizapán with his wife. It was also clear to him that he could not tell
Rosa that he was leaving—that he must sever their relationship all at once, with no
warning to her, or she would surely prevent it. And her anger and pain were so wild
that Miguel was truly in panic, knowing there were no limits to what Rosa might
do to prevent a separation.

Miguel planned his escape carefully. Most important were the books and
archival material, which he would need to complete the trilogy for Knopf and
which occupied two rooms upstairs where he worked. Over a period of some days,
while Rosa was out or otherwise occupied, box after box was removed from the

Gouache study of dance costumes by Miguel Covarrubias.
Rocío Sagaón, model.

house. Miguel had to leave most of his awesome art collection that filled the Tizapán house—all the big pieces—but he was able to remove some of his jades and some of the fine small Mezcala objects from Guerrero that could be concealed and carried out unnoticed.

Miguel had confederates in his removal of these smaller pieces. Yolotl González, a member of his museum administration class, agreed to help. She accepted an invitation to lunch at Tizapán. She remembered meeting Rosa:

> *When I was introduced to Rosa, she instantly took a dislike*
> *to me because, like the dancers, I wore long skirts and tied*
> *my hair back in a ponytail. Only later did I understand the*
> *reason; anything that reminded Rosa of the dancers was*
> *anathema. I remember hiding several pre-Hispanic pieces*
> *under my flowing skirt and shaking as I said my goodbye to*
> *her.*[41]

The housekeeper, Paz, recalled what happened on the day Miguel finally left, telling Rosa as gently as he could that he was moving to the family complex on Zamora Street. (His sister Elena and her husband, children, and sister Julia lived in the main house on Zamora, behind which were two small apartments. Pepe lived in one; Miguel would rent the other.) "Quite naturally, Rosa made a terrible scene. First she screamed and called him every bad name she could think of. This was followed with pleading and sobbing. When nothing changed his mind, she threatened suicide."[42]

Carmen López Figueroa told me that "Rosa couldn't believe this was really happening to her. She was so conditioned to controlling her life, as well as the lives of those around her, that she was incapable of gracefully letting Miguel make this decision."[43]

Not long after the separation, Rosa called her friend Nieves to take her to a local *curandera*, a kind of witch-doctor who could presumably provide herbal remedies. "When I arrived I found her disheveled and very agitated," Nieves told me.[44]

Rosa confessed that she had been to Zamora and found Rocío there, and the two had fought. "Who won?" Nieves asked, and Rosa bowed her head and said that Rocío had. "Let go of Miguel," Nieves told her. "These scenes are going to make you ill."

Paz was one of the few who knew just how ill the separation was making Rosa. The housekeeper confessed:

> *I felt a great deal of compassion for Señora Rosa, although*
> *my true sympathies were with Miguel. El Señor was a*
> *wonderful person to work for, always kind and considerate.*
> *In all the years, he never lost his temper. When la Señora*
> *would get upset over something and scream, he would wink*
> *at me behind her back. He nearly always could talk to her in*
> *his quiet way, and she would calm down.*

When he left her, it was another story. La Señora
suffered inordinately. Sometimes she spent the whole day
crying. She was so despondent that I was frightened. When
she couldn't stand it any longer, she would ask me to call the
Señor to tell him how sick and exhausted she was. I would go
to the phone and dial his number and say that the Señora
was very sick: "Her heart is giving her trouble. She can't
breathe." Once I had to tell him that the Señora had just
taken a bottle of pills. He would drop whatever he was doing
and rush to the house.

Miguel's move afforded him little relief. He still felt responsible for Rosa, and she constantly harangued him for money, either calling Zamora or sending messages with Paz. According to Rocío, when it was time for Miguel to pay the living expenses at Tizapán for whatever (dog food, the servants' bills, property taxes), he sat down and did a painting or two and sold them to Misrachi.

"I never saw Miguel in a bad mood or even lose his temper," Rocío told me. "The only thing that caused him great anxiety was not having his work ready on time."

But surely Rosa caused him anxiety as well. "[She] continued to pressure Miguel," Rocío said. "She called the apartment at all hours of the day and night and would show up when and where we least imagined."

Rosa became obsessed with her lost love, possessed by her own need to track Miguel down. Nieves remembers:

If she didn't find him at Zamora Street, she would go
from restaurant to restaurant where she knew he liked
having lunch with friends. When she found him, she would
stand over the table accusing him of all sorts of sordid things.
Mortified, Miguel would stand up, abandon his half-eaten
food and his companions to escort her home.

To make matters worse, Rosa went around telling
anyone who would listen how badly Miguel was treating her.
It might happen anywhere, at the museum, at the university,
at parties, and even on a street corner. She would rush up to
the person and rail against Miguel in a loud voice.

Oftentimes in the evening, she would hire a taxi and ask
me to go with her in search of Miguel. Even though I didn't
want to accompany her, I couldn't say no. She would have
the cab driver take her around to all his favorite haunts. I
was always so afraid we might find him. I knew what Rosa
was capable of. I felt so sorry for him.

Even more embarrassing was a time when Rosa and I
went to a gallery opening, and we stopped to say hello to the
ex-president of Mexico, Portes Gil. He asked her how she

was. She answered, "My old man has left me. He is going round with a slut." It was awful. The poor thing couldn't help herself.

I recall another scene, but this time I was downtown with Miguel. As we were walking along, Miguel said in a voice full of panic, "Here comes Rosa." He held his portfolio up to his face in a meager attempt to hide behind it. I had to tell him, "Miguel, you are only making yourself more visible." It was amusing to see, but at the same time pathetic.

Many of Rosa's friends began to avoid her. If they would not participate in her elaborate schemes to confront Miguel, she would accuse them of disloyalty and was liable to behave violently. It was best to keep out of her way. Sometimes, however, it was not possible to avoid Rosa's madness. One afternoon at Zamora, while the Covarrubias family was having lunch and Rocío was present, Rosa appeared in the doorway brandishing a gun. Miguel's brother Luis leaped up and dragged Rocío out of the room while Miguel moved toward Rosa. Nothing could have embarrassed him more than such a scene in front of his sisters. Without a word, he took Rosa by the arm and led her out of the house and took her home.

Aside from the nearly constant fear of ambush and physical harm that Rosa inspired in Rocío, the young woman was also suffering the ire of her own family over her romance with Miguel. Rocío's father had died when she was fourteen, and her older brother, Nacho López (who became a highly respected photographer), took to heart his position as head of the household. He had his sister's reputation to protect; he certainly would not permit her to live with Miguel out of wedlock, nor to spend the night with him. In those days, a young woman of Rocío's careful upbringing followed the rules, although it made her life very difficult.

One cannot help but think of Rosa at Rocío's age. By the time Rosa was in her early twenties, she was performing in vaudeville and on Broadway, and she was on her way to becoming the toast of the town. She lived by her own rules, no one else's. She did what she wanted, without the constraints of propriety and family that bound Rocío. Surely it was Rosa's carefree and successful past that made it so difficult, indeed impossible, for her to accept this marital and emotional failure.

CHAPTER 12 *I remember hearing a loud shouting match.*
Rosa was standing on the street by the gate
screaming in English, and Miguel, in his quiet
voice, was trying to persuade her to go home. Of
course, my mother couldn't keep from interfer-
ing. She ran outside and told Rosa that if she
ever came back again, she would call the police
and have her arrested.[1]

F THE FIFTIES, PART THREE (1955–1957)

or Miguel's ten-year-old niece, María Elena Rico Covarrubias,
Miguel brought an unmatched level of celebrity, intensity, and fascination into her
humdrum life on Zamora Street.

> *What I remember most about Miguel was that he was*
> *always working, working. . . . If ever I had to go to his*
> *apartment for something late at night or in the early*
> *morning, I always found him at his work table wearing his*
> *blue pajamas. . . .*
> *He was someone larger than life, a curious man who*
> *spoke seven languages. To me there was an aura of enchant-*
> *ment and mystery about him. I was intrigued with the*
> *famous people that I had read about in magazines and*
> *newspapers who often called or came to see him. I recall*
> *meeting Dr. Atl and Diego Rivera.*

One of the things that impressed María Elena most about Miguel "was his ability to speak and write in Chinese."

> *Because of this, my cousin Florita and I decided to study Chinese, in order to earn our famous uncle's admiration. We would come back from our lessons and go to Miguel's apartment. He would begin in Spanish, "I am . . . ," etc., and we would say the sentences in Chinese. When we went to school we pretended that we spoke Chinese fluently. We succeeded in impressing our teachers and classmates.*

"[Miguel] was forever talking about China," María Elena continued, remembering those days when her uncle lived with them, during which he remained committed to his work with the Friends of Popular China.

> *[He] received large deliveries of propaganda material, magazines, and books from China, which he stored in his apartment or in our garage. Most of the magazines were written in English, and he would translate the interesting articles into Spanish for Mexicans to read. . . .*
>
> *Frequently he received calls from the Chinese embassy. Rosa and he were friends with the ambassador and his family. They were especially friendly with their daughter, Doreen Yang Feng, who had worked with Miguel on the mural map for the Museum of Popular Arts and who wrote a cookbook that Rosa often used. . . .*
>
> *Hardly a day went by when he didn't receive a call from abroad. He didn't have a phone in his apartment, so he had to use ours. When he was out, I took his messages. Once he received a call from China. I was excited because the call was coming from halfway around the world. I ran across the patio shouting, "Quick, quick, you have a call from Peking!" I was wide-eyed with admiration, listening to him speak in Chinese.*

Miguel's sister Elena also "adored her brother," according to María Elena, "and always worried about him, and was forever giving him advice." When Miguel had been living at Zamora Street for some months, the situation with Rosa had not improved, Rocío's family did not relent in her strict curfew, and Miguel was profoundly unhappy, so Elena began to encourage her brother to marry Rocío. His marriage to Rosa had been a civil ceremony, not valid in the eyes of the Catholic church, she insisted. The offense to the church was especially painful to Elena, who thought of herself as a good Catholic and was in effect condoning an adulterous relationship under her very roof—as her brother Pepe liked to point out to her.

Remarrying was the only way to end it between himself and Rosa, she told Miguel. Obviously Rosa would not let go otherwise.

Both of Miguel's sisters had turned against Rosa long before Miguel established a relationship with Rocío. Over the years minor differences had escalated into major resentments. The sisters had considered Rosa not properly respectful to their mother—a fatal sin—and now she was making their beloved brother miserable. Rocío, on the other hand, met with their approval.

Elena appealed to Rocío to consider how much better her family (also loyal Catholics) would feel if she legitimized her relationship with Miguel. Elena also went to the parish priest and persuaded him of the rightness of such a marriage, perhaps with a generous gift to the church.

Miguel must have wished his insistent sister would find some other occupation; but Elena was relentless, and finally Miguel and Rocío spoke to one another about marriage. Neither had any deep feeling for the church—Miguel was opposed to the entire ecclesiastic system, and he felt no compunction about the morality of their relationship. Rocío agreed with Miguel that marriage was not necessary. But, ultimately the two went along with Elena's scheme "in order to make everyone happy," as Rocío put it.[2]

Unfortunately, not everyone was happy. When Rocío told her mother of their plans, the older woman was furious. "As long as he is married to Rosa, this church ceremony is not valid," Rocío recalled her mother saying. "God is well aware of the fact that he is not divorced from Rosa. Who are you trying to fool? If you insist on going through with this, no one from our family will be there." And no one was.

"In spite of this blow, as well as how we ourselves felt about the ceremony, we got married with a wedding mass and all!" Rocío told me.

> *I had a friend make me a beautiful white poplin dress with ruffles,* ranchera *style, and I wore a white silk* rebozo *over my shoulders. . . .*
> *We set out at ten in the morning for the church. Miguel's two sisters and his brother Pepe with his wife Lulu were already waiting for us there. . . . Vidya Peniche was the Matron of Honor of the Knot.[3] Once we were safely inside, the church door was locked to prevent Rosa from entering, in case she had somehow learned of the impending marriage. . . . I remember that we were very nervous, and as the priest talked, Miguel sweated and winked roguishly at me. . . . The wedding mass was like any other; the priest gave his sermon, and the mass was over in a flash. Afterwards our small group went to lunch.*

Back at Zamora at the end of the day, María Elena remembers her mother entering the living room where the rest of the family was gathered and announcing, "It's done. Now my brother Pepe can't say that I am condoning Miguel's affair with Rocío."

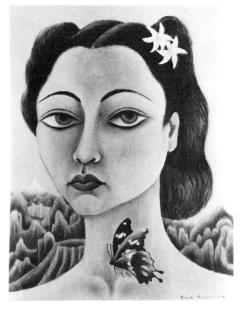

Self-portraits by Rosa Covarrubias, owner Malu Block.

Rocío regretted that they had no photos taken that day:

> *because the whole scene embarrassed [Miguel]. He knew it*
> *was one big sham. Only a very few close friends were aware*
> *that we had married. It wasn't important to me whether the*
> *world knew or not. I never told anyone else because the*
> *marriage contradicted everything Miguel believed in.*
> *Friends and foes would have been more than justified in*
> *questioning his morality in accepting a church marriage*
> *when he continually ranted against the Catholic church. He*
> *believed strongly that the Church had done a great disservice*
> *to the well-being of the people of Mexico.*
>
> *Curiously enough, though . . . , there was a special*
> *magic for both of us about the event. It seemed to clear the*
> *air. We felt at peace, and we celebrated our good fortune,*
> *surrounding ourselves with people who cared about us.*
>
> *In the end, I believe Miguel accepted this bogus marriage,*
> *because although he hadn't been able to stand up to Rosa, he*
> *had had the courage to go against his beliefs for one brief*
> *moment to show everyone how much he cared for me. Miguel*
> *felt relieved, and like me, he thought that things would now be*
> *different. In my happiness, I was even so naive as to think how*
> *wonderful it would be if Rosa could now be our friend. . . . Of*
> *course such an accommodation was impossible.*

The Fifties, Part Three 217

Rocío's happiness enabled her to overcome the difficulty of still not being able to live with her husband, for her family did not recognize their union and continued to protect her reputation by not allowing her to spend the night at Zamora.[4]

Regardless, Rocío perceived her relationship with Miguel as a kind of miracle. "For me it was overwhelming," she told me. "To love someone and in return be loved, and on top of this to create works of art together. I cannot measure the joy." And she was secure in the knowledge that Miguel considered their relationship exceptional as well. "Shortly after our marriage," she remembered, "Miguel said, 'What we have between us is something very special. However long it lasts, three, four, five, or six years, we must live them fully.'"

Miguel and Rocío spoke of having children. Miguel and Rosa had postponed that option until it was too late. "I told him that it would be different for us," Rocío said. "I was young, and I wanted us to have a child together." But Miguel did not want to condemn a child to the possibility of diabetes, an inherited disease that plagued him more and more; and he was thirty years older than Rocío. "Who knows how long I'll live," he told her, "I wouldn't want to leave you alone with the responsibility."

Ten years had passed since Miguel had agreed to illustrate William Prescott's *The True History of the Conquest of Peru* for George Macy's Limited Editions. Discouraged, Macy had at last taken the project to another talented illustrator, Everett Gee Jackson, and was about to strike a deal with him for the work when Harry Block mailed Macy some sample pages of what Miguel had been working on over the years. Macy melted and wrote, "Your drawings are touched, as well as brushed with genius. I don't suppose that I need to tell you how greatly I wish it were easier to get these drawings out of you, my genius friend."[5]

Several months later an antagonism erupted that had been brewing for years. Not long after Miguel and Rosa had toured Central America with the Macys in 1949, Miguel received a statement of his account with the publisher which indicated that the cost of the trip had been deducted from his royalty payments. It had been Miguel's impression that the trip was Macy's gift, and without confronting Macy, he fumed about it. Over the years he mentioned this unfair treatment to one or another friend. Finally, Macy learned about it. He was outraged. In fact, the trip had not cost Miguel anything, according to Macy, except their friendship:

> *I paid every item of expense for Rosa and yourself, from the time we all left Mexico City to the time we all reached New York in the boat. I paid every transportation bill, every hotel bill. I clearly remember one occasion when, at Colón, I found you at the cashier's window starting to pay for your cabin; and I pushed you out of the way, with the statement*

that you were not permitted to pay for anything. I remember
that you seemed embarrassed; and, to cover that embarrass-
ment, I said, loudly so the cashier could hear, that after all
your expenses were being charged to your "royalty account.
Then, so that you would not have to say that you had been
the object of charity at the hands of a bloody capitalist, I did
make a fictitious charge of the total expenses to your "royalty
account." But you knew that to be a fictitious action . . . , that
I paid all the expenses for Rosa and yourself, and you paid
out not one penny. . . .

If you would send me a note containing a flat apology, I
would accept it. Otherwise, I would have no pleasure in
being the publisher of any drawings you might make;
obviously, if I had heard this story before you started on the
Prescott, I would never have asked you to start it. . . . If I
hear nothing from you, I will conclude that I am not to hear
from you and that you will have abandoned the making of
these pictures.[6]

Apparently, Miguel did not respond, and Macy went back to Everett Jackson, who accepted the job of illustrating Prescott's book.

At least it was one less obligation. Whatever else Miguel felt, he must have felt relief.

In the summer of 1955, Miguel was in the labyrinth of his second Indian art book for Knopf, one that would cover Mexico and Central America. He had much of this material already at hand, but he and Rocío still managed to find reasons to explore Mexico together. She recalled:

> *We discovered villages that Miguel had never been to*
> *and often had our lunch in a remote part of the countryside*
> *overlooking some lovely green valley. We even went as far as*
> *the pyramid of El Tajín near Papantla, Veracruz, to see*
> *some dances unique to that area. Miguel always returned*
> *enchanted from these excursions. . . .*
>
> *Miguel spent all his free time working on his books.*
> *Whenever I could, I accompanied him to Tlatilco where he*
> *was still researching. On the evenings when I was able to*
> *persuade him to take some time off, we went to the theater.*
> *On Saturdays, he still liked to visit La Granja, a well-known*
> *antique store where he sometimes purchased folk art,*
> *paintings done by villagers, colonial furniture, Talavera*
> *pottery, and rare plates of Dolores Hidalgo pottery.*

Experimental collage by Rosa Covarrubias.

In addition, Rocío had daily classes in dance and choreography at Bellas Artes, a teaching schedule, rehearsals, and performances. "I attended Miguel's classes of museum administration and primitive art. Several times a week, I took [English and French] classes," she added.

Miguel also remained involved in Bellas Artes, designing the sets for "La Comedia del Arte" and "El Alma en Pena," with music by Joseph Hayden and Silvestre Revueltas, respectively, and for Aaron Copland's "Salón México," all for the 1955 season. In 1956, Miguel built the sets for playwright Carlos Solórzano's "La Mano de Dios," the sketches of which were published in 1957 in a book of the play.

The sets comprised a church, a jail, and a mountain. Solórzano commented: "For Miguel the stage was no more than a poetic frame deliberately flat like a popular *retablo*. . . . In Miguel's scenography, as in all his work, simplicity dominates without sacrificing grandeur."[7]

Solórzano described Miguel as "scrupulous" and "tireless" in his workmanship: "If he wasn't satisfied with the way the panels looked, he would retouch them himself, illuminating them with color. He was aware of the smallest flaws." Santos Balmori declared there was no doubt that Miguel "was gifted with a deeply felt

understanding for the stage." Piña Chán believed "he was the only recreator of pre-Hispanic and colonial forms who managed to escape an affected style."[8]

Still working for the Friends for Popular China, Miguel found the time to research and write a scholarly article on Chinese architecture ("La arquitectura en China"), which he presented in August 1955 at the University of Mexico. (That October, Rocío and Guillermo Arriaga danced "Zapata" at the sixth anniversary celebration of the Republic of Popular China, and both Miguel and Xavier Guerrero spoke.)

Miguel delivered his manuscript on the Indian art of Mexico and Central America to Knopf in 1956, and then he set his vision farther south to complete his trilogy. Daniel Rubín de la Borbolla was going to South America on museum business, and he took with him a list of objects in Peru's pre-Columbian museum of which Miguel hoped he could acquire photographs. Miguel planned to visit Peru himself, perhaps later in the year; for now, he worked on organization and illustrations for the book. Rocío remembers, "There was a sense of urgency now about the way he worked. It was as if he perceived something ominous."

Whatever urgency Miguel felt did not prevent him from going off on a tangent. In this case, it was with André Emmerich on an exhibition (for the United States) of the ancient stone sculptures, figurines, masks, and effigies from the Mezcala River Basin in Guerrero where, ten years earlier, Miguel had projected the Olmec beginnings. (It was for this show that Miguel and Emmerich named the culture and the art "Mezcala.")

Rosa, meanwhile, was still suffering. She confided her pain and her resolutions to get on with her life in frequent letters to Nelson Rockefeller during this time. "I hate to complain about my life," she wrote in March 1956, "but since I must make a new one, I want to do it with a vengeance." Two months later she wrote again: "I am getting so restless to travel again. No matter how I feel, I am not doing anything very constructive here. I just woke up to the fact that one is either dead or alive, and I better be alive."[9]

Mirnalini Sarabahi, who had performed at Bellas Artes during the 1951 summer season, operated a dance school in India, and she extended an invitation to Rosa to come work with her. Nelson Rockefeller agreed to try to find a sponsor for Rosa, since she could not afford to make such a trip herself. Meanwhile, he and Mary sent Rosa some money to help her out, and Rosa wrote, "It comes in mighty handy as Miguel complains he has no money. But last night I saw him in the theatre with *la tipa* [a contemptible woman] and I can't tell you how I felt. It was the first time I saw him since the 3rd of June. He has not come near the house."[10]

Such sightings inspired rages in Rosa. Her threats kept everyone nervous and on guard, and Miguel felt as much guilt and confusion as anger. Just as Rocío could not assert herself with her mother and brother and take possession of her own independence, neither could Miguel do the same with Rosa. It was a terrible situation, and Miguel's health suffered — his ulcer caused him untold misery. María Asúnsolo remembers that he began to say to friends, "The three Rs [Rosa, Rocío,

and his new secretary Rosario] are making my life hell. I can't handle them anymore." Nieves Orozco Field remembered Dolores del Río confiding to her, "The witches are sucking him dry," referring to Rosa and Rocío.[11]

Miguel might joke that the women in his life were the source of his troubles, but Vidya Peniche insists, "It was Miguel who brought misfortune upon himself by not resolving anything with Rosa before he married Rocío." Today we know that ulcers react to stress. It is little wonder Miguel was ill. Vidya points out that Miguel could not resist new projects and had so many going simultaneously as to always undermine his efforts at focusing on one. She considered that his work habits were very disorganized and that he frequently squandered his time. And then, "When angry letters arrived from his editors, he became very anxious. He would stop whatever he was doing and turn to the contracted work he had with the particular publisher. Everything would go along fine, until something else distracted him."[12]

Fernando Gamboa told me that Miguel "was acutely anguished by the passing of time. Consequently, he was always in a hurry. His forehead, slightly damp, accentuated the impression he gave of a man overwhelmed by urgency."[13]

Soon, no matter how much milk or yogurt or ice cream he consumed, or how many Maalox tablets he chewed, the aggravation, abetted by cup after cup of strong black coffee—perhaps as many as twenty-five a day—and innumerable cigarettes, became unbearable.

"Miguel had been a diabetic since he was a young man," Aline Misrachi reminded me:

> [He] never took care of himself or watched his diet. He was much too fat and didn't care enough to do anything about it. He detested going to see a doctor. Never one to be a slave to anything, for years he had been very irresponsible about taking his insulin. Even though it was a lifesaving medicine, Miguel wouldn't listen to anyone.[14]

It became impossible for Miguel to eat due to the pain. He began to lose weight, and at first, as Fernando Gamboa recalled, he "was delighted because he always had the complex of being a fat boy." Then there came mornings when he could not get out of bed. One morning he did get up, and he collapsed. He needed a hospital and surgery.

Putting principle before pain, Miguel asked his family to take him to the Hospital Juárez for the indigent poor. Journalist Selden Rodman reported:

> I rejoined Spratling for lunch at Sanborn's and we spoke of Covarrubias. We agreed that he will probably die in a few days if he can't be talked into going to a decent hospital. But Miguel insists that if he must go again to the hospital he will return to the state ward where he was so badly cut up and prematurely released. This is part of his Marxist complex.

> *Better to die "collectively" than be saved in a "capitalist" private institution.*[15]

Elena overruled Miguel's request. He was admitted to the Institute of Nutrition, a government-run general hospital that specialized in gastroenterology and whose director was a friend of Rubín de la Borbolla.

Rodman, who had known Miguel for more than thirty years, was in Mexico City during his hospitalization, and he heard from an art dealer (probably Misrachi) that Miguel was "in the hospital undergoing surgery . . . 'because his wife refuses to give him a divorce. He wants to marry a young dancer.'"[16]

"As soon as he felt a little better," another friend, the painter Raúl Anguiano, recalled:

> *Miguel could hardly wait to leave the hospital so he could have some tacos. And I have no doubt that is what he did. Miguel didn't know how to take care of himself. Shortly thereafter, I saw the newlyweds at an embassy party. Miguel looked very rundown. He was carrying Rocío's coat over his arm. Rocío was full of vitality, and Miguel seemed very sad.*[17]

Rodman visited Miguel at Zamora that November 11: "He was just out of the hospital," Rodman wrote.

> *I would hardly have recognized him—hollow-eyed, yellow-skinned, gray-haired—as the bouncy, cosmopolitan cartoonist of the late twenties. . . .*
>
> *"We'll talk about you, and your new writings about art," he said, "the next time you come here." I had a presentiment we wouldn't, but I tried to smile and told him to take care of himself. The nurse was waiting patiently in the doorway with a tray of medicines. I noticed that her dress was dirty and that she wore no shoes.*[18]

Miguel believed he would recover. The recovery was just taking longer than it should—like everything else in life, he may have thought. His lingering illness eventually won over Rocío's family, who lifted their restrictions against the couple living together, but by now Rocío's role was that of nurse rather than wife. And her nursing did not help. His incision would not heal, he was in awful pain, and he could not even move.

In desperation, Rocío made repeated visits to the Russian embassy, beseeching them to take Miguel to Russia to cure him (at the time, Mexicans had great faith in Russian medicine), but she was not successful.[19] After a short time at home, against his will, Elena took him back to the hospital.

Miguel's friend Frederick Field and another collector, George Pepper, visited him there. Field remembered:

He was in a miserable state ward with many other patients.
It took us a while to find him. You could hardly see him,
there were so many flowers beside his bed. We tried to do
something about having him moved, but we were not able to
do so. It was terrible to see.[20]

The situation worsened. Miguel developed the gamut of hospital-related miseries. First, bed sores on his back that would not heal caused him pain rivaling his stomach pain. Then his lack of movement caused lack of circulation, and his diabetes reacted by blackening his feet. Then he developed pleurisy. His chest ached, he wheezed for air, and he began to spit up a yellow sputum, which the doctors assured Rocío was a good sign—"the poison coming out."

Rocío was distraught, as much from the seriousness of Miguel's condition as from the threat of running into Rosa at the hospital. "It was hard on me to arrive at the hospital with my heart in my throat fearing a confrontation," she recalled. "Miguel . . . told me to run if I saw Rosa. Just imagine having to worry about her under such troublesome circumstances!"

Miguel had begged his doctors to keep Rosa away from his room. Nevertheless, she tried to reach him. Rocío recalled one afternoon she will never forget: "I saw this figure rushing toward me. It was Rosa. She began pummeling me about the head. Miguel's sister Elena, hearing loud screaming, rushed out and slapped Rosa on the face. We all had to be separated."

On another occasion, Rosa enlisted Diego Rivera to help her get into Miguel's room. Selden Rodman reported:

She wanted [Miguel] to sign some papers, presumably to
ensure that she would inherit his priceless pre-Columbian
collection. Diego, torn between Rosa and Miguel, as were
most of their friends . . . agreed to accompany her. When
they arrived, the doctors refused them admittance to the
dying man. Diego stormed and shouted, went out and
returned with several policemen. But the doctors lined up in a
phalanx against the sick man's door and stood firm.[21]

After this episode, Elena had Miguel moved to a private room and hired bodyguards to stand outside his door. She herself spent most days attending him. Vidya Peniche sat with him in the mornings. "Although I was pregnant with my first child," Vidya told me, "I went every morning. And Miguel was happy to see me. He would never have asked for anything himself. It was characteristic of him to not want to bother anyone."

One afternoon when Elena arrived to sit with him, Miguel reported that he had dreamed he had gone to heaven and liked it, and then to hell and didn't like it at all. Elena was elated. She took the dream to mean that her brother had finally become a believer.[22] More likely, he was teasing her.

Fernando Gamboa visited Miguel two or three days before he died:

*Self-portrait expressing Rosa's pain over Miguel's involvement
with Rocío.*

> *He already had the look of death about him. I believe he
> was just plain worn out. He let himself die. . . . He said to
> me, "I am going to die. . . . Last night death appeared before
> me. I felt death's presence."*
>
> *I wanted to ask Miguel if he had written a testament.
> However, in the end I didn't dare because it seemed to me as
> if I was finishing him off.*

Miguel drifted in and out of comas at the end. Rocío thinks that twenty-four
hours before he died, Miguel realized he was dying:

> *He was very weak and each breath was torturous. He
> could no longer talk, but as I held his hand, he never took his
> eyes off me. I can tell you that his expression was not the look
> of a man who wanted to die.*
>
> *I spent the night with him. At dawn, an orange liquid
> poured from his mouth. I was foolish enough to think this
> was another good sign. I left for my classes, and I was
> practicing at the bar when Luis came running to tell me*

Miguel was dying. I went with him still dressed in my leotards.

When we arrived at the hospital, I found Miguel very quiet, almost without breath. I took his hand, and just like that, he died! I had arrived just in time to see him take his last breath. I couldn't believe it. A few more minutes and I wouldn't have seen him alive. How was it possible?

Rocío remained sitting by Miguel's bed while Elena and Luis notified the rest of the family, who arrived one by one. To Rocío, it seemed as if she sat in the eye of a storm:

As soon as someone dies, those in charge are in a hurry to get rid of the body and the relatives. The nurse covered Miguel's face with a sheet. The attendants started to clean the room. They didn't really give us time to mourn or say goodbye.

Miguel's sisters took care of all the arrangements with the Gayoso Funeral Agency. It was almost as if I had died along with Miguel. I couldn't do or say anything.

The hospital signed off on Miguel with cold statistics: date of death, 5 February 1957; time of death, 3:45 P.M.; cause of death, an ulcerous perforation from which septicemia resulted. Many of Miguel's friends believed, as Frederick Field did, that "the surgeon had bungled the operation and perforated the pancreas." However, one of Miguel's doctors had told Selden Rodman that Miguel "had no will to go on living—being cognizant of the fact that even the little dancer had begun to play around, now that he was an invalid."[23]

Rosa was visiting Leon and Ruth Davidoff when she learned of Miguel's death. "She was devastated and in shock," Ruth recalled. "I think what hurt the most was the fact that she had not seen him before he died." The comment is eerily echoed by one Rodman wrote in his *Mexican Journal*: "At least [he] died without having to face again the woman who had humiliated him publicly so often."[24] The Davidoffs took Rosa back to Tizapán, where Carmen López Figueroa found her, inconsolable, and took her home.

The two women had been estranged for two years, but Carmen was a true friend to Rosa (in spite of Rosa's once having written to Rockefeller, "Watch out, Carmen 'the kiss of death' is on her way North."). "The first few days she stayed in her room and cried all day long," Carmen recalled. "My mother finally went in to see her and told her she didn't want anyone crying in the house. Within ten minutes, she had Rosa laughing." Rosa stayed with Carmen and her family for six months.[25]

The family had wanted to hold Miguel's wake at Bellas Artes, but Alvarez Acosta decreed that Miguel's status did not warrant the honor—Bellas Artes wakes were traditionally for heads of state and other dignitaries.

Instead, the body was removed to the National Museum of Anthropology and History on Moneda Street.

Everyone of importance in Mexico's theatrical, artistic, intellectual, and political worlds was there, including Eusebio Dávalos, poet Antonio Castro Leal, painter José Chávez Morado, Alfonso Caso, Diego Rivera and his new wife Emma Hurtado de Rivera, David Siqueiros, Rufino Tamayo, Carlos Orozco Romero, Manuel Horta, Ernesto García Cabral, singer Pedro Vargas, Emilio "El Indio" Fernández, Inez Amor, Guillermo Keys, Rut Rivera, Adolfo Best Maugard, Ignacio Fernández Esperón ("Tata Nacho"), art historian Jorge Crespo de la Serna, designer Francisco Cornejo, Ester Chapa from the Friends of China Committee, Román and Beatriz Piña Chán, Mario Vázquez, Daniel Rubín de la Borbolla, art critic Margarita Nelken, and many, many others. It seemed that all of Mexico mourned.

A chapel was set on a small patio up two flights of stairs. Rocío remembers that she, Miguel's sisters, and several friends were standing near the closed casket, which was covered with flowers and topped with a crucifix that had belonged to Miguel's mother, when she heard someone whisper, "Here comes Rosa," and everyone turned.

> She was dressed in black, with long black veils covering her head and face. Overcome with grief, two friends held her up by the arms. She was like a hanging bell. From an artist's point of view, the figure she presented was beautiful, yet when one observed her closely, horrible, because there were no limits to her suffering. To hear her uncontrollable sobbing and watch her collapse as she approached the coffin was devastating.
>
> Quite unexpectedly, she rose up and screamed, "Who put that cross on Miguel's coffin? Take it off! He wouldn't have wanted it there. He wasn't a Catholic." Elena shouted back that he was, and to leave it. They argued back and forth.
>
> Rosa turned toward the coffin weeping, "Miguel, why did you abandon me?" and other such sad musings. Everybody in the hall heard her and was stricken with grief.

As Rosa continued to cry so pitiably, Pancho Cornejo, who was quite drunk, moved to her side. He carried an antique candelabra and a beautiful bright-colored Indian *rebozo*. He removed the cross, replaced it with the lit candelabra, and arranged the *rebozo* around the coffin. He then burst into loud sobs, which served to distract the crowd from Rosa.[26]

Suddenly chaos broke out. María Elena turned toward the noise and saw Rosa standing next to Dolores del Río with a pistol in her hand. María Elena told me, "I remember that my mother started to cry. People were running every which way."

Rocío told me she had begun "to feel sick." Fernando Gamboa, who had dressed his friend's body ("one of the most difficult things I ever had to do"), went

Miguel, ca. 1955. Photograph by Nickolas Muray.

to Rosa and spoke to her, then found Rocío in the crowd and told her that Rosa intended to kill her. She must leave immediately.[27]

Miguel's sisters convinced Rocío to stay away the next day, too, when Miguel would be buried. "'You must not give Rosa the opportunity to play out any of her wild notions. Don't try to come,'" Rocío recalls them warning her. "'You know in your heart how much Miguel loved you. This is what really matters. . . .' The next day I stayed home. I don't even know where he is buried. I have never visited his grave site. It is not important."[28]

Miguel's casket was carried out of the National Museum at four in the afternoon by his brothers Pepe and Luis, Fernando Gamboa, and Luis Aveléyra Arroyo de Anda, the museum's director. He was buried forty minutes later at the French cemetery on Cuauhtémoc Avenue in the Covarrubias family crypt.[29]

Journalist Raúl Valencia spoke at the gravesite. "Miguel Covarrubias is part of the sentiments, language, and roots of Latin America to which in life he gave so much," he said. "We stand before his grave knowing that Miguel Covarrubias is destined for immortality." And Alfonso Caso mourned, "With his death, a multiple of still unspoken ideas and significant matter were forever lost."[30]

CHAPTER 13 *In reality, the disposition of Miguel's collection had*
been decided long before his death. The collection
was only put into the hands of the museum [the
National Museum of Anthropology and History] for
the sole purpose of having a neutral party safeguard
the collection until a satisfactory resolution was
worked out by the concerned parties. With this in
mind, a patrimony was formed by the university [the
Autonomous University of Mexico] with the intention
of acting as a moral authority over the collection
until the appointed time when it was given to what-
ever institution in the name of Miguel and Rosa.[1]

B AFTERWARD
(1957–1970)

y the time Miguel realized he might be dying and should make
some provisions for his family (not to mention his by-now fabulous art collection)
in a formal will, he was too weak to hold a pen. He had told many people over many
years, including Fernando Gamboa and Rubín de la Borbolla, that he meant his
collection to remain in Mexico City, specifically in the National Museum of
Anthropology and History, for which he had worked so hard. His desire to share
Mexico's great cultural wealth with the world began with his desire that Mexicans
themselves know of their rich history, and he repeated that wish to Eusebio
Dávalos, director of the National Institute of Anthropology and History, and
museum director Luis Aveléyra Arroyo de Anda, when they visited him in his
hospital room before his death.[2]

But Miguel died intestate and, as he had never formally divorced her, still
legally married to Rosa.

Within twenty-four hours, Elena and her sister and brothers had sealed
Miguel's apartment, which housed the rare small pre-Columbian Mezcala pieces
that he had managed to sneak out of Tizapán when he moved into the apartment
on Zamora Street.

A much larger collection of some five hundred pre-Hispanic objects from Mezcala and Tlatilco, including small- to medium-sized Olmec figures, was currently on loan to Fernando Gamboa, who had curated an exhibition of them (La Exposición Arte de México) in 1952 in Paris and in 1953 in London. Afterward, Miguel had asked Gamboa to keep the collection at his own home until Miguel could find a place for it. "He didn't want Rosa to get her hands on it because he was afraid of losing it," Gamboa explained.[3] Within twenty-four hours of Miguel's death, Gamboa transferred all five hundred pieces from his home to the Museum of Anthropology and History.

Meanwhile, Elena, Julia, Pepe, and Luis called on Román Piña Chán, Eusebio Dávalos, and Luis Avéleyra Arroyo de Anda to enter Miguel's rooms and make an official inventory of the Mezcala art there and his Olmec pieces, as well as the Tlatilco collection that Muriel Porter Weaver had catalogued some years before. Everything was then removed to the museum.

No one consulted Rosa. The family believed that Miguel's four siblings would share Miguel's estate in accordance with Mexican law. María Elena recalled that they did not believe Rosa had any proprietary interest. The fact that Rosa was a United States citizen and, by the laws of her country—in which the two were married—Miguel's one legal heir, did not play a part in the family's discussions.[4]

When Rosa discovered what had been secured by the museum, she was furious. She agreed that the removal of the collection from Zamora Street was necessary to safeguard it from breakage or robbery, but she was terribly insulted by the way the family had gone about it. "They removed everything in the middle of the night, like contraband," she told me.[5] Later, María Elena confirmed that the collection had been moved under cover of darkness. Rosa was also terribly angry that Piña Chán, Dávalos, and Avéleyra Arroyo de Anda had done their cataloguing without consulting her. Who better than she knew every piece and its history and provenance? It seemed to her almost a conspiracy against her.

Rosa's confidant, Nelson Rockefeller, had written his condolences, and Rosa wrote back that Miguel's death "hurt me very much and I am still in a state of depression and bewilderment. I am so alone, more now than ever.... The idols will be all I have. But I have Miguel's four brothers claiming it under strange circumstances."[6]

The family's intention was clearly to avoid Rosa, but surely not to deprive her of what they deemed her fair share. The fact was that they feared her; her unmitigated pain and anger were difficult for any of her friends to face, let alone a family who no longer had any special love for her. The prospect of negotiating with Rosa over anything having to do with Miguel appealed to no one.

Rosa consulted an attorney. Miguel's collection had been as much hers as his. She herself had chosen and purchased several pieces with her own money. Furthermore, she did not believe that Miguel's brothers and sisters wanted to share anything with her. She didn't trust them at all.

A few months later, when forty pieces from Miguel's pre-Hispanic jewelry collection turned up for sale in New York City at Maurice Bonnefoy's Gallery

D'Arcy, Rosa knew she had been right. She wrote to Nelson: "It's such a mess. I don't know how much more stupidity I can stand. Why are people so mean?"[7]

Bonnefoy had purchased the pieces from the Black Tulip Gallery in Dallas; the Black Tulip had bought them from Everett Rassiga, an American Airlines pilot and art aficionado—and a friend of Miguel's brother Pepe. (Pepe also worked for American Airlines.) However, Pepe swore he had never trafficked in the jewels. "I gave all the pieces in my brother's apartment to Professor Luis Aveléyra Arroyo de Anda, and the transaction was witnessed by . . . Eusebio Dávalos," he told the *Excélsior* when the paper did a feature on the stolen collection.[8]

An American law firm in Mexico City represented both the Mexican government and Rosa in their action against the D'Arcy gallery. They were able to document the forty pieces as part of the Covarrubias estate and established that they were illegally removed from the country. All forty pieces were recovered and turned over to the Museum of Anthropology and History with the rest of Miguel's collection.[9]

Meanwhile, in the spring following Miguel's death, the National Museum began planning a new museum that would ultimately house all of the Covarrubias collection. Pedro Ramírez Vázquez, who would design the facility, first saw the carefully boxed pieces in the old museum basement where Luis was sorting through them for an exhibition in honor of his brother. Vázquez told the *Excélsior* that he was overwhelmed by the collection. He specifically recalled two very unusual pieces: an Olmec figure cupping his ear with his hand (today this figure is world famous; it represents a deaf man) and a small statue with three eyes, two mouths, and two noses (which was how early artists had represented movement).[10]

Rosa visited the collection, too, and she noted with growing outrage that several treasures were missing. She accosted Eusebio Dávalos and Luis Aveléyra Arroyo de Anda and demanded to know the whereabouts of the vanished pieces. They confronted the Covarrubias family. Earning Rosa's complete disgust, Luis told the two trustees that immediately following Miguel's death, his apartment had been robbed. An unknown person or persons had entered the rooms and removed several pieces before the family had sealed the doors.[11]

Obviously Luis made up this story to shift the blame away from himself and the family, Rosa thought. Now people would speculate that the "unknown persons" were agents of Rosa or of Rocío. But Rosa never suggested that Rocío might have robbed Miguel; she was positive that his brothers were to blame and that they were selling pieces of Miguel's valuable art collection abroad.[12]

When I spoke with Luis about the compromised collection, he insisted that he had had a falling out with his brother over it. Pepe had wanted to keep some pre-Columbian pieces that were Miguel's. "My brother was always quite a businessman," Luis told me. "However, I wouldn't allow him to keep anything. I even persuaded him to give up any inheritance rights we might have and deed them over to Rosa. As a result, our family was divided over this touchy situation."[13]

Rosa put about as much faith and trust in the museum to do the right thing by Miguel as she did in his family. She didn't want the collection for herself (though she contended to her death that it was rightfully hers), but she didn't want Miguel's

Rosa kissing Diego Rivera. Photograph by Nickolas Muray.

family or their confederates at the museum to have it or to profit by it, either. She announced that, as the legal owner of the collection, she would donate all of it to the Autonomous University of Mexico, which was the largest university in Latin America with 42,000 students, as she told Rockefeller in a letter,[14] and where at the time, Daniel Rubín de la Borbolla was a regent.

Rubín de la Borbolla defended Rosa's decision, explaining:

> *At first, Rosa agreed to accept that the repository be with the Museum [of Anthropology and History]. However, something or someone changed her mind. I am not aware of what or who. Perhaps what contributed to this was Rosa's continued dissatisfactions with the explanations she was getting from the museum staff. Whatever the reason, she suggested the university should straightaway establish a museum with Miguel's collection as the foundation. Because of this, we were accused by some of trying to take the collection away from the Museum of Anthropology. As attractive as her offer*

was, the university abided by the law, and it would have been impossible to do anything illegally. We never had the intention of keeping the collection. What we wanted was to comply with Miguel's wishes. This is the truth.[15]

While the wheels of justice turned slowly and the new museum was still under construction, the collection remained in the National Museum. In November 1958, museum director Luis Avéleyra Arroyo de Anda, along with other government officials, inaugurated the Covarrubias wing. It contained 675 separate pieces. Luis Covarrubias had made the installation himself over a period of several months, drawing on what his brother had taught him.

When the collection became public, Luis Avéleyra Arroyo de Anda declared that Miguel had bequeathed to the Mexican people "a collection of Olmec art that was then the most important in the world, notwithstanding some extraordinary examples in private collections."[16]

The objects of greatest value, perhaps, were those from the pre-classic horizon. The first vitrines a visitor encountered contained the nucleus of Miguel's Olmec collection, superb figurines made of jade and other semi-precious stones and other small, modeled clay figures. Beyond these rested rare pieces from Veracruz, Guerrero, Michoacán, Colima, Jalisco, and Nayarit, representing the Olmec, Mezcala-style, Zapotec, Maya, Huasteca, Mexica, Chaneque, Toltec, and Teotihuacán cultures. There were the astonishing laughing heads from Veracruz; the two unusual pieces that Vázquez had mentioned, the deaf man and the animated figure; a dwarfish figure without a mandibula; and two Mezcala figures joined at the spine (apparently representing Siamese twins—the Indians often memorialized nature's oddities in their pieces). Olmec masks with jade jaguar lips were displayed, as were a Teotihuacán head with plumed headdress and a Colima dog chewing on an ear of corn.

Art critic Julio Scherer García wrote for *Excélsior:*

> *It wasn't enough that the objects were rare or valuable. [Miguel] demanded something more: line, form, and objects which were harmoniously conceived and executed.*
>
> *In the objects on display palpates the temperament of Miguel Covarrubias, a man devoted to beauty above all else. He discovered it in pre-Hispanic creations and gave the best he had to offer to this quest. It did not matter that he had to pass through long periods of poverty, family sorrows, unending trips in pursuit of an object only measuring thirty centimeters.[17]*

It took ten years to resolve Rosa's dispute with the Museum of Anthropology. Ultimately, according to Mary Anita Loos, the Mexican Department of Education paid her $40,000 (U.S.) for the 675-piece Covarrubias

collection (though Rosa claimed there had been closer to a thousand pieces)—and they designated that the museum would continue to house it.[18]

The Museum of Anthropology and History moved to its new quarters in Chapultepec Park in the early 1960s. When Rosa visited the new installation, she discovered that the Covarrubias collection had been dispersed according to culture and region, and of the original collection, only twenty-five of Miguel's pieces were displayed. The others, she was told, were in storage; but Rosa was not permitted access to the storage area for confirmation.[19]

Over the ensuing years, she claimed to see some of those missing pieces that she knew so well in galleries in the United States. She believed that someone, perhaps the museum itself, was selling pieces to "Yankee millionaires" and galleries.

Yankee millionaires were not alone in reaping the fruit of Miguel's collection. Rosa told me about a cocktail party she attended in the sixties at the home of an important Mexican government official. She had walked outside to look at the patio and garden and had come across one of Miguel's rare pre-Hispanic stone figures, now a fountain gurgling water through a hole drilled in the mouth.

Rosa was vocal in her distress over the fate of what had been, at least representationally, Miguel's life work as a collector. Many of Miguel's friends, including Daniel Rubín de la Borbolla, Andrés Henestrosa, and Fernando Gamboa, agree with Rosa that a wholesale robbery had occurred. Gamboa tried to explain it to me:

> *Once the government buys a piece of art, the original does tend to disappear. The idea is that the object belongs to the state, and since those who govern are the state, why, then the object belongs to them.*
>
> *In this case, I believe that kind of immature thinking was particularly true, and not dishonesty, though granted there are always some dishonest people. In any event this is the explanation of what happened to Miguel's wonderful collection. I was very upset and voiced my protest. The fact that the government had bought the collection didn't give it the right to abolish it.*

Others who knew Rosa believed she may have fabricated, or at least embellished, the facts regarding her husband's collection. It became her cause célèbre. In fact, Rosa's accusations have never been proved. The museum explains that it no longer displays any collections of individual donors. All objects are now categorized and shown in sections reserved for specific cultures only. Objects not on display are categorized similarly in the museum's storerooms.[20]

However, when questioned, museum officials remain evasive to this day. If one asks to check the Miguel Covarrubias inventory against the pieces on display and those stored in the museum, appointments are always cancelled.[21] The true facts and the actual disposition of Miguel's collection may never be known.

George Balanchine and Rosa with pre-Columbian necklace, Mexico City.

\mathbf{M}iguel's book, *Indian Art of Mexico and Central America*, a scholarly examination of the region's early art and culture, was published posthumously in the year of his death. Holger Cahill, writing for the *New York Times,* noted respectfully that the value of Miguel's work went far beyond his dearest interest, which was "transculturation," his belief that Meso-America had been influenced by contributions from Asia and the Pacific Islands. "He brought to his studies in archeology the artist's sensitivity and quick insight and knowledge of art history," Cahill wrote.[22] But what became of the draft of the last book in his trilogy, about Indian art of South America and of his voluminous research notes and hundreds of drawings and photographs for that book remains a mystery. Pepe had typed up Miguel's notes, and Luis had worked on the drawings with his brother, but neither could say what happened to any of it.

Rubín de la Borbolla had brought a set of negatives back from Peru for Miguel's possible use in this third book—the focus was mainly on the Incas—and had then seen the book outline and a nearly completed first draft. Rubín de la Borbolla made an effort to trace the manuscript, hoping to be able to complete it himself—he, better than anyone else, understood and appreciated Miguel's global vision of cultural Meso-America, and he had consulted with Miguel during most phases of his work since the early forties—but he never did locate it.

Several years after Miguel's death, Rosa's sister Mae heard from a writer friend of hers in Los Angeles that one of the Covarrubias brothers had consulted with him about work on an unfinished manuscript, though so many years later neither Mae nor the writer could recall any details of that consultation or the ultimate results.[23] The manuscript has not resurfaced so far as we know.

Michael Coe, a well-known archeologist and professor at Yale University for whom Miguel was "one of my huge heros," remembers two other "lost" books—heavily illustrated notebooks of Olmec legends and myths—that Miguel recorded, probably in the 1940s, and that "Bill Spratling had somehow gotten hold of. . . . He tried to sell them to Nelson Rockefeller, who turned them down because he thought Spratling was asking too much. Eventually Spratling willed them [or possibly sold them] to Mel Ferrer and Audrey Hepburn." Ferrer and Hepburn eventually divorced, and what became of the notebooks is not known. The two books had been photographed, however, by the pre-Columbian collector George Pepper, and that facsimile now belongs to his ex-wife, Jeanette Bello.[24]

Eventually Rubín de la Borbolla's wife, Sol Arguedas, translated *The Eagle, the Jaguar, and the Serpent* and *Indian Art of Mexico and Central America* into Spanish (through the National Autonomous University Press in 1961). When Elena Poniatowska read the two books, she wrote, "[Miguel's] work is so important, so decisive in the field of archeology that all one can do is bow one's head."[25]

Sol's work on Miguel's books was another affront to Rosa's sensibilities, which grew more and more beleaguered as she aged. Sol remembered:

> *Once Miguel was gone, we no longer saw Rosa because she had never liked me. We had tolerated one another out of respect for our husbands' friendship.*
>
> *I was very young when I married Daniel. Everybody in our group was at least twenty years older than I. Here I was, a very unsophisticated young girl from a province of Chile. Rosa had a very cruel side to her, and she wasn't bashful about showing it. Whenever I think of Fernando Gamboa's wife, Susana, I do so with gratitude because she protected and defended me from Rosa's onslaughts.*
>
> *My husband Daniel was extremely close to Miguel. They were each other's confidants. They had worked together over thirty years. It used to amuse me that they always addressed each other with the formal usted, instead of the familiar tu. It was how they showed the enormous respect they had for one another. Daniel never had a dearer friend than Miguel. He was so devastated when Miguel died that soon after he had a heart attack himself.*
>
> *Sometime after Miguel's death, [when] I was working on the translation of his books . . . Rosa's dislike of me surfaced once again. "What gives you the right to do such a thing?" she yelled at me. "How dare you try to translate a book written in*

*English when you don't even speak the language!" It was true,
I didn't speak English; but I could read and understand the
text, which was what was necessary to do the job.*

*When [her bullying] didn't work, Rosa took a different
tack, insisting we must forget Miguel. She didn't want his
name mentioned; she didn't want anyone she knew working
on anything of his. It served only to remind her of him, which
was more than she could bear. She wanted to erase his
memory. It was sad.*[26]

Rosa had become a figure of pity among so many who had once counted her
as a friend. Her madness over Miguel's affair had alienated just those people who
might have comforted her now; instead she became convinced that all those friends
had been *his* friends only, all along. Esperanza Gómez, a dancer who married
Arnold Belkin, called her "a tragic figure, alone in a country where she now felt
alienated and left out, fighting for what she believed was hers."[27]

T he friends who remained urged Rosa to move closer
to the center of the city. Tizapán was remote, and Rosa no longer drove. But, as
María Asúnsolo remarked, "No one could advise her. Rosa had always been
stubborn. Those of us who wanted to keep her friendship had to accept her as she
was or lose her."[28] Many chose to lose her, and Rosa was outraged by these
defections, which made her all the more bitter.

Many friends, however, stuck by Rosa. Georgia O'Keeffe came to stay with her
for two weeks when Rosa returned home to Tizapán from Carmen's house. In
August Rosa accompanied John Huston and the French stage actress Suzanne
Flon to Palenque, Tulum, and Chichén Itzá.[29] The Rockefellers certainly did not
desert her. Until Miguel's estate was settled, they gave her one thousand dollars a
month on which to live, and although Nelson had arranged for Rosa to take her trip
to India, she kept putting it off while her suit against the museum was still pending.
She wrote to Nelson on 20 April 1959:

> *When we win a point and are about to move forward
> Mr. Spratling's lawyer is there to stop us on some stupid
> technical point. I really don't know what to do about him. He
> is in Mexico by the skin of his teeth anyhow. . . .*
>
> *Nelson, again I thank Mary and you for the opportunity
> to work and meditate on my future life in the Orient. My eyes
> will be always open to primitive art and its possibility.*[30]

When Rosa needed help again, Mary and Nelson bought some of her paintings.
And in 1965, when Rosa expressed the desire to return to Bali before she died, Mary
Rockefeller paid for the trip. But when Nelson left Mary for a younger woman—
Rosa referred to such young interlopers as "hateful whores"—her twenty-year

José Luis Cuevas and Bertha (wearing Rosa's dress) on wedding day.

correspondence with Nelson and their intimate relationship came abruptly to an end. Rosa would have nothing more to do with him.[31]

Rosa existed on a small income from the royalties on Miguel's books and from some American stock she owned. It was barely enough to cover her living expenses and maintain Tizapán, which, along with all its contents, was finally designated as Rosa's inheritance. "Contents" meant all the furnishings plus the Huastec breast-plates, all the large pre-Columbian pieces that had remained in the house and garden, the collections of African, Balinese, and Mexican folk art, costumes from many countries, and modern paintings.[32]

Rosa could easily have sold off the collectables, but outside of a few decorative colonial pieces she let go to the antique store *La Granja*, Rosa refused to part with what she considered a valuable assemblage of art.[33] She had a personal respect for what it took to accumulate a first-class collection—the patience, the years, the perspective. She had no children to whom the Covarrubias collections could be bequeathed, but she intended that the collections should find a proper home in museums after her death. She was not going to break up what she wanted to be remembered for, in exchange for a fuller larder.

A year after Miguel's death, Rosa applied for a two-thousand-dollar grant from the Wenner-Gren Foundation for Anthropological Research, proposing to write and provide photos for a book she wanted to call *The Living Dead,* on dance and sculpture in Bali, Java, and India.[34] Apparently her application was not successful. She tried again, this time writing an article about visiting Walter Spies in Bali, which she sent off to her old friend, Jane Belo Tannenbaum, who passed it along to Hans Rhodius, a Dutch collector and great admirer of Spies who was then writing a book about him. Rhodius used Rosa's piece or at least a portion of it. Much later Jane wrote to Rosa: "I have, when I think of you, a great nostalgia for Bali, and the contribution you made to Hans Rhodius' book about Walter Spies brought home to me as no other passage did the lively experience of knowing him and seeing Bali partly through his eyes."[35]

Rosa thought of capitalizing on her culinary reputation by writing a cookbook. It was not a new idea. In 1947 George Macy had sent her a contract with Limited Editions for such a book, and later she entered into a contract with Heritage Press, but she had not followed through. Now, her old friend Salvador Novo, a gourmet and chef himself, encouraged her, and he made an effort to keep her active in that direction by enlisting her to work with him on a mass-market booklet of recipes and menus, on designing a booth for a food fair the city hosted, and by assisting him in the kitchen at a banker's gastronomic club called La Capilla.[36] They talked about Rosa doing a book of international dishes and of collaborating on a book of exclusively Mexican cookery.

Rosa and Paz worked on compiling recipes for years and outlining and developing chapters, but ultimately there was no book. Although Aline Misrachi attributes this to laziness, this seems too harsh an assessment. In spite of all her talent and all her material, Rosa could not pull out of the formative stages of authorship. "After her death," Aline told me, "her friend Julie, an American married to Juan Gallardo [a Mexican architect], who was herself a good cook, inherited those recipes. Julie meant to finish the book, but in the end she didn't do anything with them either."[37]

Another friend who encouraged Rosa in her creative life was the architect Luis Barragan, who became internationally recognized for his own rare talents more than a decade later. Barragan had always liked Rosa's paintings, and he urged her to pursue her art, although she was no longer interested in mining Indian themes for inspiration. She turned instead to still lifes, tropical flowers, insects, and butterflies. In 1965 Rosa sold an oil on canvas (of a vase of mixed flowers with butterflies), to the Greenhouse Spa in Dallas, Texas, where it hangs to this day.

Mary Anita Loos thought Rosa could have been a great painter, but she lacked the drive. "I remember a painting of an orchid she did in which she had caught the spirit of the orchid," Mary Anita told me.

José Luis Cuevas remarked on Miguel's influence in Rosa's work. "She was a magnificent disciple," he said. "I liked her women in white and her self-portrait, which was as fine as the one she painted of Dolores del Río. Rosa's paintings were much more interesting than those that Luis Covarrubias painted imitating Miguel."[38]

Rosa's room at Tizapán was a world unto itself. It was separate from the main house, down a narrow pathway from the kitchen door. It was large—large enough to be part bedroom, part studio, part gallery. It had its own bathroom, with walls and floor of terra-cotta and a sunken tub made of black and white Talavera tile from Puebla with a shelf all around it full of shells she had gathered on exotic beaches.[39]

Her bed was covered in red and white raw silk from Bali. A small painting of blue morning glories and a small head of Rosa, painted by Miguel, hung on either side of one of Rosa's own paintings of Tehuantepec women over the headboard. In front of the bed, an elaborately carved and incised Mexican cypress armoire held her clothes. Fine embroidered cotton lace covered her dressing table, on which lay a collection of early American glass. Antique chests from Olinalá, Michoacán, sat on the floor on either side of the dressing table.

Elsewhere in the room, a collection of large western pre-Hispanic sculptures and palmate stone figures from Veracruz crouched on top of tables or on the floor. (These pieces were almost all purchased by Rosa. A few of them had been gifts from Miguel, who knew her passion for them.) One stand supported a collection of nineteenth-century toys, sugar figures, and skulls for All Saints' Day (one with her name spelled out in bright red foil). Others held toys and treasures from Bali, China, Africa, Alaska, and Mexico.

Rosa loved jewelry, especially primitive jewelry. In one corner of the room, above her writing table, she had lined shelves with boxes, pottery jars, and dishes filled and spilling over with Mexican jade, shell, and silver jewelry. Another shelf held Balinese gold and ruby necklaces and rings, all in a jumble with ivory and wooden bracelets from Greece and Africa.[40]

The house was still a magical place. The actor Carlos Rivas remembers it vividly. "I loved her house," he told me in 1986. "It was warm, I tell you. A luncheon was always a party because Rosa was such a marvelous hostess."[41]

Rosa had begun to give luncheons again for those friends who had stood by her—Salvador Novo, Diego Rivera, and Roberto Montenegro; Luis Barragan, John Huston, and Buckminster Fuller, when they were in town; and her women friends, Dolores, María, Columba, and Malú. To this old crowd, Rosa introduced a group of attractive young men who became her new friends—the painters José Luis Cuevas, Pedro Friedeberg, and Juan Soriano; actors like Carlos Rivas, Rock Hudson, and Richard Chamberlain; Manuel Reyero, an architect; and Swedish businessman Eric Noren.

The young men took her to the movies and the theater, to a gallery opening, or to dinner. Carlos Rivas became especially close to Rosa. They met in 1960 in Durango, where John Huston and "El Indio" Fernández were filming *The Unforgiven*, in which Rivas (and Audrey Hepburn) had a role. (After Miguel's death Huston made it a point to invite Rosa to join him for any shooting he did in Mexico. They were together on the day John Kennedy was assassinated, while Huston was filming *Night of the Iguana* in Mexico.)[42]

"[Rosa and I] became bosom friends," Rivas told me:

Rosa permeated the air with love and affection. The only way I can describe her accurately is to say that she was a passionate woman. Not only that, she was brilliant and well-read. The things she talked about fascinated us: her trips around the world, her international collection of friends, her experiences in the theater. She could discuss painting, anthropology, archeology, and primitive art with great facility. Her expertise never ceased to amaze us.

She was a very earthy woman. No matter what she did, it came right out of her pores. Her house—you'd walk into her house, and everything was earthy—the floor, the pottery flower vases, the wooden cooking utensils, and big clay pots where she made the most delicious beans. Her kitchen was like a movie set. . . .

There was a tree trunk in one corner of the patio. I had thought it was a sculpture, but it was just something that had caught her eye on a country outing. Everything that occupied the outside of the house seemed to have just come up from the earth.

The two of them often went to the theater together or off on one or another day trip. "She loved to go on excursions," Rivas remembered. "I often invited her to spend the day in Cuernavaca. We would go to *Las Mañanitas,* a charming country inn with a spectacular garden. She would sit under the shade of a tree and sketch the entire afternoon."

Rivas and Rosa went on longer trips together, also, once to Barcelona where they visited Gaudí's spectacular buildings and to Sevilla to see the flamenco dancers; there, Rosa told Rivas about the greatest flamenco dancers of all, Vicente Escudero, whom she had met in Paris in the 1920s, and La Argentina, whom she had known in New York. Because Rosa knew so much about so many things and because "she had a healthy sense of humor and was always enthusiastic," as Rivas says, "she made a delightful traveling companion."

Rosa was close to seventy during the early 1960s, but it is unlikely Rivas knew that. He told me, "Rosa was so full of life, you couldn't pinpoint her age. In that respect she was like . . . Margo Albert. They were extraordinary women."

Margo and Eddie Albert also kept in frequent touch with Rosa from Los Angeles after Miguel died, and they extended her a standing invitation to visit them whenever she could. Rosa went quite often, and Margo threw wonderful parties for her when she came, inviting old friends like Bernadine Fritz, Mary Anita Loos, and others of the Alberts' Hollywood set like Rivas, Rock Hudson, Sam Jaffe, Yul Brynner, and costume designer Irene Sharaff. (Columba Domínguez tells a story about "El Indio" wanting to introduce Miguel and Rosa to Yul Brynner in 1953 when he and "El Indio" worked on a film together, but Brynner went fishing in Acapulco instead. "El Indio" was astonished at Brynner's choice, declaring, "Hell, there's fish everywhere, but only one Rosa and Miguel!")[43]

And so Rosa got along in society, but she was less than stable. The museum wars went on for ten years. The disposition and disappearance of Miguel's cherished collection ate at Rosa, and she had never recovered from his having abandoned her for Rocío. Jealousy had poisoned her. She was likely to fly into a rage or a depression at the slightest provocation, and she saw provocation where others could not, especially when she drank. At a weekend party at Rivas's house in San Miguel Allende, this was the case when Rosa decided Carlos was paying too much attention to another woman in the swimming pool, and she began to pelt her presumed rival with glasses.[44]

On another occasion in a theater lobby, Rivas recalled, "She imagined I was making a pass at Columba Domínguez, and she flew at Columba in a rage, shouting invectives. Everyone stopped talking to look at us. It was very embarrassing."

It was not possible to reason with Rosa. "You could fall out of favor with her very easily," Rivas said:

> She was jealous of her best friends. She couldn't tolerate competition of any kind. Unfortunately, when I became seriously interested in the young woman who became my wife, Rosa dropped me. If she couldn't have me to herself, she no longer wanted my friendship.
>
> I was sorry we no longer saw each other. I missed all the fantastic things about Rosa. She was a genuine character.

One thing that Rosa was not any longer, however, was beautiful. Once, after seeing her dance in the *Music Box Revue*, an admirer had written that she was "the Queen of Fairies, and life is sweeter and the world brighter because of Rose Roland." But when Fito Best Maugard ran into Rosa unexpectedly in the mid-1960s, he confided to Beatriz Tames, one of Dolores del Río's cousins, "I couldn't believe that beautiful dancer with the exquisite body was the same person who now stood before me."[45]

Juan Soriano, one of the young painters who knew Rosa through the 1960s, recalled:

> Rosa aged with the quickness of a rose deprived of sun and water. Hers had been a very great beauty, but now that beauty had become something strangely enormous and imposing. She wore huge Tehuantepec skirts. She had grown very fat. But she still had those extraordinary eyes with yellow centers. She was always somewhat of a mystery to me—a matriarchal figure full of hate.
>
> My friends and I would go over to her house to cheer her up. She would cook us one of her fabulous meals. We would get drunk, dance wildly, and fall to the floor. We would bite her until she laughed like a crazed old hag.[46]

Soriano offered these jaundiced conclusions:

> *Her story is very tragic indeed. If she had used her brains,*
> *she might have saved her marriage. By forsaking her*
> *physical relationship with Miguel and assuming the role of*
> *the eternal companion, I don't believe he would ever have left*
> *her. As fate would have it, there was no compromise in Rosa.*
> *She had to be number one in every facet of Miguel's life. She*
> *was incapable of sharing him with another woman. She*
> *didn't understand what a popular Mexican proverb tells us,*
> *"A pair of tits has more sway than two wagons."*[47]

In the late 1960s, Rosa came to rely more and more on her friends, the architect Luis Barragan and the painter José Luis Cuevas. Both men cared deeply for Rosa. Cuevas told me:

> *[Rosa] will always represent for me and be among those*
> *immense feminine presences who enriched Mexican culture in*
> *the twenties and thirties. She possessed an extraordinary*
> *beauty fueled by fiery passions and strength, like Tina*
> *Modotti and Lupe Marín. Perhaps Rosa was the most*
> *beautiful. You have only to judge from her photographs.*[48]

"[Barragan and I] were Rosa's favorite male companions albeit that we came from two different generations," Cuevas told me. "One week I would be in favor, the next, Barragan. She played us one against the other. . . . It was a kind of Russian roulette to see who would win."

Ultimately, Barragan won. He was there for Rosa when she needed advice, when she needed a shoulder on which to cry, and when she needed money. She referred to him as her "boyfriend" to Paz.[49] He offered her company and encouragement, and by the end of the 1960s, Rosa had little of either. Her spirit had turned bitter with her jealousies. She complained that her friends did not show her enough attention. In her anger, she lashed out at Paz, who had always stood by her, who went every Sunday with Rosa to place fresh flowers at Miguel's grave and to tend the gravesite, and who had behaved more like a devoted mother than servant toward Rosa. Rosa's insults were finally too much even for Paz. She moved away from Tizapán, leaving Rosa to her own devices and Barragan's compassionate ear.

None of this was therapeutic for Rosa's high blood pressure, nor was Mexico City's high altitude. (Rosa told Mary Anita that it was a "sacrifice" for her to live in Mexico because of the altitude.) Soon she could add bad stomach pain to her list of complaints. She was overweight, and she developed internal problems. When she finally went to a doctor, she was diagnosed with an acute gall bladder condition, pancreatitis, and heart failure. She needed immediate gall bladder surgery and was

Georgia O'Keeffe photographed by Rosa Covarrubias on a visit.

admitted to the Santa Elena hospital at the beginning of 1970. She remained there for two months. (According to Dorothy Cordry, Rosa could not pay her hospital bills; Barragan covered both her surgery and hospital expenses.)

Good-hearted Paz could not leave Rosa alone in these circumstances. She called Rosa and went to visit her. "We kissed and made up," Paz told me. Rosa introduced Paz to her nurses as "my Nana," took Paz's hand in hers, and said, "Thank goodness, Paz, you have finally come to take care of me."

Paz did take care of her, bringing Rosa's favorite dishes to her hospital bedside as she had done for Miguel when he was ill at Zamora. "I would try and make her eat," she recalled:

> *She was very weak and didn't have the strength to feed herself. It got so that she didn't want anyone else but me to feed her. When the doctors told her she could go home, I agreed to stay at the house to look after her. As soon as we arrived at Tizapán, I wanted to put her to bed. Instead, she insisted on calling all her friends to let them know that they could come to see her.*

Bertha Cuevas, José Luis's young wife, had also become close to Rosa in the late 1960s, and she remembers Rosa's call:

> "Darling, I am back. Come over," Rosa said. But the voice on the other end was so unlike hers. The timbre was different. I was worried. María Asúnsolo and I were the only ones who visited her daily. I spent mornings with her, and María stayed the afternoons. I'll never forget how fantastic a friend María was to Rosa. She knew instinctively how to treat a sick person. She consoled and encouraged her. I think it is because María is more spontaneous, protective, and loving than I am.
>
> Although Luis Barragan and Dolores del Río stopped by whenever they had time, it wasn't that often. Dolores would only visit if everything had been tidied up. She required an atmosphere of order and serenity. I can still see Rosa sitting in bed with a ribbon in her hair and a lovely cover on the bed that Dolores had given her. (When Rosa died, by the way, Dolores asked for it back.) Sometimes she covered her hair with a kerchief. She was desperate to get well so she could get her hair dyed.

For Bertha, who was in her twenties at the time, Rosa's illness opened her eyes to mortality, and it frightened her.

> During her stay in the hospital, Rosa had lost a tremendous amount of weight, but she didn't look like she was dying. I was shocked when she didn't get better. It was only then that I realized how sick she was. The day before she died, she must have sensed something, because she gave me all her keys to keep until she was better, and she asked me to lock everything up and be sure and check the main house. She no longer trusted the servants.

Rosa's concerns were clearly justified. After her death, several paintings and other artifacts were missed and ultimately discovered in the possession of Paz's son, Ernesto. Luis Barragan brought legal action against the young man and was able to recover most of the stolen items.

"The last thing I secured was the armoire in the bedroom," Bertha continued.

> I can still remember that big bunch of keys. They represented something final for me.
>
> As I walked from her room towards the gate, I looked back over my shoulder. The main house was closed and dark. The only signs of life were the lights in her bedroom and a

*candle in the kitchen window. Everything seemed different.
It was very dismal, and I felt very sad.*

*The next morning as I was about to go out, María called
to tell me that Rosa had died. We both rushed to Tizapán.
Rosa was laid out on the bed. Paz told us she had been in a
good deal of pain for the past two days and had not been
able to sleep. Her physicians had not allowed any sleeping
pills or pain medicine because of her heart. She couldn't
sleep, she couldn't eat, and she had been getting much
weaker. The day before, she had fancied some strawberries,
and María Asúnsolo had gone all over Mexico City looking
for some—it was no mean task, as strawberries are only
imported to Mexico—but María found some.*

*That fateful morning, Paz prepared her a breakfast of
cream of wheat and strawberries. She told us she hoped that
she could get Rosa to eat something.*

Paz picked up the tale:

*She ate a few strawberries and then said to me, "Put your
arm here." She lay her head against my arm for a few
minutes. She looked up at me and smiled. Then suddenly she
stood up from her chair and said, "Right now, María, let's
go!" And she fell back dead. Thank God it was a peaceful
death.*

María went to make the funeral arrangements for Rosa, and Bertha sat with the body:

*I had to stay alone with Rosa for many hours. I kept a
vigil over the body until one o'clock in the afternoon. I sat in
a little chair in front of her. I will never forget her feet. The
toenails hadn't been cut. Her feet looked dirty. I was badly
shaken by this.*

*An hour passed, then two, then three, and no one came
by to see her, and María did not return. It took so long
because the officials at the American embassy couldn't find
Rosa's registration. They were looking under Rolanda, and
she was registered under her family name—Cowan. . . .*

*Paz and I dressed Rosa in her favorite blue-green silk
flowered dress. Finally, the attendant from the Gayoso
Funeral Agency came to take her away. They wrapped her
in a cold, grey rubber sheet with black straps and took her
out just like a package. I shall never forget it. It was a
horrible sight.*

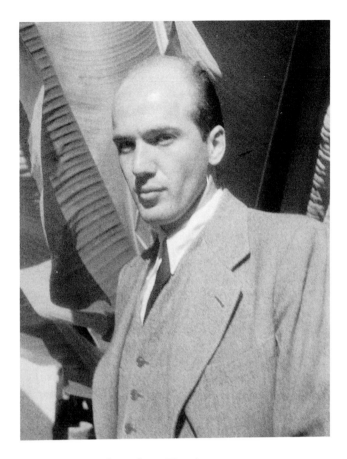

Luis Barragan in the garden at Tizapán.

> *That night we went to the funeral parlor for the rosary.*
> *We were still the same little group [María, Columba, and*
> *Paz]. The following morning at the service before Rosa's*
> *interment, María and her husband Mario Colín, Malú and*
> *Harry Block, Luis Barragan, Rosa's friend Cabezón Dávila,*
> *Trixie [another of Dolores del Río's cousins], and Rosario*
> *received the mourners who came to pay their last respects. I*
> *can still picture Paz wrapped in her black shawl, standing*
> *near the coffin crying. Rosa was buried in the Garden*
> *Cemetery in Mexico City.[50]*

After the funeral, Rosa's closest friends returned to Tizapán. Bertha was "shocked to see how they went through her closets, drawers, and so forth. It horrified me because Rosa had always been so possessive of her things." The friends agreed that Dolores del Río should take all the important pre-

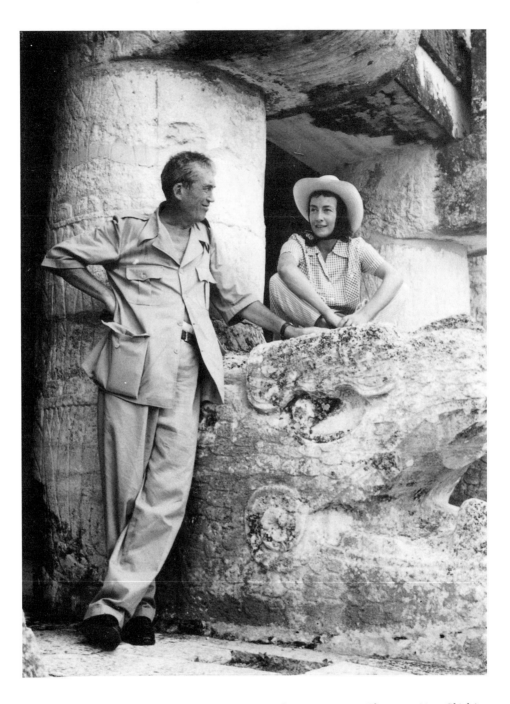

John Huston and French actress Suzanne Flon on a visit to Chichén Itzá. Photograph by Rosa Covarrubias.

Hispanic pieces, including Rosa's valuable jewelry, to her house for safekeeping. "Her chauffeur loaded everything into the station wagon," Bertha recalled.

Rosa had given her will for safekeeping to María Asúnsolo's husband, Colín, an attorney, although he had neither drawn it up nor read it. Rosa had sealed the document inside a manila envelope addressed to Luis Barragan. After her death, Colín and María invited Barragan to their home to retrieve the document. On the weekend after Rosa's funeral, in the presence of Dolores del Río and María Asúnsolo, Colín handed the envelope to Barragan. Barragan, a tall, elegant man, always perfectly gracious, said thank you and left.[51]

"We were all taken by surprise when Barragan did not open the envelope," María told me. "We assumed he would read it aloud, and we would witness its contents. We never did find out what was inside that envelope. . . . I believe he gave us what he wanted to and kept the rest for himself."

Rosa had left her entire estate to Barragan, and she named him the executor of her will as well, a source of great consternation among her other friends. María Asúnsolo thought the estate should have been put in the hands of a probate lawyer. Andrés Henestrosa was absolutely insulted. He believed he would have been a far better choice. "I am more cultured and well-versed in Mexican history and literature," he told me, "more so than Luis Barragan or Carlos Chávez, whom she also considered. I would have taken better care of the collections and defended their integrity. Instead, no one seems to know what happened to them."[52] But in fact, after Miguel's death, Rosa had stopped seeing the Henestrosas. She considered them disloyal for having kept company with Miguel and Rocío.

Even those who did not have opinions about Rosa's choice of Barragan, or Barragan's integrity, did have opinions about the length of time it took for him to finally distribute Rosa's bequests. Barragan had to attend to pressing financial obligations of his own first—he had made some unfortunate real estate investments. In fact, the gift of Tizapán proved to be his salvation. He remodeled the house and property and sold them. In the meantime, he had all of Tizapán's furnishings, including the various collections—a lifetime's worth of possessions that represented two extraordinarily productive lives—removed from the premises, inventoried (the inventory took two years), and stored.

All of this, also, rankled Rosa's closest friends. María Asúnsolo and Nancy Oakes believed the house in Tizapán should have been converted into a museum and its contents kept intact there to honor the two Covarrubiases.[53] But Rosa had told Barragan she did not want any of their possessions, especially any of the collections that she still controlled, left in Mexico. She had never forgiven the National Museum of Anthropology for having squandered what they had received of Miguel's. She was convinced that private collections donated to Mexican institutions had no chance of survival: no museum had the means to safeguard them against theft; none could even protect collections against deterioration, and none could afford restorations.

Rosa specified that various items should go to various museums and collectors in the United States and Europe, though she must have known the Mexican government would not look kindly upon their export. (The government took a

proprietary interest in all valuable Mexican artwork, both old and new, and in fact, in non-Mexican collections as well.) Nevertheless, she was adamant that Miguel's drawings and gouaches (which were mostly of American subjects he had done for American magazines) should go to the Library of Congress in Washington, D.C., and with the assistance of Alan Fern, now director of the Portrait Gallery at the Smithsonian, that wish was fulfilled.

The Mexican folk art collection was offered to several museums in Mexico, but none showed interest. In 1977, Pedro Rodríguez, founder and director of the Mexican Museum in San Francisco, accepted the pottery, toys, Indian costumes, and jewelry for his museum, where they reside today. Some of Miguel's and Rosa's Balinese collection found its way to the Smithsonian. An English dealer purchased the African pieces.

Barragan spent the rest of 1970 restoring the house and grounds. This, too, was controversial. Barragan painted the whitewashed walls in strong pinks, oranges, and blues—colors never used before in formal architecture—part of how Barragan distinguished himself in that field. He then subdivided the property and sold the main house to Bertha and José Luis Cuevas. Bertha spoke to me about it:

> The house was very special for me and José Luis. It was where we were married and where my oldest daughter was baptized. Rosa used to tell me she wanted us to live there. Instead we had to buy it. Even the price seemed unfair. [Barragan] charged us 850 pesos [$100] a square meter, more than other property in Tizapán was going for at that time.
>
> I don't know when it was decided that Barragan would sell off the Tizapán property. However, I do know that two years before she died, Rosa had wanted to subdivide and sell a section of the outer garden for income to live on. She told us that Barragan was going to help her do this; then she would hire a chauffeur to take her around the city. As it was, there were times when she didn't even have money for a taxi.
>
> Unfortunately, [Barragan] took his time, and she died before he got around to doing anything. Imagine, she could have lived like a princess! Instead, it was architect Barragan who benefitted from the sale.[54]

Like Bertha, María Asúnsolo believes that:

> Luis Barragan manipulated Rosa. He visited her every Tuesday. He brought her flowers and champagne, red roses, a book on butterflies, or something delicious to eat. I think the reason Rosa left him everything was because she felt obligated—he paid her hospital bill when she had no money, and he put his chauffeur and Cadillac at her disposal, which she loved.

María Asúnsolo.

More than that, María said, she believes that Rosa had fallen in love with Barragan.[55] No one knows precisely the depth of their relationship, emotional or financial. Perhaps Rosa owed Barragan a considerable sum and repaid him by deeding him the Tizapán property. Perhaps not. It seems more important to know that Rosa trusted Barragan completely and that she left him her most valuable asset, confident that the decisions he made regarding Tizapán would be the right ones.

There were other decisions that Rosa did not leave to his discretion, but that she enumerated in a handwritten letter to Barragan that accompanied her will.[56] Specifically, Rosa left to Dolores del Río several large Tarascan pre-Hispanic pieces, some pottery, some stone pieces, and a pre-Hispanic necklace; to Mary Anita Loos, her Kachina dolls and antique Mexican wedding chests; to John Huston, a portrait of herself by Miguel; to Bil Baird, the book rights on Miguel's books for Knopf still in circulation; to Margo Albert, her American stocks; to Adriana Eller Calles, a small Diego Rivera portrait of herself, a gold pre-Columbian bird pendant, and a small hammered-gold bird.

Alfred Katz, a public relations man who was a friend of both Margo Albert's and Rosa's for many years, was also remembered (although I do not recall his gift).[57]

Carmen López Figueroa, Nieves Field, and María Asúnsolo each received a pre-Hispanic necklace. Rosa also bequeathed María her star sapphire ring, which she had always worn and which Miguel had bought for her in China. José Luis Cuevas received some books, and the Cuevases' daughter, Rosa's goddaughter Mariana, received her costume and folk jewelry.

Unfortunately, even the eventual distribution of these keepsakes caused anger and upset among the recipients. Over the years Rosa had promised various items to various friends, and sometimes she had promised the same item to more than one person. Sometimes she made a promise and then changed her mind. She had promised the small Rivera portrait of herself to María Asúnsolo, for example, and ultimately Barragan kept that promise in spite of what Rosa had written in her will. It was a similar situation with the Tizapán house, which Rosa once had promised to Margo and Eddie Albert for their son (Rosa's godson), Edward. But on a visit to Los Angeles in the 1960s, Rosa had decided she disapproved of young Edward and his friends, who played loud rock and roll music and smoked marijuana.[58] Instead, she left Margo her stocks. Margo was terribly hurt and was never sure if the explanation Barragan made to her was true or if he had taken the house for himself in spite of Rosa's wishes.

However, even María Asúnsolo, not a defender of Barragan, remembers that in the last year of Rosa's life, she was constantly revising her will. "She kept thinking about her things, adding this person, changing that." She was "like a seventy-two-year-old woman going on six," according to Mary Anita Loos.

José Luis Cuevas told me:

> One day when I was visiting, she pointed to Diego's life-size portrait of her and said, "This will be yours." It was a splendid painting, but it would have been dishonest of me to accept this gift. At the time I was a detractor of Diego's way of painting, of the Mexican school of painting in particular. I wanted change. Instead I said to her that I would like the self-portrait she had done which hung in her bedroom in a mirrored frame. She was very moved and took it down from the wall right then and there and gave it to me.

On another occasion Rosa told Cuevas that she was leaving him Miguel's research library, but "when we were called to come and collect our inheritance, it consisted of a few coffee-table art books," Bertha recalled. "Some were books that had been gifts to Rosa. Several read 'to Rosa from Luis Barragan,' and some were books that José Luis himself had given Rosa in years past. Some still had the gift cards inside with 'to Rosa from José Luis.'" Rosa made Miguel's library a gift to the Benjamin Franklin Library in Mexico City. It has since become part of the Miguel Covarrubias Archives in Puebla, Mexico.

Bertha remembered that Rosa had promised her jewelry to Bertha's daughter. "Instead, Barragan gave us a collection of costume jewelry stuffed in shoe boxes, which is worth nothing," Bertha complained. But Rosa had a great attachment to

her collection of costume and folk jewelry, each piece of which had been carefully chosen on her travels abroad. These may indeed have been just the pieces Rosa intended for Bertha's daughter.

At different times, Rosa told both María Asúnsolo and José Luis Cuevas that Miguel's small portrait of her over her bed would be theirs when she died. She promised various other paintings to Columba, María, and others. Rosa had become close friends with the businesswoman Elena Gordon after Miguel's death, and Elena was very kind to Rosa during the last years of her life. Rosa visited her in Cuernavaca, accompanied her to Erongaricuaro in Jalisco, where her textile factory operated, and became especially fond of Elena's daughter Margarita, a popular Spanish dancer then. "Behave yourself, work hard, and these paintings will be yours," Rosa told Margarita, gesturing at the walls at Tizapán.[59] But in the end she left nothing to Margarita or Elena. María Asúnsolo was so embarrassed, she gave Rosa's wristwatch to Elena. More embarrassing was Rosa's treatment of Paz, who received a miniscule pension and Rosa's beloved parrot—a poor reminder of Rosa's generosity of spirit.[60]

Not all of Rosa's friends felt cheated. Bil Baird, Alfred Katz, and Mary Anita Loos were all touched at being remembered, and John Huston told me this story:

> *Miguel had done a beautiful small oil portrait of Rosa. I saw it for the first time after his death, and I admired it. She said, "Take it, John." I told her I couldn't possibly. It represented the happiest time in her life.*
>
> *After Rosa died, Luis Barragan called me. She had left me that painting. My daughter Angélica has it in her house today.*[61]

About a year after Rosa's death, María Asúnsolo and Bertha Cuevas went together to visit Rosa's grave at the Garden Cemetery in Mexico City. "To our shock and amazement," Bertha told me, "[Barragan] had not even purchased a tombstone. There was only a wooden cross. Can you imagine that? Would you call that friendship? This is a *sinvergüenza de siete suelas* [a scoundrel to the nth degree]. He should have commissioned a beautiful figurative sculpture." Ultimately, Barragan had a simple marble stone placed at Rosa's gravesite.

Our past is dispersed over many lands and places. Covarrubias has rediscovered it and grafted it onto a tree rooted in our own land and time, so that it may grow and give new flowers and fruits.[1]

T EPILOGUE

here have been four major exhibitions of Miguel's paintings and drawings since his death, the first hastily assembled in March 1957 at the Antonio Sousa Gallery in Mexico City, about which *Novedades* wrote, "with one quick look, it will prove how much the vanished artist was worthy of our esteem."[2]

In 1981, Carlos Sotomayor, director of the Metropolitan Gallery, along with Santos Balmori and Arnold Belkin, hosted a homage to Miguel and an exhibition of his work. Belkin referred to Miguel as "the Renaissance artist of his day: the living example of how a painter could embrace all fields of learning and enrich the arts with his vision and talent. He was for my generation an example of the universal man."[3]

In 1984, the National Portrait Gallery of the Smithsonian Institution arranged an exhibition of Miguel's caricatures and a catalogue. Then in 1987, the Centro Cultural Arte Contemporáneo Museum of Mexico City curated the most comprehensive show of all, representing every aspect of Miguel's work from caricature to collection. A beautiful 264-page Spanish-language catalogue accompanied the show, containing essays about Miguel—the caricaturist, illustrator, author, research scholar, professor, mapmaker, museologist, anthropologist, archeologist,

set designer, dance director, and collector—with black-and-white and color reproductions of his work, photographs of himself, his collection, his sets, his friends and his family, a comprehensive bibliography of his books and articles, and a complete chronology.[4]

It's surprising, when one reads all that he accomplished, to remember that Miguel died at the age of fifty-three. I think he may have been one of the most multifaceted men in the artistic and cultural history of Mexico, "another famous national glory," as Salvador Novo put it.[5] I believe he contributed more than many of the better-known and more widely feted Mexican artists of his time, such as Orozco, Rivera, or Siqueiros. Their murals and canvases surely opened windows on Mexico to the rest of the world, but Miguel gave us canvases, books, maps, choreography, and lost civilizations. He opened vistas on Mexico, and through Mexico and his art, he communicated something even deeper than the nationalism that occupied most of his contemporaries.

In looking for what was essentially Mexican—the spirit of Mexico—he discovered what was essentially human: the shared spirit, the soul of humankind. This is what his maps succeeded in communicating. This is where his work in anthropology had taken him, what archeology had demonstrated to him, and why he became such a staunch advocate of transculturation. This discovery of the vibrant element of mankind, obvious in art throughout history and apparently common to all societies, was his motive in working toward cultural exchange as a means to forge friendships among countries, especially between China and the new world.

Miguel's search for the spirit of his country may have been inspired by the revolutionary philosopher Vasconcelos at the dawning of Mexico's cultural renaissance, and that inspiration grew and grew until Miguel became "the encyclopedic artist of Mexico's rebirth," as Antonio Rodríguez eulogized in *El Nacional*.[6] From the beginning, Miguel's natural and passionate curiosity, his broad-based talents, his sharp powers of observation, and his enthusiasm etched his direction; and his direction was that of a star-burst, out from the center, explosive and brilliant.

I think what enabled Miguel to be successful in so many different arts and sciences—and I include language as one of those sciences—was his incredible ability to sift through all external paraphernalia to arrive at the essence of whatever interested him. This talent, clearly the secret to fine caricature ("There is something almost religious in the pure magic of a line capturing a human character," Al Hirschfeld said of Miguel's work[7]), informed nearly everything Miguel touched, enabled him to communicate in many languages, and was fundamental to his sophisticated approach to anthropology and to his highly respected archeological definitions.

"[Miguel] had a wild talent for seeing everything graphically," Hirschfeld reminisced. Alfonso Caso embellished, "[Covarrubias] was an artist in the full meaning of the word, bringing his knowledge of ethnology, anthropology, and archaeology to art." It put Miguel "in a unique position" to make an extraordinary contribution to art, as well as to these other and several sciences.[8]

It is true that Miguel was not a perfect man. His inability to refuse new assignments or requests, coupled with the inability to give less than everything to every project, no matter how big or small, robbed him of concentration, energy, and health. His weakness in managing his domestic life and his paralysis in the face of confrontation were not minor personality problems. I can't help but wonder what Miguel might have accomplished if he had not been burdened by these psychological circumstances.

This, however, is idle speculation. Miguel's legacy is great enough in his work left behind, in what we have learned from him about previously unknown races and civilizations, in what remains of his collections in various museums, and in his enormous gift to Mexico of rediscovery and pride.

In the beginning of my work on this book, I was struck that so many of Miguel's friends used the word "genius" to describe him. (Ethel Smith called him a visionary and told me, "I'm an atheist, and the only time one has doubts is when one is in the presence of a genius like Miguel."[9]) By the end of my research into Miguel's life, I understood how appropriate the designation was.

John Huston thought that a genius was "someone who sees things in a way that illuminates him . . . ," and I believe that Miguel's quest for the essential spirit of man illuminated him. Huston also believed that a genius "enables one to see things in a different way," and "this was also true of Miguel. I can honestly say that he was one of the few geniuses I have known."[10]

Decades earlier, Marcet Haldeman-Julius had seen something similar in Miguel:

> *For while it is true that talent often is brought to its fullest fruition only through adversity, genius is inevitable. Unerringly selecting its own medium, it is neither debatable, [n]or to be resisted. Of this fact, one more proof is Miguel Covarrubias.*[11]

L E F T : *Covarrubias family crypt in the Panteón Francés, Mexico City.*

R I G H T : *Rosa's tombstone in Panteón de Jardín, Mexico City.*

NOTES

ABBREVIATIONS

Names of individuals and institutions frequently cited in the notes have been identified by the following abbreviations:

AWMCC	Adriana Williams's Miguel Covarrubias Collection, San Francisco, Calif.
CCAC	Centro Cultural Arte Contemporáneo, Mexico City
GM	George Macy
LC	Luis Covarrubias
MC	Miguel Covarrubias
MCA	Miguel Covarrubias Archives, Universidad de las Américas, Puebla, Mexico
MOMA	Museum of Modern Art, New York, N.Y.
NR	Nelson Rockefeller
NRAC	Nelson Rockefeller Archive Center, North Tarrytown, N.Y.
RC	Rosa Covarrubias
RCS	Rosa Covarrubias Scrapbook, Library, Museum of the Performing Arts, New York Public Library at Lincoln Center, Dance Collection, New York, N.Y.
RS	Rocío Sagaón
UNAM	Universidad Nacional Autónoma de México

1. BEGINNINGS (1904–1923)

1. Antonio Rodríguez, "La universidad rescata importante obra de Covarrubias," *Gaceta de la Universidad* 9, no. 3 (Jan. 1962): 1.

2. Mexican government documents, María Elena Rico Covarrubias, personal papers (Mexico City), listing José Covarrubias's services in the educational and architectural fields, in public service, and on government commissions. There are seventy-eight such listings.

3. Hayden Herrera, *Frida: A Biography of Frida Kahlo* (London: Bloomsbury Publishing Ltd., 1989): 23.

4. Ernest Gruening, *Mexico and Its Heritage* (New York: The Century Co., 1928): 63.

5. Telegram, President Venustiano Carranza to José Covarrubias, María Elena Rico Covarrubias, personal papers.

6. "Lotería nacional para la beneficiencia pública," *Fortune* (22 Dec. 1932): 80.

All of José Covarrubias's uncles were distinguished and had a positive influence on their nephew.

Francisco (1833–1889) was a topographical engineer. It was his map of the valley of Mexico which pinpointed precisely the location of the Federal District.

José Díaz (1842–1883) was Secretary of Justice and Public Education. His book *La instrucción pública en México,* written in 1875, has been reprinted because of its relevance to Mexico today.

Juan (1837–1859) was a newspaperman and a poet. He was a member of the liberal forces and was executed by the conservative troops of Leonardo Márquez.

7. Unless otherwise noted, family recollections of María Elena, Alejandra, and Luis Covarrubias are from interviews with author, Mexico City, July 1986, Feb. 1987, and Dec. 1990, and recollections of Bertha Caballero de los Olivos Duclaud, interview with author, Mexico City, Dec. 1990.

8. Some of José Covarrubias's paintings, including *Cock Fight,* remain at the Zamora Street house.

9. "Covarrubias, Mexican Artist of Negro, Says Paris Lacks of 'Popular Art,'" *Paris Herald,* Nov. 1927; and "Mexican Artist, Twenty-One, Famous," *New York Tribune,* 24 Nov. 1925.

10. Miguel Covarrubias, *Negro Drawings* (New York: Alfred A. Knopf, 1925), Introduction.

11. Corazón Grau, "Covarrubias Doesn't Believe in Teachers," *The Tribune Magazine* (Manila), July 1930.

12. Tomás Ybarra-Frausto, "Miguel Covarrubias: Cartógrafo," *Miguel Covarrubias: Homenaje* (Mexico City: CCAC, 1987): 127.

13. LC, interview with author, Mexico City, 3 July 1986 and 11 Feb. 1987. Among those "amusing caricatures" that Ruiz recalled were "the patriarchal figure" of Engineer Alvarez and Professor Bribiesca's "stone age jacket" in Manuel Gutiérrez Nájera's "Miguel Covarrubias y sus caricaturas neoyorquinas," *El Universal Ilustrado,* 21 Feb. 1924, *Notas Artísticas.*

14. The lottery operated from a commodious estate, previously the residence of the well-known banker and son-in-law to Díaz, Nacho de la Torre. Most recently, the Covarrubiases' new residence had belonged to the Ponce family from Yucatán, Mérida.

15. The Chapultepec became the White House for Mexican presidents. Cortez had been its first resident; Calles was its last—it is a museum today.

16. Marcet Haldeman-Julius, "Miguel Covarrubias," *Haldeman-Julius Quarterly* (January 1927): 62.

17. LC recalls that his mother's dinners were often the talk of the town. In the late 1920s, one such dinner, featuring Juanzontle chile, was described with such enthusiasm by its participants (including the museologist René d'Harnoncourt, the caricaturist Ernesto García Cabral, editor Manuel Horta, and the artist Adolfo Best Maugard), that the *Excélsior,* the city's most important newspaper, made a note of it in its social chronicle.

18. Carlton Beals, *Mexican Maze* (New York: The Book League, 1931); and Anita Brenner, *Idols behind Altars* (New York: Payson and Clarke, Ltd., 1929).

19. Raoul Fournier, interview with Elena Poniatowska, "Raoul Fournier, Carlos Solórzano y Justino Fernández hablan de Miguel Covarrubias," *Novedades,* 9 May 1957.

20. Ibid.

21. Nájera, "Miguel Covarrubias y sus caricaturas neoyorquinas." In fact, MC *did* make a terrific advertisement for the Mexican specialty restaurant, Café Tacuba, founded in 1912. A promotional pamphlet produced by the current owners declares: "At its inception this was a dairy store that specialized in Mexican candy, whose secret recipes we still prepare. It was the exquisitely delicious taste of these treats that nearly induced the painter Miguel Covarrubias to

break through the glass window to assault the rice pudding, the flans, the cajetas, the cocada, etc., as if it were Christmas all year round!"

22. Nájera, "Miguel Covarrubias y sus caricaturas neoyorquinas."

23. "Miguel Covarrubias: 'El Chamaco,'" *Revista de Revistas*, 24 Feb. 1957.

24. Raoul Fournier, interview with Poniatowska, "Raoul Fournier . . ."

25. Solórzano, interview with Poniatowska, "Raoul Fournier . . ."; Adolfo Fernández Bustamante's recollection in "Miguel Covarrubias, el gran caricaturista mexicano," *Revista Nuestro México* (Aug. 1932).

26. Daniel Cosío, *El Mundo* (19 May 1923): 3–8.

27. Adolfo Best Maugard, interview with Elena Poniatowska, "Elena Poniatowska reconstruye la vida de Miguel Covarrubias," *Novedades*, 22 April 1957.

28. Alfredo Ramos Martínez, an early agitator for the emancipation of Mexican art, established one of the first free open-air schools in 1913 in Santa Anita, on the outskirts of Mexico City. With Obregón's endorsement, the program was successful enough to spawn a book— *Drawing Method: Traditional Revival and Evolution of Mexican Art*, with illustrations by Miguel Covarrubias, published in July 1923, and subsequently translated into English.

29. Nájera, "Miguel Covarrubias y sus caricaturas neoyorquinas."

30. Earle K. James, "The Mexican Open Air Art Schools," *The Arts* 7 (6 June 1927): 308. *See also* Arturo Casado Navarro, *Gerardo Murillo: El Dr. Atl* (Mexico City: UNAM, 1984): 17. Gerardo Murillo changed his name to the Aztec *Atl*, which means "water," to demonstrate his pride in his Indian roots. An exhibition of Mexican Indian children's paintings exemplifying Best's ideals traveled to Paris, Berlin, Japan, and Guatemala, as well as some cities in the United States, and as the catalogue records, "aroused the greatest excitement and admiration and have influenced the beginnings of smaller movements elsewhere." (p. 59)

31. Brenner, *Idols behind Altars*, 249.

32. "Muralism, sung and danced," in José Tablada, "Mexican Painting Today," *International Studio* 6, no. 1 (Jan. 1923); "Still remembered . . . ," in *Mexican Folkways* 6, no. 1 (1930).

33. Nájera, "Miguel Covarrubias y sus caricaturas neoyorquinas." Covarrubias's friend Emilio Amero was a muralist and lithographer.

2. THE TWENTIES, PART ONE (1923–1924)

1. Octavio Barreda, interview with Elena Poniatowska, "Elena Poniatowska reconstruye la vida de Miguel Covarrubias," *Novedades*, 22, April 1957.

2. Tablada is also credited with the introduction of haiku to Mexico following his visit to Japan in 1900. In his Fifth Avenue shop in New York, this poetic tribute hung above his desk: "Women pass on Fifth Avenue/So close to my eyes/So far from my life." The poem, "En Nueva York/Quinta Avenida," also appears in Tablada's *Al sol y bajo la luna*, and in his collected works, *Obras*, edited by Héctor Valdés (Mexico City: UNAM, 1971): 327.

3. In *Vanity Fair*, MC contributed his own volley against negative Mexican stereotypes in a series of drawings. Miguel Covarrubias, "Our Southern Neighbor—Mexico in Movies and Reality," *Vanity Fair* 27, no. 5 (Jan. 1927): 48–49.

4. Marcet Haldeman-Julius, "Miguel Covarrubias," *Haldeman-Julius Quarterly* (Jan. 1927): 60.

5. This was Barreda's first post in the diplomatic corps. Barreda became Mexico's vice-consul in London in 1928.

6. Octavio Barreda, interview with Poniatowska, "Elena Poniatowska reconstruye la vida de Miguel Covarrubias."

7. Letter, MC to José Covarrubias Acosta, Mexico City, 1923, MCA.

8. Carl Van Vechten, Preface to *The Prince of Wales and Other Famous Americans*, by Miguel Covarrubias (New York: Alfred A. Knopf, 1925).

9. Ibid. Barton, born in 1891 in Kansas City, Missouri, was considered by *Vanity Fair* in 1924, "the best known and most widely followed of our caricaturists." (John Updike, "A Case of

Melancholia," *The New Yorker* [20 Feb. 1989]: 112–120.) Barton contributed frequently to *Life, Puck, Harper's Bazaar, Cosmopolitan, Vanity Fair,* and *The New Yorker* in the twenties and thirties and was a personality among New York's "in crowd." He married four times before he was forty. Shortly after Barton's fourth divorce in the spring of 1931, he "got into bed, in silk pajamas; pulled the covers up to his chin; and, while holding a cigarette in his left hand, shot himself through the right temple."

10. Richard Merkin, *Introduction to The Jazz Age as Seen through the Eyes of Ralph Barton, Miguel Covarrubias and John Held Jr.* (Providence: Museum of Art, Rhode Island School of Design, 1968).

11. Carl Van Vechten, Preface to *The Prince of Wales.* Later Van Vechten marveled: "I have always held it as an axiom that a caricaturist should know his subject for ten years before he sat down to draw him. . . . [But Covarrubias] has relieved me of that superstition. Ten minutes with any of them was all he required. The results are not superficial. . . . [The subjects] are all set down so vividly that posterity might study them to better advantage in the art of Covarrubias than through written criticism of their work." Carl Van Vechten, *The Reviewer,* vol. 4, 1923–1924, (New York: Johnson Reprint Company, 1967): 103.

12. Of the publications, the *Nation* is perhaps the most notable: the 27 Aug. 1924 issue was devoted to Mexico. MC illustrated three articles including "Mexico's Credit: The Vital Issue," by Rafael Nieto, with caricatures of Mexico's President Alvaro Obregón and President-elect Plutarco Elías Calles, the author's grandfather. MC's illustrations for Anna Cora Mowatt's *Fashion* were reproduced in *Modes and Manners* for an article regarding small theater in New York. Cora Mowatt, "Divertissements," *Modes and Manners* (Oct. 1924): 31–32.

13. Van Vechten, Preface to *The Prince of Wales.* In 1925, Van Vechten made a similar observation in his novel *Firecrackers,* which he dedicated to MC. In the book, a character muses about "a young Mexican boy, Miguel Covarrubias, who created caricatures of celebrities who he knew only by sight and name, which exposed the whole secret of the subjects' personalities. Here was clairvoyance." Carl Van Vechten, *Firecrackers* (New York: Alfred A. Knopf, 1925): 127–128.

14. Witter Brynner, *Journey with Genius* (New York: The John Day Co., 1951): 28.

15. Ibid., 30. Lawrence wrote *The Plumed Serpent* while living in Mexico, and Brynner suggests that Covarrubias was the prototype for his Mexican character who conducts a tour of Mexican frescoes. Brynner recalls that "Lawrence was always gentle with Miguel, even when they disagreed as to the quality of the Mexican painters whom Covarrubias revered. Lawrence found that most of the paintings were ugly." (Ibid., 29.)

Before the Lawrences left Mexico they were invited to a party at the home of the British Consul-General. In a letter to Brynner dated 17 November 1923 from Mexico City, Lawrence writes: "Tonight we're going out to dinner . . . at Tlalpan . . . all in evening dress. How's that for committing suicide on the spot? My dinner jacket is so green with overripeness. I'm going to look for Covarrubias." James T. Boulton, ed., *The Letters of D. H. Lawrence,* vol. 4, June 1921–March 1924 (Cambridge, Eng.: Cambridge University Press, 1987): 534.

16. *The Whitney Club Catalogue: The Covarrubias Exhibition* (New York, Whitney Club, 1924). A few years later Marcet Haldeman-Julius noted, "For one so green, Miguel had the uncanny ability to make lots of money. He charged what seemed a lot for his drawings and made more money than any other Mexican artist. This was an extraordinary accomplishment for a foreigner, let alone a boy of nineteen!" Haldeman-Julius, "Miguel Covarrubias," *Haldeman-Julius Quarterly,* Jan. 1927.

17. José Juan Tablada, "Inolvidables días del Whitney Club," *El Universal,* 2 Aug. 1925.

18. Octavio Barreda, interview with Elena Poniatowska, "Elena Poniatowska reconstruye la vida de Miguel Covarrubias."

19. An example of a Covarrubias *corrido* (translated by Christopher Winks) from the private collection of Octavio Barreda (Mexico City):

> *Vengo a cantar un corrido*
> *que vale la pura plata,*

que cuenta la vida y hechos
y al gran Tablada retrata.

El Señor don José Juan
Tablada de Forest Hills,
que vive muy retirado
del New York y el trajín.

El ilustre mexicano
que ha vivido en el Japón,
que qué perico en la luna.
Según cuenta una versión.

Escritor de gran valor
y poeta muy florido,
a quien todos van a ver
cuando a New York han ido.

Coyotes chocolateros
que lo iban a visitar,
allá en el México lindo
los tamales a tragar.

De todo aquella camarada
era el coyote mayor,
cada tarde tamalada
y atole con alfajor.

Toda aquella palomilla
se transplantó a Nueva York,
sigue como la langosta
dando la lata al siñor.

A la simpática Nena
siñora de José Juan,
hija de Cubita bella,
aquí le vengo a cantar.

Les presentan sus respetos
Luis Hidalgo y Covarrubias
y voraz y afilado el diente
el diente de don Matias.

Carlos Chávez y Tamayo,
Pancho Agea y Best Mogar,
Barredita y Ciro Méndez,
Harry Block vienen a cantar.

Mr. Schell y Mr. Bragdon,
aquellos ilustres gringos,
también la Señora Sprage,
Blanquita y sus pericos.

De Paris, y última hora
el aigre ha traído un recado
de Rosa la Bailadora
que de ustedes se ha acordado.

Aquí se acaban mis versos
debajo de una nevada
y que los haga mejores
el gran José Tablada.

—Miguel Covarrubias

I've come to sing a corrido
that's worth the purest silver
it tells of the life and deed
and portrays the great Tablada.

That's Señor Don José Juan
Tablada of Forest Hills
who lives in complete seclusion
from New York's hurly-burly.

This Mexican so illustrious
who once lived in Japan
like a blowhard on the moon—
Or so one version puts it—

Is a writer of highest worth
And a very flowery poet.
When folks go to New York
They all drop by to see him.

And the chocaholic coyotes
Who came to pay him a call
down there in lovely Mexico
to wolf down his tamales.

Of all that gang of coyotes
he was top dog for sure,
every afternoon, tamales
and atole con alfajor.

That whole sick crew of riffraff
up and moved to NYC
just like a plague of locusts
to go and bug his Highness.

And now I've come to sing
to the delightful Nena
the missis of José Juan
and daughter of fairest Cuba.

Luis Hidalgo and Covarrubias
present their respects to you
as does the voracious and sharpened
tooth of Don Matias.

Carlos Chávez and Tamayo
Pancho Agea and Best Maugard
Barredita and Ciro Méndez,
Harry Block—all came to sing.

Notes to page 21

Mr. Schell and Mr. Bragdon,
those illustrious gringos,
along with Mrs. Sprage,
Blanquita and her parrots.

A last-minute message from Paris
brought by a passing breeze
from Rosa the lovely dancer
shows that you're in her thoughts.

And now my verses are done
beneath the falling snow
and may they be improved
by the great José Tablada.

— Translation by Christopher Winks

20. The orchestra is described by Margarita Nelken, "Ensayo de exégesis de Rufino Tamayo," *Cuadernos Americanos* 74, no. 6 (Nov.–Dec. 1955): 242. Elena Poniatowska reports on MC's nickname, *Botelloncito de Guadalajara,* in her 1957 interview with Octavio Barreda, "Elena Poniatowska reconstruye la vida de Miguel Covarrubias." The "Marquis" is from unsigned letter to MC, 1923, in MCA.

21. MC, notes, MCA.

22. Octavio Barreda, interview with Poniatowska, "Elena Poniatowska reconstruye la vida de Miguel Covarrubias."

23. LC, interview with author, Mexico City, Sept. 1987.

24. Mary Anita Loos, interview with author, Los Angeles, Sept. 1985. According to Loos, years later some of the chorus girls had become society's most respected matrons, which amused Covarrubias whenever he met them at social events.

25. Adolfo Best Maugard interview with Poniatowska, "Elena Poniatowska reconstruye la vida de Miguel Covarrubias."

26. Mae Hutchins, interview with author, Long Beach, Calif., 1985 and 1986 for Rose's family background.

27. Rose Rolanda was baptized Rosemonde Della Cowan at Queen of Angels Church in Los Angeles.

28. Fernando Gamboa, interview with author, Mexico City, 2 July 1987.

29. In 1915, Rose had apprenticed with Morgan at a summer session at the University of California at Berkeley. A second session was held in 1916. A *San Francisco Examiner* dance critic commented on the performance: "Who could fail to remember one of the Morgan dancers? Who could even by an effort of will, forget the beautiful Californians of the marvelously plastic figures and the flying feet?" *San Francisco Examiner*, 3 Sept. 1916.

30. Undated, unidentified newspaper clipping, RCS.

31. Quotation is from "Will Dance To Jazz Next," *Los Angeles Times,* undated article, Marion Morgan File, San Francisco Library of Performing Arts, San Francisco, Calif. For a description of Rose's career teaching dance see articles in RCS. One of Rose's star pupils was Martha Lorber, who went on to a successful career in movies.

32. "We were the first..." is from "Art in Dancing Causes California Girls to Puff at Orpheum Rehearsal," undated, unidentified newspaper clipping, Marion Morgan File, Library of Performing Arts, San Francisco, Calif. For McLean's other observations see Selma Miller, "Morgan Dancers Live in Art/Oblivion of Self Their Goal," undated, unidentified newspaper clipping, Marion Morgan File.

Vanity Fair described the Morgan style as "strongly self-expressive and, with their perfectly developed bodies, the dancers conformed to an ideal type of physical beauty." *Vanity Fair,* July 1922. Because of their poetic loveliness and ideal spirituality, their dance friezes were

compared to works by the French symbolist painters Puvis de Chavannes and Jean-Jacques Henner.

33. See RCS for Buford Gordon Bennett's article, "The Girl of the West Most Beautiful in World, Says Marion Morgan," *Los Angeles Evening Express*, 20 Nov. 1922. Although Marion Morgan preferred tall girls, this fact didn't bother Rose, who, although only five feet tall, projected a forceful stage presence.

34. RC interview in "An Accidental Career," The Playgoer Column, unidentified, undated newspaper, RCS.

35. Arnold Genthe's photograph of RC appeared in *Vanity Fair* (Aug. 1919); another appears in his *The Book of Dance* (International Publishers: Boston, 1920): 119. Goldberg's photos appeared in *Vanity Fair* (May 1919): 28–29; Baron de Meyer's image appeared in "The Tattler," *Theatre Arts,* 11 Dec. 1919.

36. RC interview in unidentified newspaper article, 1921, RC file, the Library and Museum of the City of New York's theater collection, New York, N.Y. RC debuted as a choreographer in *Over the Top* with the "Jewel Dance."

37. Charles Darnton, "The New Plays," *World,* 3 Dec. 1919. Darnton noted her "uncommon grace" and wrote: "Her legs, like Isadora Duncan's are so much a part of her performance that they do not seem conspicuous. With the others, legs are legs, and the display can scarcely be viewed in an artistic light." The *Vogue* photographic essay ran in November 1920.

38. Tourneur began his career as an illustrator and graphic designer. He had been an assistant to the sculptor Rodin and later for the painter Puvis de Chavannes, with whom he worked on decorative panels for the Boston Library. In artistic vision, the Morgan Dancers had been compared to a de Chavannes painting.

Film Commentary notes that "Tourneur was a director with vision, imagination, and an immense grasp of all the arts. With his keen sense of symbolic values, he carried cinema to the point where it expressed the evasive virtues of Maeterlinck, the subtle evocations of Verlaine, and the twilight harmonies of Debussy." "Maurice Tourneur: the First of the Visual Stylists," *Film Commentary* 9, no. 2 (March–April 1973): 24–31.

According to the "Going Out Guide" (*New York Times,* 2 Feb. 1976), Tourneur made sixty films between 1914 and 1920, averaging a feature a month.

39. See RCS for the poem and note.

40. The music for *The Rose Girl* was written by Anself Goetl, Rose's friend from the days when he conducted the music for *The Lilac Domino.* Henri Bendel was the show's talented young costume designer; Rose's comment "syncopate[d] the rhythm . . ." is in an unidentified clipping in RCS.

41. Willie Howard to RC, undated letter, RCS. Willie Howard was manager of the Winter Garden Theater.

42. *Theatre Magazine,* May 1921; Alexander Woollcott, review of *Music Box Revue* by Irving Berlin, *New York Times,* 23 Sept. 1921.

43. "Aristocrats of the Dance," *Theatre Magazine,* Feb. 1923. Nickolas Muray photographed Rose frequently between 1920 and 1925. It is likely that she introduced him to MC.

44. Letter, Robert Benchley to RC, 8 Dec. 1921, RCS.

45. Metropolitan Opera Equity Show, cited in the *Pittsburgh Sun*, 2 May 1921, RCS. The show raised $30,000. (Rose's scrapbook contains the Victory Ball program.) RC also appeared at the Brooklyn School of Music in 1921 and at the American Committee for Russian Relief, where she seduced her audience as a Russian vamp. RC developed a keen interest in Russian culture and people after this experience, and she continued to perform on their behalf. Another of her charitable appearances in 1921 was with Hope Hampton, Paul Whiteman, and Irving Berlin for the "Save-a-Home Fund." She also danced for members of the Polynesian Club at the Hotel Astor. See RCS for newspaper clippings that refer to her appearances for Russian Relief and the Polynesian Club and a program from the "Save-a-Home" event. See RCS also for an illustration from *Vogue,* in which she models a bathing suit over the caption, "Rose Roland noted for her charming dancing in 'The Rose Girl' abandons herself to the joys of the surf in a flapper beach

suit of crimson and white wool jersey." See RCS for undated, unidentified newspaper clipping which describes RC being honored by the student body of the New York School of Design who chose her as the ideal dancer for whom to create a costume. The clip discusses the "effect [Rose] had on her audience with her exotic face and her strange manner of dressing her hair like a Hopi Indian. Good enough for a hand itself. Add to this her superb body and one had to applaud the students' perfect choice."

46. A review of *What Do Men Want?* (*Theatre Magazine*, May 1921, RCS) deemed her dance "a ballet of great beauty showing a grove of bewitching beauties dressed after the manner of Isadora Duncan. The young dancers symbolize Youth, Love, The Honeymoon, Wealth, Ambition, Passion and Truth as they assail man."

47. See RCS for production costs of the *Music Box Revue*. For Philadelphia critic's quote, see "Beautiful Womanhood," unidentified newspaper clipping, Nov. 22, RCS. For quote about South Seas number, see *Theatre Magazine* 37 (Feb. 1923): 23.

48. Reference to "glossy haired dancer" in *Chicago Sun* clipping, partially dated 1923; "gods be thanked!" quote in "This Week in Chicago," unidentified newspaper, RCS. Rose also performed for an Equity Ball in Chicago, adorning the stage in "a white beaded velvet gown combined with white lace with a white ivory comb and, gracefully wrapped around her, an exquisite Spanish shawl." Unidentified Chicago newspaper, 30 Dec. 1923, RCS.

49. Ruth Page, telephone interview with author, 1985. Page joined the *Music Box Revue* in 1923. She had danced with Rose's frequent partner, Chester Hale, in 1922 in an Actor's Equity Benefit. (In 1933 she was the only Caucasian in an all-Negro cast that included Katherine Dunham in the musical *Guiablesse*.)

50. See RCS for miscellaneous newspaper clippings and articles on Heppenstall. Heppenstall's costume studies were considered to be "still portraits." One of Heppenstall's designs for Rose placed her "on a gaily impossible green bank with a conventionalized landscape as background for her costume of hooped skirts and delicate bodice."

After Heppenstall graduated, he became the chief designer for Lady Duff Gordon, the creator of "Lucille" frocks (sold in London, New York, and Chicago). Soon after that, he returned to Pittsburgh and became an instructor at Carnegie Mellon University, but he still delighted in making costumes for his "most wonderful model." He designed one for Rose when she worked for the Follies, "to blend with the languid charm and rhythmic vitality of the music, and to merge with the bewitching and exotic personality of Miss Roland," as noted by Mary Ellen Armstrong in "An Artist Passes," unidentified newspaper clipping, May 1923, RCS.

51. RC, interview before she sailed for Europe, unidentified, undated newspaper clipping, RCS. (This comment was the first recorded indication that Rose was interested in collecting art and antiques.)

52. Ibid.

53. Poiret's quotation in unidentified article, RCS. Dan Klein states: "From 1915 till 1925 Paul Poiret was the undisputed dictator not only of what women should wear, but also of the decor that would best complement the clothes he designed. His colours and designs were strongly influenced by Diaghilev's Ballets Russes." Dan Klein, *Art Deco* (London: Treasure Press, 1974).

54. See RCS for color photo in unidentified, undated magazine published in Río de Janeiro. RC remained a phenomenon to write about and photograph for many years. In 1929, *Excélsior*, one of Mexico's leading daily newspapers, featured her in Veracruzano dress, and, in that same year *L'Art Vivant*, dedicated to Mexican art and artists, ran a photograph of one of Montenegro's portraits of her. (Rose's friend Tina Modotti's photos of Dr. Atl, Diego Rivera, and Roberto Montenegro appeared in the same issue.)

55. In *Round the Town,* Rose played the heroine in Marc Connelly's sketch, "The Girl from W. J. Z." Another pleasing number was called "Chiquita," in which Rose and Roberto Medrano "danced through the intricacies of the tango with all the flash and fervor of old Granada." *Journal of Commerce* (New York), May 1924.

In two of the *Forty Immortals,* Hopwood was depicted as a man-goat holding a flower with Rose's face in the center. The Folies Bergére used a similar backdrop with both characters. At one

time Hopwood had five plays on Broadway. He wrote *The Gold Diggers, Double Exposure, The Best People,* and collaborated with Mary Roberts Rinehart on *The Bat,* which was a phenomenal hit on Broadway during the 1920 season.

56. See RCS, undated, unidentified newspaper articles for details of RC's engagement to Hopwood.

57. Ibid. Hopwood died of a heart attack while wading in the sea off Juan Le Pins in 1928.

3. THE TWENTIES, PART TWO (1924–1929)

1. "The Mexican Artistic Invasion," *Literary Digest,* 25 June 1927.

2. Before returning to New York, MC visited Los Angeles to meet with friends, Ramón Beteta and Guty Cárdenas. They introduced him to the previous artistic director for Standard Oil, Francisco Cornejo. Cornejo invited MC and eleven other Latin American artists to design a page for the company's 1925 calendar. Responding to Cornejo's request for illustrations with a national theme, MC's illustration depicted the Mexican Indian Feather Dance. The Mexican tourist department used the image for a poster and a travel brochure.

3. Unless otherwise stated, recollections of Al Hirschfeld are from interview with author, New York City, 21 Sept. 1985. Commenting on Covarrubias's simplicity of style, the Valentine Gallery catalogue for the Miguel Covarrubias exhibit in 1928 noted: "The simplification that is such an important element in the Covarrubias drawings is seldom attained. He begins a picture after no more than the most summary of thumbnail sketches, but he is willing to draw and redraw until his acute sense of pictorial rightness is satisfied. The final result is usually deceptively simple. It has a look of immediate and spontaneous creation."

4. Maxine Block, ed., "Who's News and Why," *Current Biography* (New York: The H. W. Wilson Co., 1940): 201–202.

5. Fernando Gamboa, interview with Elena Poniatowska, "Fernando Gamboa y Daniel Rubín de la Borbolla hablan de Miguel Covarrubias," *Novedades,* 5 May 1957.

6. Alexander King (1899–1965) was born in Vienna. He was a prolific book and magazine illustrator, editor, playwright, and writer. In 1932 and 1933, he published seventeen issues of a magazine called *Americana,* surely one of the sharpest pictorial and literary satires of that period. The recollection of the naked woman in the tree was made by Bil Baird, interview with the author, New York City, 1985.

7. Abbe Niles, Introduction to *The Blues: An Anthology,* edited by W. C. Handy (New York: Albert and Charles Boni, 1926). MC, an inveterate collector by now, began immediately to accumulate the best jazz and blues albums, and by the end of the twenties he owned an important collection envied by his friends.

8. *Vanity Fair* 23, no. 4 (Dec. 1924): 60–61.

9. *El Universal,* 30 Nov. 1924.

10. Alain Locke, ed., *The New Negro* (New York: Albert and Charles Boni, 1925). "The dramatic flowering . . ." is from Alain Locke, "Harlem: Mecca of New Negro," *Survey Graphic* 6 no. 6 (March 1925): 627.

11. Edward E. Waldon quotes from a letter White wrote to Hughes in *Walter White and the Harlem Renaissance* (Port Washington, N.Y.: Kennickat Press, 1978): 131. George M. McClellan's note to Hughes is cited in Arnold Rampersad, *The Life of Langston Hughes* (Oxford: Oxford University Press, 1988): 135.

12. Langston Hughes to MC, undated letter, MCA. Ultimately, Hughes's *Fine Clothes to the Jew* was published without illustrations. Discussing Covarrubias's movement from caricature to illustration, Carlos Mérida points out, "Such an admirable disposition for graphic plasticity as that of Covarrubias, would naturally incline him toward books and it is in this field that he has revealed himself as a true master and in which he has achieved and is still achieving his greatest triumphs." Carlos Mérida, "Critical Notes," *Modern Mexican Artists* (Mexico City: Frances Toor Studios, 1937).

13. Heywood Broun quotation is from *Blues* dustcover. Langston Hughes quotation is from the review of "Blues — by W. C. Handy," *Opportunity*, published by the National Urban League (Aug. 1926): 258. (*Opportunity* along with *Crisis* were the Afro-American magazines of the day.) Johnson's comments are from the *Saturday Review of Literature*.

Van Vechten also voiced an opinion: "To the format of the book I can offer nothing but praise. . . . The dustwrapper, the cover, and the illustrations are by Miguel Covarrubias, an artist for whose work I cherish the highest admiration and for whom, therefore, I find it difficult to summon up more glowing superlatives than those I have already employed. I may perhaps express my concrete opinion by stating succinctly that in his drawings for this volume, Covarrubias has transcended all his previous work . . . you will find you cannot only *see* these people, you can also *hear* them." Bruce Kellner, ed., *Keep A-Inchin' Along* (Westport: Greenwood Press, 1979): 35.

14. This inscribed copy is in the author's collection.

15. Carmen Aguilar Zinser, "Miguel Covarrubias: La maravilla de lápiz," *Excélsior*, 16 Jan. 1971. RC quotation from interview with Elena Poniatowska, "Elena Poniatowska reconstruye la vida de Miguel Covarrubias," *Novedades*, 28 April 1957: 1–5.

16. Rosa Covarrubias, unpublished essay, "The China I Knew," AWMCC.

17. Lee Simonson was one of the Theatre Guild's first scenic directors and editor of the magazine *Creative Art*. The Gaities program documents Rose's career as a covergirl. RCS, New York, N.Y.

18. Albert Carroll, "The Garrick Gaities," *New York Times*, 25 June 1925. Carroll describes the elaborate set: "At the back a ledge of yucca or maguey, leaves black-green and grays. On your right the little cafe for pulque, that fierce and far-famed drink of Mexico. The house has diamond patterns on the front of it. There are twisted, harsh tree trunks to the left. Otherwise there is only the glare of light over the piles of oranges, the figures in their cloaks, their serapes, sombreros, shawls, long waisted trousers and full skirts, bare feet high heels, brown skins, dirt, rouge and rice powder."

In a review of the Gaities, Ben Ali could not resist pointing out the sharp cultural contrasts: "A Mexico of Tata Nacho's vernacular 'sones' appears stylized by the talented Miguel, and our good Yankees, inflated with romance, howl with glee over the 'wonderful Mexico.' There is even a pulque shop that attempts valiantly to draw attention to itself, while the poor comics on stage, dying from thirst in the middle of New York, have to drink pasteurized milk on stage, dreaming of their savage drinking bouts, aboriginal drinking sprees in that Mexico so picturesque, so far away." Ben Ali, "La obra del Chamaco en Nueva York," *El Universal Ilustrado*, 6 June 1925.

Tata Nacho (Ignacio Fernández Esperón) was a popular songwriter. "La Borrachita" and "La Chaparrita" are still popular today.

19. Ralph Barton, "Every Thorn Has Its Rose," *The New Yorker* (27 June 1925): 14.

20. "Opening of New Guild Theatre," undated, unidentified newspaper clipping, RCS.

21. Kellner, *Keep A-Inchin' Along*, 35.

22. *La Revue Nègre* set described in *Theatre Arts Monthly* 10 (1926). Unfortunately, all of the theater archives for that show have been stolen. Carl Van Vechten, letter to Hunter Stagg, in *Letters of Carl Van Vechten*, edited by Bruce Kellner (New Haven, Conn.: Yale University Press, 1987): 84.

23. Josephine Baker's recollections are from *Les Memoires de Josephine Baker* (Paris: KRA, 1927). MC's influence on Parisian designers is cited in Patrick O'Connor, *Josephine Baker* (Boston: Little, Brown & Company, 1988): 30.

24. Ralph Barton, "It Is To Laugh," *New York Herald Tribune Book Supplement*, 25 Oct. 1925.

25. "Miguel Covarrubias Finds an Artist's Idyll in Bali," *Life* 27 (Sept. 1937): 46.

26. *Sherwood Anderson and Other Famous Creoles*, drawn by William Spratling, arranged by William Faulkner (New Orleans: Pelican Bookshop Press, 1926).

27. MC's first book for the Bonis and Friede, tentatively titled *The Book of Dance*, was proposed to contain a minimum of twenty-five drawings and a collection of photographs. However, other projects always seemed to take precedence over this one. After MC's extreme success with *Negro Drawings* in 1927, the Bonis and Friede again attempted to publish the project.

They agreed to retitle the work, *One, Two, Three, Kick*. MC conducted a significant portion of the research, made many sketches, and collected scores of photographs, but the economic crash of 1929 prevented the book's completion. It was never published.

The Bonis and Friede numbered many distinguished black writers among their authors, including the precocious Richard Bruce Nugent, a protégé of the scholar Alain Locke. Nugent died in 1987. Thomas A. Goldwasser calls him "the last survivor of the Harlem Renaissance." Catalogue no. 45 (Berkeley, Calif.: Serendipity Books, Inc., 1989).

In the mid-1920s, Nugent was working on an experimental erotic novel, *Smoke, Lilies and Jade,* for which he used Miguel Covarrubias, Rudolf Valentino, Langston Hughes, and Harold Jackman (a friend of Hughes), as models for one of his principal characters, Beauty. The first chapter of this work-in-progress appeared in the inaugural issue (Nov. 1926) of *Fire!,* a magazine "devoted to younger negro artists," the inspiration of Wallace Thurman, Zora Neale Hurston, Langston Hughes, and company. The issue also included poetry by Countee Cullen, Langston Hughes, Anna Bontemps, and a short story of Hurston's. The Negro press called *Fire!* "all sorts of bad names," Hughes recalled in his autobiography *The Big Sea* (New York: Thunder's Mouth Press, 1986), largely because of the Nugent piece. *Fire!* appeared in reprint (Metuchen, N.J.: The Fire Press, 1982). Unfortunately Nugent never completed his book.

28. Sherrill Schell, "Covarrubias Staged," *Boston Evening Transcript,* 19 Dec. 1925.

29. *Theatre Arts Monthly* 10 (1925). The *New York Times* also described the sets in its review: "For the prologue in a fanciful forest, [Covarrubias] daubs blossoms and leaves across a flat-drop with the profusion and speed of a sky-rocket. Two immense toadstools on one side create an impression of extravagance and serve as a convenient seat for Androcles' corpulent wife. The first act shows the Colosseum and part of the Forum in distorted perspective." *New York Times,* 24 Nov. 1925.

30. Gilbert Gabriel, *Daily News,* 2 Nov. 1925.

31. *Theatre Magazine* (1 Feb. 1926): 16.

32. Quinn Martin, the first writer to consider motion pictures equal to the other arts, reviewed *Aloma:* "All the genius for apt and adept camera placement which long has reposed in the trick box of M. Maurice Tourneur has been brought into play richly." *The Arts* 9 (Jan.–June 1926): 288.

33. Diego Rivera painted five oils of Rose over the years, and she appears in his mural at the Hotel del Prado. Roberto Montenegro painted her twice, and she was photographed by Alfred Stieglitz, Edward Steichen, Paul Strand, Man Ray, George Hoyningen-Huene, Nickolas Muray, Donald Cordry, Henri Cartier-Bresson, Gjon Mili, Bob Capa, and Eliot Elisofon.

34. MC's comments on Cuban ceremonies and music are from his article "Voodoo Blackens the Night-Spots," *Vogue* 89, no. 5 (1 March 1937). His drawings from this trip ran in "Dark Denizens of Harlem's Haunts," *Vanity Fair* 28, no. 4 (June 1927): 69.

35. "This is Really Paris," *Vanity Fair* 29, no. 1 (Sept. 1927): 52–53; "Personages," *Vanity Fair* 29, no. 3 (Nov. 1927): 56; and "An Assortment . . . ," *Vanity Fair* (May 1929): 82–83.

36. María Luisa Cabrera de Block, interview with author, Mexico City, 1987. During the Covarrubiases' 1926–1927 visit to Paris, Man Ray was living with the American photographer Lee Miller.

37. RC, interview with Elena Poniatowska, "Elena Poniatowska reconstruye la vida de Miguel Covarrubias," 1–5.

38. The 1928 Valentine Gallery Catalogue (AWMCC) for this exhibition drew attention to "a series of singular portrait studies for which Miguel Covarrubias became famous. In the exhibition, there are forty-four drawings, seven paintings and one very beautiful screen called 'The Celestial Bodies.'"

39. Ralph Barton, Preface to *Negro Drawings,* by Miguel Covarrubias (New York: Alfred A. Knopf, 1927). Six black-and-white studies from *Negro Drawings* illustrate Carl Jung's "Your Negro and the Indian Behavior," *Forum* 83, no. 4 (Jan.–June 1980).

40. Archie Green, "Miguel Covarrubias's Jazz and Blues Musicians," *J. E. M. F. Quarterly* 13, no. 45 (Winter 1977): 185; Frank Crowninshield, Introduction to *Negro Drawings,* by Miguel Covarrubias (New York: Alfred A. Knopf, 1927).

41. Walter Pach, "An Artist Looks on Harlem," *New York Herald Tribune* (6 Nov. 1927): 89.

A reviewer of the book for the Greensboro Press (N.C.) did not think "any other man has pictured the Negro of this continent with the combination of faithfulness and artistic understanding which this Mexican puts into his sketches whether they be pen and ink or line or wash drawings or studies in color." Teresa Grana, quoting a book review by the Greensboro Press in "Miguel Covarrubias, Drawings and Caricatures of Harlem" (master's thesis, George Washington University, 1985): 50.

42. Henry McBride, "Gifted Young Caricaturist Has All Harlem in His Debt," *Sun* (New York), 24 Dec. 1927.

43. Countee Cullen, "The Dark Tower," *Opportunity* 6. no. 2 (Feb. 1928): 52.

44. Marcet Haldeman-Julius, "Miguel Covarrubias," *Haldeman-Julius Quarterly* (Jan. 1927): 62.

45. *British Encyclopedia Britannica,* 20th ed., s.v. "caricature."

46. Langston Hughes, *The Big Sea: An Autobiography* (New York: Thunder's Mouth Press, 1990): 315.

47. Ibid., 316.

48. Zora Neale Hurston, *Dust Tracks on the Road: An Autobiography* (Philadelphia: Lippincott Co., 1971): 177.

49. Marcet Haldeman-Julius, "Miguel Covarrubias," 61.

50. Ethel Smith, telephone interview with author, Palm Beach, Florida, 1986.

51. José Clemente Orozco, *Letters to Jean Charlot and Unpublished Writings: 1925–1929* (Austin: University of Texas Press, 1974): 44.

52. Andrés Medina, " Miguel Covarrubias y el romanticismo en la antropología," *Nueva Antropología* 4 (Mexico City: UNAM, 1976).

53. José Juan Tablada, *La feria* (New York: F. Mayans Publisher, 1928).

54. Fernando Gamboa, interview with author, Mexico City, 1987; Fernando Gamboa, interview with Elena Poniatowska, "Fernando Gamboa y Daniel Rubín de la Borbolla hablan de Miguel Covarrubias," *Novedades,* 22 Apr. 1957.

55. Andrés Henestrosa, interview with author, Mexico City, 1987.

56. The well-known American anthropologist and folk art collector, Donald Cordry, credited Fred Davis with having contributed greatly to the understanding and collecting of Mexican folk art by demonstrating that "really good pieces of Mexican popular arts are so fine in design and so exquisite in color that they would fit into any environment." Erna Fergusson, *Mexico Revisited* (New York: Alfred Knopf): 305. In the 1940s, Davis took five of MC's favorite women to lunch at Sanborn's House of Tiles (where Davis worked). On this occasion, he presented each of them with a large silver pin shaped like a tree, hung with opals, after a design of MC's called "The Tree of Modern Art," whose branches represented various schools and whose leaves each bore a "modern" painter's name.

57. Fergusson, *Mexico Revisited,* 307.

58. Corey Ford wrote to Covarrubias: "I didn't write you before to congratulate you on the gorgeous caricatures you did for *Meaning No Offense* because the identity of 'John Riddell' was supposed to be more or less a secret. But I've just seen the caricature of Joan Lowell you did, and if that isn't sheer genius, I never saw it. The thing is perfectly superb. Any success the Riddell book may have had is due largely to you." Letter, Corey Ford to MC, 27 April 1928, MCA.

59. "Caricatured Negroes," quotation is from Robert Hemenway, Introduction to *Born to Be,* by Taylor Gordon (Seattle: University of Washington Press, 1925; reprint 1975): xxi–xxii; Melvin P. Levy, review of *Born to Be,* by Taylor Gordon, *The New Republic* (1 Jan. 1930): 175; "the drawings . . ." from letter, Taylor Gordon to Carl Van Vechten, James Weldon Johnson Collection, Yale University; "like geometrical . . ." quotation is from Aubrey Bower, *News,* 29 Oct. 1929, Taylor Gordon file, the Schomberg Library.

The *Opportunity* review, by Eugene Gordon, read: "The most interesting feature of the book, aside from the drawings by Covarrubias, is the language in which it is written." *Opportunity* (Jan. 1930): 22. However, the *Crisis* review was very negative: "Covarrubias has illustrated the book; and not being an art critic, my judgment on the success of his work is worth little. I am frank to say,

however, that I think I could exist quite happily if Covarrubias had never been born." *Crisis* (April 1930): 129.

Another review reads: "Covarrubias famous for his pictures of Negroes has caught the spirit of the book as no other artist could have." Unidentified, undated newspaper clipping from Taylor Gordon file, the Schomberg Library, Harlem, N.Y.

60. See Grana, "Miguel Covarrubias . . .," 67, regarding Covarrubias's illustrations of Huston's *Frankie and Johnny*.

61. John Huston, interview with author, Los Angeles, 1986. Huston became a close friend of the Covarrubiases and remained so. Nearly twenty years after they had collaborated on *Frankie and Johnny*, Huston was in Mexico shooting *The Treasure of the Sierra Madre*, one of the first American films to be made entirely on location outside of the United States. Huston had chosen Tampico on the northwest coast of Mexico as the set for his film, and he was shooting pre-production material with a small crew when a local newspaper published the rumor that the Huston film was anti-Mexican. Huston claimed that the local Mexican population "had risen in righteous indignation and threatened us, going so far as to throw stones at our camera crew." None of this was true, but it attracted media attention, and soon Huston received word from Mexico City to discontinue filming. John Huston, *An Open Book* (New York: Alfred A. Knopf, 1980): 143.

Upon reading about the incident in the morning paper, Covarrubias telephoned his friend Huston. On Huston's behalf, MC and Diego Rivera conveyed Huston's assurances to President Miguel Alemán. "Thanks to these old friends, Huston was able to resume shooting in April." Lawrence Grobel, *The Hustons* (New York: Charles Scribner's Sons, 1989): 287.

62. Laurie Lisle, *Portrait of an Artist* (New York: Washington Square Press, 1981): 217; caricature of Georgia O'Keeffe, *The New Yorker* 5, no. 20 (July 1929): 21.

63. Gabriel Figueroa, interview with author, Mexico City, July 1989. Although Dolores del Río began making movies in the United States, her mature work in the forties, filmed in Mexico, is considered her best. These films included *Flor Silvestre* and *María Candelaria*, both of which were made in 1943 and directed by Fernández ("El Indio").

64. Miguel Covarrubias, "Slapstick and Venom," *Theatre Arts Monthly* (August 1938): 593.

65. Mildred Constantine, *Tina Modotti: A Fragile Life* (London: Paddington Press, Ltd., 1975): 145. Mella was murdered on 10 January 1929. Modotti's friends' letters, dated January 16, defended the artistic nude photographs of the couple taken by Modotti that were published in the papers to point out her immorality.

66. Miguel Covarrubias, "Notas sobre máscaras mexicanas," *Mexican Folkways* 5, no. 3 (1929–1930): 116. See also *Mexican Folkways* (April–June 1930) for MC painting, "A Village of the Tropics." He was so enthusiastic about the magazine that he persuaded his father to buy advertising space in it on behalf of the National Lottery.

67. In the introduction to the catalogue *Mexican Arts* [(New York: Metropolitan Museum of Art, 1930): xii], d'Harnoncourt described the show as attempting "to organize the achievements of the Revolutionary struggle of the last twenty years as well as to show some of the contributions which anticipated and helped produce it." From this he hoped his audience would gain a deeper appreciation for Mexican culture.

68. Frances Toor, *Mexican Folkways* 7, no. 4 (1932): 209.

69. Bruce Kellner, ed., *Letters of Van Vechten* (New Haven: Yale University Press, 1987): 111. *Nigger Heaven* was published in 1926 without illustrations, but Knopf planned a deluxe edition of the book with an introduction by James Weldon Johnson and illustrations by the American-born English artist, E. McKnight Kauffer. Unfortunately, Kauffer was delayed in submitting his work, and the Depression had weakened the market for expensive books. The edition was never published.

70. Bruce Kellner, letter to author, 21 Dec. 1986. As for the snubbing, Barton wrote Van Vechten in the summer of 1927. Kellner reports: "Now and then [Barton] heard a sour note, or thought he did, in the otherwise seamlessly happy music that the year seemed always to be playing. Passing through Paris, Miguel Covarrubias did not take time to spare, since he was on his way to North Africa to draw the natives, but Barton was 'dashed and hurt,' he wrote Van Vechten. He may have been jealous, too. Covarrubias was prodigiously prolific and had become

Vanity Fair's most popular artist. Barton was accomplishing little." Bruce Kellner, *The Last Dandy* (Columbia: University of Missouri Press, 1991): 162.

Kellner (letter to author, 18 Aug. 1993) refers also to Barton's "marathon bouts of melancholia and paranoia. . . . in which he seemed to think EVERYBODY was against him, and it is entirely possible that he merely invented what he thought was a slight."

4. THE THIRTIES, PART ONE (1930–1932)

1. Terence Grieder, "The Divided World of Miguel Covarrubias," *Americas* 5, no. 23 (5 May 1971): 24.

2. *New York Times,* 21 April 1930.

3. *New York Times,* 2 May 1930.

4. Kent Cliff attracted an affluent crowd, and the Highlands, as they are called by locals, boast some grand estates, as well as smaller but also exquisite homesites. Historical churches and government mansions dating back to the early eighteenth century cover the landscape.

5. Robin King (Alexander King's son), interview with author, San Francisco, Calif., 26 Aug. 1991. Wedding reminiscences of RC in interview with author, Pasadena, Calif., 1964; Justice of the Peace Emory S. Daniels officiated.

6. George Gershwin's orchestral poem, "An American in Paris," premiered in New York in 1929, and Steinway and Sons commissioned Covarrubias to design an illustration of it that would capture the spirit of Gershwin's Paris in the twenties. MC won a medal for the illustration at the Ninth Annual Exhibition of Advertising Art in May 1930, and it was used in Steinway's advertisements in *Vanity Fair* and *McCall's*. *Miguel Covarrubias Caricatures* (Washington, D.C.: Smithsonian Institution Press, 1985): 139.

7. F. S. C. Northrup wrote of Krause's photo essay on Bali: "His book was significant in telling the world about the little known island and its extraordinary culture, and it helped persuade more writers and photographers to follow him. One among them was Miguel Covarrubias, who later wrote that Dr. Krause's photographs inspired in him 'an irresistible urge' to see Bali for himself." F. S. C. Northrup, *The Meeting of East and West* (New York: The Macmillan Co., 1946): 7. See MC handwritten notes, AWMCC, for details of the itinerary of their journey to the Far East.

According to Alexander King's son, Robin, his father had never visited the island. King had become a Bali enthusiast from listening to the stories of Bali told by the black American photographer Andre Roosevelt, who had lived in Bali for five years. Roosevelt had corralled the journalist Hickman Powell to write a book about it and King to illustrate it. *The Last Paradise* was published in 1930 by Jonathan Cape and Harrison Smith, Vail-Ballou Press, New York. Roosevelt later produced a film entitled *The Kris,* subtitled *Goona-Goona,* the Balinese word for magic. "Goona-goona" became smart Americanese for sex allure in the 1930s.

8. Corazón Grau, "Covarrubias Doesn't Believe in Teachers," *The Tribune Magazine* (Manila), July 1929. See also Teresa Grana, "Miguel Covarrubias' Drawings and Caricatures of Harlem" (master's thesis, George Washington University, 1985): 72–73; and MC, personal notes, AWMCC.

9. MC, personal notes, AWMCC.

10. Miguel Covarrubias, Introduction to *Island of Bali* (New York: Alfred A. Knopf, 1937): xxi.

11. Ibid.

12. John Selby, review of *Island of Bali,* by Miguel Covarrubias, "Literary Guidepost," unidentified, undated newspaper, AWMCC.

13. Covarrubias, *Island of Bali,* 71.

14. I Gusti Alit Oka Degut, interview with author, Denpasar, Bali, 1985.

15. Covarrubias, *Island of Bali,* 103.

16. Ibid., 219.

17. Gregor Krause, *Bali Erster Teil: Land und Volk Zweiter Teil, Tanze, Tempel, Feste* (Hagen: Folkwang-Verlag G. M. B. H., 1920).

18. Anak Agung Ngurah Gedé Sumatra, interview with author, Denpasar, Bali, 1985. Sumatra died two years later, in Dec. 1987, at the age of forty-eight.

19. Ni Ketut Reneng, interview with author, Denpasar, Bali, 1985.

20. Anak Agung Gedé Mandera interview with author in Peliatan, Bali, 1985. (Mandera passed away in 1987.) Walter Spies wrote that Mandera's music was "like the rays of the sun, gently caressing the skin." Hans Rhodius and John Darling, *Walter Spies and Balinese Art* (Amsterdam: Terra, Zutphen Publishers, 1980): 43. Mandera's orchestra eventually traveled to Paris.

21. Ibid.

22. Covarrubias, *Island of Bali,* xxi.

23. Ibid., xxii.

24. The month in Shanghai during MC's sojourn in 1930–1931 is noted in Teresa Grana's "Miguel Covarrubias' Drawings and Caricatures of Harlem" (master's thesis, George Washington University, 1985): 73. The book *China* was published in 1931 and dedicated "To Rose and Miguel Covarrubias, from their friend, MC." It is interesting to note that during his days in the Díaz administration, Miguel's father had studied Chinese immigration to Mexico.

25. MC, personal notes, AWMCC.

26. Rhodius and Darling, *Walter Spies and Balinese Art,* 39.

27. Covarrubias, *Island of Bali,* xxii–xxiii.

28. Pearl Buck, review of *Island of Bali,* by Miguel Covarrubias, *Asia,* Jan. 1938; Anak Agung Gedé Sobrat, interview with author, Ubud, Bali, 1985. Sobrat died on 30 Sept. 1992.

29. I Gusti Madé Sumung, interview with author, Mas, Bali, 1985.

30. Covarrubias, *Island of Bali,* 41–42.

31. Ibid., 11.

32. Miguel Covarrubias, "The World and the Theatre," *Theatre Arts Monthly* (Aug. 1936): 578.

33. Edwin C. Hill, "Human Side of the News," *Journal,* 23 Dec. 1937.

34. Covarrubias, *Island of Bali,* xxiii.

35. Ibid.

36. Note, Gide to MC, Paris 1931, MCA, citing Gide's encouragement.

37. Regarding MC's gouaches, the critic Edward Alden Jewell wrote: "Although Covarrubias' paintings are generally referred to as gouache, the definition is not precise. He uses plain water, but his technique imparts a shiny surface. He thus gains luminous quality that watercolors lack." Jewell, "Covarrubias in the Tropics," *New York Times,* 21 Jan. 1932.

38. *Valentine Gallery Exhibition Catalogue,* 1932.

39. Henry McBride, "A Gifted Mexican in Bali," *New York Post,* 25 Jan. 1932. *Antiques* magazine attributed the change in MC's style to Bali's culture: "Something in the atmosphere of Bali has transmuted gross exaggeration to a kind of poetic hyperbole that succeeds in conveying a truer visualization than any purely literal transcript could possibly afford. . . . The blending [of 'an intensely subjective but utterly honest point of view' and Miguel's keen perception of objective reality] is clearly instinctive and sympathetic, not the outcome of intellectual processes. Its particular emphases are of today; its fabric, the immutable stuff of which all true art is composed." *Antiques* (Jan.–June 1932): 138.

40. Jewell, "Covarrubias in the Tropics."

41. The French black writer René Maran, whose writing represented an inner struggle, as well as a moral and spiritual search, was a strong supporter of African rights, and he became involved with the Pan-African movement from its inception in the early thirties. Maran's *Batouala* was highly praised by black Americans seeking racial identity. *Batouala* expressed strong feelings of racial pride. Black Americans marvelled at the evidence Maran had gathered to prove Africa's artistic potential. The book became a "cause célèbre" in the weekly issues of Marcus Garvey's *Negro World* for its detailed recounting of a savage Africa, the nation's implicit hatred of whites, and its underlying eroticism. In 1922, *Batouala* was first published in English by Adele Szold-Seltzer.

MC had met Maran while living in Paris in 1926. Subsequently, the two men had corresponded, and upon the decision by the Limited Editions Club to reissue *Batouala,* MC seemed the perfect choice for illustrator.

MC's Balinese illustrations appeared in *Vanity Fair* 38, no. 3 (May 1932); Ibid. 43, no. 5 (Jan. 1935); and Ibid. 45, no. 6 (Feb. 1936).

42. Undated letter, Walter Spies to MC, MCA.

5. THE THIRTIES, PART TWO (1932–1937)

1. I Gusti Madé Sumung, interview with author, Ubud, Bali, 1985.

2. Frank Tannenbaum, *Peace by Revolution: An Interpretation of Mexico* (New York: Columbia University Press, 1933). RC interview with Elena Poniatowska, "En memoria de Miguel Covarrubias," *Novedades,* 28 April 1957.

3. Corey Ford, *The Time of Laughter* (Boston: Little, Brown and Co., 1967): 8.

4. Melanie Kahane, interview with author, New York City, June 1985.

5. Bernard F. Reilly, Jr., Introduction to *Miguel Covarrubias Caricatures,* (Washington, D.C.: Smithsonian Institution, 1985). Enthusiastic about the "Impossible Interviews," MC's father suggested several follow-up series: "Ingenuous Monologues," "Indiscrete Thoughts," "Absurd Controversies," "Fascist Dreams," or "Bolchevique Plans." Letters, José Covarrubias Acosta to MC, MCA.

6. See the Miguel Covarrubias file, the Evergreen House Foundation, Baltimore, Md., for correspondence regarding the Garrett commission.

7. Frank Crowninshield to MC, 18 Aug. 1933, AWMCC.

8. MC to Frank Crowninshield, 22 Dec. 1933, MCA.

9. MC, personal notes, MCA.

10. MC, personal notes, AWMCC.

11. Miguel Covarrubias, *Island of Bali* (New York: Alfred A. Knopf, 1937): xxiv.

12. Ibid., xxv.

13. *Life,* 27 Sept. 1937.

14. Ni Ketut Reneng, interview with author, Denpasar, Bali, 1985; Anak Agung Gedé Mandera, interview with author, Peliatan, Bali, 1985.

15. Covarrubias, *Island of Bali,* 46.

16. Unless otherwise stated, recollections of the Covarrubiases' trip to China are from RC's unpublished essay, "The China I Knew," AWMCC.

17. Robert Mountsier, "Does His Work While Traveling," *Sun* (New York), 8 Jan. 1938.

18. Alfred Barr, MOMA's first director, assumed that position in 1929 at the age of 27.

19. Zora Neale Hurston, *Dust Tracks on a Road* (Urbana: University of Illinois Press, 1984): 177.

20. Charlotte Mason to MC, undated letter, MCA.

21. Charlotte Mason to MC, 21 Jan. 1935, MCA.

22. *Vanity Fair,* Jan. 1935.

23. "Biography of an Island Set in the Southern Seas," Review of *Island of Bali,* by Miguel Covarrubias, *Sun* (New York), 20 Nov. 1937.

24. Other artists in the exhibition were Victor DePauw, Isamu Noguchi, Dunoyer de Segonzac, John Sloan, and Moses Soyer (all became famous painters and sculptors).

25. John Martin, "The Dance: A Festival," *New York Times,* 9 Aug. 1936.

26. "The Bali prints are new and stimulating," declared New York's *Evening Post,* "One is based on a design found in a temple, painted on a thin wafer. This is a young girl with the proud, fan-shaped flower headdress and triangular skirt of the islands. Another is the brilliant batik motif that Bali women love—imaginative birds, flowers and butterflies flung against bold colors." Cecile Gilmore, "Gaiety of Bali Woos Jaded Gothamites; Covarrubias Is the Designer of New Prints," *Evening Post* 20, 30 Dec. 1937 (Bali comes to Franklin and Simon department store).

The film, documenting Balinese festivals, ceremonies, and cremations, was much admired. As noted by the puppeteer Bil Baird: "Miguel had a very good eye for the camera, and his film is a work of art. Today it provides us with important documentation of dances and ceremonies which are no longer performed in the same manner (such as cremations) or no longer exist. All transfers of the film were done at my studio." Bil Baird, interview with author, New York, 1985.

27. *American Trade Journal,* Dec. 1937, and *New York Times,* 31 Jan. 1938.

28. Review of *Island of Bali,* by Miguel Covarrubias, *Colorado Springs Gazette,* 5 Dec. 1937; Review of *Island of Bali,* by Miguel Covarrubias, *Waukesha (Wisc.) Freeman,* 15 Jan. 1938.

29. *The Nation* and *Herald Tribune* quotations are from Maxine Block, ed., "Who's News and Why?," *Current Biography* (New York: The H. W. Wilson Company, 1940): 202.

30. Terence Grieder, "The Divided World of Miguel Covarrubias," *Americas* (May 1971): 24.

31. Ibid., 24.

32. I Gusti Alit Oka Degut, April 1985, Denpasar, Bali. Years later, the Balinese welcomed Mexico's President López Mateos, on a state visit to Bali (during his 1958–1964 term), with the greeting: "He comes from the land of the Guru, Miguel Covarrubias, the teacher." Carmen Aguilar Zinser, "Miguel Covarrubias: La maravilla del lápiz," *Excélsior,* 16 Jan. 1971.

33. Fernando Blanco, interview with author, Ubud, Bali, 1985.

34. Pearl Buck, review of *Island of Bali,* by Miguel Covarrubias, *Asia* (Jan. 1938): 8. Although Buck believed MC had not been transfigured spiritually, she did acknowledge a spiritual bond he had made with the island: "Sometimes a man goes traveling and comes upon a new country, whose face is strange to him and yet instantly lovelier than any other. He stays to discover and to see, and grows more and more in love with all he finds. The bond is mutual. He gives himself to the country, perhaps something he has never given before, and from the country receives what none has been able to give him. It is a spiritual union."

35. Ibid.

36. "Biography of an Island Set in the Southern Seas," *The Sun Book Review* (New York), 20 Nov. 1937.

6. THE THIRTIES, PART THREE (1935–1939)

1. Terence Grieder, "The Divided World of Miguel Covarrubias," *Americas* (May 1971): 24.

2. The Covarrubias family (MC's nieces, Alejandra and María Elena) still owns the house.

3. Harry Block interview with Elena Poniatowska, "Alfonso Caso, Harry Block y Diego Rivera hablan de Miguel Covarrubias," *Novedades,* 12 May 1957.

4. *The Bone* is mentioned in *The Carnegie Exhibition of Modern Painting* catalogue: "It is a work closely related to the self-important portraits of the Mexican provinces. The manner in which the room is viewed in the painting accentuates the presence of the personality depicted." The painting also appeared in MOMA's "Twenty Centuries of Mexican Art." It was purchased by the Mexican government for the Palace of Fine Arts Museum's collection in Mexico City and, most recently, has toured in the 1991–1992 exhibition "Many Splendors of Mexico." For details on the sale of *Río Tehuantepec* see letter from Elena Duclaud Covarrubias to MC, 1935, MCA.

5. Jean Charlot, *The Mexican Mural Renaissance: 1920–1925* (New York: Hacker Art Books, 1979): 144.

6. Roberto Mountsier, "Mexican Artist 'Paints' Mexico," *Sun* (New York), 22 Jan. 1938; Miguel Covarrubias, *Mexico South: The Isthmus of Tehuantepec* (New York: Alfred A. Knopf, 1962): xxii.

7. Federico Cantú was born in Nuevo Leon in 1908 and became a talented painter and engraver of Catholic subjects. (Cantú painted a portrait of the author's immediate family in a Mexican landscape.) María Izquierdo, born in Jalisco in 1904, is known for her paintings of Indian toys, children, and horses using brilliant Indian colors. Xavier Guerrero was born in Coahuila in 1896; he was a muralist, easel painter, and a member of the League of Revolutionary Artists and Writers. He was also Tina Modotti's lover, a close friend of MC, and a member of the Friends of China. Guerrero was blacklisted for his political affiliations. Tamiji Kitigama was a Japanese painter who lived in Mexico. A Russian painter, Angelina Beloff, had been Diego Rivera's mistress and bore his son in 1912 in Paris. Alice Rahon was a surrealist painter and wife of the surrealist Wolfgang Paalen who founded the magazine *DYN.* Carlos Mérida was a muralist born in Guatemala in 1893, but who worked and lived in Mexico from 1919 and became the director of Mexico's Palace of Fine Arts in 1947.

8. The American Artist Group described the *Lindy Hop* lithograph: "He has managed to

convey some measure of the grace and elegance, the innate feeling for rhythm, those quick and baffling transitions of tension and relaxation, that make this famous dance such a delight to the eye.... Such a lithograph as this is the fruit of countless observations and drawings from real life, in which the essential movements and gestures are gradually stylized into their most telling and powerful form." *Original Etchings, Lithographs and Woodcuts by American Artists*, no. 1 (New York: American Artists Group Catalogue, 1936): 18.

9. Zora Neale Hurston, *Dust Tracks on a Road* (Urbana: University of Illinois Press, 1935): 177.

10. María Luisa (Malú) Cabrera de Block's recollection is from Olivier Debroise, "Cronista de una decada prodigiosa," *Miguel Covarrubias: Homenaje* (Mexico City: CCAC, 1987): 83. Biddle's letter to Roosevelt reads in part: "There is a matter which I have long considered and which some day might interest your administration. The Mexican artists have produced the greatest national school of mural painting since the Italian Renaissance. Diego Rivera tells one that it was only possible because Obregon allowed Mexican artists to work at plumber's wages in order to express on the walls of the government buildings the social ideals of the Mexican revolution. The younger artists of America are conscious as they have never been of the social revolution that our country and civilization are going through; they would be eager to express these ideals in a permanent art form if they were given the government's cooperation." *Introduction 1935: The Year and the Arts* (Hempstead, N.Y.: Emily Lowe Gallery, Hofstra University, 1935).

11. Lou McLean, "Mexico's Great Caricaturist Is a Union Man and a Progressive," *People's World* (San Francisco), 12 Jan. 1939.

12. Charlot, *The Mexican Mural Renaissance*, 243.

13. Ibid.

14. The *Taller* was responsible for the monumental collectively created posters that became popular in Mexico City in the late thirties, at a time when publicity images were in their infancy. The *Taller* membership kept to the highest aesthetic standards and helped transform art in Mexico into a means of social education and reform, producing placards for political marches and many editions of graphics that focused on scenes and images from the Mexican revolution.

15. McLean, "Mexico's Great Caricaturist Is a Union Man and a Progressive." MC was consistent in expressing his nationalism in art; his early illustrations for Best Maugard's Indian motifs is perhaps the purest expression of that, but his own books *Mexico South* and *Indian Art of Mexico and Central America* are other examples; and perhaps most profound of all in this regard is the contribution he made to the art of dance in his country in the early 1950s.

16. José Covarrubias Acosta to MC, undated correspondence, MCA. José Covarrubias had three books published: *Tierras y colonización* (1912), *El problema rural en México* (1917), and *La trascendencia* (1922). A fourth book was never published.

17. Elena Duclaud Covarrubias to MC, MCA.

18. MC, notes, MCA.

19. "519 Watercolors, 125 from Abroad in Chicago's International," *Art Digest* (15 March 1936): 15.

20. In the "War and Fascism" exhibition catalogue, artist Rockwell Kent wrote: "Of the millions—and there are such millions—who want to pursue the cultivation of their garden which is America in peace and ordered security, art is the voice. For God's sake listen to it." Rockwell Kent, Foreword to *War and Fascism* (New York, 1936). April 1936 was the date of another exhibit for MC; the Colorado Fine Arts Center showed his painting "The Band."

21. Elena Duclaud Covarrubias to MC, MCA.

22. The extraordinary affection Doña Elena held for Miguel is clear. Once she said, "I always thought that he was a little bit crazy, but he turned out to be a good man and a model son." Elena Duclaud Covarrubias, cited in obituary, "Miguel Covarrubias," *Herald Tribune*, 6 Feb. 1957.

23. Rose Covarrubias, "I Have Two Kitchens," AWMCC.

24. Michael D. Coe, *The Jaguar's Children: Pre-Classic Central Mexico* (New York: The Museum of Primitive Art, 1965): 10.

25. Miguel Covarrubias, "Tlatilco, Archaic Mexican Art and Culture," *DYN: The Review of Modern Art*, no. 4–5 (1943): 40.

26. Miguel Covarrubias, "Tlatilco: El arte y la cultura preclásica del Valle de México," *Cuadernos Americanos* 60, no. 3 (May–June 1950): 153.

27. Details of the brickyard at Tlatilco are from the following sources: André Emmerich, *Art before Columbus* (New York: Simon and Schuster, 1953): 23; Frederick Field and Nieves Field, interview with author, Mexico City, 28 July 1986; Fernando Gamboa, interview with author, Mexico City, 26 July 1986.

28. Miguel Covarrubias, "El arte 'Olmeca' o de La Venta," *Cuadernos Americanos* 51, no. 3 (July–Aug. 1950): 153.

29. Ibid., 153. The Chaneque-type figure belonged to the Olmec jaguar cult of dwarfish jade creatures, considered "true poltergeists." Bernal also notes that "Covarrubias believes them to be celestial spirits of rain who became transformed into the rain god of the Classic period." Ignacio Bernal, *The Olmec World* (Berkeley: University of California Press, 1969): 101.

30. Covarrubias, "El arte 'Olmeca' o de La Venta," 153.

31. "Covarrubias quickly realized . . ." is from Michael Coe, *America's First Civilization: Discovering the Olmecs* (Washington, D.C.: American Heritage Publishing, 1968): 95; "extended skeletons . . ." is from Michael Coe, *Mexico*, rev. ed. (New York: Thames and Hudson, 1986): 49–51.

32. Covarrubias, "Tlatilco: El arte y la cultura preclásica del Valle de Mexico," 157.

33. Frida Kahlo to MC, undated note, MCA.

34. "Little Lady, Big War," *Sandglass* 26, no. 9 (Heritage Club): 3. (Insert in *Uncle Tom's Cabin* for subscribers.) *Uncle Tom's Cabin* was the last book on Negro life that Miguel illustrated. His sets, illustrations, drawings, and paintings were created from 1925 to 1938. Covarrubias was among the first "discoverers and disseminators," as Archie Green described him in *J. E. M. F. Quarterly,* of black humor, dance, and music in America. As a Mexican, he found in Harlem an American expression with which he could identify. This body of work represents Covarrubias's vision of and sensitivity to a culture within a culture. Furthermore, he provides a means of understanding an ethnic identity during its emergence during the twenties and thirties. Covarrubias's interests included black culture in Cuba and Africa.

35. The Mexican watercolors were well chosen, according to the *New York Times* review of the exhibition: "As a whole this section has more similarity and more sense of nationalism than any of the other[s]. The solid designs and color one expects are dominant in the works shown." Of his own work, Miguel picked *Marquesan Dance, Marquesan Chief with Visitors,* and *Rice Granary,* about which the *Times* wrote: "His color is rich and haunting and above all his work is full of vitality. His work was always good natured, documentary yet decorative, sharply, precisely drawn. Like all modern Mexican painters, he uses color vividly. But unlike most, he never dramatically distorts form or content." "200 Water-Colors Seen in Brooklyn," *New York Times,* 8 May 1937.

36. MC to Nickolas Muray, undated letter, collection of Mimi Muray.

37. Several years later Nickolas Muray asked MC to be the godfather of his child, whom he named Michael (Mimi) Brooke, after MC, even though the child was a girl. (Her godmother was the actress Judith Anderson). Mimi told me, "I am constantly getting mail addressed to Mr. Michael Muray, although I never did get a draft notice." Mimi Muray, interview with author, Salt Lake City, Utah, July 1986.

38. MC to Nickolas Muray, 16 Oct. 1937, collection of Mimi Muray.

39. Carmen López Figueroa, interview with author, Acapulco, Mexico, 1988.

40. Ibid., for Figueroa's brief affair with MC; Robin King (Nettie King's son), interview with author, San Francisco, 26 Sept. 1991, for Nettie's relationship with MC.

41. Unless otherwise noted, MC's recollections of the June 1937 trip to Tehuantepec are from personal notes, AWMCC.

42. Covarrubias, *Mexico South: The Isthmus of Tehuantepec* (New York: Alfred A. Knopf, 1962): xxv.

43. Ibid., xxiii; *Mexican Art and Life,* no. 4 (Oct. 1938).

44. Madame Chiang Kai-shek, honorary president of the association, spoke at this benefit dinner on 24 Nov. 1937. Mai Sze—possibly an intimate of MC's—was secretary-treasurer. MC's friend Dr. Lin Yu Tang also spoke at the event to help the Chinese victims of Japanese aggression.

MC, RC, the Van Vechtens, and Chester and Bernadine Fritz all attended in support of the victims.

45. "Artists of Bali," Exhibition Catalogue (New York: M. A. McDonald Gallery, Feb. 1938). Covarrubias wrote of this exhibition's revolutionary works: "Five or six years ago a revitalizing revolution changed the art in Bali. Young artists of a new type appeared in the villages and created schools. Boys made pictures that were reminiscent of Persian and Indian miniatures with a dash of Beardsley and the Douanier Rousseau. The new artists were quick to grasp the possibilities of the new materials and, by their inherent fantasy, love for the decorative and eagerness for technical perfection, were able to create a new Balinese art."

46. Frances E. Brennan, quoting Walter Winchell in a letter to MC, 2 June 1938, AWMCC; Ibid. MC's illustrations appeared with two other articles in *Fortune:* "Covarrubias' Pacific," in May 1939, and "The Japanese," in Feb. 1942.

47. "Democracy and fascism" quotation is from Joe Louis, Edna Rust, and Art Rust, Jr., *Joe Louis: My Life* (New York: Harcourt Brace Jovanovich, 1978): 137; Andrés Henestrosa, interview with author, Mexico City, Feb. 1987.

War fever was running high in 1938. Joe Louis's fight with German Max Schmeling appealed to all of America. Even President Roosevelt had been caught up; he invited the "Brown Bomber" to the White House just before the fight and told him, "Joe, we're depending on those muscles for America." Two minutes into the first round, Joe knocked Schmeling out. (Louis, Rust, and Rust, *Joe Louis*, 103.)

48. Telegram, Philip Youtz to MC, 28 June 1938, MCA. Presumably, the Covarrubiases attended the opening of the world's fair in San Francisco in February. RC to NR, 20 Feb. 1939, NAR Papers, NRAC.

49. Statement by the president accompanying lithographs of the six mural maps, Pacific House, 1939.

50. Moisés Sáenz to MC, undated correspondence, MCA. On MC's acceptance, Youtz wrote: "You have a unique style and a great fund of knowledge which will enable you to dramatize the educational purposes we have in mind. We are thrilled you have accepted this commission." In addition, MC was named general consultant of development for Pacific House, the fair's "theme building," and Youtz asked him "to contribute your ideas especially for the dance program, color scheme, and any other phase which might interest you personally." Youtz to MC, 8 July 1938, MCA.

51. MC worked with Alfred L. Kroeber, head of the Department of Anthropology at the University of California at Berkeley and, through correspondence, with Dr. Erna Gunther from the University of Washington, among others.

52. MacKinley Helm, *Modern Mexican Painters* (New York: Harper and Brothers Publishers, 1941): 196. Anne Medalie of San Francisco and Elizabeth Mitchell from Colorado Springs were part of MC's team. Anne Medalie was a Russian-American painter who moved to Ajijic, Mexico, after her work with MC. She had several successful exhibitions in Mexico City, including one at the Palace of Fine Arts.

The two outline maps were prepared by Van Der Grinten with the advice of Dr. Carl O. Sauer, head of the geography department of the University of California at Berkeley. They were the first maps of the world to be drawn with the Pacific Ocean as the center, giving Pacific House the distinction of having published the first Pacific world maps of their kind. Miguel Covarrubias, Introduction to *Pageant of the Pacific* (San Francisco: Pacific House, 1940).

53. Eugen Neuhaus, *The Art of Treasure Island* (Berkeley: University of California Press, 1939): 6.

54. LC, interview with author, Mexico City, 11 Feb. 1987 and 3 July 1986, in which LC recounted the story as Miguel had told it to him.

55. *Fortune,* May 1939; three maps were reproduced in this issue. Eugen Neuhaus, *The Art of Treasure Island*, 119. MacKinley Helm, *Modern Mexican Painters*, 195.

56. See "United Action for Defense of Mooney" in Bertram Wolfe file, Bancroft Library, University of California.

57. José Covarrubias, Editorial, *El Imparcial*, 1913, María Elena Rico Covarrubias personal papers.

58. Frank Tannenbaum, *Peace by Revolution: An Interpretation of Mexico* (New York: Columbia University Press, 1933): 161–162.

59. Octavio Barreda, interview with Elena Poniatowska, "Elena Poniatowska reconstruye la vida de Miguel Covarrubias," *Novedades,* 28 April 1957.

60. Daniel Rubín de la Borbolla, "Miguel Covarrubias 1905–1957," *American Antiquity* 23 (Salt Lake City, Utah: The Society for American Archeology, 1957–1958): 64.

61. Miguel Covarrubias, *Island of Bali* (Alfred A. Knopf, 1937): 164; Ibid., 163.

62. Ibid., 401.

63. Ibid.

64. Ibid., 400.

65. MC also did a caricature of Mooney for the socialist newspaper, *People's World* (San Francisco), 12 Jan. 1939, probably in conjunction with the parade. Ben Shahn produced a series of gouaches of Mooney for an exhibition in New York in 1933, and Diego Rivera wrote the introduction to the exhibition's catalogue.

66. Lou McLean, "Mexico's Great Caricaturist Is a Union Man and a Progressive," *People's World,* 12 Jan. 1939.

67. Ibid.

68. MC to Nickolas Muray, collection of Mimi Muray, 25 April 1938.

69. Alfa was an especially beautiful young woman, with whom MC may have had an affair. MC wrote to Nick Muray (25 April 1938) "Alfa, as beautiful as ever, is leaving with me (!) for Tehuantepec." She became one of MC's favorite models. Alfa married Henestrosa in the 1940s, and her sister Nereida became a doctor.

70. "The most admired beauty . . ." quotation is from Hesíquio Aguilar, "María Asúnsolo, bellísima musa," *Impacto,* May 1983, 14; María Asúnsolo, interview with the author, Mexico City, March 1986, documenting her reminiscences. During the 1940s, María Asúnsolo became a muse to writers, poets, painters, and sculptors. Nearly all of Mexico's most important painters did portraits of her. Consequently, Asúnsolo's gallery/apartment, GAMA, a gathering place for young artists and intellectuals, came to house a distinguished collection of paintings and portraits of her. In 1990 the Mexican government purchased this important portrait collection.

A note about Nahuí Olín, mentioned in María's recollection: her real name was Carmen Mondragón; like Dr. Atl, she assumed an Indian name as a sign of her devotion to her roots. She was another exotic beauty whom everyone painted and with whom everyone fell in love, including MC, who did a watercolor of her that was used in an ad for Bradford Paint Company and that Nick Muray ultimately owned. Diego Rivera also painted her. She was the figure representing "Erotic Poetry" in his mural in the auditorium of the Preparatory School in Mexico City; he also used her as a model for a figure in the amphitheater of Bolívar.

71. Synopsis of *The Creation of the World* in letter, Carlos Chávez to Walt Disney, 19 Oct. 1939, AWMCC.

72. Caso is quoted in letter from Chávez to MC, 23 Nov. 1939, AWMCC. Caso (1896–1970) was a student of law as well as of his native country. Indian subjects became a specialty of his, and he distinguished himself as an archeologist when he discovered the fabulous cache of pre-Colombian jewelry in tomb no. 7 at Monte Albán in 1932. Stokowski first came to Mexico in 1931 and became a close friend of MC's. He stayed with the Covarrubiases in Tizapán when he conducted Shostakovich's 7th Symphony in Mexico in 1943.

73. MC to Henry Allen Moe, 28 Dec. 1939, AWMCC.

74. Ibid.

7. THE FORTIES, PART ONE (1940–1942)

1. Fernando Gamboa, interview by Elena Poniatowska, "Fernando Gamboa y Daniel Rubín de la Borbolla hablan de Miguel Covarrubias," *Novedades,* 5 May 1957.

2. See the Limited Editions Club publication for subscribers, 1942, for Harry Block's comments.

3. MOMA Archives: PI Scrapbook, #45. NR announced the exhibition in an article, "Mexican Art Show Will Be Held Here," *New York Times,* 21 Feb. 1940, projecting that the show would "contribute to a better understanding of the people and the cultural life of Mexico . . . To know the arts of Mexico is to know and understand the Mexicans themselves for the two are so inseparably interwoven. One cannot come to know and love the arts of this country without developing a great warmth and affection for the people themselves."

4. Diego Rivera, Frida Kahlo, Olga Tamayo, Rufino Tamayo, Miguel Covarrubias, Rosa Covarrubias, and Alfred Barr assembled for the lunch at El Patio in Mexico City to select a name. "I've got it," Miguel exclaimed. "Twenty Centuries of Mexican Art!" Jorge Alberto Manrique and Teresa Del Conde, *Una mujer en el arte mexicano,* (Mexico City: UNAM, 1987): 65.

5. NR to MC, 27 Jan. 1940, Rockefeller Foundation Archives, RG.4, Series Projects, Subseries MOMA Mexican Exhibition, Box 138, Folder 1354, NRAC.

6. John Abbott to NR, 2 Feb. 1940, RG.4, Series Projects, Sub-series MOMA Mexican Exhibition, Box 138, Folder 1354, NRAC.

7. Monroe Wheeler to NR, 6 March 1940, RG.4, Series Projects, Sub-series MOMA Mexican Exhibition, Box 138, Folder 1354, NRAC.

8. Monroe Wheeler to NR, 1 May 1940, RG.4, Series Projects, Sub-series MOMA Mexican Exhibition, Box 138, Folder 1354, NRAC.

9. "Series Arranged of Mexican Music," *New York Times,* 1 May 1940.

10. Museologist Daniel Rubín de la Borbolla in "Miguel Covarrubias: 1905–1957," *American Antiquity* 23, no. 1 (July 1957): 64. MC's critics quoted in MacKinley Helm, *Modern Mexican Painters* (New York: Harper Brothers, 1941): 195; this critic was obviously misinformed about Miguel's nationality.

11. MC to Henry Allen Moe, 4 April 1940, Miguel Covarrubias File, John Simon Memorial Foundation Guggenheim Foundation, New York, N.Y.

12. MC to Nickolas Muray, undated letter (probably April or early May 1940), collection of Mimi Muray. MC commented more on Lee Ya-Ching: "I have extra . . . information that Chinese official circles discouraged the flight of which, no doubt, Hilda Yen had a hand. What a shame that such petty feminine jealousies prevented putting the name of China high in Mexico."

Though he mentions it only in passing, attending the First International American Indian Congress was a great honor. MC continued to participate in these annual events whenever he could.

The film on which Steinbeck and Kline collaborated was *Mexico for the Mexicans.*

13. *Arizona Republic* (Phoenix), 14 April 1940. Some of the boxes must have been nested, and some held separate pieces to be joined together for display.

14. Lucien Weil, telephone interview with author, 1990; Tina Martin, daughter of Alberto Misrachi, interview with author, Salt Lake City, Utah, 13 July 1986.

15. María Luisa Cabrera de Block, interview with author, Mexico City, 1987; Biddle's proposal in Henry McBride, "Viva Mexico," *Sun* (New York), 18 May 1940; and *Dallas Herald,* 5 June 1940.

16. MOMA Archives: PI Scrapbook, #4, "Mexican Art Show Spans 2000 Years," *New York Times,* 15 May 1940; RC's painting *Tehuanas* appeared on the cover of the *Christian Science Monitor* on 8 June 1940. Thrilled by this achievement, Rose sent a copy to her sister, Mae.

17. The grant award was delayed for many months. The funds were to support MC from 1 May 1940–May 1941. However, by August 1940 MC had to write Moe requesting that the funds be wired so he could travel to Tehuantepec in September.

18. MC to Henry Allen Moe, 4 April 1940, Miguel Covarrubias File, John Simon Guggenheim Memorial Foundation, New York, N.Y.

19. RC to NR, 19 July 1940, NAR RG III 4e, Series Countries, Sub-series Mexico, Box 62, Folder 433, NRAC.

20. RC to NR, 19 July 1940, Box 138, Folder 138.69B, NRAC.

21. Miguel Covarrubias, *Mexico South: The Isthmus of Tehuantepec* (New York: Alfred A. Knopf, 1962): 37. An MC caricature of Paxtián accompanied an article about the Indian leader in an unidentified Mexico City newspaper, 19 Aug. 1940.

22. MC quotation from Covarrubias, *Mexico South: The Isthmus of Tehuantepec,* 16.

Covarrubias took many photos of the Cordrys during this trip. As they pursued their studies, the Covarrubiases were eager for the company of Donald Cordry, who was so knowledgeable about the Mexican Indian. Not only did the two men exchange expertise, as avid collectors, but also art objects. Dorothy Cordry recalls an unusual Olmec figure in Donald Cordry's collection that Covarrubias had coveted amiably for years. Cordry finally traded the sculpture to Covarrubias in exchange for four ivory carvings from MC's collection. Dorothy considered MC a major influence on her husband. Certainly Covarrubias made a major contribution to Cordry's career by introducing Donald to his cousin from Spain, Margarita Covarrubias the Baroness de l'Angers, who had been living abroad. The Baroness, an art collector herself, was living at the time with the elder Covarrubiases on Zamora Street, and she became Cordry's biggest client. (Cordry was designing folk jewelry to support his Indian research.) Dorothy Cordry, interview with author, Cuernavaca, Mexico, 1985.

23. Covarrubias, *Mexico South: The Isthmus of Tehuantepec,* 374–375.

24. Ibid., 403–404.

25. André Emmerich, *Art before Columbus* (New York: Simon and Schuster, 1963): 23. Also collecting in Tlatilco at the same time as Covarrubias and Diego Rivera were Dr. Milton Arno Leof, an American dentist living in Mexico, and his wife; Franz Feuchtwanger, a German anthropologist; Frederick Vanderbilt Field, an American scholar; George Pepper, American film producer (considered by Fred Field to be one of the most discerning of all the collectors of Columbian art); and Jacques Lipschitz, the French sculptor.

26. Quotation from Selden Rodman, *Mexican Journal* (New York: The Devin-Adair Company, 1958): 29. Prices of burial finds cited by archeologist Arturo Romano, interview with author, Mexico City, 1987.

Leon Davidoff, a well-known industrialist and collector met MC one night when Covarrubias was doing guard duty. Davidoff recalls: "I had a textile factory near Tlatilco. The boiler blew up in the middle of the night. There was no communication possible. No lights, no phone, etc. I went out to try and stabilize the walls so that they would not fall down on the machinery.

"A young man took over, telling the workers what to do. I was impressed with the way he was thinking on his feet. Who are you? 'I'm here guarding the brickyard in Tlatilco to prevent plundering of grave sites.' Needless to say, we became friends." Much later, Mrs. Davidoff (daughter of Alberto Misrachi) remembered a "marvelous portrait" Rosa did of their daughter. Leon and Ruth Davidoff, interview with author, Cuernavaca, Mexico, 1989.

27. Matthew Stirling, while exploring the region of the Colossal Heads along the northern coast of the isthmus, found a Mayan monument that he could identify as dating from 291 B.C. This discovery was identified as the new world's oldest dated man-made relic at the time.

28. Daniel Rubín de la Borbolla, "Miguel Covarrubias: 1905–1957," *American Antiquity* 23 (1957–1958): 64.

29. To their everlasting credit, Mexico's representatives at that meeting issued a declaration for the protection of Indian arts, whereby the foreign export of any of these rare pieces would be illegal.

30. Miguel Covarrubias, *Indian Art of Mexico and Central America* (New York: Alfred A. Knopf, 1957): 50.

31. Matthew W. Stirling, "Early History of the Olmec Problem," *Dunbarton Oaks Conference on the Olmec,* October 28–29, 1967, edited by Elizabeth P. Benson (Washington, D.C.: Dunbarton Oaks Research Library and Collection, Trustees for Harvard University, 1967): 1.

32. *National Geographic Magazine* 80, no. 3 (Sept. 1941): 287; Ibid., 302; Ibid., 302.

33. Ibid., 287.

34. MC to Henry Allen Moe, 22 Feb. 1941, AWMCC. Caso, Covarrubias's old friend, was director of Mexico's National Institute of Anthropology and the discoverer of the famous "Monte Albán jewels." MC apparently did not leave Monte Albán empty-handed. Upon seeing Dolores del Río in Mexico City, he gave her an idol from the site with a note that read, "If you contemplate this piece for a few months, you will become an enthusiastic collector." And she did. MC to Dolores del Río, MCA.

35. MC to Henry Allen Moe, 22 Feb. 1941, MC File, John Simon Guggenheim Memorial Foundation, New York, N.Y. Bertram Wolfe wrote about Miguel's "boyish, yet informed curiosity, his slightly bulging observant eye, his skillful pencil and brush," and Rose's "sensitive camera," during their visit. Bertram D. Wolfe, "The Zapotec Heritage," review of *Mexico South* by Miguel Covarrubias, *New York Times*, 27 Oct. 1946.

36. Ibid.

37. MC to Henry Allen Moe, 22 Feb. 1941.

38. Bil Baird, interview with author, New York, 1986.

39. Miguel Covarrubias and Daniel F. Rubín de la Borbolla, eds., *El arte indígena de Norteamérica* (Mexico City: Fondo de Cultura Económica México, 1945): 9–10.

40. GM to MC, 18 March 1941, AWMCC.

41. María Luisa Cabrera de Block, interview with author, Mexico City, 1987.

42. MC to GM, undated letter, AWMCC.

43. Henry Block, Introduction to *The Discovery and Conquest of Mexico*, by Bernal Díaz del Castillo (Mexico City: The Limited Editions Club, 1942): xiii.

44. Ibid. Such high praise might be criticized as biased, coming from MC's personal friend and editor, but his evaluation has been repeatedly validated by other experts. *The Discovery and Conquest of Mexico* is listed among the twelve outstanding typographical printed books in Europe and America between the fifteenth and twentieth centuries. Ernesto de la Torre Villar, *Breve historia del libro en México* (Mexico City: UNAM, 1990): 152.

45. GM to MC, Nov. 1942, AWMCC. (*The Discovery and Conquest of Mexico*, published in Mexico by Harry Block for Limited Editions, was not reviewed by American critics.) After the publication of Miguel's version of *The Discovery*, his good friend, radio commentator Ben Grauer, became interested in Bernal Díaz del Castillo's original manuscript. Grauer was a collector of rare books — his library had at least 5,000 such gems. He found the original in Guatemala and lobbied the United States Congress to raise money to enable the Library of Congress restore the delicate, aged pages. Seven years of bureaucratic wrangling ensued before Grauer was successful in getting the book into this country.

46. Bertha Cuevas, interview with author, Mexico City, 1984.

47. The word *milagros* translates as "miracles." They are votive offerings, like silver charms in various shapes: of a human heart or leg or head or arm, or in the shape of one or another animal. Their offering beseeches the saints to bestow a miracle or cure on the representational object.

48. Rose Covarrubias, "I Have Two Kitchens," AWMCC.

49. Ibid.; Verna Cook Shipway and Warren Shipway, *Mexican Homes of Today* (New York: Arch Book Publishing Co., 1964): 111.

50. Carmen López Figueroa, interview with author, Acapulco, Mexico, 1988.

51. Rose Covarrubias, "I Have Two Kitchens," AWMCC.

52. Columba Domínguez, interview with author, Mexico City, Feb. 1987.

53. "Recetas de cocina de Rosa Covarrubias," unidentified newspaper, AWMCC.

54. Rose Covarrubias, "I Have Two Kitchens," AWMCC.

55. Miguel Covarrubias illustrated one of his earliest maps of New York's best restaurants for *Vanity Fair* in 1929. Among his personal effects was a little brown book in which he had listed his favorite New York eateries: Lindy's, Sardi's, the Cuban restaurant Club Yumuri, the Russian Tea Room, Canton Village, La Conga, Ruth Lieb's, and the Ching Gong Room.

56. "Recetas de cocina de Rosa Covarrubias"; and Rose Covarrubias, interview with author, San Rafael, Calif., 1966.

57. George Christy, *Harper's Bazaar,* undated. Alberto Misrachi commented on Rose's painting: "I do not consider her a significant painter, but her style was fresh and spiritual and owes much to Mexican folklore." Alberto Misrachi, interview with author, Mexico City, 1 July 1987.

58. Dolores del Río returned from Hollywood to live permanently in Mexico in 1943. She became one of RC's most valued friends. RC was not the only Covarrubias connected with the silver screen, however. One of MC's mural maps in the Hotel Prado became the backdrop in a

scene of Julio Bracho's "Canasta de Cuentos" in 1955 (a film for which Gabriel Figueroa was cameraman). John Huston, interview with author, Los Angeles, 1985.

59. RC sold the portrait of María Félix to "El Indio" Fernández, but he never paid her for it and it came back into her possession before she died. Nancy Oakes, interview with author, Palm Beach, Fla., 1985. Oakes's husband, Baron Hoyningen-Huene, worked for *Vanity Fair* in 1929 photographing movie stars in Hollywood. In 1935, he free-lanced for *Harper's Bazaar*. In 1946 his book *Mexican Heritage* was published, dedicated to Estrella Boissevain, Rose Covarrubias, and Carmen López Figueroa, all friends in Mexico. Hoyningen-Huene, George Reyes, and Alfonso Reyes, *Mexican Heritage* (New York: J. J. Augustin Publishers. 1946): 5.

60. RC interview with Bertha Cuevas, "Añoranzas de la vida de un pintor ilustre: Rosa Covarrubias," *Novedades* (Aug. 1969): 3. Dorothy Cordry recalled how Rose had improved upon a nineteenth-century painting that belonged to Donald. "Something about the balance," disturbed him, and he asked Rose to see what she could do. She added a butterfly to one corner and a dog to another, and Donald loved it. Dorothy Cordry, interview with author, Cuernavaca, Mexico, 19 May 1985.

61. *Harper's Bazaar*, April 1942, 68.

62. Ibid.

8. THE FORTIES, PART TWO (1942)

1. Diego Rivera, interview with Elena Poniatowska, "Alfonso Caso, Harry Block y Diego Rivera hablan de Miguel Covarrubias," *Novedades,* 12 May 1957.

2. See RC's unpublished essay, "I Have Two Kitchens," AWMCC, for all details of the party quoted in this chapter. "Vaseline" glass was a tableware of unusual transparent colors, called "Depressionware" in the United States in the 1930s.

3. William Spratling, *File on Spratling* (Boston: Little, Brown and Co., 1932): 116. Spratling describes the work: "In the frescoes he managed to incorporate various denizens of the ocean, frigate birds, Samoans in a canoe and, of course, a lovely Indian on her back. At the opposite end of the panel with the lovely female body, Miguel put in the brown body of a diving boy, underwater and reaching down. The figure of the boy gave Miguel a great lot of trouble, since he had always been essentially a painter of buxom women. He had to rub out the legs several times and one morning in his studio in Tizapán, to help him solve the problem, I took my clothes off and stood on my head, leaning my legs upward against the wall."

4. The dedication in Spratling's *More Human Than Divine* is quoted by Sandraline Cederwall and Edwin J. Schwartz in a document to accompany their November 1992 show of Covarrubias and Spratling at the Santa Fe gallery/shop in San Francisco.

5. William Spratling to RC, 7 June 1940, AWMCC, outlines this agreement; Dorothy Cordry, interview with author, Cuernavaca, 1985.

6. Paz Celaya, interview with author, Mexico City, 5 May 1984 and March 1988.

7. Giselle Freund, "Miguel y Rosa Covarrubias en su hogar," *Novedades,* 14 Oct. 1951.

8. Unless otherwise stated, recollections of María Asúnsolo are from interviews with author, Mexico City, Nov. 1984, May 1985, July 1986, Feb. 1987, and Dec. 1990; photo essay, "From Mexico to the States," *Vogue* (15 Jan. 1942).

9. Oumansky and his wife died in an automobile accident on their way to a new post in Guatemala. Beloved by many in Mexico, their friends organized a memorial service at which Alfonso Caso, Carlos Chávez, and Dolores del Río spoke, and Chávez conducted Shostakovich's Seventh Symphony; from the memorial service program, MCA.

10. Unless otherwise stated, recollections of Carmen López Figueroa and Mary Anita Loos are from interviews with author, Acapulco, Aug. 1988, and Los Angeles, May 1986, respectively.

11. Unless otherwise stated, recollections of Columba Domínguez are from interview with author, Mexico City, Feb. 1987.

12. Laurie Lisle, *Portrait of an Artist: A Biography of Georgia O'Keeffe* (Washington Square Press: New York, 1986): 366.

13. "El Indio" Fernández, with a Henry Higgins-like enthusiasm, encouraged Columba to accentuate her Mexican beauty by dressing in native folk dress and plaiting her hair with bright colored ribbons. He also insisted that she educate herself in world history, philosophy, English, Italian, French, classical dancing, and painting.

14. By 1948, Columba had a few small roles in several of "El Indio's" movies, but she gained prominence in *Pueblerina*, a dramatic film that won best picture of 1948 in Mexico and for which Alejandro Galindo won the best actor award. The film also took best photography. (Gabriel Figueroa was behind the camera.) Both Rosa and Miguel were fascinated by Columba's beauty. Miguel and Diego both painted portraits of her.

15. Orozco Nieves Field and Frederick Field, interview with author, San Rafael, Calif., 28 July 1986. Frederick Field, a distinguished scholar and member of the Vanderbilt family, had a reputation as America's wealthiest and most generous heretic. Blacklisted during the McCarthy era, Field left the United States and took up residence in Mexico. (Frederick and Dashiell Hammett went to jail together for refusing to reveal names.) Frederick was a major collector of pre-Hispanic artifacts and wrote two books on pre-Hispanic seals. When he returned to the States in the late 1960s, he made a gift of his important seal collection to the Mexican people. Miguel gave Frederick a copy of *Indian Art of Mexico and Central America* inscribed with a caricature of himself and a note that read: "For Freddie, who has been bitten by the same spider! Anthropology. With best wishes for bigger and better Tlatilcos." Inscription from Frederick Field's private papers, Minneapolis, Minn.

16. Alfa Henestrosa, interview with author, Mexico City, June 1987.

17. Margo was best known for her role in *Lost Horizon* as the young woman who left Shangri-La, only to age dramatically in a matter of moments.

18. Mary Anita Loos, interview with author, Los Angeles, Sept. 1986.

19. Ibid.

20. Covarrubias did, however, become an editor and advisor to a new magazine, *DYN. DYN* was the creation of the painter and collector Wolfgang Paalen, who strove for "the most truly representational journal of developments in modern art." *DYN* no. 6 (1944). Both Covarrubiases became regular contributors. Wolfgang Paalen was Austrian by birth, but he had lived and traveled throughout Europe, British Columbia, and Alaska, where he pursued his passion for Amer-Indian art. Arriving in Mexico in 1939 with the invasion of the surrealists André Breton, Alice Rahon, Remedios Varo, and Leonora Carrington, Paalen decided to stay in Mexico. *DYN*'s Dec. 1943 issue was devoted to the Amer-Indian, and Miguel contributed a piece entitled "Tlatilco: Archaic Mexican Art and Culture." Other contributors in that issue included Jorge Enciso, Alfonso Caso, Alice Rahon, Wolfgang Paalen, and photographers Eva Sulzer, Manuel Alvarez Bravo, and RC. *DYN* was published in English, and Paalen unsuccessfully had hoped to publish it simultaneously in French. The magazine's last issue, in November 1944, featured an Anaïs Nin short story, "The Eye's Journey," illustrated with photographs by RC, and an illustrated article, "La Venta Colossal Heads and Jaguar Gods," by MC.

21. Adela Fernández, *"El Indio" Fernández, vida y mito* (Mexico City: Panorama, 1986): 96.

22. Ibid.

23. Paz Celaya, interview with author, Mexico City, March 1988.

24. RC to José Limón, 23 Oct. 1952, José Limón Archives, Library and Museum of The Performing Arts, New York Public Library at Lincoln Center, Dance Collection, New York, N.Y. RC's letter also describes a visit to Georgia O'Keeffe in Albuquerque, N.M. O'Keeffe introduced RC to Hopi culture, including a rain dance where men dance with rattlesnakes in their mouths. RC said: "After Bali, it was the most extraordinary thing I have ever seen."

25. RC, interview with Elena Poniatowska, "Elena Poniatowska reconstruye la vida de Miguel Covarrubias," *Novedades*, 28 April 1957.

26. Michael Coe, *America's First Civilization: Discovering the Olmecs* (Washington, D.C.: American Heritage Publishing, 1968): 95.

27. Andrés Henestrosa, "La nota cultural," *El Nacional* no. 9999 (Feb. 1957).

28. The preliminary exploration of Tlatilco was financed by Willard H. Carr; Hugo Meodano Koer, a Mexican archeologist, was site director.

29. Alfonso Caso, interview with Elena Poniatowska, "Alfonso Caso, Harry Block, y Diego Rivera hablan de Miguel Covarrubias," *Novedades*, 12 May 1957.

30. Miguel Covarrubias, *Indian Art of Mexico and Central America* (New York: Alfred A. Knopf, 1957): 53.

31. William Spratling, *File on Spratling* (Boston: Little, Brown and Co., 1932): 156.

32. Frederick Field, interview with author, San Rafael, Calif., 1986.

33. Matthew Stirling, "Early History of the Olmec Problem," *Dunbarton Oaks Conference on the Olmec,* October 28–29, 1967, edited by Elizabeth P. Benson (Washington, D.C.: Dunbarton Oaks Research Library and Collection, Trustees for Harvard University, 1967): 5.

34. Coe, *America's First Civilization: Discovering the Olmecs,* 148.

35. Covarrubias, *Indian Art of Mexico and Central America,* 54.

36. "How during . . ." from André Emmerich, *Art before Columbus* (New York: Simon and Schuster, 1963): 21; "It is easy . . ." from Covarrubias, "El arte 'Olmeca' o de La Venta," 168.

37. Eulogio Guzmán Acevedo, graduate student, Department of Latin American Studies, UCLA; letter, July 1993.

38. Ibid.

39. Covarrubias, *Indian Art of Mexico and Central America,* 81 and 83.

40. Matthew Stirling, "Early History of the Olmec Problem," 6.

41. See Ignacio Bernal, *The Olmec World* (Berkeley: University of California Press, 1968): 31, for a description of the opposition's forces. Arturo Romano recalled the exclamation from the audience during an interview with the author, Princeton University, 11 April 1986.

42. Miguel Covarrubias, "El arte 'Olmeca' o de La Venta," 155.

43. Peter David Joralemon, "The Olmec Dragon: A Study in Pre-Columbian Iconography," *Origins of Religious Art and Iconography in Pre-Classic Mesoamerica,* vol. 13, edited by H. B. Icholson (Los Angeles: UCLA Latin American Center Publications, 1976): 29.

44. Tomás Ybarra-Frausto, notes on Miguel Covarrubias, AWMCC. MC's article, "Tlatilco: El arte y la cultura preclásica de Valle de México," *Cuadernos Americanos* 60, no. 3 (May–June 1950), describes the findings (graves, utensils, pottery, stone carvings) and the early settlers of Tlatilco: "The findings at Tlatilco represent the maximum flowering during the Zacatenco period, which for the moment, is the oldest manifestation of culture of the ancient agriculturists of pre-Classic Mexico."

45. Román Piña Chán, interview with author, Mexico City, June 1987. Chán's dedication read: "Our intention is to offer the reader a vision of 'the Jaguar People' or the Olmec archeological culture, the root of Mesoamerican civilization, one of the greatest of all pre-Hispanic cultures, and the most admired by Miguel Covarrubias to whose memory we dedicate this work." Román Piña Chán and Luis Covarrubias, *El pueblo del jaguar* (Mexico City: Consejo para la Planeación e Instalación del Museo Nacional de Antropología, 1960): 7.

46. Guests at the wake were recorded in an undated obituary in *Excélsior,* 1957, MCA.

9. THE FORTIES, PART THREE (1943–1949)

1. Interview with Fernando Gamboa, in Elena Poniatowska, "Fernando Gamboa y Daniel Rubín de la Borbolla hablan de Miguel Covarrubias," *Novedades,* 5 May 1957.

2. Jeanette Bello, interview with author, Los Angeles, Nov. 1986.

3. Muriel Porter Weaver, interview with author, Conference of the Olmec Presence in Central Mexico at Princeton University, Princeton, N.J., 11 April 1987.

4. Among MC's first students were "Tete" Dávalos, Iker Larrauri, Luis Covarrubias, and Mario Vázquez who would become the first director of the Museum of Anthropology in Chapultepec Park. All became respected experts in the field. Leonor Morales, *Wolfgang Paalen*

(Mexico City: UNAM, 1984): 35; and Jorge Alberto Manrique and Teresa del Conde, *Una mujer en el arte* (Mexico City: UNAM, 1987): 95.

5. Unless otherwise stated, recollections of Arturo Romano are from interview with author, Mexico City, July 1987.

6. Romano also said: "Many of his theories and drawings for his book *The Eagle, the Jaguar, and the Serpent* evolved from the work at our roundtable. A good example is the drawing of the development of the pre-Classic, which was first presented at the Conference at Tuxtla, Gutiérrez, in 1942."

7. Unless otherwise stated, recollections of Román Piña Chán are from interview with author, Mexico City, 1987.

8. Unless otherwise stated, recollections of María Asúnsolo are from interviews with author, Mexico City, June 1984, Nov. 1984, March 1988, and Dec. 1990.

9. Unless otherwise stated, recollections of Mary Anita Loos are from interviews with author, Los Angeles, Sept. 1985, May 1986, Sept. 1986, and Oct. 1992.

10. Sylvia Navarrete Bouzard, "Miguel Covarrubias," *Miguel Covarrubias: Homenaje* (Mexico City: CCAC, 1987): 69.

11. The Committee of War Relief for Russia was organized by the University Club in Mexico City. It attracted such artists as Inez Amor, Raúl Anguiano, Olga Costa, Carlos Mérida, Juan O'Gorman, Pablo Neruda, María Asúnsolo, and María Luisa Cabrera de Block. Guillermina Bravo and Miguel designed the invitation to the 9 March 1942 meeting at which the Chilean poet Pablo Neruda addressed the public. Subsequently, Miguel Covarrubias, Dolores del Río, María Asúnsolo, and Alfonso Caso organized a tribute to the Mexican communist leader Vicente Lombardo Toledano.

12. Unless otherwise stated, recollections of Carmen López Figueroa are from interview with author, Acapulco, Mexico, 1988.

13. Edward Alden Jewell, "Art in Advertising," *Art News* (1–14 May 1952): 31. The De Beers copy read: "A half-lifetime, the old tree has guarded their names and held the secret of their shining youthful happiness locked in its leafy heart. They have never returned. For their path stretched far beyond the farthest blue horizon glimpsed by the birds in its tip-top branches. But somewhere in a city across the world, a woman looks into the brilliant stone on her finger and sees it all again — tree, birds, sun and youth and love." Rosamund Frost, "It Pays to Advertise," *Art News* (23 Aug. 1952): 12.

14. See MCA for notes on the Stephen Lion Corporation job.

15. Promotional release, the Associated American Artists, AWMCC. The map was painted in brilliant egg tempera, finished in oil paints, and then reproduced by gelatone facsimile process. Focusing on folklore and folklife, MC used regional cultural icons: the cowboy and Indian for the Southwest, the Negro in the South, a Midwestern farmer, an East Coast tycoon, and a West Coast miner. The association's exuberant promotional material claimed: "The 'Covarrubias America' represents the highest achievement in decorative map publishing history. Never before — perhaps never again — has such an astonishing feat been accomplished. For this truly significant work of art brings home the real meaning of this great land and the important things we are fighting for. It will help you dedicate yourself anew to the American way of life." In 1944 Covarrubias also made a map of Florida which was published in *Life* magazine.

16. Tomás Ybarra-Frausto, "Miguel Covarrubias: Cartógrafo," *Miguel Covarrubias: Homenaje* (Mexico City: CCAC, 1987): 127.

17. Matthew Stirling, "Stone Monuments of Southern Mexico," *Bureau of American Ethnology Bulletin* (March 1943): 4.

"Colarubia," literally, "blond tail," became another nickname for MC when the young son of a mutual friend, Patricio Rincón Gallardo, mispronounced Covarrubias.

Reviewing "Carmen Jones," *Life* magazine stated: "Here again Covarrubias demonstrated his remarkable talent for recreating movement . . . and for portraying character development. Each of the opera's five scenes is done in a predominant color." "Carmen to Carmen Jones," *Life* (8 May 1944): 70–74.

18. MOMA Archives: RdH Papers; Box #4, file folder #306. Monroe Wheeler in *A Tribute* [René d'Harnoncourt, 1901–1968], October 8, 1968, Sculpture Garden, The Museum of Modern Art (New York: Museum of Modern Art, 1968), unpaginated.

Monroe Wheeler notes that René d'Harnoncourt had become world famous for establishing "juxtapositions and sequences that illuminated certain universals and interrelations between one culture and another, and inheritances from generation to generation. One of his devices was to indicate cultural and artistic kinships, emphasizing things with lighting and color contrasts in such a way as to stimulate the visitor to make his own comparisons. This method, which all exhibition directors now practice, but which he pioneered and excelled, was especially applicable to theme shows."

MC, having collaborated with d'Harnoncourt for nearly ten years, certainly shares credit for the pioneering work in that field. MC had used the same techniques in his own "Mexican Mask" show. The North American Indian art show earned MC a reputation for expertise in the area of Indian arts and crafts, and he received an appointment to the Indian Arts and Crafts Board in Washington, D.C.

19. Unless otherwise stated, recollections of Sol Arguedas and Daniel Rubín de la Borbolla are from interviews with author, Mexico City, Feb. 1987 and July 1987.

20. Román Piña Chán, interview with author, Mexico City, June 1987.

21. GM to MC, 25 April 1945, AWMCC.

22. Ibid.

23. GM to MC, 16 July 1945, AWMCC.

24. Unless otherwise stated, recollections of Rachel and Stan Knobloch are from interview with author, Berkeley, Calif., Nov. 1991.

25. Unless otherwise stated, recollections of Robin King are from interview with author, San Francisco, Calif., Sept. 1991.

26. Fernando Gamboa, interview with Elena Poniatowska, "Fernando Gamboa," *Novedades*, 5 May 1957.

27. John Huston, interview with author, Los Angeles, 1985.

28. Sono Osato, *Distant Dances* (New York: Alfred A. Knopf, 1980). Sono Osato used MC's portrait for the cover of her autobiography. Osato had been dancing professionally in Europe since she was fourteen. MC met her in the summer of 1935 when she toured Mexico with the Ballet Russe of Monte Carlo. She joined the New York Ballet Theatre Company in 1941.

The only Covarrubias memorabilia remaining from this era is a coupon ration book in MC's name which shows his address as 101 West 58th Street. MC was in Mexico, though, most of the time during the years of war and focused more on the historical past than the historical present.

29. Harry Block, Insert #201 in Pearl Buck, trans., *All Men Are Brothers*, by Shih Nai-an (New York: Limited Editions Club, 1948): 3.

30. Miguel Covarrubias, "Art of the South Seas," *Vogue* (1 Feb. 1946): 131; MOMA Archives: RdH Papers; Box 4, file folder #306; Edward Alden Jewell quote, MOMA Archives: PI Scrapbook, #64, "420 Art Objects Shown in Display," *New York Times*, 30 Jan. 1946.

MC contributed four gouaches for the *Arts of the South Seas* catalogue by Ralph Linton and Paul S. Wingert. D'Harnoncourt spoke appreciatively of his old friend many years later, saying "Not only did Miguel create invaluable documents in these paintings, but more important, he gave the public the opportunity to see primitive art as filtered through the sensibility of a fine artist."

Sol Rubín de la Borbolla remembered that her husband and MC had chosen "many fine pieces" in Chicago for the "South Seas" show when the foursome had traveled through the States in 1943. After the show, many of these pieces were kept by the Mexican government in exchange for several equally rare pre-Hispanic relics. The South Seas pieces remain in the Museum of Cultures to this day and have become far rarer as a result of a fire destroying what remained of the collection in Chicago. Sol Arguedas and Daniel Rubín de la Borbolla, interview with author, Mexico City, Feb. and July 1987.

31. MOMA Archives: RdH Papers, Box 4, file folder #306, "Two Shows Open at Museum of Primitive Art," Press Release 45122-3 (undated).

32. MOMA Archives: PI Scrapbook, #64, Elizabeth McCausland, "Arts of South Seas at Modern Museum," *Springfield (Mass.) Union and Republican,* 3 Feb. 1946; and Press Release 46129-5 (undated), René d'Harnoncourt Papers, Art of Installation, Box 4, file folder #306, MOMA Archives.

33. Diego Rivera, "Covarrubias Captures Mood of Mexico," review of *Mexico South,* by Miguel Covarrubias, *New York Times,* undated; Charles Poore, "Books of the Times," *New York Times,* 26 Oct. 1946; Mary Butler, *Book Reviews,* 1947, AWMCC.

Knopf's press release (AWMCC) on the book acknowledged several artists who had contributed to the book's success: "[Miguel's] wife took many of the photographs, the poet, Langston Hughes, translated into English the Tehuantepec ballads and the composer, Carlos Chávez, made the musical transcriptions. The archaeologists, Alfonso Caso and Matthew Stirling along with the American writer, Bud Schulberg had reviewed the manuscript."

RC contributed ninety-six pages of photographs, described by Diego Rivera as superlative. Rivera also pointed out MC's reasons for publishing in English: "He knows his friends north of the border will become interested in his country if he speaks to the Americans in their own language." Rivera, "Covarrubias Captures Mood of Mexico," 2.

34. Andrés Medina, "Miguel Covarrubias y el romanticismo en la antropología," *Nueva Antropología* 4 (Mexico City: UNAM, 1976).

35. Miguel Covarrubias, *Mexico South: The Isthmus of Tehuantepec* (New York: Alfred A. Knopf, 1945): 323.

After reading *Mexico South,* Vladimir Bobri, president of the Society of the Classic Guitar, wrote to congratulate MC and to request permission to publish the arrangement of *La Zandunga* that Chávez had constructed for the book. "We would be also very grateful," Bobri wrote, "if you could possibly send us a small line drawing of a Tehuana guitar player to be used in connection with the music." Vladimir Bobri to MC, 1 Nov. 1946, MCA.

The president of Mexico, Lázaro Cárdenas, received two copies of the book as gifts, and he wrote to Covarrubias, "I congratulate you on this important work which advances the culture of this country. I will donate one of these copies to the library of Jiquipan, my native village." Lázaro Cárdenas to MC, 1 Mar. 1947, MCA.

36. For details regarding the sales of *Mexico South,* see unidentified newspaper clipping, 9 Dec. 1946, AWMCC.

37. André Emmerich, *Art before Columbus* (New York: Simon and Schuster, 1963): 77.

38. Mimi Crossley, "Ancient Olmec Site Unearthed in Mexico," *Washington Post,* 26 April 1986, citing MC's "Topology."

Covarrubias designated two distinct styles from Guerrero and one from the nearby state of Mexico as Mezcala, which are known to be in error today. "Had Covarrubias not died prematurely," Gay insists, "his keen sense of observation would certainly have led him to distinguish between the Mezcala, Chontal, and Sultepec traditions." Carlo Gay, *Mezcala Architecture in Miniature* (Brussels, Belgium: Académie Royale de Belgique, 1984): 13.

39. Emmerich, *Art before Columbus,* 77.

40. André Emmerich interview with author, New York, Sept. 1989. Emmerich recalled: "I first met Miguel when I went to Mexico in the early fifties to learn about pre-Columbian art. [Miguel had been studying pre-Columbian art since the thirties.] I was introduced to art dealers as well as to many of the well-known collectors of art from this period. . . . I learned by being around them and by observing. However, without a doubt, the best person to be with was Miguel. Sooner or later everyone came to see him: archeologists, vendors, and other collectors. I learned much from his drawings. Miguel was a kind of genius, generous of spirit and generous with his knowledge."

41. Gillet G. Griffin, Conference on the Olmec Presence in Central Mexico, 11 April 1987, Princeton University, Princeton, N.J.

42. GM to MC, 11 June 1946, AWMCC.

43. Telegram, GM to MC, 13 Nov. 1946, AWMCC

44. Rafael Abascal y Macías, "Miguel Covarrubias antropólogo," *Miguel Covarrubias,* 165.

45. Román Piña Chán, interview with author, Mexico City, June 1987.

46. Ibid.

47. Antonio Rodríguez, "Pintura didáctica" (undated but undoubtedly 1947), *El Nacional*, "Panorama de las artes plásticas." In the same year, perhaps as a tie-in, MC illustrated a map of Mexico for *Holiday* magazine that "included more than a hundred specific items and symbols to interpret Mexico, its topography, resources, agriculture, commerce, industry, archeology, its people and their arts. Here is the color, shape and feel of the land." "Map of Mexico," *Holiday* 2, no. 3 (March 1947): 42–43.

MC could have become famous for his maps alone. In 1947 *Holiday* magazine published a Covarrubias map of Mexico, with the statement: "Covarrubias has long been recognized as a master in the art of painting decorative maps. The brilliance of conception and careful execution of detail characteristic of all his work are evident in this cartograph painted for *Holiday*."

48. Interview with MC in unidentified newspaper clipping, AWMCC: "I have had to refine all my sketches and to make all these study maps. Furthermore, since I want each drawing to be as authentic as possible, I have had to consult many books and to make a thorough study of natural history, flora and economy . . . and so much more. With the help of the geographer Jorge Vivo, I have worked for many months in order to feel at home with the complicated task of map making." The interview continues: "The kinds of synthetic resins he used for the murals were the same as those used to paint cars and fingernails. Another name for this material is pyroxylin, which is the same as nitrocellulose or gun cotton, as the painter affirms with his gracious smile, 'Here everything is explosive!'"

49. Arnoldo Martínez Verdugo, interview with author, Mexico City, July 1992.

50. An MC painting similar to his *An Afternoon in Xochimilco*, without the American couple, appeared in *Mexican Life* 13 (January 1937): 16. The version painted for the Ritz is his only work in which Mexicans and Americans are pictured together on one canvas.

51. RC to NR, 12 Aug. 1947, Collection NAR, RG.4, Project Series, Sub-series Andean Institute, Box 90, Folder 867, NRAC. Rosa had been encouraged by anyone who ever had the pleasure of dining at Tizapán to write a cookbook. The project languished. Macy sent Rosa a book contract for *The Rose Covarrubias Cook Book*, which she intended to compile and to illustrate from her most exotic international dishes.

52. RC, interview with author, San Rafael, Calif., 1963; "Those Ugly Things Were the Covarrubias Pre-Columbian Art," *The News* (Mexico City), 8 March 1964.

53. NR to RC, 29 Sept. 1947, Collection NAR, RG.4, Project Series, Sub-series Andean Institute, Box 90, Folder 867, NRAC. Rockefeller's letter discusses his donation. His partner was the American Institute of Andean Research. Rockefeller wrote: "I want to tell you that I am particularly delighted to contribute towards this work because of the association with the Mexican Government, Alfonso Caso, and you [Rosa] and Miguel, as well as with some of our other friends." Ibid.

See Gordon F. Ekholm, "Memorandum: Understanding on the Palenque Project," MCA, for notes on the project. See Muriel Porter Weaver, *The Aztecs, Maya and Their Predecessor* (New York: Seminar Press, 1972): 178, for a description of the archeological discoveries.

54. Information on Pacal from Eulogio Guzmán Acevedo, July 1993. The archeologist A. V. Kidder described the tomb as "sumptuous" in letter to NR, 3 Dec. 1952, Sub-series Andean Institute, Box 90, NRAC; André Emmerich, *Art before Columbus* (New York: Simon and Schuster, Inc., 1963): 135.

55. RC to NR, 26 May 1954, Sub-series Andean Institute, Box 90, NRAC.

56. "Those Ugly . . . ,"*The News*.

57. GM to MC, 10 Oct. 1947.

58. MC had used decorative "wall writing" and brush calligraphy for his illustrations. Before the book was printed, a curator of the East Asiatic Collection of Columbia University checked it for accuracy. "The wonder is not that there are a few errors, but that Covarrubias, a non-Chinese, should have been so accurate and made so few mistakes." Memorandum about Covarrubias's calligraphy cited in letter, David J. Way to GM, 15 June 1948, AWMCC. Pearl Buck to George Macy, 19 Nov. 1948, AWMCC.

59. Archeologist Alfred V. Kidder was one of the first recipients of Viking's commemorative medal, which showed Greek, African, American, and Chinese dancers and was struck in heavy embossed bronze with a three-inch diameter. Fejos had written Miguel: "As I wired you yesterday, the medal drawing arrived and everyone is lyrical, with myself leading the chorus. The original drawing will be framed to hang in the place of honor over our library mantel. The enclosed check for $500 is, I know, absurdly small, but you may be assured that our gratitude to you is great." Paul Fejos to MC, 26 March 1947, MCA.

60. Other student collaborators on this second dig at Tlatilco with the Institute were José Luis Lorenzo, Luis Avéléyra Arroyo de Anda, Josefina Ortíz Rubio, Eduardo Paraón, and Hugo Moedano.

61. Arturo Romano, interview with author, Mexico City, July 1987.

62. Vidya Peniche, interview with author, Mexico City, Feb. 1988. Vidya was from the Yucatán in Veracruz, and MC loved her regional drawl and her ethnic jokes which, she recalls, he collected and repeated to all his friends.

63. Page had asked MC to design costumes and scenery for a ballet she choreographed for the Ballet Russe de Monte Carlo in New York in 1940, and he had not been able to oblige. He hated saying no to "Billy Sunday" and always regretted not having worked with the great choreographer. Letters, Ruth Page to MC, 17 Feb. 1940, and 17 Feb. 1947, Ruth Page Files, Library and Museum of Performing Arts, New York Public Library at Lincoln Center, Dance Collection, New York, N.Y.

64. In 1950, *The New Yorker* published a twenty-five-year anniversary album with several Covarrubias caricatures; one of Calvin Coolidge led off the section on the twenties. MC was gratified with the recognition (as well as with the much-needed royalty payment that accompanied his copy of the album). The Penguin Books proposal included a request for Covarrubias illustrations and authorship for books tentatively titled: *Mexican Folk Art, Mexican Archeology, Latin American Flora, Latin American Fauna, Pre-Buddhist Chinese Art,* and *Polynesian Art.* Penguin Books proposal, MCA.

65. Dorothy Miller (Container Corporation) to Melvin Kohler, 2 Sept. 1948, Dr. Erna Gunther File, Department of Anthropology, University of Washington (Seattle).

Alfred Kroeber, anthropologist and author, wrote to MC in 1946 to say he had heard about MC's course on primitive art from Wigberto Jiménez Moreno (an archeologist and professor who had worked with MC at Tlatilco) and to ask MC to consider teaching a summer session in anthropology at the University of California in Berkeley. Covarrubias was flattered, but he refused the offer. Alfred Kroeber to MC, A. L. Kroeber File, Bancroft Library, University of California, Berkeley.

It was Dr. Erna Gunther, head of the Department of Anthropology at the University of Washington, who had proposed Covarrubias for the Walker-Ames Professorship on the basis that "the combination of his artistic appreciation of other cultures with his keen observation in ethnology make him a unique figure in our field." The position would have paid $3000. Dr. Erna Gunther notes, 23 Aug. 1948, Erna Gunther File, Department of Anthropology, University of Washington, Seattle.

66. Herbert Weinstock to MC, 8 Dec. 1948, MCA.

67. MC to Alfred Knopf, undated letter, MCA, referring to Weinstock's 8 Dec. 1948 letter.

10. THE FIFTIES, PART ONE (1950–1952)

1. Fernando Gamboa, interview with Elena Poniatowska, "Fernando Gamboa y Daniel Rubín de la Borbolla hablan de Miguel Covarrubias," *Novedades,* 5 May 1957.

2. Trygve Lie to MC, undated letter, MCA. Proposals and photographs of work came from many member nations. MC and his colleagues selected the works and the placement. MC's contribution to the new headquarters was a fantasy map of the member countries with the tall, slim UN building in the center, a futuristic airplane above, and a shark for counterpoint below. This was not the first time MC had been approached by an international organization. In 1948,

UNESCO asked MC to contribute ideas on education using graphic materials to teach Latin American children.

3. LC, interview with author, Mexico City, 1986.

4. Katherine Dunham, interview with author, Stanford University, Stanford, Calif., 1989.

5. Unless otherwise stated, recollections of John Huston are from interview with author, Los Angeles, Oct. 1985.

The anthropologist Melville Jacobs discussed Covarrubias's status as a "topnotcher in scientific anthropology": "His start in creative art has made his name that of a leader known the world over, but his more recent research and publications on the American Indians of Middle America have also put him among the leaders of scientific anthropology. He is a man of rare modesty and scholarly integrity, as well as of enthusiasm and ability to stimulate." Erna Gunther File, Department of Anthropology, University of Washington, Seattle.

6. Dorothy Cordry, interview with author, Cuernavaca, Mexico, 19 May 1985.

7. Unless otherwise stated, recollections of Vidya Peniche are from interview with author, Mexico City, Feb. 1987.

8. Museologists Iker Larrauri, Alfonso Soto Soria, Mario Vázquez, Jorge Angulo, and Miguel Celorio, interviews with Elena Poniatowska, "Un acontecimiento editorial. México rescata a Miguel Covarrubias traduciéndolo por primera vez al español," *Novedades*, 15 Oct. 1961.

9. Mary Anita Loos, interviews with author, Los Angeles, Sept. 1985 and May 1986.

10. Patricia Aulestia de Alba, "Miguel Covarrubias: En la danza," *Miguel Covarrubias: Homenaje* (Mexico City: CCAC, 1987): 199.

11. Gabriel Figueroa, interview with author, Mexico City, 1991. *Flor Silvestre, María Candelaria,* and *Las Abandonadas,* with Dolores del Río, filmed in 1942 are considered his best works. Covarrubias later defined his goals for the Bellas Artes: "1. To investigate Mexican dance in general, both the ceremonial and the regional. 2. To expand dance courses in more schools within Mexico City, as well as in the interior. 3. To perfect the professional courses of the Academy of Mexican Dance in order to establish solid bases in the search for a profound and authentic national art." *Excélsior,* 7 April 1951.

Furthermore, in an interview with Luis Suárez, Covarrubias stated his aspirations "to create a school of dance that reaches the height of our pictorial school." But he also believed that "the indigenous is animated by the universal," thus he welcomed outside influences such as José Limón's. "Are you not afraid of failing?" Suárez asked him. "Every new undertaking has this possibility. It is preferable to take the undetermined risk, he said, than to take the safe path and not make progress." Luis Suárez, "La danza y su desarrollo, *El Nacional,* 2 Dec. 1951.

12. Colombiana Moya, Josefina Lavalle, Rosa Reina, Guillermina Peñalosa, Elena Jordán, and Raquel Gutiérrez, interviews with author, Mexico City, 1987. (Quotations cited from informal conversation, not attributable to any one source.)

13. Ibid. Influenced greatly by Rosa's advice, Antonio de la Torre became the company's dance master and instructor of modern dance. Guillermo Keys Arenas was retained to teach classical ballet. Xavier Francis, a member of the Martha Graham School of Dance, also auditioned and became a member of the faculty at Bellas Artes, another coup for the school.

14. María Asúnsolo, interview with author, Mexico City, June 1985.

15. Herbert Weinstock to MC, 28 Aug. 1950, MCA.

16. Nettie King to MC, 30 March 1951, MCA. Argentine dictator, Juan Perón, was to have been the subject of the drawing.

17. GM to MC, 14 June 1955, MCA, citing Macy's reminiscences.

18. Mary Anita Loos, interview with author, Los Angeles, 1986; and María Asúnsolo and Columba Domínguez, interviews with author, Mexico City, 1986 and 1987.

19. Salvador Novo, "La lección de José Limón," *Novedades,* 21 Sept. 1950. Limón's company performed "The Moor's Pavanne," "Bach's Prelude and Fugue," "La Malinche," and "Lament for Sánchez Mejías."

20. Guillermo Arriaga, "Miguel Covarrubias: En la danza," *Miguel Covarrubias,* 183. Doris Humphrey restaged one of her masterworks, "Pasacalle," for her Mexican students during this visit.

21. Unless otherwise stated, Rocío Sagaón's (RS) recollections are from interviews with author, Jalapa, Mexico, June 1986 and July 1988.

22. Rosa Reina and Guillermina Peñalosa, interview with author, Mexico City, 1987. The former Bellas Artes students reminisced: "Miguel made us study music as well as music interpretation. The majority [of us] had no music training, which is of utmost importance for a dancer. He made us take acting classes and talked to us about Mexican theatre, comparing the work of Seki Sano, a great theatrical director in Mexico, to Russia's Stanislavsky."

23. One of these "outsiders," Arnold Belkin (one of Rocío's many admirers), described the experience: "Who among us was not affected in his drawing by the bodies in motion and by the music which accompanied them? All the painters of my generation were profoundly affected by our contact with the dance. We learned about Mexican music, handicrafts, the translations of legends and myths, and we even learned about Mexican history.

"We hung around the dance classes so that we could draw the dancers. Juan Soriano, Tomás Parra, Roberto Doníz, and myself. Miguel understood that art is not specialization merely in one discipline, but is the whole range of artistic expression in all of its manifestations." Arnold Belkin, "Víctimas de nuestra amnesia," *Uno Más Uno,* 5 Sept. 1982, and interviews with author, 1989 and 1990.

Both Belkin and Soriano designed sets and costumes for ballets at Bellas Artes in 1954.

24. RS spoke further of Covarrubias's influence: "Miguel observed us in class throwing out ideas, and he encouraged us to keep trying. This is how the ballet 'La Manda' was created. The story was written by Juan Rulfo, now a famous Mexican writer, the ballet was choreographed by Rosa Reina, and the music was composed by Blas Galindo. It grew out of our academic classes with Miguel and was inspired by 'Las Soldaderas' [The Women Soldiers], a painting by Siqueiros we had seen with Miguel on a museum trip."

25. Alfa and Andrés Henestrosa, interview with author, Mexico City, 1988.

According to Mary Anita Loos (interview with author, Los Angeles, May 1986): "the beautiful Nieves Field" appeared on stage in the opening season as well.

New ballets in spring and winter 1951 were: "Los Cuatro Soles" and "Tonantzintla," choreography by Limón, sets and costumes by Covarrubias; "Diálogos," choreography Limón, sets and costumes by Julio Prieto; "La Manda" by Rosa Reina, sets and costumes by José Chávez Morado; "Tierra" (very Mexican in feeling) by Elena Noriega, sets and costumes by José Morales Noriega; "Redes" by José Limón, sets and costumes by MC; "Huapango" by Beatriz Flores with sets by Miguel and costumes by Rosa. All of the ballets on which Miguel worked were based on Mexican themes. *Artes de Mexico,* "La Danza en Mexico," numbers 8/9, March/August 1955.

26. Carlos Solórzano, interview with Elena Poniatowska, "Raoul Fournier, Carlos Solórzano y Justino Fernández hablan de Miguel Covarrubias," *Novedades,* 19 May 1957.

Santos Balmori concurred that "without a doubt he was gifted with a deeply felt understanding for the stage. Up until the Fifties he was the only recreator of pre-Hispanic and Colonial forms who had managed to escape an affected style." Santos Balmori, "Homage to Miguel Covarrubias," *Miguel Covarrubias: Homenaje* (Mexico City: CCAC, 1987).

27. Román Piña Chán, interview with author, Mexico City, June 1987.

28. Walter Terry, "Mexico Produces a New Triumvirate," *Dance Magazine* (June 1951): 17 and 40.

29. Ibid. MC also established a calendar/bibliography of all the Indian holidays in which ceremonial or folk dance was present and a repertory of Mexico's characteristic regional dances as part of his effort to revitalize the nationalistic aspect of dance. He was also active in helping Indian dancers upgrade costumes and musical instruments for their performances. Patricia Aulestia de Alba, "Miguel Covarrubias: Su lección," *Miguel Covarrubias: Homenaje* (Mexico City: CCAC, 1987): 203.

30. José Limón to RC, undated letter, José Limón Archives, Library and Museum of the Performing Arts, New York Public Library at Lincoln Center, Dance Collection, New York, N.Y.

31. RC to Limón, undated letter, José Limón Archives.

"The little Mex girls were quite the hit of the whole season—not only for dancing but also

for their winning ways and studies." RC to NR, 5 Oct. 1951, NAR Collection, RG III 4e, Series Countries, Sub-series Mexico, Box 52, Folder 433, NRAC.

32. Department of State National Archives, "Miguel Covarrubias," 811. 00B, Communist International/262.

33. Octavio Barreda, interview with Elena Poniatowska, "Fernando Gamboa y Daniel Rubín de la Borbolla hablan de Miguel Covarrubias," *Novedades,* Apr. 1957; Al Hirschfeld, interview with the author, New York City, 1984.

34. Department of State National Archives, "Miguel Covarrubias," 811. 00B, Communist International/262.

35. Many of MC's friends were among the members of the New York committee that served the "Cultural and Scientific Conference for World Peace," among them Muriel and Paul Draper, she a socialite, writer, and great friend of Van Vechten, her son an accomplished tap dancer, both blacklisted during McCarthy's reign; the actor Howard Da Silva; Langston Hughes; Franz Boas, the anthropologist and mentor of Zora Neale Hurston; and Lion Feuchtwanger, whose son, Franz, wrote *The Art of Ancient Mexico,* illustrated with photographs of pre-Columbian art from MC's private collection. Another friend of MC's who made the blacklist was Margo Albert, who was appearing with close personal friends of MC, Frederick March, Leland Hayward, and Everett Sloane, in *A Bell for Adano* on Broadway. Ultimately, it ended her acting career.

36. Peace conference publications in MCA.

37. Arnoldo Martínez Verdugo became secretary-general of the central committee of the Mexican Communist Party in 1977 and was a presidential candidate in 1981 for the Unified Socialist Party. Today, through the Centro de Estudios del Movimiento Obrero y Socialista for the socialist workers' movement, he publishes *Memoria,* a magazine that has featured MC's caricatures on several covers and his illustrations in several issues. (A painting of Rosa's has also appeared in *Memoria.*)

38. Elena Duclaud Covarrubias to MC, MCA.

39. "Geografía e historia del folklore," *Tiempo* 19, no. 474 (1 June 1951). This issue of *Tiempo* magazine featured on its cover a section of MC's mural map for the museum (the last of his career). MC served on the museum's board of directors with Alfonso Caso, the engineer Ignacio Marquina, the anthropologist Jorge Enciso, Daniel Rubín de la Borbolla, Adolfo Best Maugard, Roberto Montenegro, and Rosa Covarrubias.

40. Carlos Espejel, interview with author, Mexico City, March 1988.

41. LC, interview with author, Mexico City, 1986. Luis went on to say: "The mural turned out to be a true masterpiece. Mexico is lucky to have it. MC charged very little for this mural because he very much wanted to have one of his works in a Mexican public institution. As a matter of fact, it was almost a gift to the museum."

42. Tomás Ybarra-Frausto, "El Chamaco y sus mapas," *Miguel Covarrubias,* 183.

43. According to Rocío, Rosa threatened to destroy the mural if MC used Rocío's portrait.

44. RC, "A Letter to Miguel Covarrubias," *Dance Observer* (August–September 1951): 102–104.

45. Winthrop Palma, "José Limón," *Dance News Annual* (1952); Walter Terry, "Mexico Produces a New Triumvirate," *Dance Magazine,* June 1951.

"Los Cuatro Soles" was the story of the destruction of the world by water, wind, and fire and the battle between the two gods Quetzalcóatl and Tezcatlipoca to gain control of the survivors. One is reminded of an earlier collaboration of MC, Carlos Chávez, and Salvador Novo in 1939, when they tried to interest Disney in a similar plot.

MC would again take up this theme in 1953 when he was commissioned by Peter and Waldo Stewart to design a mural embellished with Mexican colors to be displayed on the Stewart Building in Dallas, Texas. This mural, *Genesis, the Gift of Life,* is unique because MC used the Venetian glass technique of brilliant glass mosaic for his composition. The theme of the mural was inspired by various indigenous New World motifs from Mexico's pre-Hispanic past he had recently used in "Los Cuatro Soles," but also by symbolic imagery from native North American cultures that he studied for the exhibition "El Arte Indígena de Norte America" in 1945. The mural was completed in 1954.

46. RC, "A Letter to Miguel Covarrubias," 102–104.

47. Beatríz Flores, telephone interview with author, Sept. 1988.

48. RS recalled the beginning of her affair with MC in interviews with author in 1985 and 1986. The style of dialogue is her conversational recreation, a tool she used in speaking with the author which helped her recall the past.

49. One of Mexico's well-known art critics, Juan José Arreola, described RC's *Three Tehuanas* leading a procession on Holy Friday: "In its radiant simplicity one finds the essential qualities of Mexican popular art; polychromatic earthenware, painted and repoussé tinware and the subtle and laborious craftsmanship of perforated paper. These seem to be the elements of this painting which the artist has conceived on three superimposed planes, three variants of the same theme.

"Popular fervor and charm with a singly dramatic note: the Calvary of the rural church or the sharp image of the Dolorosa. Having painted this holy vision of rich colors, Rosa Covarrubias has composed a true Holy Week bouquet with faces and flowers sharply scented with Mexican aroma." Unattributed, undated newspaper clipping, AWMCC.

50. Regarding these oil paintings, RS commented further: "The drawings should have been mine, but somehow ended up in the Antonio Souza Gallery. I believe they were at Zamora at the time of MC's death. Perhaps one of his sisters sold them to the gallery, but the fact is that I never saw them again."

11. THE FIFTIES, PART TWO (1952–1954)

1. Fernando Gamboa, interview with author, Mexico City, 1987.

2. Unless otherwise stated, recollections of Rocío Sagaón are from interview with author, Jalapa, Mexico, 1985.

3. RC to José Limón, 23 Oct. 1952, José Limón Archives, Library and Museum of the Performing Arts, New York Public Library at Lincoln Center, Dance Collection, New York, N.Y.

4. Patricia Aulestia de Alba, "Miguel Covarrubias: Su lección," *Miguel Covarrubias: Homenaje* (Mexico City: CCAC, 1987): 212. The winter season premiered "La Hija de Yori," choreography by Rosa Reina, music by Blas Galindo, and sets and costumes by Antonio López Mancera; "La Poseída," choreography by Guillermo Keys Arena, music by Silvestre Revueltas, and sets and costumes by Antonio López Mancera; "Antesala," choreography by Guillermo Arriaga, sets and costumes by Santos Balmori; "Muros Verdes," choreography by seven of the dancers, including Rocío, with costumes by Mancera and MC; and Rocío's own "Movimientos Perpetuos," with sets and costumes by MC and music by the French composer Poulenc.

5. Unless otherwise stated, recollections of Vidya Peniche are from interviews with the author, Mexico City, 1987.

Fernando Gamboa, then subdirector of the National Institute of Bellas Artes, the dance company's parent organization, was another source of scholarships for the five dancers selected to attend Connecticut College's summer program. MC to Fernando Gamboa, 30 June 1952, MCA. Covarrubias's letter stressed the importance of these cultural exchanges.

6. Alberto Misrachi, interview with author, Mexico City, 1988 and 1989. Alberto, nephew of Alberto Misrachi (founder of the first Misrachi Gallery), learned the art of running a gallery from his uncle. Years later, after a disagreement, the elder Misrachi opened a second gallery in the Zona Rosa district of Mexico City. The younger Alberto remembers MC fondly: "I personally managed his paintings when he was dealing with my uncle. Before long, we became the best of friends. Miguel was first associated with us when he did some illustrations for a special edition of . . . the *Island of Bali*. He made around one hundred extra drawings, and we added one to each leather-bound book. It was a very beautiful edition.

"We also produced another special edition of *Indian Art of Mexico and Central America*. We made only twenty leather-bound copies, each with a reproduction of an antique map of Mexico and an original drawing of Miguel's. He completed this book just before he died in 1957. Today it is very valuable because of the small size of the edition. During the period when Miguel was working at Bellas Artes, I saw him nearly every day. He came by to drink coffee, to talk to me, and to see who was in the gallery, which was the center of social activity in downtown Mexico City.

Here Miguel met friends, painters, socialites, collectors, and even beautiful female tourists. Rosa was always pushing Miguel to paint. Every week either she or Miguel would bring his finished work to me. He was extraordinarily prolific. I remember in one weekend Miguel did two oils, twenty drawings, and several gouaches. My client Pedro Armendáriz, the Mexican movie idol, bought a lot of his work. We would pay Rosa whenever we sold anything, which was often, because, as I said, he was one of the gallery's most sought after artists. The fact is, we couldn't keep his work in stock." Ibid.

7. Guillermo Arriaga, interview with author, Mexico City, 1987.

8. Mexico's system of sweeping clean the administrators (and often the programs) of a previous presidency, regardless of the value of the personnel or the programs, is costly. The article by Covarrubias is "La danza," *México en el Arte* (12 Nov. 1952): 103–115. It includes a brief history of dance tradition in Mexico, profiles the Bellas Artes principal dancers and choreographers, and describes the ballets which the company had presented during his tenure. Once again, MC promoted the avant-garde notion that a choreographer should be well-versed in his country's archeology, ethnology, and history.

9. RC to José Limón, Oct. 1952, José Limón Archives, Library and Museum of the Performing Arts, New York Public Library at Lincoln Center, Dance Collection, New York, N.Y.

10. Carlos Chávez to MC, 29 Nov. 1952, MCA.

11. Vidya, MC's secretary, remarked: "When Miguel first formed the dance company, the dancers were criticized for their lack of satisfactory dance techniques. This may have been true, but it was not the most important thing, because in time the technique improved. What was important was the thought-provoking and inspiring concepts that emerged out of the dancers' contact with Miguel and, as a consequence, the ballets that were created."

12. Raúl Flores Guerrero, "Contemporary Dance," *Artes en México* (Mexico City: CCAC, 1987): 197. Distinguished Mexican choreographers, dancers, and critics refer to Covarrubias as the "Diaghilev of Mexico" because he took his company and his audience on a cultural journey through dance, and he worked with the most innovative and talented composers and set and costume designers.

13. Guillermo Arriaga, "Miguel Covarrubias en la danza," *Miguel Covarrubias: Homenaje* (Mexico City: CCAC, 1987): 197.

14. Arnold Belkin, interview with author, Mexico City, Dec. 1990.

15. Written by a friend of MC's, the scholar and dental surgeon Dr. Samuel Fastlich, with a preface by Alfonso Caso, the book described "the ancient indigenous practice of filing the teeth and encrusting them with jade, marcasite and other stones." In addition to MC's drawings, the book contains photographs of ancient surgical instruments. Alma M. Reed, *The Ancient Past of Mexico* (New York: Crown Publishers, 1966): 99.

Three Mexican researchers dedicated themselves to the study of early dentistry: Fastlicht, Daniel Rubín de la Borbolla, and Xavier Romero. MC's drawing of a mural fragment discovered in Tepantitla, Teotihuacán, which probably represented a tooth filing, became an emblem for the Mexican Dental Association Society. Covarrubias made an amusing duplicate for Fastlicht's home, substituting his friend for the Indian dentist and himself for the patient depicted in the original.

16. GM to MC, 1952, MCA.

17. Stanley Marcus to MC, 25 Feb. 1952, and MC, handwritten note, MCA.

18. Miguel Covarrubias, *Obras Selectas del Arte Popular* no. 5 (Mexico City: Museo Nacional de Artes e Industrias Populares, 1953): 12. Covarrubias wrote: "The sense of fresh and violent color, the macabre humor are all qualities and characteristics that have perhaps been the most decisive influence in the generation of modern Mexican painting. From José Guadalupe Posada to Leopoldo Méndez, Alfredo Zalce, Diego Rivera, José Clemente Orozco, Rufino Tamayo, Chávez Morado, etc., all of the contemporary Mexican painters have encountered and drunk deeply from the fountain of folk art. Thus, Mexican popular art is a motivating element of a new aesthetic." MC loaned several of his own folk art and costume collections to the exhibition.

19. Antonio Pineda, now a famous silversmith in Mexico, who won the competition recalls: "I was a friend of all three men, but there was something about Miguel—his laughing and giving

nature—that made him unique. I own several of his works which are still on the walls of my house." Antonio Pineda, interview with author, Taxco, Guerrero, Mexico, 1990.

20. Andrés Henestrosa, interviews with author, Mexico City, June and Feb. 1987.

"Zapata" premiered in Mexico that November at Bellas Artes. Choreographed for two dancers, Rocío Sagaón and Guillermo Arriaga danced representing the Earth and Zapata. Raúl Flores Guerrero described the ballet: "[E]arth gives birth to Zapata. It is she that gives him the first light, the first breath. . . . And in this wondrous birth the little Rocío Sagaón acquires the grandiosity of the Siqueirian Earth, identifying herself with the pre-hispanic Goddess of Birth in artistic expression and poetry." Guerrero also notes: "Ever since this ballet was created, Rocío, in her role as Earth has projected an emotion which ends in transforming her into an artistic symbol of all that is Mexico." Raúl Flores Guerrero, *La danza moderna mexicana 1953–1959* (Mexico City: INBA, 1990): 34.

For RS, "it was the culmination of all our hard work. Those who came backstage after had tears in their eyes." Rocío Sagaón, interview with author, Mexico City.

21. MC to RS, 9 Aug. 1953, Rocío Sagaón personal papers (Jalapa, Mexico). The letter only caught up with her at the end of the troupe's two-month tour.

22. Eli Gortari, interview with author, Mexico City, Feb. 1987.

23. *Boletín* no. 1, June 1954, the Mexican Society of Friends of Popular China. An unpublished poem of Mao Tse-tung's appeared in that first issue along with a comprehensive article "On Education and Culture in the New China" by MC which concluded the report with these words: ". . . in such a short period all these miraculous realizations in the life of the Republic of Popular China are its best testimonial to the country's unity and discipline, and to the determination of the people of China, a people who have always been essentially humanitarian, democratic, and creative, to achieve their leaders' goals in the realm of art and culture. The purpose of their program being to improve and consolidate the manner in which these goals are carried out in different areas of the country, to elevate the quality of what is already being accomplished, and to continue to advance."

Covarrubias's advisors, who would each function for a year as the society's president, were Xavier Guerrero and Eli Gortari. (In 1947 Guerrero's leftist politics had caused him to be denied a visa to the United States. Covarrubias, Rivera, Orozco, and Siqueiros were also denied visas. All petitioned the Artists Equity Association in New York to protest.) During that same period, in the late 1940s, Aldous Huxley contacted MC for similar support in protesting the persecution of the poet Pablo Neruda by the Argentine government. See MCA for the telegram on Guerrero's behalf from Robert Gwathmey and Joseph Hirsch to MC, 10 May 1947, and the telegram on behalf of Pablo Neruda from Aldous Huxley.

Diego Rivera served on the society's board of directors along with other members of the National Art Commission, among them photographer Manuel Alvarez Bravo, painters Olga Costa and Enrique Yáñez, and the graphic designer Alberto Beltrán.

24. Alfred Knopf to MC, 8 June 1953, MCA.

25. RC to NR, 31 May 1954, Collection NAR, RG III 4e, Series Countries, Sub-series Mexico, Box 52, Folder 433, NRAC.

26. Selden Rodman, *Mexican Journal* (New York: The Devin-Adair Company, 1958): 96. Rodman wrote: "Two hundred people were invited, but two thousand showed up [at the opening]."

27. Olivia Zuñiga, *Mathias Goeritz* (Mexico City: Editorial Intercontinental México, 1963): 33. Mathias collaborated with the sculptor/painter Henry Moore and Carlos Mérida, each of whom painted a mural for the space, as well as Rufino Tamayo and the sculptor Germán Cueto.

28. Mathias Goeritz, interview with author, Mexico City, 1990.

29. Dorothy Cordry, interview with author, Cuernavaca, Mexico, 19 May 1985.

As early as 1945, Rosa and Miguel revealed their differing views about social gatherings, which foretold their later political disagreements. Salvador Novo describes Miguel's reaction to a lavish party that Alberto Avramov held in his palace. "Covarrubias was indignant over the twenty tables of pheasants endlessly being replenished, the champagne flowing like water, and the cigarette butts on carpets that cost forty thousand pesos; indignant because he felt that the party,

which he calculated had cost between eighty and a hundred thousand pesos, was an insult to hunger." On the other hand, Novo had not seen Rosa, but he imagined that she had been happy at the party. Salvador Novo, *La vida en México en el tiempo de Manuel Avila Camacho* (Empresas Editoriales: México, 1965): 319.

30. Mae Hutchins (Rosa's sister), interview with author, 19 May, 1985; letter, Mae Hutchins to RC, 1953, MCA. Mae told me: "Rose was very angry with me because she couldn't break the will. From the time I was an adult, she was always after me [about our father], asking 'How can you let him talk to you that way?' I never answered him back, you see. Which was quite different from Rose, who wouldn't take any nonsense from him. . . .

"The whole thing was really her own fault. She never treated Dad right. She even refused to see him when he went to Mexico."

According to Mae Hutchins, RC's father called the Zamora Street house and spoke to Pepe, who told him how to find Tizapán. When he arrived, RC would not see him. Mae admits her father was a difficult man, and clearly, RC was her father's daughter.

31. Inspired by the fifteenth-century romance of the daughter of the king of Spain and a page of the court, "Romance" was choreographed by Guillermo Arriaga, with music by Pergolesi/Respighi.

Caso wrote in the preface of his book, *El pueblo del sol:* "I was fortunate in having an artist of the stature of Miguel Covarrubias to illustrate the book, an artist who also possessed a thorough knowledge of the ancient cultures of Mexico." Alfonso Caso, *El pueblo del sol* (Mexico City: Fondo de Cultura Económica, 1953). The book was later translated into English by Lowell Dunham and published in 1958.

32. *New York Times Book Review*, 9 Dec. 1954. Miguel Covarrubias, *The Eagle, the Jaguar, and the Serpent: Indian Art of the Americas, North America: Alaska, Canada, the United States* (New York: Alfred A. Knopf, 1954). The book jacket offers a concise synopsis: "[A] comprehensive survey of the origins of the people of the New World. Covarrubias discusses the many theories of possible migrations and of the arrivals of later influences from Siberia, Europe, and the South Pacific. He estimates the art of the American aborigines and elaborates a basic scheme for the history, technology, and aesthetics of American Indian-Eskimo art for all of North America, Middle America, and South America." In the *New York Times* review, 9 Dec. 1954, the critic cites its importance: "In his text Covarrubias touches on many ideas that in recent years have attracted public notice: the possible drifting of rafts across the South Pacific; the use of Carbon 14 in dating archaeological objects; theories of the descent of man and the intermingling of races; and the ways archaeologists use art objects for dating their finds. Beyond its scholarship, beyond even its richness of reference and its unique comprehensiveness perhaps, this is a beautiful book. It is in every sense an American publishing event of the first importance."

33. Review of *Mexico South: Island of Tehuantepec* by Miguel Covarrubias, *Time* (18 Nov. 1946): 38.

34. Daniel Rubín de la Borbolla, "Miguel Covarrubias: 1905–1957," *American Antiquity* 23 (1957–1958): 64.

35. Holger Cahill, "Pathways to the Past," review of *The Eagle, the Jaguar, and the Serpent* by Miguel Covarrubias, *New York Times* (7 Nov. 1954): 3.

36. Ibid.

37. Alfredo Serge, "Talk with Mr. Covarrubias," *New York Times*, 7 Nov. 1954. Serge asked MC what he meant to prove with his new book. MC responded: "I do not try to find conclusions. I fight against pre-conceived ideas. . . . I took archeology as a means to understand the process of art, and particularly of modern art. My only intention is to attain a status of well-informed preparation, so as to be able to grasp the motivation of art."

38. Ibid. MC had reconstructed a true environment to display objects in these galleries. Although the big work was completed, MC continued to devote his time and talents to the museum. Alfredo Serge wrote that MC was "presently engaged in preparing an exhibit of world and American pre-history, a special section for pre-Columbian music, another for Mexican costumes and a couple of displays concerning Africa and Japan."

39. MC, "Act of Homage on the 36th Anniversary of the Russian Revolution," 15 Nov. 1954, MCA. Covarrubias was still active in the Friends for Popular China group, as well, and attended the Americans for Peace Conference held in Mexico City in 1954. Ex-presidents Adolfo de la Huerta and Lázaro Cárdenas also attended, as well as Cuba's ex-president Fulgencio Batista, socialist Henry Wallace, Charlie Chaplin, and Thomas Mann.

40. María Asúnsolo, interview with author, Mexico City, 1984.

41. Yolotl González, interview with author, Mexico City, Feb. 1987.

42. Unless otherwise stated, recollections of Paz Celaya Barbeito are from interviews with author, Mexico City, Nov. 1984 and March 1988.

43. Carmen López Figueroa, interview with author, Acapulco, Mexico, Sept. 1988.

MC's niece, María Elena, remembers her mother, Elena, painting a different picture of MC's separation from Rosa. Elena claimed to have "kidnapped" MC from Tizapán herself and brought him to live in Zamora in order to protect him from Rosa. María Elena Rico Covarrubias, interview with author, Mexico City, Feb. 1987.

44. Unless otherwise stated, recollections of Nieves Field are from interview with author, Mexico City, Feb. 1987.

12. THE FIFTIES, PART THREE (1955–1957)

1. Unless otherwise stated, recollections of María Elena Rico Covarrubias are from interviews with author, Mexico City, Feb. 1987. María Elena remembers RC shouting in English. By relinquishing the Spanish language, RC's speech became a symbol of her disaffection with everything Mexican.

2. Unless otherwise stated, recollections of Rocío Sagaón are from an interview with author, Jalapa, Veracruz, Mexico, June 1985.

3. The Matron of Honor of the Knot places a gold cord symbolizing the bonds of matrimony over the shoulders of the wedding couple.

4. Since RS did not live with MC, RC clung to the illusion that there was still the possibility of a reconciliation.

5. GM to MC, 7 Feb. 1955, MCA.

6. GM to MC, 14 June 1955, MCA. GM died the following year in May, and his wife Helen took over his enterprises.

7. Carlos Solórzano, interview with Elena Poniatowska, "Raoul Fournier, Carlos Solórzano y Justino Fernández hablan de Miguel Covarrubias," *Novedades,* 19 May 1957.

8. Ibid.; Santos Balmori, *Homenaje a Miguel Covarrubias,* Catalogue for Miguel Covarrubias Exhibition (Mexico City: Galería Metropolitana, 1981); Román Piña Chán, interview with author, Mexico City, June 1987.

9. RC to NR, 9 March 1956, Collection NAR, RG III 4e, Series Countries, Sub-series Mexico, Box 52, Folder 433, NRAC; RC to NR, 4 May 1956, Collection NAR, RG III 4e, Series Countries, Sub-series Mexico, Box 52, Folder 433, NRAC.

10. RC to NR, 15 June 1956, Collection NAR, RG III 4e, Series Countries, Sub-series Mexico, Box 52, Folder 433, NRAC.

11. María Asúnsolo, interview with author, Mexico City, June 1985; Nieves Orozco Field, interview with author, Mexico City, Dec. 1988.

12. Unless otherwise stated, recollections of Vidya Peniche are from an interview with author, Mexico City, Feb. 1988.

13. Unless otherwise stated, recollections of Fernando Gamboa are from an interview with author, Mexico City, Feb. 1986.

14. Aline Misrachi de Soni, interview with author, Mexico City, Feb. 1987. Aline is married to Dr. Jorge Soni, Miguel's heart specialist.

15. Selden Rodman, *Mexican Journal* (New York: Devin-Adair, 1958): 52.

16. Ibid., 23.

17. Raúl Anguiano, interview with author, Los Angeles, 9 July 1990. Raúl's brother-in-law, Dr. Jesús Bustos, occupied the bed next to Miguel's during his hospital stay. "It was the first time that he had met Miguel," Raúl said, "but they became friends instantly because Miguel was such a gentle and refined person that one couldn't help but like him."

18. Rodman, *Mexican Journal*, 28–30.

19. Regarding Mexicans' faith in Soviet medicine, Rodman notes hearing "that Diego had been keeping several mistresses happy after Frieda's death until, last year, a cancer developed where calculated to interfere most with this activity. The 'capitalist' doctors had wanted to amputate, but the painter had flown to the Soviet Union where he had received at least a partial cure, returned, married his present wife, and started to paint again with renewed faith." Ibid., 23.

20. Unless otherwise stated, recollections of Frederick Field are from interview with author, Kentfield, Calif., July 1986.

21. Rodman, *Mexican Journal*, 227.

22. María Elena Rico Covarrubias, interviews with author, Mexico City, Feb. 1987 and Dec. 1991.

23. Rodman, *Mexican Journal*, 227. There is no evidence that Rocío was unfaithful, as the doctor suggested, but Columba Domínguez believed it was a possibility since Rocío "wanted a famous man." When Columba went to Italy to work on the movie "L'Edera" in 1950, friends called her and told her to hurry back because Rocío was flirting with "El Indio." Columba Domínguez, interview with author, Mexico City, Feb. 1987.

24. Ruth and Leon Davidoff, interview with author, Cuernavaca, Mexico, Jan. 1990; Rodman, *Mexican Journal*, 227.

25. RC to NR, 14 March 1945, Collection NAR, RG III 4e, Series Countries, Sub-series Mexico, Box 52, Folder 433, NRAC; Carmen López Figueroa, interview with author, Acapulco, Mexico, Sept. 1988.

26. RS, interview with author, Mexico City, 1985.

27. Fernando Gamboa, interview with author, Mexico City, 2 July 1986.

28. Vidya Peniche and several friends went to Rocío's house after the burial, and Peniche commented: "I was struck by how calm she was. I was considerably more distressed than she." Vidya Peniche, interview with author, Mexico City, Feb. 1988.

29. The Covarrubias family crypt is designed as a chapel topped with a cross. The door has an elaborate ironwork, and above it is an inlaid sculpture of the face of Christ on a cloth, under which is the inscription, "Familia Covarrubias." Trees surround the crypt, and a graceful bougainvillaea bush climbs one side.

30. Raúl Valencia, interview with author, Mexico City, 4 Feb. 1957; Alfonso Caso, interview with Elena Poniatowska, "Alfonso Caso, Harry Block y Diego Rivera hablan de Miguel Covarrubias," *Novedades*, 12 May 1957.

13. AFTERWARD (1957–1970)

1. Unless otherwise stated, recollections of Daniel Rubín de la Borbolla are from an interview with author, Mexico City, Feb. 1987.

2. MC's sister told her daughter, María Elena, this several days before he died. MC had asked her to become the executor of his will. Covarrubias had made an effort to make out a will, but ultimately he was too ill to hold a pen. María Elena Rico Covarrubias, interview with author, Mexico City; Dávalos and Arroyo de Anda's recollection in Julio Scherer García, "Se enriquecen los tesoros mexicanos," *Excélsior* 290, no. 15 (21 Nov. 1958): 13.

3. Unless otherwise stated, recollections of Fernando Gamboa are from interview with author, Mexico City, Feb. 1986.

4. Unless otherwise stated, recollections of María Elena Rico Covarrubias are from interviews with author, Mexico City, Feb. 1987 and Dec. 1991.

5. Unless otherwise stated, recollections of RC are from interviews with author, Mexico City, 1969.

6. RC to NR, 10 March 1957, Collection NAR, RG III 4e, Series Countries, Sub-series Mexico, Box 52, Folder 433, NRAC. Rockefeller expressed his condolences: "All of us here have thought of you so much during these last days after receiving the news of Miguel's death. He was a truly great person and made so many wonderful contributions. As one looks back the confusion of the immediate past fades into the memory of the long span of years. I am sure you must feel that very strongly yourself." NR to RC, 21 Feb. 1957, Collection NAR, RG III 4e, Series Countries, Sub-series Mexico, Box 52, Folder 433, NRAC.

On May 12, Rosa heard that Nelson was making a trip to Mexico. She wrote: "I'll be waiting for the telephone call the morning of the 24th. It's such a shame that Mary will not be with you. I will miss her terribly. We had such good fun at Palenque." RC planned a luncheon for him on the 26th, to which she had invited René d'Harnoncourt and his wife Sara. RC to NR, 12 May 1957, Collection NAR, RG III 4e, Series Countries, Sub-series Mexico, Box 52, Folder 433, NRAC.

7. RC to NR, 10 March 1958, Collection NAR, RG III 4e, Series Countries, Sub-series Mexico, Box 52, Folder 433, NRAC.

8. Julio Scherer García, "El tesoro de Covarrubias expuesto en el museo; la viuda lo reclama," *Excélsior* 293, no. 15 (22 Nov. 1958).

9. Ibid. Frank Rashap was the attorney of record on this case for the law firm Hardin, Hess, and Eder.

10. Julio Scherer García, "Primeras reparaciones en el Museo de Antropología," *Excélsior* 566, no. 14 (19 May 1957).

11. RC and LC, conversations with author, Mexico City, July 1986 and 11 Feb. 1987, for details of this account. Over the years, RC had come to distrust and dislike Luis. Arnold Belkin, who once shared an apartment with Luis and worked with him in the theater department at Bellas Artes (MC during his tenures had secured a job there for his brother), remembers: "Luis had a contentious personality, and he always had money problems that caused him to do troublesome, untrustworthy things. Luis copied Miguel's style of painting, and as he perfected his technique, falsified paintings when he needed money. This was one of the reasons Rosa disliked him." Arnold Belkin, interview with author, Mexico City, Dec. 1990.

Vidya Peniche described Luis as "a very selfish man. Even with his wives and children he was irresponsible and undependable. In later years he had the habit of disappearing; once for as long as ten years! However, MC was very protective of his younger brother who worshipped him." Vidya Peniche, interview with author, Mexico City, 1987.

12. RS did not receive an inheritance from MC, although he had given her various gifts (paintings and books) during their relationship. After his death, she went on a dance tour through Asia and Europe. She remained in Paris and married George Vinaver, a photographer whom she had met previously in Mexico. Now living in Jalapa, Veracruz, they have three children. Today RS is director, choreographer, and dance teacher at Efímera, a thriving dance company in Veracruz (her husband and children are also part of the company). Both of her daughters are dancers. The elder is an expert in Indian classical dance, and the younger has studied dance in Africa. Her son is a fine sculptor who has studied and worked in Japan. RS is also an accomplished lithographer and potter.

13. Unless otherwise stated, recollections of Luis Covarrubias are from interview with author, Mexico City, July 1986.

14. RC to NR, 10 March 1958, Collection NAR, RG III 4e, Series Countries, Sub-series Mexico, Box 52, Folder 433, NRAC.

15. Unless otherwise stated, recollections of Daniel Rubín de la Borbolla are from interview with author, Mexico City, Feb. 1987.

16. Julio Scherer García, "Se enriquecen los tesoros mexicanos."

17. Ibid.

18. RC's relationship with the museum was controversial, often resulting in open argument. She defied the tax authorities more covertly. Datuk Lim Chong Keat, a friend who met RC in 1957, recalls her "stashing away Miguel's antiques from estate duties people." Datuk Lim Chong Keat to author, 6 Jan. 1993, Singapore. Unless otherwise stated, recollections of Mary Anita

Loos are from interviews with author, Los Angeles, Sept. 1985, May and Sept. 1986, and Oct. 1992.

19. Noemi Atamoros, "Dónde están 975 piezas arqueológicas?" *Excélsior*, 23 July 1969.

20. Arturo Romano and Luis Aveléyra Arroyo de Anda, interview with author, Mexico City, June 1987.

21. Scholar Tomás Ybarra-Frausto and the author were not able to attain access to research materials on two occasions. Further inquiries were clearly discouraged.

22. Holger Cahill citation in "Yesterday," *New York Times*, 10 Nov. 1957. In addition to Knopf's publication, Alberto Misrachi reminded me that his uncle's gallery produced a special edition of twenty leather-bound volumes of the book. Alberto Misrachi, interviews with author, Mexico City, 1988 and 1989.

23. Mae Hutchins, interviews with author, Los Angeles, 1 June 1985 and 11 Nov. 1986. Mae Hutchins contacted the writer, who confirmed the story, after our interview, but he could not recall the details.

24. Michael D. Coe, telephone interview with author, Nov. 1991. One amusing drawing in the Olmec notebooks is of an Olmec child biting his father on the behind (from Jeanette Bello's copy of the notebook). The caption reads:

> *Oh! Sharper than a serpent's tooth*
> *is an ungrateful child*
> *Particularly when his bite*
> *a bottom has defiled.*
> *One blushes not to think*
> *it was a meditated plan.*
> *What is worse is when this*
> *evil child was father to the man.*

Michael Coe added a section to his book, *America's First Civilization*, from the Miguel Covarrubias Olmec notebooks. MC did a similar study book heavily illustrated with drawings of Mexican jades, now owned by Mrs. Dudley Isby in Philadelphia.

25. Elena Poniatowska, "Un acontecimiento editorial: México rescata a Miguel Covarrubias traduciéndolo por primera vez al español," *Novedades*, 15 Oct. 1961. Not one book of Miguel's had been translated into Spanish until 1980, when *Mexico South* was published in Spanish, largely as a result of the efforts of Mexican author Juan Rulfo. Until Sol's translation, most Mexicans had never read any of Covarrubias's great works, such as *Island of Bali* or *Mexico South*. Mary Anita Loos explained that MC wrote in English because the literary marketplace was English-speaking and in New York. Mary Anita Loos, interviews with author, Los Angeles, 1 Sept. 1985, 20 May 1986, Sept. 1986, and Oct. 1992.

26. Sol Arguedas, interview with author, Mexico City, July 1992.

27. Esperanza Gómez, interview with author, Mexico City, July 1991.

28. Unless otherwise stated, recollections of María Asúnsolo are from interviews with author, Mexico City, 1 June 1984, 11 Nov. 1984, March 1988, and Dec. 1990.

29. RC to NR, 29 Aug. 1957, Collection NAR, RG III 4e, Series Countries, Sub-series Mexico, Box 52, Folder 433, NRAC. RC mentions O'Keeffe and her trip with Huston and Flon.

30. RC to NR, 20 April 1959, Collection NAR, RG III 4e, Series Countries, Sub-series Mexico, Box 52, Folder 433, NRAC.

31. RC's reference to "hateful whores" was recalled by Mary Anita Loos. Jeanette Bello, interview with author, Los Angeles, Nov. 1986. RC went alone, to Java as well as Bali, and visited all her old friends: I Gusti Alit Oka Degut, his son Summatra, Sobrat the painter, and Pollock the dancer. She returned very distressed, and she described sitting on a balcony in Bali overlooking the rice fields and hearing about the millions of people who had been slaughtered in the war of independence in 1945 under Sukarno. I Gusti told her that the rivers ran red with blood. RC was horrified that such a thing could happen to the gentle people beloved by RC and MC.

Rosa had asked me (Adriana Williams) to accompany her on the trip to Bali, but I could not get away. According to RC's friend Datuk Lim Chong Keat, Buckminster Fuller had agreed to go with her, but had to cancel the trip at the last minute. Datuk Lim Chong Keat to author, 6 Jan. 1993, AWMCC.

32. Manuel Ortíz Vaquero (antique dealer), interview with author, Mexico City, Feb. 1987.

33. Ibid.

34. Copy of RC's application to the Wenner-Gren Foundation, MCA. RC described the proposed book as "photographs with text on ceremonial and modern dance in actuality, and its depiction in sculpture on temples." She particularly wanted to "trace ceremonial dance in these countries in order to separate the Hindu classical forms from the Indonesian." She gave as her qualifications her work with Dr. Alberto Ruz during three summers in Palenque and her assistantship to MC at the National School of Dance at Bellas Artes. René d'Harnoncourt, Efrén del Pos, the secretary of the University of Mexico, Daniel Rubín de la Borbolla, José Limón, and Doris Humphreys were listed as her references. She named the National Autonomous University of Mexico (UNAM) and Nelson Rockefeller as her sponsors.

35. Jane Belo Tannenbaum to RC, 19 May 1955, AWMCC.

36. La Capilla was founded by a wealthy Mexican industrialist, Don José María Escobedo. Novo recalled, "Once or twice a month, I had to offer a menu of international dishes, and Rosa proved herself worthy of her renown as a culinary genius. The members always applauded the excellent luncheons she helped me prepare. It was a lot of work and a lot of fun." Salvador Novo, "Cartas a un amigo," *El Heraldo,* 1 April 1970.

37. Aline Misrachi de Soni, interview with author, Mexico City, Feb. 1987.

38. Unless otherwise stated, recollections of José Luis Cuevas are from an interview with author, Mexico City, June 1984. RC had met José Luis Cuevas in 1955 when MC had already moved to Zamora Street. According to Cuevas: "I never met Miguel, but one sensed his presence in Tizapán because one saw his objects, books, paintings, and drawings everywhere. Knowing that one of my interests was film, Rosa gave me some of Miguel's drawings and watercolors that had to do with the movie world. She was a very good friend to me and my wife Bertha."

39. Cibeles Henestrosa, the Henestrosas' daughter, remembers being fascinated by that bathroom at the age of seven or eight. "Every time my parents took me along on a visit to Rosa's house, I always asked permission to go there. I had never seen one quite like it." Cibeles Henestrosa, interview with author, Mexico City, Feb. 1987.

40. "Madame Miguel Covarrubias," *Harper's Bazaar* (April 1942): 68. The photographs for this article were taken by Baron Hoyningen-Huene, who married RC's friend Nancy Oakes.

41. Unless otherwise stated, recollections of Carlos Rivas are from interview with author, Los Angeles, May 1986.

42. Huston recalled: "[Miguel and Rosa's] split was an ugly affair. Rose, whom I loved, could be pretty vicious. I saw this a couple of times, but only in connection with [Miguel's having left her]. After Miguel died, I would always invite her to my filmings in Mexico. I knew that Rose was dreadfully lonely." John Huston, interview with author, Los Angeles, Sept. 1985. *The Unforgiven* starred Audrey Hepburn and Burt Lancaster. Rivas played Lost Bird in the film.

43. Columba Domínguez, interview with author, Mexico City, Feb. 1987. Soon after MC's death, an old friend of the Covarrubiases', Vijaya Lakshmi Pandit who had been the Ambassador from India to the United Nations, invited RC to visit her in India. Since RC couldn't afford the journey to India, Pandit instead sent her sister and daughter to visit RC in Mexico.

44. Carlos Rivas, interview with author, Los Angeles, June 1985.

45. Major W. Boss (the Royal Military College of Canada) to RC, 15 Nov. 1922, the Rose Roland-Covarrubias Collection, the Dance Collection, New York City Public Library, N.Y.; Beatriz Tames, telephone interview with author, Dec. 1990, quoting Fito Best Maugard.

46. Juan Soriano, interview with author, Mexico City, Feb. 1987.

47. Ibid.

48. Unless otherwise stated, recollections of José Luis Cuevas and Bertha Cuevas are from interview with author, Mexico City, 1984. In 1992, Cuevas made a gift of his work to Mexico, along

with his collection of Latin American paintings. In addition, he donated his two-story bronze statue of a woman, entitled "La Giganta" (perhaps symbolic of his fascination with larger-than-life women such as Tina Modotti, Frida Kahlo, Ruth Rivera, and Rosa Covarrubias).

49. Unless otherwise stated, recollections of Paz Celaya are from interviews with author, Mexico City, 5 Nov. 1984 and 11 March 1988.

50. RC's death certificate records her death at 9:30 A.M. on 25 March 1970, at the age of seventy-one. She was actually seventy-five. Her personal physician, Dr. Jorge Soni Cassani, listed the causes of death as heart failure and generalized arteriosclerosis. Witnesses were Mrs. Paul Camargo de Schell, born in Paris; Nieves Orozco de Field, born in Solitepec, Hidalgo, Mexico; and María Asúnsolo de Colín, born in Chilpancingo, Guerrero, Mexico.

51. María Asúnsolo and Bertha Cuevas, interviews with author, Mexico City, 1984.

52. Andrés Henestrosa, interviews with author, Mexico City, 1 June 1987 and 11 Feb. 1988.

53. María Asúnsolo, interview with author, and Nancy Oakes, telephone interview with author, Palm Beach, Fla., Jan. 1985.

54. Today the house belongs to Diego Rivera's daughter, Lupe Rivera, who purchased it in 1988.

55. RC inscribed a book to Barragan in 1959, "In grateful remembrance of our friendship through all these years! With too much love, Rosa Covarrubias." Perhaps María is correct.

56. RC's will, Luis Barragan private papers, Mexico City.

57. The book published by the Smithsonian Institution in 1985, *Miguel Covarrubias: Caricatures,* was dedicated to Alfred Katz (1915–1983), who served as a member of the Swann Foundation for Caricature and Cartoon. In 1984, the Swann Foundation sponsored an exhibition of Miguel Covarrubias caricatures, "The Metropolitan Opera Centennial," at the National Portrait Gallery in Washington, D.C.

58. RC, conversation with author, San Rafael, 1967 (and confirmed by Mary Anita Loos), citing the details and changes of her will; RC had promised the house to the Alberts and then reversed her decision.

59. Elena Gordon, interview with author, Cuernavaca, Morelia, Mexico, 19 May 1985.

60. María Asúnsolo, interview with author, Mexico City, Nov. 1984.

61. John Huston, interview with author, Los Angeles, Oct. 1985.

EPILOGUE

1. Diego Rivera, Foreword to *Valentine Gallery Exhibition Catalogue: Paintings, Watercolors, and Drawings of Bali* (New York: Valentine Gallery, 1932). "Covarrubias' Paintings from Bali," 11 Jan. 1932.

2. J. J. Crespo de la Serna, "Miguel Covarrubias," *Novedades,* 24 March 1957.

3. Arnold Belkin, interview with author, Mexico City, Dec. 1990; and *El Universal,* 26 Feb. 1981.

4. *Miguel Covarrubias: Homenaje* (Mexico City: CCAC, 1987).

5. Salvador Novo, *La vida en el período presidencial de Miguel Alemán* (Mexico: Empresas Editoriales, 1967): 642.

6. Antonio Rodríguez, "Muerte de Miguel Covarrubias," *El Nacional* (Mexico City), Feb. 1957.

7. Unless otherwise stated, recollections of Al Hirschfeld are from interview with author, New York, 21 Sept. 1985.

8. Alfonso Caso, interview with Elena Poniatowska, "Alfonso Caso, Harry Block y Diego Rivera hablan de Miguel Covarrubias," *Novedades,* 12 May 1957.

9. Ethel Smith, telephone interview with author, Palm Beach, Fla., May 1985.

10. John Huston, interview with author, Los Angeles, Oct. 1985.

11. Marcet Haldeman-Julius, "Miguel Covarrubias," *Haldeman-Julius Quarterly,* Jan. 1927, 63.

SELECT
BIBLIOGRAPHY

BOOKS IN ENGLISH

Amory, Cleveland, and Frederic Bradlee, eds. *Vanity Fair: A Cavalcade of the 1920s and 1930s*. New York: Viking Press, 1960.

Baird, Bil. *The Art of the Puppet*. New York: The Macmillan Company; Toronto: Collier-Macmillan Limited, 1965.

Burbank, Addision. *Mexican Frieze*. New York: Coward-McCann, Inc., 1940.

Carpenter, Patricia F., and Paul Totah, eds. *The San Francisco Fair: Treasure Island, 1939–1940*. San Francisco: Scottwall Associates, 1989.

Castillo. *See* Díaz del Castillo.

Cederwall, Sandraline, Hall Riney, and Barnaby Conrad. *Spratling Silver*. San Francisco: Chronicle Books, 1990.

Charlot, Jean. *Art-Making from Mexico to China*. New York: Sheed and Ward, 1950.

——. *The Mexican Mural Renaissance: 1920–1925*. New York: Hacker Art Books, 1979.

Chase, Stuart. *Mexico: A Study of Two Americas*. New York: The Macmillan Company, 1931.

Coast, John. *Dancers of Bali*. New York: G. P. Putnam's Sons, 1953.

Daniel, Ana. *Bali: Behind the Mask*. New York: Alfred A. Knopf, 1981.

de Zoete, Beryl, and Walter Spies. *Dance and Drama in Bali*. London: Faber and Faber Limited, 1938.

Díaz del Castillo, Bernal. *The Discovery and Conquest of Mexico*. Mexico City: Limited Editions Club, 1942.

Field, Frederick V. *Pre-Hispanic Mexican Stamp Designs*. New York: Dover Publications, Inc., 1974.

Gessler, Clifford. *Pattern of Mexico*. New York: D. Appleton-Century Company, Inc., 1941.

Grobel, Lawrence. *The Hustons*. New York: Charles Scribner's Sons, 1989.

Hirschfeld, Al. *Al Hirschfeld's World*. New York: Harry N. Abrams, Inc., 1981.

Jackson, Joseph Henry. *Mexican Interlude*. New York: The Macmillan Company, 1936.

Lawrence, D. H. *Mornings in Mexico*. 1927. Reprint. Salt Lake City, Utah: Gibbs M. Smith, 1982.

Luhan, Mabel Dodge. *Movers and Shakers*. Vol. 3. New York: Harcourt, Brace and Company, 1936.

McPhee, Colin. *A House In Bali*. Toronto: Longmans, Green and Company, 1944.

Mérida, Carlos. *Modern Mexican Artists*. Mexico City: Frances Toor Studios, 1937.

Neuhaus, Eugen. *The Art of Treasure Island*. Berkeley: University of California Press, 1939.

The New Yorker Twenty-Fifth Anniversary Album, 1925–1950. New York: The New Yorker Magazine, 1951.

Powell, Hickman. *The Last Paradise*. Toronto: Jonathan Cape Ltd., 1930.

Pratley, Gerald. *The Cinema of John Huston*. Cranbury, N.J.: A. S. Barnes and Co., Inc., 1977.

Quirk, Lawrence J. *Claudette Colbert: An Illustrated Biography*. New York City: Crown Publishers, 1985.

Robinson, Roxana. *Georgia O'Keeffe: A Life*. New York: Harper and Row, Publishers, 1989.

Strode, Hudson. *Timeless Mexico*. New York: Harcourt, Brace and Company, 1944.

Tyler, Ron. *Posada's Mexico*. Washington, D.C.: Library of Congress, 1979.

Van Nimmen, Jane. *Lightest Blues: Great Humor from the Thirties*. Edited by Giboire Clive. New York: Imago Imprint Inc., 1984.

Wolfe, Bertram D. *The Fabulous Life of Diego Rivera*. New York City: Stein and Day, 1963.

BOOKS IN FRENCH

Chadourne, Marc. *Libération.* Abbeville, France: Les Amis d'Edouard. No. 140. 1928.

Rivet, Paul. *Mexique Precolumbian*. Neuchatel and Paris: Editions Ides et Calendes, 1954.

BOOKS IN SPANISH

Arce, Manuel Maples. *Modern Mexican Art (El arte mexicano moderno)*. London: A. Zwemmer, 1943.

Belkin, Arnold. *33 años de producción artística*. Mexico City: Instituto Nacional de Bellas Artes, 1989.

Dallal, Alberto. *La danza en México*. Mexico City: UNAM, 1986.

Espejel, Carlos. *Olinala*. Mexico City: Museo Nacional de Artes e Industrias Populares, 1976.

Félix, María. *47 pasos por el cine*. Mexico City: Joaquín Mortiz/Planeta, 1985.

Gamboa, Fernando. *Embajador del arte México*. Mexico City: Consejo Nacional para la Cultura y las Artes, 1991.

Henestrosa, Andrés. *Los caminos de Juárez*. 1972. Reprint. Mexico City: Fondo de Cultura Económica, 1982.

———.*Los hombres que dispersó la danza*. Mexico City: Editorial Porrúa, 1984.

Juárez, Benito. *Flor y látigo: Ideario político*. Mexico City: Boletín Bibliográfico de la Secretaría de Hacienda y Crédito Público, 1957.

Maugard, Adolfo Best. *Método de dibujo: Tradición resurgimiento y evolución del arte mexicano*. Mexico City: Departamento Editorial de la Secretaridad Educación, 1923.

Navarro, Arturo Casado. *Gerardo Murillo: El Dr. Atl*. Mexico City: UNAM, 1984.

ARTICLES

Arriaga, Guillermo. "Zapata, Ballet." *Artes de México* 3 (March–April 1954): 69–80.

Caso, Alfonso. "L'Art zapotec." *L'Art Vivant au Mexique* 122 (January 1930): 48–49.

———."Richest Archeological Find in America." *National Geographic Magazine* 62 (October 1932).

Covarrubias, Miguel. "La danza prehispánica." *Artes de México* 8–9 (March–April 1955): 7–16.

"Covarrubias on paper." *Smithsonian* 15 (November 1984): 174–178.

Cuevas, José Luis. "Cara homenaje." *Artes de México* 2 (Winter 1988): 37–58.

"Down Mexico Way." *Vogue*, 15 January 1942, 58–63.

Figueroa, Gabriel. "Declaración de oficio." *Artes de México* 2 (Winter 1988): 23–27.

———."Palabras sobre imágenes." *Artes de México* 2 (Winter 1988): 37–58.

Fuentes, Carlos. "Una flor carnívora." *Artes de México* 2 (Winter 1988): 27–36.

Genin, Auguste. "Coup d'oeil ethnologique." *L'Art Vivant au Mexique* 122 (January 1930): 48–49.

Mena, R. "Le Musée National de Mexico." *L'Art Vivant au Mexique* 122 (January 1930): 58–61.

Monsiváis, Carlos. "Gabriel Figueroa: La institución del punto de vista." *Artes de México* 2 (Winter 1988): 62–84.

Luhan, Mabel Dodge. "Awa Tsireh." *The Arts,* June 1927, 298–300.

Sánchez, Alberto Ruy. "El arte de Gabriel Figueroa." *Artes de México* 2 (Winter 1988): 20–23.

Stirling, Matthew W. "Discovering the New World's Oldest Dated Work of Man." *National Geographic Magazine* 76 (August 1939): 183–218.

———. "Great Stone Faces of the Mexican Jungle." *National Geographic Magazine* 78 (September 1940): 309–334.

Vertiz, José Reygadas. " L'Archéologie mexicain." *L'Art Vivant au Mexique* 122 (January 1930): 42–45.

Von Wiegand, Charmion. "Little Charlie, What Now?" *New Theatre,* March 1936, 6–13.

EXHIBITION CATALOGUES

Ancient Art of Latin America: From the Collection of Jay C. Leff. New York: The Brooklyn Museum, 1966.

Art Mexicain du precolombien à nos jours. Paris: Musée National d'Art Moderne, 1952.

50 años de pintura en México. Mexico City: Instituto Nacional de Bellas Artes S. E. P. Galería José María Velasco, 1968.

d'Harnoncourt, René. *El arte del indio en los Estados Unidos.* Washington, D.C.: The National Indian Institute, U.S. Department of the Interior, 1943.

Festival de formas en homenaje a Fernando Gamboa: A sus 40 años como museógrafo y difusor de la cultura. Mexico City: Universidad Autónoma Metropolitana, 1985.

Golden Gate International Exposition, San Francisco, 1939: Contemporary Art. San Francisco: H. S. Crocker Company, Inc., Schwabacher-Frey Company, 1939.

Homenaje a 5 pintores mexicanos desaparecidos. Mexico City: UNAM.

The Image of America in Caricature and Cartoon. Fort Worth, Tex.: Amon Carter Museum of Western Art, 1975.

Linton, Ralph, and Paul Wingert with René d'Harnoncourt. *Arts of the South Seas.* New York: The Museum of Modern Art, 1946; Mexico City: Universidad Autónoma de México, 1954.

Mexican Arts. New York: American Federation of the Arts, 1930–1931.

Mexican Works from the Vaughan Collection. Fredericton, Canada: Beaverbrook Art Gallery, 1979.

México Arte Moderno II: Diego Rivera, José Luis Cuevas, Rafael Coronel, Francisco Toledo, Leonora Carrington, Pedro Friedeberg, Miguel Covarrubias, Leonardo Nierman, Tomás Parra and Ernesto Paulsen. Mexico City: Cámara Nacional de Comercio, 1977.

Miguel Covarrubias: Homenaje. Mexico City: CCAC, 1987.

Pictorial California and the Pacific: Golden Gate International Exposition. Los Angeles: Eugene Swarzwald, 1939.

Pre-Columbian Art. Los Angeles: Otis Art Institute, 1963.

Reiss, Winold. *Winold Reiss 1886–1953 Centennial Exhibition—Works on Paper: Architectural Designs, Fantasies, and Portraits.* New York: Shephard Gallery, 1986.

El retrato mexicano contemporáneo. Mexico City: Instituto Nacional de Bellas Artes, 1969.

Santos 90 Balmori: En su nonagésimo aniversario exposición retrospectivo. Mexico City: Instituto Nacional de Bellas Artes, 1989.

INDEX

Motion pictures. *See* Films
Muray, Nickolas: friendship with Miguel, xiv, 51–52, 96–98, 100, 141, 161; Miguel as godfather of child of, **167**, 278n37; Miguel's letters to, 108, 113–115, 120; photos of, **167**, **170**, **173**; photos of Rosa by, 31, 32, 270n33
Murillo, Gerardo (Dr. Atl), 12, 13, 98, 108, 178, 214, 261n30
Museum of Modern Art, Mexican exhibition, 111–116
Museum of Popular Arts and Industries, 190–192
Music Box Revue, 30–31, 32, 33, 34, 242, 267n49

Nacho, Tata, 21, 41, 51, 87, **91**, 181, 227, 269n18
Nájera, Manuel Gutiérrez ("Caballero Puck"), 9, 14
National Museum of Anthropology and History, 120, 168–169, 208, 227, 229–234, 249
National School of Anthropology and History, 152–154, 181
Nehru, Mrs. Pandit, 141
Nelken, Margarita, 227
Neuhaus, Eugen, 104
Niles, Abbe, 38, 40
Ni Polok, 61
Noche Mexicana, 13, 41
Noguchi, Isamu, 53, 141
Noren, Eric, 240
Noriega, Elena, 196
Novo, Salvador, 98, 108, 139, 183, 239, 240, 255, 297–298n29

Oakes, Nancy, 131, 141, 249
Obregón, Alvaro, 2, 12, 18, 88, 105, 262n12, 277n10
O'Connor, Patrick, 42
O'Gorman, Edmundo, xv
O'Gorman, Juan, xv
O'Higgins, Pablo, 89
O'Keeffe, Georgia, 55–56, 139, 158, 237, **244**, 285n24
Olín, Náhui, 108, 280n70
Olmecs, 144–150, 151–152, 166
O'Neill, Eugene, 37, **50**, 53, 58, 100
Orendain, Gabriel, 204
Orozco, José Clemente, 8, 52, 53, 87, 88, 89, 96, 116, 200, 255
Orozco, Nieves, 137, 139–140
Osato, Sono, 162, 288n28
Oumansky, Constantin A., 138
Over the Top, 28
Owen, Gilberto, 53

Paalen, Wolfgang, 119, 139, 158, 276n7, 285n20

Pach, Walter, 48, 70, 100
Page, Ruth, 32, 175, 267n49, 291n63
Palenque, 170–171, 204, 205, 303n34
Paley, Mrs. William, 116
Parker, Dorothy, 20
Pattinson, Mr. and Mrs., 61, 75
Pavlova, Anna, 28
Paxtián, Juan, 117, 281n21
Pellicer, 139
Peñalosa, Gillermina, 182
Peniche, Vidya, 174, 179, 191, 197, 209, 222, 224, 291n62, 296n11, 301n11
Pepper, George, 223, 236
Piña Chán, Román, 149–150, 152–153, 159, 186, 221, 227, 230
Pogany, William, 34
Poiret, Paul, 34
Poniatowska, Elena, 8, 21, 41, 53, 71, 105, 143, 144, 236
Poore, Charles, 165
Portes Gil, Emilio, 212
Posada, José Guadalupe, 8
Poulenc, François, 69
Powell, William, 46
Power, Tyrone, 32, 141
Prescott, William, 159, 170, 175, 182, 199, 208, 218–219
Puck, Caballero. *See* Nájera, Manuel Gutiérrez

Quintero, José, 141

Radin, Paul, 104
Rahon, Alice, 88, 276n7
Randall, Carl, 32
Randall, I., 34
Rassiga, Everett, 231
Ray, Man, 20, 47, 69, 270n33
Reagon, Caroline Dudley, 42
Reilly, Bernard F., Jr., 72
Reiss, Winold, 34, 39, 52
Reneng, Ni Ketut, 65–66
Revueltas, Silvestre, 186, 220
Revue Nègre, La, 42
Reyero, Manuel, 240
Reyes, Alfonso, 139
Rhodius, Hans, 67, 239
Rice, Elmer, 55
Rico Covarrubias, María Elena, 214–215, 227, 230, 299n43
Riddell, John. *See* Ford, Corey
Ríos, Alfa. *See* Henestrosa, Alfa
Ríos, Nereida, 108, 280n69
Ritz Hotel mural, 169
Rivas, Carlos, **189**, 240–242
Rivera, Diego: as artist, 8, 9, 53, 88, 89, 96, 100, 127, 255, 277n10; caricature of, 11; exhibition catalogue by, 69, 280n65; and

Squires, Ruth, 55
Stagg, Hunter, 42
Steichen, Edward, 20, 47, 270n33
Stein, Gertrude, 19, 47, 69, 138
Steinbeck, John, 114, 281n12
Steward, John, 89
Stewart, Peter and Waldo, 294n45
Stieglitz, Alfred, 20, 270n33
Stirling, Matthew, 120–123, 145, 157, 282n27
Stokowski, Leopold, 109
Stowe, Harriet Beecher, 96, 100, 278n34
Strand, Beck, 55–56
Sumatra, Anak Agung Ngurah Gedé, 65
Sumung, I Gusti Madé, 67–68
Swadesh, Maurice, 190
Syndicate of Revolutionary Painters, Sculptors, and Engravers of Mexico, 89
Sze, Mai, 115, 278n44

Tablada, José Juan, 8, 11, 14–15, 17–21, 38, 52, 53, 261n2
Taller de Grafica Popular, 88, 89–90, 277n14
Talmadge, Norma, 32
Tamayo, Olga, xiv, 108, 139
Tamayo, Rufino: as artist, 8, 12, 53, 96, 199, 205; and exhibition of Mexican arts and crafts, 13; friendship with Miguel and Rosa, xiv, 139; guitar playing by, xiv, 21, 108; at Miguel's funeral, 227; photo of, 173
Tames, Beatriz, 242
Tannenbaum, Frank, 71, 90
Tehuantepec, 87–88, 96, 98–100, 108, 117, 119, 120–123, 143
Theater: Garrick Gaieties, 41–42; marionette show Love's Dilemma, 21–22, 41; in Mexico City, 6–7, 53, 56; Miguel's designs for, 13, 19, 22, 41–42, 45, 51, 270n29; Rosa as dancer in, 22, 28, 30–35, 41–42, 56; Ziegfeld Follies, 32, 33. See also names of specific plays
Thompson, J. Eric S., 147
Tillet, James, 140
Tlatilco, 92–95, 119–120, 143–145, 148, 151, 152, 158, 170, 172–174, 177, 219, 282n25
Toledano, Vicente, 188
Toor, Frances, 57, 116, 155
Tourneur, Maurice, 28–29, 46, 266n38, 270n32
Toussaint, Manuel, 116

Traven, Bruno, 141
Trotsky, Leon, 163
Trueblood, Edward Gatewood, 150

Ulises Theatre, 53
United Nations building, 177, 291n2

Vaeth, Frank, 32
Vaillant, George, 122
Valencia, Raúl, 228
Van Vechten, Carl: books by, 262n13; friendship with Miguel, 19–20, 34, 36, 37, 42, 54, 60, 86; and Harlem Renaissance, 37, 39, 54; on Miguel's illustrations, 48, 58, 262n11, 262n13, 269n13
Vargas, Pedro, 227
Vasconcelos, José, 12, 87, 119, 179, 255
Vázquez, Mario, 227, 286n4
Vázquez, Pedro Ramírez, 231
Vélez, Lupe, 7, 17
Villarreal, Pascual, 191
Villaurrutia, Xavier, 53, 97, 108, 139

Walrond, Eric, 38
Waters, Ethel, 37
Weaver, Muriel Porter, 151–152, 172, 230
Weber, Lois, 32
Weill, Lucien, 116
Weinstock, Herbert, 175, 182
Welles, Orson, 56, 141
Weston, Edward, 46
Wheeler, Monroe, 111, 288n18
White, Walter, 39
Whitney, John Hay, 116
Whitney, Mrs. Payne, 21
Wilbur, Ray Lyman, 101
Winchell, Walter, 100
Wingert, Paul, 164
Wolfe, Bertram D., 123, 283n35
Wood, Grant, 89
Woollcott, Alexander, 30, 60
World's Fair murals, 93, 94, 100–104
Wynn, Ed, 28

Ybarra-Frausto, Tomás, xvi, 149, 156, 191, 302n21
Youtz, Philip, 100

Ziegfeld Follies, 32, 33